THOMAS EAKINS

The Heroism of Modern Life

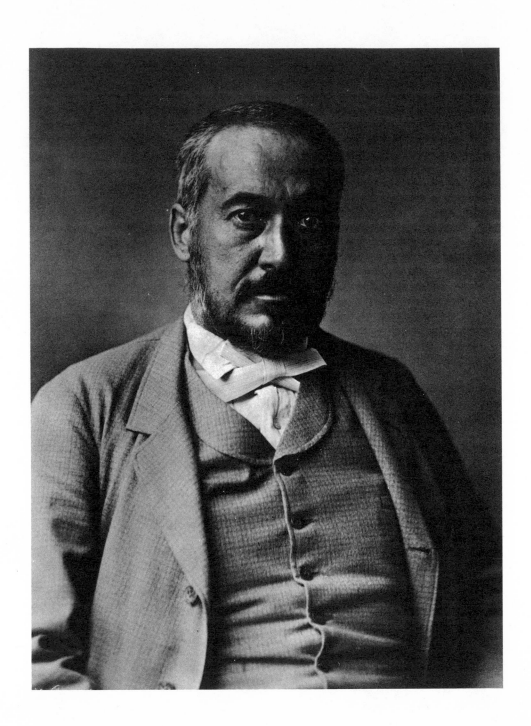

THOMAS EAKINS

The Heroism of Modern Life

BY ELIZABETH JOHNS

PRINCETON UNIVERSITY PRESS, PRINCETON, NEW JERSEY

Library of Congress Cataloging-in-Publication Data
Johns, Elizabeth, 1937-
Thomas Eakins, the heroism of modern life.
Bibliography: p. Includes index.
1. Eakins, Thomas, 1844-1916. 2. Painting, Modern—
19th century—United States—Themes, motives.
3. Painting—Psychological aspects. I. Title.
ND237.E15J64 1983 759.13 83-42606
ISBN 0-691-04022-2
ISBN 0-691-00288-6 (pbk.)

This book has been composed in Linotron Janson

Princeton University Press books are printed on acid-free paper
and meet the guidelines for permanence and durability of the
Committee on Production Guidelines for Book Longevity of the
Council on Library Resources

Color plates printed by Princeton Polychrome Press, Princeton, New Jersey
Text printed in the United States of America

3 5 7 9 10 8 6 4

Figure 1 (Frontispiece). *Thomas Eakins*, photograph by
Frederick Gutekunst, 1893.

The cover illustration is a detail from *The Gross Clinic*, 1875,
The Jefferson Medical College of
Thomas Jefferson University, Philadelphia; the photograph is
reproduced courtesy of Philadelphia Museum of Art.

To my mother and father

CONTENTS

LIST OF ILLUSTRATIONS ix

DIMENSIONS OF EAKINS' WORKS xv

ACKNOWLEDGMENTS xvii

PREFACE xix

CHAPTER ONE. Eakins, Modern Life, and the Portrait 3

CHAPTER TWO. *Max Schmitt in a Single Scull*, or *The Champion Single Sculls* 19

CHAPTER THREE. *The Gross Clinic*, or *Portrait of Professor Gross* 46

CHAPTER FOUR. *William Rush Carving His Allegorical Figure of the Schuylkill River* 82

CHAPTER FIVE. *The Concert Singer* 115

CHAPTER SIX. *Walt Whitman* 144

BIBLIOGRAPHIC ESSAY 171

INDEX 197

LIST OF ILLUSTRATIONS

UNLESS otherwise noted below, works are oil on canvas by Thomas Eakins and photographs have been provided by the owners of the work.

Figure 1. (Frontispiece) *Thomas Eakins*, photograph by Frederick Gutekunst, 1893. Philadelphia Museum of Art: Bequest of Mark Lutz.

FOLLOWING PAGE 10

Figure 2. *Thomas Eakins*, photograph by an unknown artist, c. 1868. Philadelphia Museum of Art: Bequest of Mark Lutz.

Figure 3. *Charles Baudelaire*, photograph by Etienne Carjat, c. 1863. International Museum of Photography at George Eastman House.

Figure 4. *Thomas Carlyle*, photograph by Julia Margaret Cameron, c. 1868-1869. International Museum of Photography at George Eastman House.

Figure 5. *Ralph Waldo Emerson*, photograph by Curtis and Cameron, c. 1868. Courtesy of the Library of Congress.

Figure 6. Sir Joshua Reynolds, *Samuel Johnson*, 1756. National Portrait Gallery, London.

Figure 7. Thomas Gainsborough, *Carl Frederic Abel*, 1788. Henry E. Huntington Library and Art Gallery, San Marino.

Figure 8. J. L. David, *Alphonse Leroy*, 1782-1783. Musée Fabre, Montpellier. Photograph by Claude O'Sughrue.

Figure 9. Charles Willson Peale, *Benjamin Franklin*, 1789. The Historical Society of Pennsylvania, Philadelphia.

Figure 10. Thomas Sully, *Benjamin Rush*, 1811. Pennsylvania Hospital, Philadelphia.

Figure 11. John Neagle, *Thomas Birch*, n.d. Courtesy of the Pennsylvania Academy of the Fine Arts, Philadelphia, Gift of John F. Lewis.

Figure 12. Jean-Léon Gérôme, *Dante*, engraving 1861. Courtesy of the Library of Congress.

Figure 13. Léon Bonnat, *Portrait of John Taylor Johnston (1820-1893), First President of the Metropolitan Museum of Art, 1870-1889*, 1880. The Metropolitan Museum of Art, Gift of the Trustees, 1880.

Figure 14. Diego Velázquez, *Martinez Montañés*, 1636. Museo del Prado, Madrid.

Figure 15. Diego Velázquez, *Las Meninas*, 1656. Museo del Prado, Madrid.

Figure 16. Thomas Couture, *The Little Confectioner*, n.d. Philadelphia Museum of Art: The William L. Elkins Collection.

FOLLOWING PAGE 42

Plate 1. *Max Schmitt in a Single Scull*, or *The Champion Single Sculls*, 1871. The Metropolitan Museum of Art, Purchase, 1934. Alfred N. Punnett Fund and Gift of George D. Pratt, 1934.

Plate 2. *Max Schmitt in a Single Scull*, or *The Champion Single Sculls*, 1871, detail. The Metropolitan Museum of Art, Purchase, 1934. Alfred N. Punnett Fund and Gift of George D. Pratt, 1934.

Plate 3. *The Pair-Oared Shell* (originally *The Biglin Brothers Practising*), 1872. Philadelphia Museum of Art: Given by Mrs. Thomas Eakins and Miss Mary A. Williams.

Figure 17. *Drawing of the Girard Avenue Bridge with sketch of an oar the verso*, pencil on pa-

per, ca. 1870. Hirshhorn Museum and Sculpture Garden, Smithsonian Institution.

Figure 18. *Perspective Drawing for "The Pair-Oared Shell,"* pencil, ink, and watercolor on paper, 1872. Philadelphia Museum of Art: Purchased: The Harrison Fund.

Figure 19. *Match Between Eton and Westminster Rowed at Putney August 1, 1843: The Eton winning by fourteen boats length*, lithograph by R. F. Thomas, 1843/44. Courtesy of the Parker Gallery, London.

Figure 20. *Henry Clasper, Champion of the North of Derwenthaugh by Newcastle on Tyne*, lithograph by R. M. Hodgretts and E. Walter, c. 1860, after J. H. Make. Courtesy of Kenneth M. Newman of The Old Print Shop, New York.

Figure 21. *James Hammill and Walter Brown, in their Great Five Mile Rowing Match for $4000 and the Championship of America*, lithograph by Currier and Ives, 1867. Courtesy of the Library of Congress.

Figure 22. "Barnes Bridge," *Harper's New Monthly Magazine*, December, 1869. Courtesy of the Library of Congress.

Figure 23. "Picked Crew of London Rowing Club" and "Elliott's Boat," *Harper's New Monthly Magazine*, December, 1869. Courtesy of the Library of Congress.

Figure 24. "Harry Kelley," *Harper's New Monthly Magazine*, December, 1869. Courtesy of the Library of Congress.

Figure 25. "Walter Brown, American champion," *Harper's New Monthly Magazine*, December, 1869. Courtesy of the Library of Congress.

Figure 26. *A View of Fairmount Waterworks with Schuylkill in the Distance Taken from the Mount*, lithograph by John T. Bowen, 1835. The Library Company of Philadelphia.

Figure 27. A. A. Lawrence, *Boat Race, Boston Harbor*, 1852. Courtesy, Museum of Fine Arts, Boston, M. and M. Karolik Collection.

Figure 28. "The Rowing Courses Used on the Schuylkill River," *Turf, Field and Farm*, June 14, 1872. Courtesy of the Library Company of Philadelphia.

Figure 29. *The Biglin Brothers Racing* (orig. *The Biglin Brothers About to Start the Race*), ca. 1873. Gift of Mr. and Mrs. Cornelius Vanderbilt Whitney, National Gallery of Art, Washington.

Figure 30. *John Biglin in a Single Scull*, watercolor on paper, 1873-1874. The Metropolitan Museum of Art, Fletcher Fund, 1924.

Figure 31. *Bufford's Comic Sheet—No. 419.* Courtesy of the Library of Congress.

FOLLOWING PAGE 74

Plate 4. *The Gross Clinic*, 1875. The Jefferson Medical College of Thomas Jefferson University, Philadelphia.

Plate 5. *The Gross Clinic*, 1875, detail. The Jefferson Medical College of Thomas Jefferson University, Philadelphia.

Plate 6. *The Agnew Clinic*, 1889. The University of Pennsylvania School of Medicine. Photograph Philadelphia Museum of Art.

Figure 32. *Composition study for the Portrait of Professor Gross*, 1875. Philadelphia Museum of Art: Given by Mrs. Thomas Eakins and Miss Mary A. Williams.

Figure 33. *Study for the Head of Professor Gross*, 1875. Worcester Art Museum, Worcester, Massachusetts.

Figure 34. *Study for spectator (Robert Meyers)*, 1875. Collection of Mr. and Mrs. Daniel W. Dietrich II, Philadelphia. Photograph Eric Mitchell.

Figure 35. *Portrait of Professor Rand*, 1874. The Jefferson Medical College of Thomas Jefferson University, Philadelphia.

Figure 36. Rembrandt van Rijn, *The Anatomy Lesson of Dr. Nicolaas Tulp*, 1632. Mauritshuis, The Hague. Photograph by Editorial Photocolor Archives.

Figure 37. *An operation under ether at Massachusetts General Hospital*, photograph, ca. 1850. National Library of Medicine.

Figure 38. Anon. *Patient in the presence of Charles X after a cataract operation by Dupuytren*, ca. 1820. Musée Carnavalet, Paris.

Figure 39. *Marie-François Bichat*, engraved 1834 after painting by Emile Béranger. Published in *Le Plutarque français*, Paris: Mennachet, 1835-1841. National Library of Medicine.

Figure 40. Edouard Hamman, *Vesalius at Padua in 1546*, 1848. Musée des Beaux-Arts, Marseille.

Figure 41. *The Museum of Charity Hospital* (Scenes from the Salle de garde). In *L'Universe Illustré*, 1880, p. 216. Bibliothèque Nationale, Paris.

Figure 42. F.-N.-A. Feyen-Perrin. *The Anatomy Lesson of Dr. Velpeau*, 1864. Musée des Beaux-Arts, Tours. Photograph by Bulloz.

Figure 43. Louis Matout, *Ambroise Paré Applying Ligatures after an Amputation*, installed in the amphitheater, École de Médecine, 1864. Engraving by Goupil (painting destroyed). National Library of Medicine.

Figure 44. *The Gross Clinic*, India ink wash on cardboard, 1876. The Metropolitan Museum of Art, Rogers Fund, 1923.

Figure 45. Ward of Model Post Hospital, Medical Department, Philadelphia Centennial Exposition, photograph, 1876, showing installation of *The Gross Clinic*. Courtesy of the Library of Congress.

Figure 46. *Dr. William Thomson*, 1907. The College of Physicians of Philadelphia.

FOLLOWING PAGE 90

Plate 7. *William Rush Carving His Allegorical Figure of the Schuylkill River*, 1877. Philadelphia Museum of Art: Given by Mrs. Thomas Eakins and Miss Mary A. Williams.

Plate 8. *William Rush Carving His Allegorical Figure of the Schuylkill River*, 1877, detail. Philadelphia Museum of Art: Given by Mrs. Thomas Eakins and Miss Mary A. Williams.

Plate 9. *William Rush and His Model*, 1908. Honolulu Academy of Arts: Gift of Friends of the Academy, 1947.

Figure 47. William Rush, *Water Nymph and Bittern* or *Allegorical Figure of the Schuylkill River*, bronze cast of wooden original, 1872. The Commissioners of Fairmount Park, Philadelphia. Photograph by Philadelphia Museum of Art.

Figure 48. *Centre Square* (an early view, ca. 1809) engraved by C. Tiebout after John J. Barralet. The Historical Society of Pennsylvania, Philadelphia.

Figure 49. William Rush, *Allegory of the Waterworks* (*The Schuylkill Freed*), 1825. The Commissioners of Fairmount Park, Philadelphia. Photograph by Philadelphia Museum of Art.

Figure 50. *Fairmount Waterworks, From the Forebay*, lithograph by Childs and Lehman, 1833 (showing installation of Rush's reclining figures over wheelhouse doors; arc of spray from fountain figure visible on the left). The Historical Society of Pennsylvania, Philadelphia.

Figure 51. *Fountain and Stand-Pipe*, engraving by J. W. Lauderbach after J. D. Woodhouse. Reproduced in Earl Shinn, *A Century After, Picturesque Glimpses of Philadelphia* (Philadelphia: Allen, Lane & Scott & J. W. Lauderbach, 1875). Courtesy of the Library of Congress.

Figure 52. William Rush, *George Washington*, wood 1814. Independence Hall Historical Park Collection and City of Philadelphia Collection. Photograph by Philadelphia Museum of Art.

Figure 53. William Rush, *Self-Portrait*, c. 1822. Courtesy of the Pennsylvania Academy of the Fine Arts. Bronze cast from the original in the academy collection.

Figure 54. *Installation of Rush's Nymph with Bittern in Fairmount Park near the Callowhill Street Bridge*, photograph ca. 1876. Commissioners of Fairmount Park. Photograph by Philadelphia Museum of Art.

Figure 55. John L. Krimmel, *Fourth of July in Centre Square*, ca. 1810-1812. Courtesy of the Pennsylvania Academy of the Fine Arts: Academy Purchase from Paul Beck Estate.

Figure 56. *Study of Woman with Parasol*, 1875-1876. Hirshhorn Museum and Sculpture Garden, Smithsonian Institution.

Figure 57. *Wax Studies for William Rush Carving His Allegorical Figure of the Schuylkill River*, ca. 1875-1876. Philadelphia Museum of Art: Given by Mrs. Thomas Eakins and Miss Mary A. Williams.

Figure 58. *Composition Study for William Rush Carving His Allegorical Figure of the Schuylkill River*, ca. 1875-1876. Yale University Art Gallery: The James W. and Mary C. Fosburgh Collection.

Figure 59. Gustave Courbet, *The Artist's Studio*, 1855. Musée du Louvre, Paris. Photograph by Girardon/Editorial Photocolor Archives.

Figure 60. Eugene Delacroix, *Michelangelo in His Studio*, 1852. Musée Montpellier. Photograph by Claude O'Sughrue.

Figure 61. J.-L. Gérôme, *Rembrandt Etching a Plate*, 1861. Engraving by Goupil. Courtesy of the Library of Congress.

Figure 62. Charles Willson Peale, *The Artist in His Museum*, 1822. Courtesy of the Pennsylvania Academy of the Fine Arts: Joseph and Sarah Harrison Collection.

Figure 63. William Sidney Mount, *The Painter's Triumph*, 1830. Courtesy of the Pennsylvania Academy of the Fine Arts: Bequest of Henry C. Carey.

Figure 64. Tompkins H. Matteson, *Erastus Dow Palmer in His Studio*, 1857. Collection Albany Institute of History and Art.

Figure 65. J.-L. Gérôme, *The Artist and His Model*, ca. 1890. Haggin Collection, The Haggin Museum, Stockton, California.

Figure 66. L. M. Cochereau, *The Studio of David*, 1814. Musée du Louvre, Paris. Photograph by Musées Nationaux.

Figure 67. Alice Barber, *Female Life Class*, 1879. Courtesy of the Pennsylvania Academy of the Fine Arts: Commissioned by the School.

Figure 68. *Pen and Ink Drawing after William Rush Carving His Allegorical Figure of the Schuylkill River*, 1881. Hirshhorn Museum and Sculpture Garden, Smithsonian Institution.

Figure 69. William Merritt Chase, *The Tenth Street Studio*, ca. 1905-1906. Museum of Art, Carnegie Institute, Pittsburgh: Purchase, 1971.

Figure 70. *William Rush Carving His Allegorical Figure of the Schuylkill River*, 1908. Courtesy of the Brooklyn Museum, Dick S. Ramsay Fund.

Figure 71. *Sketch for William Rush and His Model*, ca. 1908. Philadelphia Museum of Art: Given by Mrs. Thomas Eakins and Miss Mary A. Williams.

FOLLOWING PAGE 138

Plate 10. *The Concert Singer*, 1892. The Philadelphia Museum of Art: Given by Mrs. Thomas Eakins and Miss Mary A. Williams.

Plate 11. *Professionals at Rehearsal*, 1883. Philadelphia Museum of Art: The John D. McIlhenny Collection.

Plate 12. *The Cello Player*, 1896. Courtesy of the Pennsylvania Academy of the Fine Arts: Temple Fund Purchase.

Figure 72. John Singer Sargent, *Rehearsal of the Pasdeloup Orchestra at the Cirque d'Hiver*, ca. 1870. Courtesy, Museum of Fine Arts, Boston. Charles Henry Hayden Fund.

Figure 73. Edgar Degas, *The Orchestra at the Opéra*, ca. 1869. Musée du Louvre, Jeu de Paume, Paris. Photograph Musées Nationaux.

Figure 74. George Hollingsworth, *The Hollingsworth Family*, ca. 1840. Courtesy, Museum of Fine Arts, Boston. M. and M. Karolik Collection.

Figure 75. J. M. Whistler, *At the Piano*, 1859. The Taft Museum, Cincinnati: Louise Taft Semple Bequest.

Figure 76. Edgar Degas, *Mlle. Dihau at the Piano*, ca. 1869. Musée du Louvre, Jeu de Paume, Paris. Photograph by Musées Nationaux.

Figure 77. *Home Scene*, ca. 1871. The Brooklyn Museum: Gift of George A. Hearn, Frederick Loeser Art Fund, Dick S. Ramsay Fund, Gift of Charles A. Schieren.

Figure 78. *Frances Eakins*, 1870. Nelson-Atkins Museum of Art, Kansas City, Missouri: Nelson Fund.

Figure 79. *At the Piano*, ca. 1872. Gift of Dr. Caroline Crowell, Archer M. Huntington Art Gallery, The University of Texas at Austin.

Figure 80. *Elizabeth at the Piano*, 1875. Addison Gallery of American Art, Phillips Academy, Andover.

Figure 81. Pompeo Batoni, *Luigi Boccherini*, 1800. Institut für Kunstwissenschaft, Zürich.

Figure 82. Edgar Degas, *The Cellist Pillet*, ca. 1869, Musée du Louvre, Jeu de Paume, Paris. Photograph by Musées Nationaux.

Figure 83. *F. A. Kummer*, photograph ca. 1865. From Edmund van der Straeten, *History of the Violincello*, 2 vols. (London: William Reeves, 1915; rpt. New York: AMS Press Inc., 1976). Courtesy of AMS Press, Inc.

Figure 84. *Music*, 1904. Albright-Knox Art Gallery, Buffalo, New York: George Cary, Edmund Hayes and James G. Forsyth Funds, 1955.

Figure 85. J. M. Whistler, *Arrangement in Black: Pablo de Sarasate*, 1884. Museum of Art, Carnegie Institute, Pittsburgh: Purchase, 1896.

Figure 86. *The Piping Shepherd*, wood engraving after Fortuny, *Scribner's Magazine* October 1879. Courtesy of the Library of Congress.

Figure 87. *Photograph of J. Laurie Wallace Seated on Rock, Study for Arcadia Relief*, 1883. Philadelphia Museum of Art: Bequest of Mark Lutz.

Figure 88. *Study of Ben Crowell for Arcadia*, 1883. Hirshhorn Museum and Sculpture Garden, Smithsonian Institution.

Figure 89. *Arcadia*, 1883. Metropolitan Museum of Art, Bequest of Miss Adelaide Milton de Groot (1876-1967), 1967.

Figure 90. *Arcadia*, plaster relief, 1883. Philadelphia Museum of Art: Purchased: J. Stogdell Stokes Fund.

Figure 91. *Portrait of a Lady with a Setter Dog* (Susan Eakins), ca. 1885. Metropolitan Museum of Art, Fletcher Fund, 1933.

Figure 92. Edgar Degas, *The Singer in Green*, pastel, ca. 1885. Metropolitan Museum of Art, Bequest of Stephen C. Clark, 1960.

Figure 93. *The Pathetic Song*, 1881. In the Collection of the Corcoran Gallery of Art, Museum Purchase.

Figure 94. Henry Lerolle, *A Rehearsal in the Choir Loft*, 1887. Metropolitan Museum of Art, Gift of George I. Seney, 1887.

Figure 95. *Cowboy Singing*, c. 1890. Philadelphia Museum of Art: Given by Mrs. Thomas Eakins and Miss Mary A. Williams.

Figure 96. Eakins, *Home Ranch*, ca. 1892. Philadelphia Museum of Art: Given by Mrs. Thomas Eakins and Miss Mary A. Williams.

Figure 97. *The Concert Singer*, 1892, showing carving on frame. The Philadelphia Museum of Art: Given by Mrs. Thomas Eakins and Miss Mary A. Williams.

Figure 98. Photograph of Clara Louise Kellogg as Aïda, from Oscar Thompson, *The American Singer* (New York: Dial Press, 1937; rpt. New York: Johnson Reprint Corp., 1969).

Figure 99. Paul Weber, *Portrait of an Opera Singer*, 1839. Photograph courtesy of Victor Spark.

Figure 100. *Parepa Rosa Reynolds*, engraved frontispiece to *North's Philadelphia Musical Journal*, July, 1887. Courtesy of the Library of Congress.

FOLLOWING PAGE 170

Plate 13. *Walt Whitman*, 1887. Courtesy of the Pennsylvania Academy of the Fine Arts: General Fund Purchase.

Plate 14. *Frank Hamilton Cushing*, 1895. The Thomas Gilcrease Institute of American History and Art, Tulsa, Oklahoma.

Plate 15. *Mrs. Edith Mahon*, 1904. Smith College Museum of Art.

Plate 16. *Mrs. Thomas Eakins*, 1899. Hirshhorn Museum and Sculpture Garden, Smithsonian Institution. Photograph by John Tennant.

Figure 101. *The Writing Master*, 1882. The Metropolitan Museum of Art, Kennedy Fund, 1917.

Figure 102. *Henry O. Tanner*, 1900. The Hyde Collection, Glens Falls, New York.

Figure 103. *Professor Henry A. Rowland*, 1891. Addison Gallery of American Art, Phillips Academy, Andover.

Figure 104. *Portrait of Professor Leslie W. Miller*, 1901. Philadelphia Museum of Art: Given by Martha P. L. Seeler.

Figure 105. *Portrait of Rear Admiral George Wallace Melville*, 1904. Philadelphia Museum of Art: Given by Mrs. Thomas Eakins and Miss Mary A. Williams.

Figure 106. *Salutat*, 1898. Addison Gallery of American Art, Phillips Academy, Andover.

Figure 107. *Mrs. William D. Frishmuth, or Antiquated Music*, 1900. Philadelphia Museum of Art: Given by Mrs. Thomas Eakins and Miss Mary A. Williams.

Figure 108. *An Actress* (Portrait of Suzanne Santje), 1903. Philadelphia Museum of Art: Given by Mrs. Thomas Eakins and Miss Mary A. Williams.

Figure 109. *Portrait of Archbishop Diomede Falconio*, 1905. National Gallery of Art, Washington. Gift of Stephen C. Clark, 1946.

Figure 110. *Portrait of Dr. Horatio C. Wood*, ca. 1890. Detroit Institute of Arts: City of Detroit Purchase.

Figure 111. John Singer Sargent, *Portrait of Mrs. J. William White*, 1903. Philadelphia Museum of Art: Commissioners of Fairmount Park: Mrs. J. William White Collection.

Figure 112. William Merritt Chase, *Portrait of Mrs. C. (Lady with the White Shawl)*, 1893. Courtesy of the Pennsylvania Academy of the Fine Arts. Temple Fund Purchase, 1895.

Figure 113. Cecilia Beaux, *New England Woman*, 1895. Courtesy of the Pennsylvania Academy of the Fine Arts. Temple Fund Purchase, 1896.

Figure 114. *Photograph of Walt Whitman*, c. 1887. Philadelphia Museum of Art: Bequest of Mark Lutz.

Figure 115. *Portrait of Dr. Jacob M. Da Costa*, 1893. Pennsylvania Hospital, Philadelphia.

Figure 116. Robert Vonnoh, *Portrait of Dr. Jacob M. Da Costa*, 1893. The College of Physicians of Philadelphia.

Figure 117. *The Dean's Roll Call (Portrait of James W. Holland)*, 1899. Courtesy Museum of Fine Arts, Boston, Abraham Shuman Fund.

Figure 118. *Portrait of Professor William Smith Forbes*, 1905. The Jefferson Medical College of Thomas Jefferson University, Philadelphia.

Figure 119. Robert Vonnoh, *Portrait of Dr. Jacob M. Da Costa*, 1893. The Jefferson Medical College of Thomas Jefferson University, Philadelphia.

Figure 120. William Merritt Chase, *Portrait of Dr. William W. Keen*, 1910. The Jefferson Medical College of Thomas Jefferson University, Philadelphia.

Figure 121. *Portrait of Letitia Wilson Jordan*, 1888. The Brooklyn Museum: Dick S. Ramsay Fund.

Figure 122. *Portrait of Mary Adeline Williams (Addie)*, c. 1900. Philadelphia Museum of Art: Given by Mrs. Thomas Eakins and Miss Mary A. Williams.

Figure 123. *The Old-Fashioned Dress (Portrait of Helen Parker)*, c. 1908. Philadelphia Museum of Art: Given by Mrs. Thomas Eakins and Miss Mary A. Williams.

Figure 124. *Self-Portrait*, 1902. National Academy of Design, New York.

DIMENSIONS OF EAKINS' WORKS

FOLLOWING PAGE 42

Plate 1. *Max Schmitt in a Single Scull.* 81.9 × 117.5 cm

Plate 3. *The Pair-Oared Shell.* 61 × 91.4 cm

Figure 17. *Drawing of the Girard Avenue Bridge* 10.5 × 17.5 cm

Figure 18. *Perspective Drawing for "The Pair-Oared Shell."* 80.8 × 120.8 cm

Figure 29. *Biglin Brothers Racing.* 61.3 × 91.8 cm

Figure 30. *John Biglin in a Single Scull.* 43.5 × 58.4 cm

FOLLOWING PAGE 74

Plate 4. *The Gross Clinic.* 243.8 × 198.1 cm

Plate 6. *The Agnew Clinic.* 189.2 × 331.5 cm

Figure 32. *Composition Study for Gross Clinic.* 66 × 55.9 cm

Figure 33. *Study for the Head of Professor Gross.* 61 × 45.7 cm

Figure 34. *Study for Spectator (Robert Meyers).* 22.9 × 21.6 cm

Figure 35. *Portrait of Professor Rand.* 152.4 × 121.9 cm

Figure 44. *Gross Clinic.* 65.1 × 48.6 cm

Figure 46. *Dr. William Thomson.* 188 × 122 cm

FOLLOWING PAGE 90

Plate 7. *William Rush Carving His Allegorical Figure of the Schuylkill River.* 51.1 × 66.4 cm

Plate 9. *William Rush and His Model.* 91.4 × 121.9 cm

Figure 56. *Study of Woman with Parasol.* 18.4 × 11.9 cm

Figure 57. *Wax Studies for William Rush.* 24.8 × 11.4 cm

Figure 58. *Composition Study for William Rush.* 51.3 × 61 cm

Figure 68. *Pen and Ink Drawing after William Rush.* 24.8 × 30.5 cm

Figure 70. *William Rush Carving* (1908). 92.6 × 123 cm

Figure 71. *Sketch for William Rush and Model.* 36.8 × 26.7 cm

FOLLOWING PAGE 138

Plate 10. *The Concert Singer.* 190.5 × 137.2 cm

Plate 11. *Professionals at Rehearsal.* 40.6 × 30.5 cm

Plate 12. *The Cello Player.* 162.6 × 121.9 cm

Figure 77. *Home Scene.* 55.2 × 45.7 cm

Figure 78. *Frances Eakins.* 61 × 50.8 cm

Figure 79. *At the Piano.* 55.9 × 46.4 cm

Figure 80. *Elizabeth at the Piano.* 182.9 × 121.9 cm

Figure 84. *Music.* 100.3 × 126.4 cm

Figure 88. *Study of Ben Crowell.* 26.4 × 37.1 cm

Figure 89. *Arcadia.* 98.4 × 114.3 cm

Figure 90. *Arcadia.* 29.8 × 61 × 5.6 cm

Figure 91. *Portrait of a Lady with Setter Dog.* 76.2 × 58.4 cm

Figure 93. *The Pathetic Song.* 114.9 × 82.5 cm

Figure 95. *Cowboy Singing.* 61 × 50.8 cm

Figure 96. *Home Ranch.* 61 × 50.8 cm

Figure 97. *The Concert Singer.* 190.5 × 137.2 cm

FOLLOWING PAGE 170

Plate 13. *Walt Whitman.* 76.2 × 61 cm

Plate 14. *Frank Hamilton Cushing.* 228.6 × 152.4 cm

xv

Plate 15. *Mrs. Edith Mahon.* 50.8 × 40.6 cm

Plate 16. *Mrs. Thomas Eakins.* 50.8 × 40.6 cm

Figure 101. *The Writing Master.* 76.2 × 87 cm

Figure 102. *Henry O. Tanner.* 61.3 × 51.4 cm

Figure 103. *Professor Henry A. Rowland.* 203.2 × 137.1 cm

Figure 104. *Portrait of Professor Leslie Miller.* 223.8 × 111.7 cm

Figure 105. *Portrait of Rear Admiral Melville.* 121.9 × 76.2 cm

Figure 106. *Salutat.* 127 × 101.6 cm

Figure 107. *Mrs. William D. Frishmuth.* 243.8 × 182.9 cm

Figure 108. *An Actress.* 203.2 × 151.1 cm

Figure 109. *Portrait of Archbishop Falconio.* 182.9 × 138.1 cm

Figure 110. *Portrait of Dr. Horatio C. Wood.* 162.6 × 127 cm

Figure 115. *Portrait of Dr. Jacob M. Da Costa.* 106.7 × 86.4 cm

Figure 117. *The Dean's Roll Call.* 213.4 × 106.7 cm

Figure 118. *Portrait of Professor William Forbes.* 213.4 × 121.9 cm

Figure 121. *Portrait of Letitia Wilson Jordan.* 149.9 × 100.3 cm

Figure 122. *Portrait of Mary Adeline Williams.* 61 × 45.7 cm

Figure 123. *The Old-Fashioned Dress.* 152.7 × 102.2 cm

Figure 124. *Self-Portrait.* 76.2 × 63.5 cm

ACKNOWLEDGMENTS

A NUMBER of people and institutions have made this book possible, and I would like to thank them here. My research was funded by generous grants from the General Research Board of the University of Maryland, the American Council of Learned Societies, the Wyeth Endowment of American Art, and by a year's Postdoctoral Fellowship with the Smithsonian Institution. Librarians, archivists, and historians at the following institutions gave me important assistance: the Library of Congress, the Smithsonian Institution, the Archives of American Art and the Inventory of American Painting (at the Smithsonian Institution), the National Library of Medicine, the Jefferson Medical College Archives of Thomas Jefferson University, the Alumni Association of Jefferson Medical College, the Bibliothèque Nationale, the New York Public Library, the Historical Society of Pennsylvania, the Library Company of Philadelphia, the Free Library of Philadelphia, the Academy of Natural Sciences of Philadelphia, the Academy of Music of Philadelphia, and the Camden County Historical Society. Curators at the Metropolitan Museum of Art, the Boston Museum of Fine Arts, the National Gallery of Art, the Philadelphia Museum of Art, and the Pennsylvania Academy of the Fine Arts were generous with their time. In Philadelphia, Seymour Adelman was particularly helpful, as were Darrel Sewell at the Philadelphia Museum of Art and Frederick B. Wagner, Jr., M.D., Grace Revere Osler Professor of Surgery at Jefferson Medical College; at the National Library of Medicine in Bethesda, Peter J. Olch, M.D. gave valuable encouragement. Conservators Sarah L. Fisher, Ross Merrill, and S. Ann Hoenigswald at the National Gallery of Art, Dianne Dwyer at the Metropolitan Museum of Art, and, most prominently, Marion Mecklenburg of the Washington Conservation Studio helped me immensely in studying Eakins' technique. My students at the University of Maryland, in an Eakins seminar in 1980 and in general lecture courses, asked valuable questions that kept me attentive to many points of view. I owe an unending debt to colleagues who read and criticized my manuscript in various stages. At the Smithsonian Institution, Lois Fink, Judith Zilczer, Phyllis Rosenzweig, and William Truettner gave encouraging support and advice; Lillian Miller and Ellen Miles offered valuable sugges-

tions. I was also fortunate to have close readings and commentary from Ann Abrams, Nicolai Cikovsky, Jr., Wanda Corn, William Innes Homer, Jules Prown, and John Wilmerding. The flaws that remain are, of course, my own. Special gratitude goes to my brother John B. Bennett, of the American Council on Education, a critic and editor of the highest order. Finally, I am more grateful than I can say to my husband, Max Johns, and my children, Alan and Nancy Butsch, for their good-natured interest during six years of Thomas Eakins.

PREFACE

THIS STUDY examines Thomas Eakins in the cultural context of his era, late nineteenth-century America. Of the many themes that informed that rich era, several illuminate Eakins' career so clearly as to place him—and his achievement—in a bright light. I will set them forth in this study.

My approach is a new one for Eakins scholarship (although certainly not for art historical studies in general). Previous scholars have focused on Eakins' style and on his unhappy relationship with some of his fellow Philadelphians, particularly those connected with the institutional stronghold of art in the city, the Pennsylvania Academy of the Fine Arts. Motivating my own study of Eakins is the conviction that my predecessors, fine as their studies were, did not give sufficient weight to several crucial points about Eakins' career. Important among these is the fact that Eakins had an income from his father and could paint what was significant to him. From his earliest years, he painted almost nothing but portraits.[1] No more than twenty-five of these portraits (the whole body of which involved over two hundred sitters and subjects) were commissioned. For all of the others, it was Eakins who took the initiative and secured the participation of his sitters. And although his portraits offended so many of his sitters that the rejected paintings now comprise large museum holdings, particularly in Philadelphia, year after year prominent people made the climb to Eakins' fourth-floor studio and sat through his arduous requirements for sittings. These factors have fundamental importance in assessing what painting meant to Eakins, and what his convictions meant in his time.

[1] Works that are not portraits in the usual sense are Eakins' sailing and hunting scenes (although these are more properly scenes of an admired activity than a landscape or a seascape); his scenes in the 1880s of the shore and meadows near Gloucester, N.J.; *The Fairman Rogers Four-in-Hand*, 1879 (Philadelphia Museum of Art); and *The Crucifixion*, 1880 (Philadelphia Museum of Art). Generally, however, Eakins thought of even his sporting scenes as portraits, for he wrote to his friend Earl Shinn that the watercolor and oil *A Negro Whistling Plover*, 1874 (watercolor, Brooklyn Museum; oil, now lost) portrayed William Robinson of Backneck, and that the watercolor *Baseball Players Practising*, 1875 (Museum of Art, Rhode Island School of Design) was a portrait of members of the Philadelphia baseball team, the Athletics (Eakins to Shinn, January 30, 1875, Cadbury Collection, Friends Historical Library, Swarthmore College).

In addition to Eakins' extraordinary interest in the portrait, another point seemed to me to warrant deeper attention, and that was his technique. Generally, scholars have called Eakins an "objective realist" who painted "what he saw" rather than what he imagined, and who believed his responsibility to lie in measurement and accuracy rather than allusion. In contrast, I find that his canvases are only in some areas minutely measured and "objectively" painted; in almost every work there are large areas in which his technique is free, experimental, and sometimes even deliberately clumsy. Such variety in technique calls for greater recognition and interpretation.

Thus I began my own study of Eakins with these two questions: Why did Eakins paint what he painted? Why did he paint the way that he did?

I have focused my resulting discussion on five major paintings rather than on Eakins' entire body of work. After an introductory chapter in which I set forth the contexts of nineteenth-century modernity, heroic ideals, and portraiture that influenced Eakins, I develop these themes in five chapters keyed to single paintings: *Max Schmitt in a Single Scull, The Gross Clinic, William Rush Carving His Allegorical Figure of the Schuylkill River, The Concert Singer*, and *Walt Whitman*. These chapters are focal points in a study that is chronological and cumulative.

The complex culture in which Eakins lived and worked can be analyzed from several points of view. I have chosen to take the viewpoint of geography—of Philadelphia and of Paris, against a background of concerns shared across America and Europe; of time—of Eakins' era specifically but also of the decades of the nineteenth century that preceded him; and of the values and aspirations of the people who attracted Eakins as sitters—people who wrote, made music, practiced medicine, worked in scientific laboratories, enjoyed the outdoors, and painted. In order to keep Eakins at the center of the study, I have presented in detail only some of the contextual discussions; in others, where I have judged that the material is more widely known, I have generalized.

My objective throughout has been to discuss what drew me to Eakins originally: to establish the experience within which Eakins chose his subjects and to characterize the convictions with which he painted them in his own way.

THOMAS EAKINS
The Heroism of Modern Life

Eakins, Modern Life, and the Portrait

THOMAS EAKINS was a painter of portraits. Financially independent, he followed a drumbeat from 1870 to 1910 that guided virtually no other contemporary major artist, either of America or of Europe. Some of these artists concentrated on landscapes or urban and domestic genre, others on still life and visionary scenes. Those most well known today turned their back on traditional painting techniques. In manner as well as in subject, they contributed to a deepening suspicion that art existed quite separate from the events and issues of contemporary life. Artists who painted portraits during these decades—and there were indeed quite a few of them—typically did so on commission or in moments when they were relaxing from their primary artistic work. Eakins, on the other hand, was passionately devoted to the portrait. For him, the human being was central to art—but not just any man or woman with an interesting face; rather he sought the person who in his full intellectual, aesthetic, and athletic power was definitive of the best of his times. In choosing his sitters, Eakins consistently paid tribute to such persons and to their achievements. In these choices, he drew on, explored, and celebrated cultural ideals prominent among his fellow citizens in the larger world beyond art.

That world during Eakins' lifetime was one of astounding change. The revolutions affecting it had begun early, some of them before the turn of the nineteenth century. Political egalitarianism had altered social structures, extending rights and giving new expectations to large masses of people; industrialization and material progress had brought citizens new occupations and an unparalleled number of leisure activities and comforts; educational opportunities had created an increasingly literate population and opened most of the professions to aspiring members of the middle and even of the lower classes; scientific investigation had expanded knowledge and almost wholly altered men's perception of the material world; traditional religious belief

had declined, and indeed, in many instances, had died. Acutely aware of these changes, cultural spokesmen from as early as 1840 used the term "modern" almost obsessively to define the character of their times. After 1870, when Eakins began painting, the changes so accelerated that to many observers, institutions and leaders alike seemed to be breaking off from all steadying connections with the past. More than one spokesman suggested that increasing mechanization would cause man to lose his central place in his own world.

In response to this growing sense of dislocation, a major cultural interpretation gained currency about the time Eakins was born. This was the hope expressed by such figures as Charles Baudelaire in France, Thomas Carlyle in England, and Ralph Waldo Emerson in America (Figures 3, 4, 5) that the traditional ideal of heroism could be translated into terms applicable to "modern" life. Heroism had always been a powerful concept. Before the mid-eighteenth century it had been an aristocratic ideal, associated, if not exclusively with the class itself, at least with the virtues and attainments traditionally cultivated there: nobility and courage of spirit, educated and supple intellect, moral purposefulness. Rare in tangible manifestation, heroism was an ideal of grace and selflessness that seemed to be absolutely essential to a community's continuity. During the middle and late eighteenth century, a rising group of middle-class intellectuals and scientists across Europe and in America—Voltaire, Samuel Johnson, and Benjamin Franklin, among others—had shown by example that heroic virtues could be cultivated within a variety of social positions. Their achievements demonstrated to optimistic nineteenth-century successors that heroic action came from traits of character that most men, with the encouragement of the new democratic times, had the potential to develop: the exercise of reason, firm standards of morality, and admirable self-discipline.

Although Baudelaire, Carlyle, and Emerson gave public voice to the conviction, they had serious reservations that the ideal was definable, much less achievable. The terms of community and individual experience since the late eighteenth century had changed too drastically. Baudelaire concluded his first exhibition review of the Paris Salon in 1845 with the plea that artists paint "the heroism of modern life," but in his own turbulent career, pursued through turbulent times, he was never fully sure in what precisely—in a materialistic, egalitarian culture—heroism might inhere. Carlyle, addressing a larger audience, traced the evolution of cultural heroes from early religious figures through political figures to recent intellectual figures, simultaneously

4

considering and doubting whether the average man of the nineteenth century, the heir apparent to that evolution, could cultivate even the semblance of heroic virtues. Unwilling, and perhaps even unable, to identify heroism with a specific creed or action, Carlyle finally located it in the imagination, defining it as the hero's ability to see beneath appearances to the essential. Across the Atlantic, Emerson saw heroism as an act of resistance rather than affirmation. Perhaps the least comfortable of the three men with the materiality of modern life, he held up for emulation the spiritual strength with which modern man could pit himself against the external world. For each of these men, the task of the artist was crucial. Carlyle put it best: the artist "could not sing the Heroic warrior, unless he himself were at least a Heroic warrior too."[1]

The doubts of Baudelaire, Carlyle, and Emerson were unusual in their times, and did not find echoes in less prescient spokesmen until late in the century. Most citizens on both sides of the Atlantic in the 1830s and 1840s, benefiting from the sweeping growth of educational, professional, and social opportunities, had every confidence that the eighteenth-century terms of heroism could be grafted to modern life. Their optimism became an article of faith that dominated popular and professional literature. Leaders in the new professional fields, men in commerce and industry, educators, and publishers of the vastly expanding number of periodicals and newspapers urged that men could cultivate heroism in every role—that of the physician, the writer, the pianist, the banker, the factory owner, even the athlete. Their creed had several tenets. These modern heroes would be "scientific," undertaking their work on the basis of principles developed through direct observation and experimentation; they would be "egalitarian," investigating without prejudice all phenomena, activities, and people; they would be "progressive," acutely sensitive to change, and demonstrating their awareness of it by knowing the history of their pursuit. And finally, they would be "doers." They would transform the old hierarchies, in which a man's worth was determined by his class, with the egalitarian standard of performance.

These confident articles of faith guided Eakins' sitters in their achievements. And just as the ideology with which they pursued their careers was a synthesis of eighteenth- and nineteenth-century currents—of faith in reason and discipline, and commitment to egalitarian opportunity—so was the character of the form with which Eakins honored them, the portrait.

[1] "The Poet as Hero," in *On Heroes, Hero Worship, and the Heroic in History* (New York: AMS Press, 1974), p. 79.

5

Throughout history rarely simply a likeness, the portrait early in its life had come to have a public or community function in conveying the sitter's position and accomplishments. Whether with the insignia and trappings of monarchical power, or religious authority, or scholarly integrity complementing the image of the sitter, the portrait affirmed and strengthened the values by which the community was ordered. Even portraits apparently private (like the great self-portraits of Rembrandt, for instance) that explored the psychological dimensions of a sitter in a simple bust format grew from and reinforced a commitment in the artist's culture to spiritual integrity.

Concurrent with the development of the ideal of intellectual and scientific heroism in the mid-eighteenth century, artists had begun to apply the large-scale and lavish iconography of earlier monarchical and aristocratic portraiture to portraits of the new men of the Enlightenment. Inspired to do so at least partially by their strong interest in history painting, for which there was spare patronage, artists applied the intellectual underpinnings of that tradition to the portrait. Ambitious men like Sir Joshua Reynolds and Thomas Gainsborough in England, Jacques Louis David in France, and Charles Willson Peale in America painted rich tributes to the great thinkers, writers, musicians, scientists, and statesmen of their era (Figures 6, 7, 8, 9). Prominently featuring the attributes that revealed the specific direction of the sitter's intellect and discipline—a cello, for instance, or medical instruments, or scholarly texts—these heroic portraits celebrated the faith in reason, discipline, and morality that guided not only the lives of the sitters, but the strivings of the larger community. They transcended likeness to reveal the intellectual aura of the age—an aura created not by episodic or singular events in history, but by the ongoing heroic careers of individual thinkers and doers.

As the nineteenth century saw the rise of self-made and widely admired men in all disciplines of activity who optimistically aspired to the moral discipline of their predecessors, a host of portrait painters arose to document and honor their achievements. Although few are so remembered today as Reynolds, Gainsborough, David, and Peale, they drew on the conventions so important in the work of these earlier giants to provide portrait images demanded by the new times—by the heroes themselves, by their professional institutions, and by public collections. In response to the new awareness of man's role within his environment, rather than apart from it, many portraitists came to prefer the environmental portrait, or *portrait d'apparat*, which located the sitter in the environment of his professional activity— actually at work in his laboratory, for instance, rather than simply posing at

his desk. The variation also reflected the new materialism of the times, the conviction that man was yet another creature in nature, anchored to a particular time and place from which he acted. Although in the artists' own repertory, landscape and urban scenes took on major importance, in commissioned work of all kinds—in more "public" work—the portrait was of dominant importance.

In the prolific expansion in the nineteenth century of the technology with which multiple images were made the portrait took center stage as a subject. Potential sitters were legion, as were interested audiences. With the development of the lithograph, entrepreneurs found a ready market for images of leaders in the new professions, in banking, in community and national life, even in athletics, and sold these images both as individual prints and in bound collections with accompanying texts. Often the prints were designed to appeal to a community or regional audience, with specific details of the environment in which the sitter was represented: a famous concert hall, a well-loved city view, a river or park. Biographies, both of new and of rediscovered heroes, grew in popularity, and portrait prints accompanied their appearance in periodicals. After the introduction of photography in 1839, the portrait photograph became prominent. It was fast, inexpensive, and, near the end of the century, easily reproduced in books and periodicals.

The portrait kept its place in popular public life for subtle reasons as well as the more apparent. On the one hand it was obvious that man was working wondrous changes in the rapid expansion of technology, of educational opportunities, of scientific and medical development, and in the arts. The heroes who had directed such progress deserved recognition. But it was also true that under the public celebration of modernity was an anxiety that individual man counted for less and less in the grand design. A portrait image, even a bust, of a prominent surgeon, banker, violinist, or athlete enforced the passionate hope that in an egalitarian society all men could reach prominence; and it also quieted the fear that man, with his imagination, intelligence, and discipline, would lose his place in the apparently relentness evolution of natural and man-made forces.

Extraordinarily sensitive to these tensions, Eakins explored their implications in a city that in 1870 had an admirable number of professionals working at various endeavors. These new men moved in public life with the self-confidence that flourishes in a small environment. By 1825 Philadelphia had lost its earlier political, intellectual, and financial lead in American life, and even in 1870, although the city had grown tremendously in population, it

maintained its earlier spirit of smallness. Before Eakins began his career the city had enjoyed a fine tradition in portraiture. In fact no landscape movement comparable to that in New York had ever developed among Philadelphia artists; although in the 1860s there was a rising interest in genre painting and a certain amount of landscape painting, throughout the century portraiture had generally dominated the practice and exhibition of painting in the city.[2] Most prominent in this tradition were Charles Willson Peale (Figure 9), Thomas Sully (Figure 10), and John Neagle (Figure 11), who painted a number of portraits of the city's prominent scientists, medical men, merchants, clergy, and artists. Several of these were on a grand scale; many were displayed in the institutional collections with which Philadelphians had celebrated their prominent members. Portraiture in Philadelphia flourished in printmaking, too, which from 1830 had been a major industry in Philadelphia. Over the century ambitious printmakers published a host of individual portrait prints and a number of notable print collections of portraits and biographies of eminent citizens. Finally, Philadelphia was a center of portrait photography, with major portrait studios established as early as 1839.

Although Peale and Sully did not always find that the painting of portraits matched their intellectual ambitions—Peale, in fact, often pursued with more vigor the gathering and interpreting of natural history material for his museum—Eakins, by reason of intellectual curiosity, of temperament, and of singular responsiveness to major urgings in his culture, pursued the portrait as his life work.

His education and study show him to have been led in that direction very early. He was born in 1844, in Philadelphia, to Benjamin and Caroline Eakins, the progeny of Scotch-Irish, English, and Dutch forbears who had come to Philadelphia early in the century. Benjamin Eakins was a writing master, an expert in ornamental script who embellished documents and cer-

[2] Notable Philadelphia artists who were not portraitists include the marine painters Thomas Birch (1779-1851), depicted in Figure 11 in front of a characteristic canvas by his friend John Neagle, and James Hamilton (1819-1878); the landscapist Thomas Doughty (1793-1856), who after 1832 spent most of his career elsewhere; the historical painter Peter F. Rothermel (1817-1895), best known for his 32-foot wide *The Battle of Gettysburg*, 1870; landscapist and marine painter William Trost Richards (1833-1905), who spent most of his career away from Philadelphia; landscapist Thomas Moran (1837-1926), noted for his *The Grand Canyon of the Yellowstone*, who also left Philadelphia—living in New York after 1872. A strong still-life tradition in Philadelphia dated from early in the century with the achievements of Charles Willson Peale, his son Raphaelle, and his brother James. Later still-life painters included George C. Lambdin (1830-1896) and, although they left Philadelphia in the 1880s, John F. Peto (1854-1907) and William Harnett (1848-1892).

tificates and who taught the script to young students. In his work, characterized by an attentiveness to detail and a fondness for delicate beauty, Benjamin Eakins moved easily among both new and old Philadelphia families, a man of high principles and stern morality but, according to reminiscences, unfailingly kind. After Thomas, the Eakinses had three daughters, Frances, Margaret, and Caroline. They taught the children to enjoy music, literature and languages, art, and sports—rowing, sailing, and skating especially—and instilled in them a disdain of affectation and a proper respect for morals and proprieties.[3]

In 1857, at the age of thirteen, Thomas Eakins entered Central High School. The school had been established twenty years earlier as Pennsylvania's first public high school, and it remained a unique institution in Philadelphia throughout the century.[4] Modeled on the Latin School of Boston and on a similar institution in Edinburgh, the school proposed to educate young men regardless of their social and financial background provided they could pass the competitive entrance examination. Education at the high school was to be both elite and modern: founded, that is, on both the traditional classical curriculum and a study of the modern sciences. Such an education, early leader A. Dallas Bache felt (not insignificantly, he was the grandson of Benjamin Franklin), would best prepare the general citizen for any type of occupation.[5] Indeed, as the years went by, it was primarily the offspring of

[3] The degree to which middle-class proprieties must have been stressed in the Eakins household is apparent in many of Eakins' letters written to his family from Paris (and now in the Archives of American Art, Smithsonian Institution, Washington, D.C.), in which he discusses the infractions of manners and personal decorum by intimates of the family (see, for instance, his advice to his family in a letter of June 10, 1869 not to attend an upcoming wedding). Yet Eakins also expresses disgust with affectation, setting forth his judgments with high wit (as in his lampooning of the massed chorus at the Boston Peace Jubilee, to Fanny, July 8, 1869), and sharpness (as in his disdain for organized religion in a letter to Fanny of Good Friday, 1868).

[4] See Franklin Spencer Edmonds, *History of the Central High School of Philadelphia* (Philadelphia: J. B. Lippincott and Co., 1902); and John T. Custis, *The Public Schools of Philadel-phia* (Philadelphia: Burk & McFetridge Co., 1897).

[5] Bache was asked to shape the curriculum in 1840, after he had traveled through Europe studying models for the Girard School, a private Philadelphia institution. See Bache, *Report on Education in Europe, to the Trustees of the Girard College for Orphans* (Philadelphia: Lydia R. Bailey, 1839). The curriculum he established at the school is specified in the school system's 22nd Annual Report to the Board of Controllers (the entire set is filed in the Pedagogical Library, Philadelphia), 1840, pp. 21-22. Bache assessed the curriculum's success during Eakins' years in "An Address of Feb. 10, 1859 to the Alumni Association of Central High School on Central High School Education in Retrospect," in *Report of the Board of Managers Associated Alumni of the Central High School of Philadelphia*, Philadelphia, February 23, 1905.

general citizenry who attended the high school. Every few years, to illustrate the egalitarian access the school provided, the board of supervisors printed a list of the occupations of the parents of the students, a list that included masons, cordwainers, grocers, widows, teachers, carpenters, clerks, and only very occasionally the professions.[6] Although students were taught a carefully selected body of knowledge at Central High School, more important in the philosophy of the school was emphasis on an intellectual mode assumed to be ideal for all citizens: to know the received tradition so that they could use it and call it into question, to make their own observations and draw their own conclusions, to derive from experience a set of basic principles that they could apply to many situations. The school's premises and goals fused the received Enlightenment ideals of reason, knowledge, and disciplined application with two values that had come to dominate American public life by the 1830s and 1840s: a commitment to "scientific" thinking and a championing of egalitarianism. In the intellectual world of Central High School, the only aristocracy was that earned by disciplined application.

Eakins thoroughly absorbed this point of view. In his four years at the high school, he studied Greek and Latin, French and English, classical and modern history, literature, mathematics, writing (script) and drawing, moral philosophy, and the natural sciences: botany and biology (called natural history), physics, chemistry.[7] The theoretical underpinnings of his drawing instruction underlay much of the other work as well: if a student could draw clearly (or reproduce what he saw whether it was with pencil or words), he could think clearly.[8] With published annual reports the school kept its ideals, curriculum, and achievements before the community. As a graduate of the high school, Eakins would take a certain place in that community with his fellow graduates: born not to privilege but to self-discipline; educated broadly to know much of the classical past and a great deal of the scientific present;

[6] Custis, *Public Schools*, p. 134, discusses the responsibility the school assumed soon after its founding to prove its egalitarian nature. The year Eakins entered the school, the roster of parents' occupations included carpenters, printers, blacksmiths, music teachers, stonecutters, and four physicians (40th Annual Report to the Board of Controllers, 1859, p. 140).

[7] The curriculum that Eakins followed is listed in the annual reports during his student years: 39th Annual Report (1858), pp. 126-

127; 40th (1859), pp. 122-123; 41st (1860), pp. 142-143; and 42nd (1861), pp. 170-172.

[8] This tenet, derived from the writings and method of the Swiss educational reformer Johann Heinrich Pestalozzi (1746-1827), undergirded a cross-Atlantic movement advocating universal instruction in drawing and writing; it was paramount in the work of Rembrandt Peale, an early faculty member at Central High School. See Rembrandt Peale, *Graphics: A Popular System of Drawing and Writing*, 4th ed. (Philadelphia: C. Sherman, 1841).

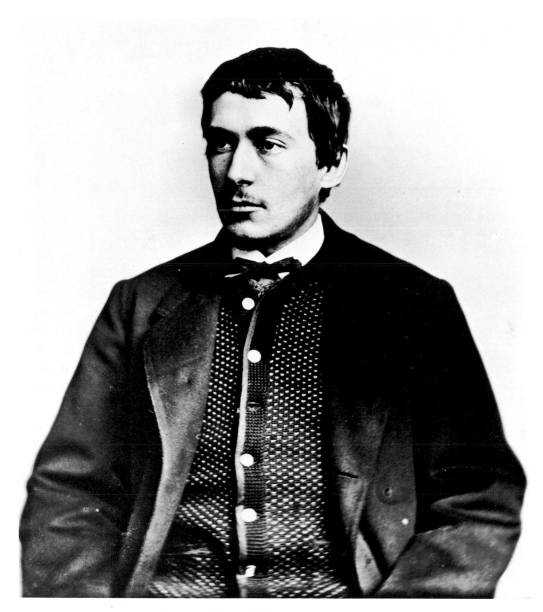

Figure 2. *Thomas Eakins*, photograph c. 1868.

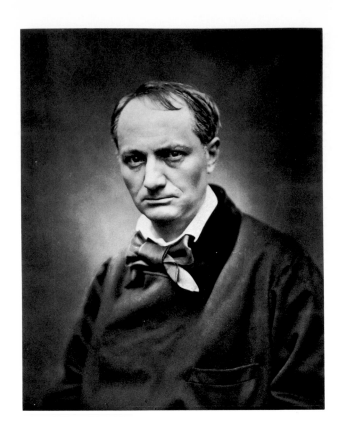

Figure 3 (Right). *Charles Baudelaire*,
 photograph by
 Etienne Carjat, c. 1863.

Figure 4 (Below, left). *Thomas
 Carlyle*, photograph by
 Julia Margaret Cameron,
 c. 1868-1869.

Figure 5 (Below, right). *Ralph Waldo
 Emerson*, photograph by
 Curtis and Cameron, c. 1868.

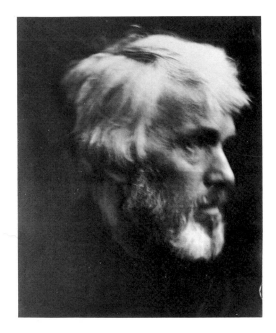

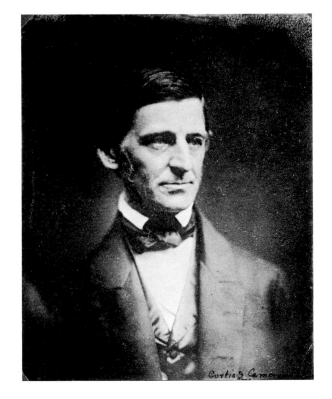

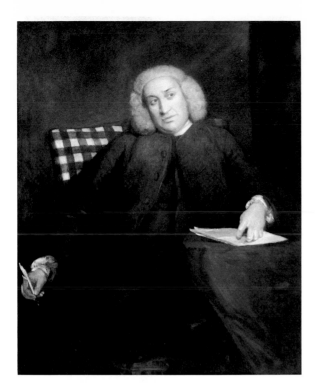

Figure 6. Sir Joshua Reynolds, *Samuel Johnson*, 1756.

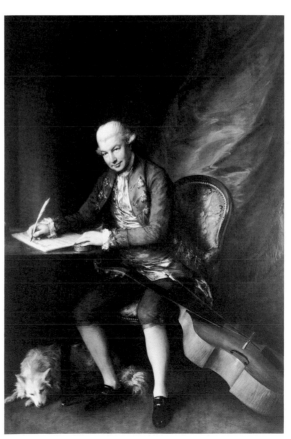

Figure 7. Thomas Gainsborough, *Carl Frederic Abel*, 1788.

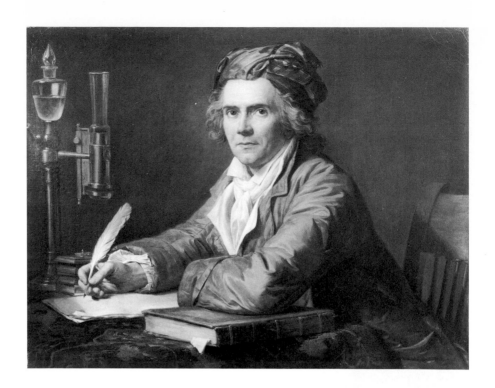

Figure 8. J.-L. David, *Alphonse Leroy*,
1782-83.

Figure 9. Charles Willson Peale,
Benjamin Franklin, 1789.

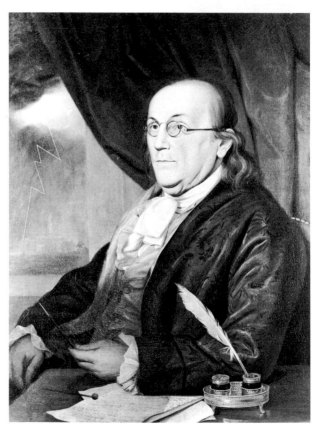

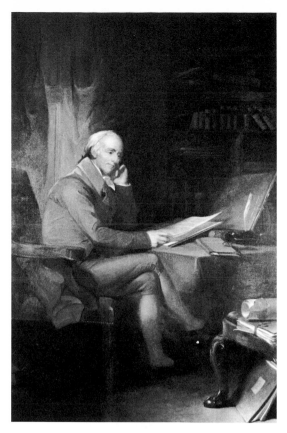

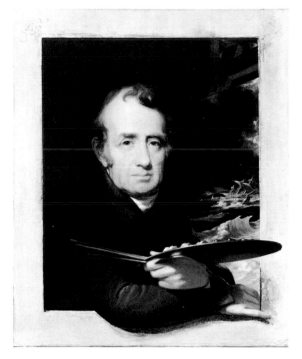

Figure 10. Thomas Sully, *Benjamin Rush*, 1811. Figure 11. John Neagle, *Thomas Birch*, n.d.

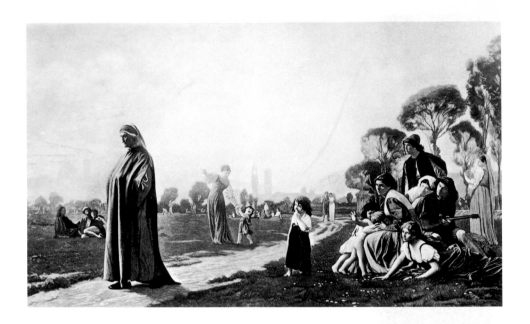

Figure 12. Jean-Léon Gérôme,
Dante (engraving), 1861.

Figure 13. Léon Bonnat,
*Portrait of John Taylor
Johnston (1820-1893),
First President of the
Metropolitan Museum of Art,
1870-1889*, 1880.

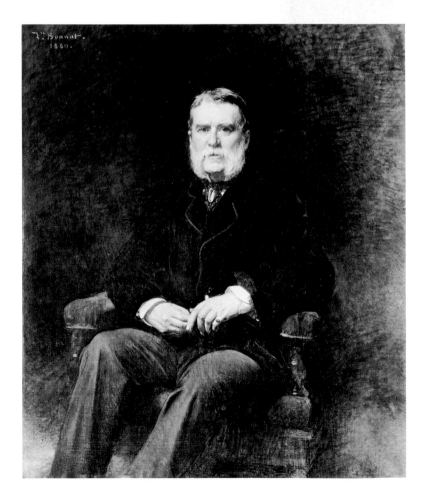

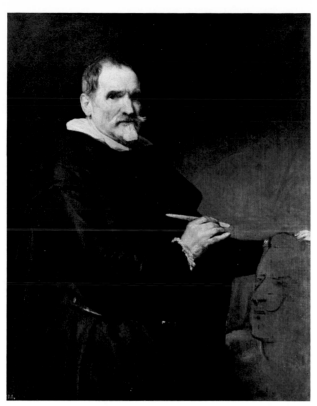

Figure 14. Diego Velázquez,
Martinez Montañés, 1636.

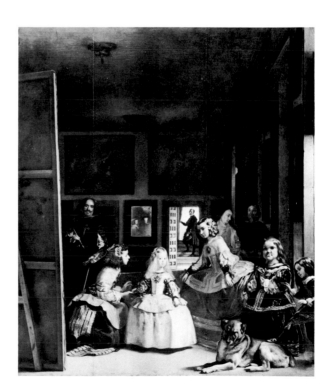

Figure 15. Diego Velázquez,
Las Meninas, 1656.

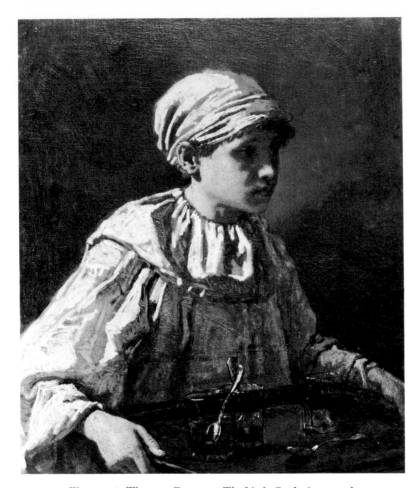

Figure 16. Thomas Couture, *The Little Confectioner*, n.d.

and competent to move freely in the intellectual, scientific, and public life of Philadelphia, guided by the ideal that inquiry and real achievement were open to all.[9]

After he finished high school in 1861, Eakins followed in his father's footsteps for a period. He helped him teach writing and embellish documents and letters; and in the fall of 1862, after an unsuccessful application for the high school professorship of writing and drawing,[10] he also enrolled in drawing classes at the Pennsylvania Academy of the Fine Arts. He later expressed regret that he had wasted so much time before he began his artistic training.[11] Although the drawing course at the academy included lectures in anatomy, a year and a half later Eakins also enrolled in anatomy instruction at Jefferson Medical College, where the course work was considerably more detailed. Of his declared intentions at this point, nothing is known.

Finally, in 1866, five years after he had graduated from high school, Eakins went to Paris to study to become an artist. His father totally approved of his course; indeed, it was Benjamin Eakins' prudence that made his son's study and his future career possible. Having invested part of his modest living in real estate, stocks, and bonds that provided a comfortable income, Benjamin Eakins was able to assure his son when he left for Paris that he would never have to depend upon painting for a living.[12] That Thomas Eakins could paint to meet his own standards—and not those of patrons—was to be a freedom fundamental to his career.

When Eakins arrived in Paris in 1866, he entered an art world characterized by great variety. Underneath the multiplicity of painting subjects that were popular in Paris and of critical opinions that were argued vigorously lay the fundamental dilemma that Baudelaire had identified: how was the artist to reconcile the overwhelming weight of the artistic past—not just the

[9] Edmonds, *Central High School*, pp. 295-310, discusses in detail the varied and impressive careers of graduates of Central High School.

[10] In the Philadelphia City Directory of 1863 and 1864 Eakins is listed as "teacher"; in 1866 as a "writing teacher." He next appears in the directory in 1873, listed as "artist." His application for the high school professorship is discussed in Elizabeth Johns, "Drawing Instruction at Central High School and Its Impact on Thomas Eakins," *Winterthur Portfolio* 15, no. 2 (Summer 1980), 139-149. Considering his father's professional identity, Eakins must have been embarrassed as well as disappointed to lose the competition.

[11] Eakins to Fanny (from Paris), June 19, 1867, Archives of American Art. Eakins did not participate in the Civil War, perhaps because of the Quaker influence on the maternal side of his family; many Philadelphians, however, chose not to volunteer.

[12] Margaret McHenry, *Thomas Eakins Who Painted* (Oreland, Pa.: privately printed, 1946), p. 9, quoting Samuel Murray.

heroic values and ideals but the specific conventions—with subjects drawn from modern life? Although artists in Paris were bringing a wide compass of modern experience onto the canvas, much of this experience was obviously not heroic in any sense of the term. There had been considerably less uncertainty in Philadelphia about the proper role of art in a changing, growing society. Not the least reason for this, of course, was that the weight of the history of art in Philadelphia was so much lighter than that in Paris. But more important, dominated as that history was by portraiture, it complemented the other concerns of Philadelphia life, whether they were those of the establishment of scientific and political institutions in the late eighteenth century or of the prominence in the nineteenth-century of merchants, ministers, educators, and medical men. With the portrait—especially that of an eminent citizen—there was no discrepancy between modernity and heroism and, in Philadelphia where such portraits had formed a veritable succession, between the art of the past and that of the present.

His earlier hesitation behind him, Eakins set goals in Paris and proceeded deliberately toward them. He enrolled in the École des Beaux-Arts, specifically in the atelier of Jean-Léon Gérôme, set up his working space, and began to write home about his studies and ambitions.[13] He found the interest of the human image inescapable. Writing his sister Frances about the paintings of his "master," Eakins was drawn to the "lifelong story" Gérôme saw in each face, to the moral universe that Gérôme could make each face and figure convey. Discussing Gérôme's recent picture *Dante* (Figure 12), Eakins wrote Frances, "No one else even if he might appreciate the grandeur of Dante's character could have rendered it. . . . [Who] can paint men like my dear master, the living thinking acting men, whose faces tell their life long story?"[14]

Eakins progressed steadily toward mastery of the portrait. Eager to believe that he could be self-sustaining financially despite his father's assurance that he would not have to be, about a year and a half into his study, Eakins wrote home, "I could even now earn a respectable living in America, I think, paint-

[13] See Albert Boime, "American Culture and the Revival of the French Academic Tradition," *Arts Magazine* 56, no. 9 (May 1982), 95-101, for a concise discussion of the teaching methods at the École des Beaux-Arts during this period. For a discussion of Gérôme, see Gerald M. Ackerman in the exhibition catalogue, *J-L Gérôme* (Dayton: Dayton Art Institute, 1972); and, for a discussion of some relationships between Eakins' later work and that of his teachers in Paris, see Ackerman, "Thomas Eakins and His Parisian Masters, Gérôme and Bonnat," *Gazette des Beaux-Arts* s. 6, 73, no. 1203 (April 1969), 235-256.

[14] To Fanny, April 1, 1869, Archives of American Art.

ing heads, but there are advantages here which could never be had in America for study."[15] A year later, he had even more confidence in his painting, and wrote to his father, "I will never have to give up painting, for even now I could paint heads good enough to make a living anywhere in America. I hope not to be a drag upon you a great while longer."[16] Even this early, although he wanted strongly to achieve financial independence, Eakins did not conceive of winning it—or, what would be important later, of keeping it—by painting anything but portraits. He spent several months in the studio of portrait sculptor Augustin Dumont,[17] pursuing work in three dimensions to aid his painting, as he would at many times in his career. With portraiture on his mind, after nearly three years with Gérôme he enrolled for a short while in the atelier of the portraitist Léon Bonnat (Figure 13).[18] And finally, he went to Madrid to study the portraits of the great Diego Velázquez (Figures 14, 15). Only after that did he attempt his first painting. He was a painstaking student, as he would be a painstaking artist.

If he was clear in his Paris studies about what he wanted to paint, he was also increasingly certain of how he wanted to paint. He had little patience with drawing. Indeed, he had studied general drawing for four years at Central High School (including mechanical drawing of various types, isometric, and perspective), and then he had drawn from casts at the academy (in fact, part of his examination for the Central High School professorship called for a copying of a cast of the Laocoön). Thus he simply boycotted Gérôme's atelier on the days the class drew from antique casts.[19] On other days, when a model posed for the class, Eakins drew assiduously, working with charcoal and stump. What Eakins wanted to do most was to paint from

[15] Lloyd Goodrich, *Thomas Eakins*, 2 vols. (Cambridge, Mass.: Harvard University Press, 1982), I, 36.

[16] Goodrich, *Eakins*, 1982, I, 50. In another letter, Eakins wrote, "That Pettit or Read [two popular Philadelphia portrait painters] get big prices does not in the least affect me. If I had no hope of ever earning big prices I might be envious, and now worthy painting is the only hope of my life and study" (Goodrich, *Eakins*, 1982, I, 48).

[17] Augustin Dumont executed many official and institutional commissions for sculpture and portrait busts; his bust of surgeon Nicolas Gerdy was in the collection of busts of eminent surgeons owned by the Society of Surgeons of Paris.

[18] For an introduction to Bonnat, see Gabriel P. Weisberg, *The Realist Tradition: French Painting and Drawing 1830-1900* (Cleveland: Cleveland Museum of Art, 1981), pp. 177-178 and 273, with bibliography.

[19] Goodrich, *Eakins*, 1982, I, 25. Eakins expressed his conviction that drawing from casts was useless in a letter to Fanny, November 13, 1867, Archives of American Art, comparing drawing from casts with fatuously practicing trills on the piano. Two years later, however, he wrote his mother that he had some plaster casts in his studio that were "very nice and useful to draw from once in a while," April 14, 1869, Archives of American Art.

13

life; and he wrote home in triumph when Gérôme judged that he was at last—after months of working with charcoal—ready to do that.[20] Thereafter Eakins drew in paint, catching the movement, the contour of the human figure in a medium that was alive, that grew and diminished, like the body. The rest of his life, in fact, he would draw with a point (like that of charcoal or pencil) only when he needed to render objects or to make an abstract scheme, like a perspective drawing.

Clarity about his goals was one thing and achieving them was another. An insistent theme in Eakins' letters home was the epic struggle of learning to use the brush. He wrote home of periods of "downheartedness" when he didn't seem to be improving, of being so far behind his classmates in his basic skills that he worked closeted in his own studio to catch up, laboring to copy studies that Gérôme had lent him.[21] Color was almost his nemesis. For at least two years his letters home recount moments of near victory spoiled at the last minute by the exasperating tendency of colors to muddle. When he began to paint in sunlight in Seville, in the last few months of his stay in Europe, he had to start all over again, adjusting the key of his colors to the unaccustomed brightness.[22]

In the midst of his struggle to attain competence, however, he was clear that virtuosity was not his objective. Disdainful of those who labored endlessly on a sketch to make it perfect, as though the preparation and not the final work were the artist's objective, Eakins insisted that technical brilliance be subordinated to the purpose of a picture. He distinguished between "accomplishment"—technique designed to win admiration—and "power"—the real, but inexplicable, achievement of strong painting.[23]

In one letter, frequently quoted, Eakins talked about technique.[24] Proper technique, he declared, was not "monkey-like" imitation. Instead, the artist "keeps a sharp eye on Nature and steals her tools." In Eakins' fondness for boating, he drew his metaphor from that world: "[The painter] learns what [Nature] does with light, the big tool, and then color, then form, and appropriates them to his own use. Then he's got a canoe of his own, smaller than Nature's, but big enough for every purpose. . . . With this canoe he can sail parallel to Nature's sailing. He will soon be sailing only where he wants to,

[20] Goodrich, *Eakins*, 1982, I, 23.

[21] Goodrich, *Eakins*, 1982, I, 25.

[22] Goodrich, *Eakins*, 1982, I, 57.

[23] Goodrich, *Eakins*, 1982, I, 52. Eakins made these distinctions again and again. He expressed disdain for artists who, in the belief they were creating art, made perfect studies.

[24] Goodrich, *Eakins*, 1982, I, 31. This letter is typically cited to define Eakins' vision as "scientific."

. . . but if ever he thinks he can sail another fashion from Nature or make a better-shaped boat, he'll capsize."

Of power in painting Eakins expressed equally strong convictions. Acknowledging the respect the painter showed for Nature's canoe, he wrote: "In a big picture you can see what o'clock it is, afternoon or morning, if it's hot or cold, winter or summer, and what kind of people are there, and what they are doing and why they are doing it."[25] But he followed with a statement of the ultimate mysteriousness of this power: "The sentiments run beyond words. If a man makes a hot day he makes it like a hot day he once saw or is seeing; if a sweet face, a face he once saw or which he imagines from old memories or parts of memories and his knowledge, and he combines and combines, never creates—but at the very first combination no man, and least of all himself, could ever disentangle the feelings that animated him just then, and refer each one to its right place."

These convictions guided Eakins' judgments about the work of painters in Paris, just as they were to guide his own work later. He had no patience for the exactitude of the painting of people such as J.-L.-E. Meissonier.[26] Such precision, he wrote Frances, far surpassed the observed world and showed no respect for nature. What Eakins admired was technique that was not contrived or flashy, but that was faithful to the look, the feel, the memories of experience. And while Eakins respected Gérôme profoundly, it was the free, exploratory technique of Thomas Couture that he took as his ideal (Figure 16).[27] He had no difficulty separating his hero-worship of his teacher from his clarity about good painting. Calling Couture the "Phidias of painting and drawing," the master of "nature and beauty on canvas," Eakins wrote Frances that "[Couture's] art and Gérôme's can hardly be compared. They are giants and children each to the other and they are at the very head of all art."[28] The careful and precise work of Gérôme radiated a self-sufficiency from planning through execution to finish, the final surface tactfully hiding the painter's process from the viewer. But the loose, sketchy work of Couture, which often revealed every step of the painter's process, evoked the tangle of memory and observation and imagination that Eakins had specified as the ideal achievement on canvas.

In less than a year Eakins would find the poles reconciled—and the results

[25] Goodrich, *Eakins*, 1982, I, 31.
[26] To Fanny, April 1, 1869.
[27] For a comprehensive study of Couture, see Albert Boime, *Thomas Couture and the Ec-* *lectic Vision* (New Haven: Yale University Press, 1980).
[28] To Fanny, April 1, 1869.

a revelation—in the work of Velázquez, Ribera, and other Spanish painters. He wrote home from Madrid: "I have seen big painting here. When I had looked at all the paintings by all the masters I had known, I could not help saying to myself all the time, 'It's very pretty but it's not all yet. It ought to be better.' Now I have seen what I always thought ought to have been done and what did not seem to me impossible. O, what a satisfaction it gave me to see the good Spanish work, so good, so strong, so reasonable, so free from every affectation. In Madrid I have seen the big work every day and I will never forget it."[29] In Velázquez and Ribera Eakins saw subject and technique united; and he saw in happy profusion the techniques of traditional indirect painting with which the painter probed, shaped, and finally resolved the form of his subject.

His letters from Europe also reveal important intellectual concerns. Eakins admired men who worked long and diligently to achieve complex goals: "I appreciate stronger than ever such men as Allendorf and Mr. Gardel [friends of his father] who have waded through such masses of stuff and afterwards have formed principles for themselves founded on simplicity."[30] He recognized that many of these people would not be public heroes, that they labored to reach standards that could be appreciated only by the few. Even his teacher Gérôme, Eakins felt, was often not properly appreciated. He resented the uninformed aside of his friend Billy Crowell that Gérôme was not a great painter: "If he knew him like I do, he would not say that."[31] Indeed it was almost a son-father worship with which Eakins admired Gérôme, Bonnat, and Couture. His associations and his heroes, Eakins seemed to feel, were his best definition of himself; he took on the excellence of those he admired.

In every endeavor and reflection, Eakins strove to find simplicity under life's variety. He was persuaded that a few basic principles could carry one through every situation, could explain every mechanical contrivance and moral dilemma. "The more one learns I think the more one sees to influence. In-

[29] Goodrich, *Eakins*, 1982, I, 54, and I, 60-62.

[30] To Fanny, June 19, 1867. Mr. Gardel was a teacher of French and a close friend of Eakins' father. I am not able to identify Allendorf. Evidently, however, these men along with the Eakins family were swept up in the new international interest in linguistics. Eakins refers to theories of language in several of his letters to his sister Frances, mentioning Friedrich Max Müller (1823-1900), the great German-born British philologist, almost as though he were a household intimate. See, for instance, letters of June 12, 1867, and June 19, 1867, Archives of American Art.

[31] To Fanny, April 1, 1869.

deed everything in the world seems to hang together and have its effect over everything else."[32] When he discussed music with his sister, he was confident that although he knew little about music technically, it "should be like other things that I do know."[33] Fascinated with the variety of languages in the world, he was persuaded that the same roots underlay them all.[34] An even deeper principle than word fragments was the concept of motion, he reasoned, for certainly sound itself was motion; and sign language—which Eakins learned in order to communicate with a deaf friend—was spoken through motion.[35] Motion was the basis of music.[36] And motion was the basis of form in painting: "Form is only another name for motion. Form was made by modelling and is seen by running the attention round it."[37] Indeed, it was perhaps motion, Eakins wrote, that was the fundamental principle of almost everything.[38] It was a conviction whose truth he would find borne out again and again in the great changes of his era.

While in Paris, Eakins explored avidly the excellence and the variety that characterized much of modern life: he wrestled, dissected in the hospital and medical school facilities, became fast friends with the Bonheur family, attended the Pasdeloup concerts, went to the opera, studied the Salon paintings every year,[39] and toured Europe one summer with his former Philadelphia classmates and another time with his father and sister. Through it all, he worked to become a painter.

He returned to Philadelphia in July of 1870, ready to embark on the career for which he had studied earnestly. "I am proud to be a Philadelphian," he had written from Paris.[40] In 1870 he found a Philadelphia obsessed with change, with growth, with "modernity." His work would be rooted in Phil-

[32] Undated fragment, no addressee, Archives of American Art.

[33] To Fanny, November 13, 1867, Archives of American Art.

[34] His letters of June 12 and June 19, 1867 contain his most extended discussions of language. In his letter of June 12, Eakins parodied with great amusement a pompous linguistic study; apparently the principal of Central High School, Mr. John S. Hart, had presented himself as an expert in the field but had not won Eakins' confidence or admiration.

[35] To Fanny, June 12, 1867.

[36] To Fanny, November 13, 1867.

[37] To Fanny, June 12, 1867.

[38] To Fanny, June 12, 1867.

[39] He wrote his mother, "I am always anxious to see pictures. After I see them very few give me pleasure but still I am just as anxious to see more," April 1, 1869. In the same letter, in a section addressed to Fanny, he reported on some of the Pasdeloup concerts.

[40] To Emily Sartain, November 16, 1866, Archives, Pennsylvania Academy of the Fine Arts.

adelphia—in its history, in the achievements of its citizens, and in its change and modernity.

He moved out slowly into the world of distinguished sitters, drawing one by one on his associations from Central High School, his rowing days, his study at Jefferson Medical College, and his participation in Philadelphia life as an adult.

CHAPTER TWO

Max Schmitt in a Single Scull,
or
The Champion Single Sculls

GLAD TO BE home after such a long apprenticeship, Eakins began his career with scenes of activities that he had missed in Paris—the outdoor pursuits of rowing, hunting and sailing with his father and close friends, and the indoor pleasures of listening to his sisters play the piano. These were activities that in one form or another people had enjoyed for centuries, but in the mid-nineteenth century they were distinctively identified with "modern" life.

He started with rowing. Although he had written his sister Frances from Paris that for fun, sailing was "much better than rowing," obviously rowing made a better painting subject.[1] He tried one compositional idea with the subject and then another, working from detailed drawings and experimenting with a variety of painting techniques. By 1874, when he finally turned to scenes of hunting and sailing, Eakins had pursued the theme through nineteen careful drawings, water colors, and paintings. The intensity of the chase is evident in every one of them.

The most successful of the rowing paintings, also Eakins' first, is *Max Schmitt in a Single Scull*, or, as he called it, *The Champion Single Sculls* (Plate 1).[2] Painted with a capability that is remarkable so soon after his discouragement in Seville, it shows much of the varied technique that he would use

[1] Eakins' letter to Frances, written Good Friday, 1868, is in the Archives of American Art, Smithsonian Institution, Washington, D.C.

[2] The painting was exhibited only once during Eakins' lifetime, and that occasion, in April, 1871, was soon after he had finished it. The catalogue for the exhibition, the Third Art Reception of the Union League of Philadelphia, lists the title of the painting as *The Champion Single Sculls* (No. 137). As this chapter will show, the painting honors one champion, and thus the title should read "The Champion, Single Sculls." Eakins' disdain for affectation extended to commas, which he regularly omitted.

throughout his career. As he was to do later as well, he filled the work with reportorial detail that was rich in metaphor. And although the subject was anchored in his own experience, it also reveals the extent to which he shared with his fellow citizens their excitement about the pursuits of modern life.

The Champion Single Sculls is a portrait of Eakins' friend Max Schmitt sculling on Philadelphia's Schuylkill River. Eakins and other oarsmen row in the middle and far distances. The tall, slender Schmitt, in the near shell, pauses to turn and look at the viewer over his right shoulder, his face, arm, and shirt lit brilliantly by the late afternoon sun. He relaxes his right arm, with his left he guides the oars, as his shell "Josie"—its name written clearly on its side—straightens out from a turn and glides toward the viewer's left. In the middle distance is Eakins, with intent face and a stocky physique. He moves away from the viewer, not relaxing but rowing with concentration, and the sun strikes him and his boat across the front. His shell has come from the left, in a gentle curve that parallels that of his friend's craft. These oarsmen have met and passed each other, each on his own mission.

Also absorbed in their own purposes are three other single scullers, in the distance—one on the far right, set off by a red shirt, one behind Eakins, in white, and a third by the bridge pier near the left. Various landmarks identify the location as on the Schuylkill: the Railroad Connection Bridge (with a train puffing across it from the right) and the Girard Avenue Bridge, peculiarly situated at an angle to each other;[3] Sweetbriar, a colonial mansion on the brow of the hill just off the river's right bank;[4] and, in a distinctive red boat near the left shore, a crew of two rowers and coxswain in Quaker dress. The spare brown of the trees on the shoreline identifies the season as autumn. Smaller details complete the scene: part of a stone house visible on the far left; near it, four ducks in the shallow water; and, in the distance, a steamboat under a puff of white steam, its mechanical character a contrast to the motive power of the scullers. Only a few thin clouds stretch across the shifting blue sky. In the raking light of late afternoon, the day nears its

[3] Both these bridges were replaced not long after Eakins painted this scene; prints in *Philadelphia and Its Environs* (Philadelphia: J. B. Lippincott and Co., 1873), p. 68, show their relationship in 1870.

[4] This distinctive mansion, built in 1797, had been incorporated into Fairmount Park in 1868. There is also, on the shoreline to the right of the bridge, a large, apparently stone structure; this may be a boathouse. Although the river banks have been landscaped as a park since 1871, a viewer may still take Eakins' point of view in the painting by looking south from the parking area off West River Drive near the Black Road intersection. In making his picture, Eakins pulled the bridges considerably closer to the viewer than they appear in actuality.

20

end; in the losses and browns of autumn, the year runs down, and the rowing season approaches its close.

The painting surface reveals precisions as well as imprecisions; these differences seem to be deliberate. Only two preparatory drawings for the painting survive; they are Eakins' very careful rendering of a pier of the Girard Avenue Bridge and on the back of that his sketch of the blade of an oar, with the inscription "left or looking out to the blade" (Figure 17). For his later rowing paintings he was to prepare elaborate perspective drawings to establish the spatial bearings of the shells (Figure 18 shows one of the drawings with which he prepared for the *Pair-Oared Shell*), and there is no reason to think that he did not do so for this first painting as well. The two small drawings that do exist point the same lesson as the later perspective studies: that with objects—which have a specific shape and place in space—Eakins wanted to be precise; that with activities he wanted to show—as his note to himself on the oar blade reveals—how an instrument with which one carries out an activity is maneuvered by the user. He told a student years later that to paint the rowing paintings he had put little figures and bits of cloth on his roof in bright sunlight; although the motif of the "bits of cloth" seems to suggest the details of his three paintings of the Biglin brothers, he was so particular about the quality of late afternoon light in his painting of Schmitt that he may have studied for this work on his roof also.[5]

On the canvas itself, Eakins seems to have moved from what he could render to what he could only approximate—from measurable objects to the unpredictable moving water, sky, and clouds. He drew the bridges and Schmitt's shell precisely to outlines that are still visible on the canvas, and then painted them, along with the tree branches and trunks in the left middle ground, with thin opaque tones that cleanly connect one outlined edge to its opposite. These are the only exact areas on the canvas, the only areas in which Eakins seems even to have tried to point matter-of-factly to objective reality.[6]

[5] Reported by Charles Bregler, in "Thomas Eakins as a Teacher," *The Arts*, March 1931, p. 384.

[6] I am explicit about Eakins' technique in this painting not only to counter the indiscriminate label of "exact realism" that his work has attracted but to show that contrary to recently popular theory, Eakins' work has little to do with a "luminist" style, either—that is, with a style of nineteenth-century landscape painting in which transparency and stillness are hallmarks. Barbara Novak, for instance, in her influential *American Painting of the Nineteenth Century* (New York: Praeger, 1969, p. 193), discusses this particular painting as a "luminist" work. Actually *The Champion Single Sculls* and other of Eakins' paintings are "transparent" and impersonal only in photographic reproduction.

Elsewhere across the canvas he caught a world whose primary reality he felt from within. He drew his technique from the masters of indirect painting whose work he had observed carefully—Gérôme, Couture, Velázquez, Rembrandt, even mid-century American landscapists. He took, and made his own, the repertory of layering, transparent glazes, opaque scumbling, and brushwork that had been explored from the time of Titian. With attention to the human form that reflected his early-expressed fascination with the body in movement, Eakins modeled the figures of Schmitt and himself with built-up layers of glazes and opaque high tones, painstakingly knitting together bodies that are specific in height, weight, and muscular action. Then he built up the environment in a number of steps. He prepared his canvas for the area of the water with a brownish-gray underpainting and pulled over it a light blue (visible just near the right edge of the tree reflections above Schmitt's scull, and near other edges across the canvas), and then, unevenly, more solemn blues, toned with gray or brown, and occasional light browns. Finally, he washed over the surface thin glazes of browns and grays that in some places reflect details along the shore, as on the left and near the bridge; in others hint a changing sky, as in the foreground; and at spots seem to suggest a quickening, short breeze.[7] With dark, regularly spaced marks he broke this varied surface to reveal the steady dip of oars and the measured movement along the river of Schmitt's and his own shells.

To brushwork, Eakins gave a strong—but not necessarily beautiful—role. He formed the sky with virtual scrubbing. Also blue over a gray underpainting, it appears as a deep, changing field, interrupted by clouds wispy in form but not in thinness of pigment. Then, for contrast, with thin, opaque washes of brown he established against the sky the flat brown-leaved tree masses on the horizon, forming their contours by pulling the blue of the sky down to lap between them. Between sky and water, over on the far left of the shore, he described with thick yellow, gray, and tan pigment the stone wall of what was perhaps a boat house; nearby, he used some of the same pigment to scrub over an area of rushes with thick strokes that are anything but rush-like. Whereas some of Eakins' technique was subtle, nowhere on the canvas did he use it to point transparently to the material world. In

[7] In studying Eakins' brushwork one must discount the lowest part of the painting, which was heavily damaged and has been restored. When the painting was exhibited in 1871, the critic for the *Philadelphia Inquirer* criticized the incompatibility of the "leaden sky," certainly a consequence of the gray underpainting, with the sunny effects elsewhere in the painting. Today the sky does not seem inharmonious with the rest of the work.

several areas, in fact, undescriptive of any forms whatsoever Eakins moved his brush back and forth, up and down the water in heavy blue crescents and dashes that communicate his presence as painter. In some places, where this brushwork finishes off a thickly painted passage, such as near Schmitt's shoulder, or in the water just this side of the bridge, it seems to mark his decision simply to stop painting in an area that had given him problems, but elsewhere the brushwork is confident and free. Signing his authorship of the painting across his own boat in the picture, Eakins asserted his craftsmanship as artist to have been as grounded in experience—and as demanding—as that of the builder of the delicate shells.

Schmitt is the hero in this personal, fall painting, but sculling, the Schuylkill, and Philadelphia expressed Eakins' proper place, too.

For rowing was an activity that Eakins knew well. He had learned to row long before he went to Paris, first going out on the river in the early 1860s at a time when other Philadelphians as well were trying out this new sport.[8] All the members of Eakins' family rowed—his father, sisters, and his mother; indeed, in their Mount Vernon Street home the family was only a few blocks from the allure of the Schuylkill for recreation in the late afternoons. From Paris Eakins mentioned rowing in several of his letters to his family—in comments that reveal the several dimensions of their enjoyment of the sport: asking his mother if she had been on the river recently to see the fall colors; suggesting to his sister Frances that she go row on the river when she found herself depressed about her progress in her piano studies; and urging that Frances and Margaret should learn to swim well since they rowed so much.[9]

Many of Eakins' friends at Central High School had also taken up rowing, and Max Schmitt, the central figure in *The Champion Single Sculls*, was prominent among them. Classmate Joseph Boggs Beale, later an artist/illustrator,

[8] Although it does not seem possible now to ascertain exactly when Eakins began rowing, I have assumed that he joined in the rising activity on the river about the time his friends did. The diary of Joseph Boggs Beale (at the Historical Society of Pennsylvania), kept from 1856 through July 1865, reveals that Beale took lessons in rowing in 1863 (entry for September 11, 1863). Beale's diary is excerpted with a focus on Beale's artistic activities in Nicholas B. Wainwright, "Education of an Artist: The Diary of Joseph Boggs Beale, 1856-1862," *The Pennsylvania Magazine of His-* *tory and Biography* 97, no. 4 (October 1973), 485-510. Eakins' letters from Paris in 1867 reveal a long familiarity with rowing.

[9] Margaret McHenry, *Thomas Eakins Who Painted* (Oreland, Pa.: privately printed, 1946), p. 3, quotes the letter of fall, 1867 about the autumn colors on the river; the other correspondence is in the collection of the Archives of American Art: Eakins to Fanny, November 13, 1867 about rowing to lift her spirits; Eakins to Fanny on Good Friday, 1868 about learning to swim.

wrote in his diary of being on the river several times a week; Eakins' chemistry professor at the high school and subject of a later portrait, B. Howard Rand, M.D., was even the president of a boating club.[10] Some Philadelphians rowed independently, while others, like Dr. Rand and Max Schmitt, rowed as members of recently formed boating clubs.[11] Joining their new enthusiasm for rowing with an equally new passion for organized activity, several of these clubs in 1858 had founded the Schuylkill Navy to sponsor semiannual regattas and championship races, and the activities brought new publicity to rowing. Whether for club activities or private relaxation, for racing or for exercise, Philadelphians took to the Schuylkill with craft of all descriptions, and from April until October the river was dotted with citizens in earnest training or just as earnest relaxation.

They were not alone in their enthusiasm. Throughout America, in fact, the years framing the Civil War saw a virtual flowering of rowing and, indeed, of many other sports. With the rise of economic prosperity a substantial number of city dwellers—new professionals, clerks, and skilled workers—enjoyed increased income and, for the first time, notable leisure. Because so many of them were engaged in exclusively mental and indoor occupations, they turned to the outdoors for relaxation. Following the nation's lingering affection for English customs, they chose their new sporting pursuits from English models that they knew through English sporting periodicals. Sports newly popular in England ranged from hunting, billiards, cricket, croquet, walking, horse racing, and yachting to rowing, and of these, rowing had particular attraction for Americans. Favorable rivers and lakes were abundant across the continent, and some of the values associated with rowing in England appealed to the developing American advocacy of leisure that was instructive, elevating, and democratic.

[10] Arthur W. Colen, writing an introductory essay to the exhibition *Drawings by Joseph Boggs Beale* (New York: Whitney Museum of American Art, 1936), and drawing on family sources for his information, also discusses Beale's enjoyment of rowing, and mentions that he often rowed with Eakins (p. 21. Colen writes that Eakins was a member of the Undine Barge Club with Beale—see Note 11, below). Eakins' chemistry professor, Dr. Rand, who was later on the faculty of Jefferson Medical College, was president of the Undine Barge Club. Printed records of the club are in the Historical Society of Pennsyl-vania.

[11] Max Schmitt was a member of the Pennsylvania Barge Club; according to Seymour Adelman, Eakins also belonged to the club, but his name does not appear in the club's records at the Historical Society of Pennsylvania. Because of Eakins' friendship with Schmitt, he perhaps had an informal rather than formal association with the group. According to Shinn in a letter of January 3, 1867 (Friends Historical Library of Swarthmore College), Eakins talked a great deal about "the Schuylkill boating club" during his first year in Paris.

24

With the passion of the convert, rowing's new devotees in America studied its many aspects. They wrote about its history, its technology, its social implications, its moral dimensions, and, most prominently, its character in America that distinguished it from its English antecedents.

These antecedents had assumed an influential pattern. For centuries, rowing in England had been associated with watermen on the Thames, who engaged in the "trade of rowing" by ferrying passengers in heavy boats from one side to the other. In the course of such ferrying, watermen had become competitive about their individual speed and skill, and a tradition developed of gentry passengers occasionally wagering on the outcome of a ride. In 1716 one of these passengers, the actor Thomas Doggett, instituted an official race—the annual waterman's race for "Doggett's Coat and Badge"—that, with some transformation in equipment, continues today. Inspired by the lively spirit with which the watermen raced, members of the gentry and aristocracy took up racing themselves in private barges late in the eighteenth century. About the same time, impressed not only with its value as entertainment but also with its benefits to health, students at Oxford began to row informally, and by 1806 students at Eton were rowing also. Rowing became institutionalized. Oxford established an official college rowing club in 1815 and Cambridge in 1827; in 1829 these clubs, rowing in eight-man barges, met in the first of the famous annual Oxford and Cambridge boat races that even today are prominent events. In the 1820s and 1830s gentleman amateurs formed the first rowing clubs, and cities began to sponsor annual regattas. With the exception of professional races by oarsmen who were usually former watermen, over only a few decades rowing was transformed into the sport of a gentleman.

By mid-century single sculling came to represent the fullest evolution of the sport. First, English boatbuilders had developed successively lighter, narrower, and longer boats that offered the rower a shell he could pull through the water by himself, and amateurs as well as professionals took up the challenge with enthusiasm. Then, the developing technology in iron made possible the invention in the 1840s of the iron outrigger. Bolted to the side of a shell to extend considerably the leverage of the oars, the outrigger reduced the necessary thickness of the gunwale of the rowing boat and, consequently—for the sake of speed—the boat's weight. The transformation was startling. A typical boat in 1820—called properly a barge—made of overlapping planks of solid oak, was thirty-five feet long, weighed 700 pounds, and in an open interior, seated ten rowers, two to a seat. In contrast, a typical single shell in 1865, made of paper-thin Spanish cedar with a single plank to

a side, was forty feet long, weighed only 35 pounds, and, with a closed top, seated one rower. If slightly longer and heavier, the modern shell seated two, four, six, or eight rowers, one to a seat. Even rowers themselves were more compact: the ideal weight of the oarsman early in the century was 200 pounds; by 1860, the ideal weight was 140 to 160 pounds.[12]

Rowing had become an art, and rowers potential heroes. The stroke called for by the modern, delicately balanced boats was not an old-fashioned hard dig into the water, but a calculated series of movements of body and oar based on principles of efficiency and grace. So disciplined and comprehensive a leisure did it seem, in fact, that rowing enthusiasts followed the lead of Thomas Arnold at Rugby and boasted that rowing was a modern reinstitution of the Greek ideal of the union of mental and physical culture.

Printmakers in England had begun to celebrate rowing in the 1820s, when university crews first earned it a respectable popularity. In the early images of university races and of city regattas prominent motifs included competing crews, spectators in the foreground, landmarks of a particularly significant point in the race (usually the start, the finish, or a moment of changing advantage midway through the race), and sometimes even pennants and party barges in the distance.[13] (Figure 19, for instance, shows the Eton team defeating Westminister at Putney, winning by fourteen boat lengths.) Later, when single sculling championships became popular, images functioned as documentary portraiture, showing champions in their shells in a location where they had won their latest victory (typically, such images were made from studio photographs with an appropriate background drawn by the printmaker). (Figure 20 is a good example, a portrait of the single sculler Henry Clasper, champion of the North of Derwenthaugh by Newcastle-on-Tyne, in about 1860.) The margins of rowing portraits set forth documentary data that satisfied both spectators and champions: the rower's weight, height, and age; an exact description of his boat; the date, location, and even

[12] Engelhardt gives weights and dimensions, *The American Rowing Almanac and Oarsman's Pocket Companion* (New York: Engelhardt and Bruce, 1873), p. 179, as do Waters and Balch, *The Annual Illustrated Catalogue and Oarsman's Manual* (Waters, Balch and Company, 1871), p. 20.

[13] Gordon Winter, "Rowing Prints for the Collector," *Apollo* (London) 25 (1937), 187-191, illustrates two rare early prints, "The First Cambridge University Crew," 1829, in the collection of the British Museum; and "The Exeter Boat" (about 1830), p. 188. A print of the Oxford/Cambridge race that is fairly common is the much later colored lithograph by A. Lipschitz, of the Boat Race of 1871 (a print is in the Historical Society of Pennsylvania). Winter illustrates an early print of the Chester Regatta, dating from 1854, p. 190.

the time of his championship race; and in some instances a summary of his entire career of championship rowing.

With an important exception, Americans followed the pattern set in England in the development of rowing. The first American rowers were professional ferrymen in waters around New York City in the 1820s, who, like their counterparts on the Thames more than a century earlier, occasionally rowed wagered races in heavy work boats. Next, amateurs developed an interest in the sport, and following the practical—but not the ideological— lead of class-conscious "gentleman amateurs" in London, formed rowing clubs in Castle Garden, spots along the Hudson (Newburgh was a very early one, followed by Poughkeepsie and Albany), Savannah, Worcester, Springfield, Pittsburgh, and Philadelphia. They began to hold races and regattas and to sponsor championships, all on the English models. Following English precedent set in the 1820s, Americans established collegiate rowing at Harvard in 1846 and at Yale the next year. The first Harvard-Yale race was rowed in 1852, in six-man barges (within a few years it was an annual event), and gradually over the next several decades other universities established rowing crews and regular regattas. Emulating the example of English professional sculling championships, a few American professional oarsmen began to compete for championship titles of various American rivers and regattas. In the tradition of American technical ingenuity, American boatbuilders made technological contributions to the development of the shell, inventing the sliding seat, and later, the paper shell; and they introduced such novelties into rowing practice as rowing without a coxswain.[14]

Although the Civil War interrupted the spread of rowing in the United

[14] According to Engelhardt, *Rowing Almanac*, 1873, p. 28, the first modern single shell built in the United States was launched in 1856 by David McKay. Experiments with a sliding seat—which enabled the rower to move forward to begin his stroke and thereby substantially increased the length of his stroke— were carried on simultaneously in the late 1850s by a number of oarsmen, including the Biglin brothers, whom Eakins painted in 1872. The paper shell was developed by the boatbuilding firm of Waters, Balch & Co. of Troy, New York, who applied over a frame single layers of paper, each one varnished individually, to produce a craft that was virtually seamless and very fast. Praising the firm's ingenuity, *Turf, Field and Farm* wrote: "Among the many peculiarly American ideas so prevalent at the present time, the very Yankee notion of molding boats from paper, is one deserving of special attention," January 20, 1870, p. 37. The coxswain, who sat in the stern of the shell facing the rowers to set their pace and steer the course, was considered indispensable until the 1860s. In the interest of saving weight and increasing speed, Americans introduced the custom of rowing without the coxswain and developed a steering mechanism that could be maneuvered by the oarsman nearest the bow with his feet. In later college rowing, the coxswain resumed his essential role.

States, within only a few years after its conclusion Americans had bought approximately two thousand boats and twelve thousand people had joined boating clubs.[15] In each rowing region enthusiasts took a comparative stance about the advancement of rowing across the country. Stimulated by expanded coverage of rowing activities in the national sporting periodicals and new interest in rowing by the local newspapers, they compared boating among cities, boat clubs, college and university crews, types of boats, and rowers themselves. Clubs in New York City, Poughkeepsie, Saratoga, Boston, Worcester, and Pittsburgh jostled in the press for superiority in size of membership, number of races in regattas, excellence of their racecourse, modernity of their boats, number of professional races held on their course, and turn-out of spectators for rowing events.[16]

Supporting the excitement of the rowing races and regattas were the values with which Americans understood the importance of the sport in meeting the challenges of modern, urban life.

First, Americans urged each other, rowing was useful to the health. Of concern to many modern citizens was the general health of their increasingly urban and sedentary (because clerical and professional) work force, and they characterized each other as "pasty" looking. Hoping that a large number of "indoor" colleagues could be coaxed to the nearest river, rowing's advocates claimed that rowing benefited the respiration, the digestion, and the muscles of legs, back and abdomen; it imparted a fresh glow to the skin. One devotee even praised the well-conditioned rower as "a study . . . for the sculptor and the artist, and no less an object of admiration to the man of science or the general public; his clear, bright eyes, his complexion, with the rosy tinge of perfect health peeping through; his upright carriage and elastic step, giving evidence that every muscle is under perfect control."[17]

Secondly, rowing demanded discipline. One kind of discipline was in physical regimen. Rowing season lasted from April to October, during which the rower worked out daily; many experts recommended two practice sessions per day—in early morning and late afternoon. The rower had to plan

[15] *Turf, Field and Farm*, March 22, 1872.

[16] This competitiveness is evident especially in the pages of *The Clipper* and *Spirit of the Times*, New York sporting journals to which correspondents sent the news of activities in their city; these reports, and often the editorials and reporting of the regular journal staffs, emphasized the relative progress of each region and encouraged rivalry.

[17] *Aquatic Monthly*, June 1874, pp. 379-380, communication of May 14, 1874 from William Wood. For other rhapsodic praises of rowing's contribution to health, see Robert B. Johnson, *A History of Rowing in America* (Milwaukee: Corbitt and Johnson, 1871), p. 20.

his sessions to develop strength as well as endurance; he had to subject himself to long, steady workouts regardless of the weather. Rowing in competition, in fact, called for such stamina that even in top condition oarsmen rarely rowed more than four or five official races per year. The discipline extended to hours off the water as well: diet was crucial—many trainers forbade all foods but boiled beef and dry bread—and eight or more hours of sleep were essential. The serious rower avoided late hours, smoking, and alcohol.[18]

Another dimension of the discipline was mental. Rowing enthusiasts urged that rowing was essentially a mental activity, directed by the intelligence. With his brain the rower sought out the most efficient type of stroke and feather—the two parts of the action that pulled the boat through the water—and analyzed them into their components so as to exercise the most complete control over their execution. The "scientific" rower, who made his body "perfectly subordinate to, and a quickly responsive and willing instrument of, the mind,"[19] understood and carefully rehearsed the basic principles of dropping the oar into the water, pulling it at precisely the right depth and tempo, removing it cleanly, and returning it—called "feathering"—to the position to begin the stroke. Devotees claimed to be able to hear a "thup" when the oar entered the water if the oarsman had begun his stroke properly and to see a certain kind of bubble when the oar left the water if the oarsman had correctly begun his feather.

Finally, the rower exemplified a "moral" discipline: his mental control prevailed in the heat of a race whether an oar broke, rain fell, or the rower himself became ill. He never set his stroke by that of a competitor, but rowed according to his own, or his crew's own, studied discipline. To bend to his passions early or late—to speed up his stroke to match the spurt of a competitor—was not to row the race with the dignity the sport demanded.[20]

As discipline could be acquired by all, spokesmen saw rowing as the ideal egalitarian, and thus American, leisure. Although professional men and busi-

[18] Rowers used the strictness of their regimen as part of their rowing character; for instance, an article on the famous Ward brothers in *Harper's Weekly*, September 30, 1871, concluded on the triumphant note that "they do not drink coffee, and smoking is strictly prohibited" (p. 909). Many advocates of rowing for young men admitted frankly that they encouraged it because the "abstemiousness and rigid self-denial" of the training had an obvious "good effect" on their morals; see *Turf, Field and Farm*, June 6, 1873.

[19] Waters and Balch, *Illustrated Catalogue*, pp. 13-14.

[20] See rowing discussed as "duty" in *Aquatic Monthly*, June, 1874, p. 374; and in Waters and Balch, *Illustrated Catalogue*, p. 145.

nessmen could afford the expensive shells and the boathouses in which to keep them, no one was excluded from rowing: people of more modest resources could form sporting clubs to share equipment. Editors of sporting periodicals wrote that the snobbishness associated with club membership in England "would never be tolerated [in America]; true merit is what we demand; a good head, a sound heart, and an untarnished reputation, will admit a man among the natural aristocracy of this great country, without a prefix or appendage to his name . . . If his hands are callous from honest labor, so much the better; he will have no blisters to prick when he rows."[21]

These were the public and rational virtues of rowing. Underneath them, and often mentioned by increasingly nature-conscious editorialists, were its more private advantages. Rowing removed one from the hubbub and the noise of the city to the restorative world of nature. Through demanding physical exercise and regenerative scenery one could work out—as Eakins advised his sister—the disappointments and frustrations of modern life. And in the best of moments rowing was positively exhilarating: the special light of early morning or late afternoon sessions on the river, the gentle sound of water closing under the oar and in the wake of the shell, the rush of moving air on the cheek, and, afterward, the pleasant tiredness of well-exercised muscles—these and more were the special, personal rewards of rowing.

Responding to the new public demand, American printmakers drew on the English tradition to satisfy the national appetite for rowing images with sheet music vignettes, periodical illustrations, and formal prints about American rowing heroes and events. General periodicals like *Harper's Weekly, Harper's Monthly*, and *Leslie's Illustrated Magazine* featured news of regattas and races, illustrating their reports with wood engravings that ranged from genre scenes to panoramic views of race courses with identifying landmarks to portraits of both individual rowers and of crews in their craft.[22] The interest

[21] *Turf, Field and Farm*, April 21, 1871, p. 244. For another celebration of the democratic quality of American rowing clubs, see Waters and Balch, *Illustrated Catalogue*, p. 16.

[22] Both Harry T. Peters, *America on Stone* (Garden City, N.Y.: Doubleday, Doran & Co., 1931), and Nicholas Wainwright, *Philadelphia in the Romantic Age of Lithography* (Philadelphia: Historical Society of Pennsylvania, 1958), list some of these sheet music vignettes. Historical societies near rowing areas—the Worcester Historical Museum and the Library Company of Philadelphia, for example—have several such images, as well as vignettes on regatta programs. Also popular, and extant in such archives, were stereograph photographs of rowing crews. Among the earliest articles on rowing to appear in a general periodical was that in *Frank Leslie's Illustrated Newspaper* August 11, 1860 on the Harvard College Regatta, July 24. By 1869 they were appearing frequently, especially in *Harper's Weekly*.

in rowing had so spread by 1867 that Currier and Ives published their first rowing print.

Much to the point of the painting Eakins would undertake in 1870, that image, "James Hammill and Walter Brown, in their Great Five Mile Rowing Match for $4000 and the Championship of America" (Figure 21), combined portraiture, documentation, and celebration. It was issued after a nationally followed match on September 9, 1867 between two of the best known professional oarsmen of the period. The race itself was a disappointment: a rematch after an earlier contest that ended in a foul, it too resulted in a victory because of a foul.[23] But the image transcends this particular race to serve larger functions: to recognize the new popularity of rowing in America, to celebrate the recent phenomenon of a national championship, to set forth portraits of each of these renowned oarsmen, to document the landmarks of Newburgh Bay, New York, where this and many other races were held, and where some of America's earliest boat clubs had originated, and to remind the viewer, with background detail, of the history of rowing.[24]

As appropriate for a popular and documentary print, the composition is easily read. It is a double portrait, but the design leaves no doubt of the rowers' relative importance. Hammill, who won the championship title, rows in the foreground position; pausing in his rowing, he looks up as though to pose for his portrait. Brown, disqualified on a foul but widely admired as a formidable rower, bends to his rowing in the middle ground; a posed portrait being inappropriate for his secondary status, his face is visible because he looks over his shoulder to check his position. The overall design of the view is ordered by parallels: first, of the racing sculls in the foreground, and of the background craft following them down the bay; and second, of the

[23] On May 21, 1867 in Pittsburgh, the men had rowed a contest for $1000 a side. Hammill withdrew before he finished, claimed a foul that was later disallowed, and Brown therefore won. The contest on September 9 was the rematch called for by Hammill, and preceded by several months of publicity. In outcome it was a reversal of the May contest: Brown fouled in swamping Hammill at the turning stake, and Hammill, although he did not finish the race, was proclaimed the new champion. Fouls occurred in rowing when an oarsman crossed into his opponent's course without a clear lead (usually this resulted in a literal collision); or when having left his original course, he returned to it in a manner that blocked the progress of his opponent who by rights had moved into it himself. Until late in the century when oarsmen associations set forth clear rules on fouls, the interpretation of judges was hotly contested.

[24] These details include two six-oared shells with coxswain, a reference to the collegiate origins of the sport; a four-oared shell without coxswain, a more modern racing boat than the six-oared; and other aquatic phenomena of the "modern" boating center: smaller rowing craft, yachts, schooners, and steamers.

matching diagonals of the rowers' oars. This simplicity violates, for the sake of explicitness, the accuracy with which the rowers' use of their arms and backs is depicted. A slight asymmetry relieves the stasis of the resulting pattern: each rower is slightly to one side of the center of the design, balancing it, and the different positions of their bodies give the scheme momentum. The printmaker documents the occasion with margin data that provide the date of the race, time, boat dimensions and builders, racers' names, and the details of the judgments of fouls committed.

Even nearer in time to Eakins' own rowing images—in fact, only a few months before he returned from Paris—an essay in *Harper's Monthly* brought together in subject and illustrations the most important motifs in English and American rowing.[25] The essay reported and analyzed the first International University Boat Race, a race between Harvard and Oxford held in England the previous summer that was the conversation topic of the year among rowing enthusiasts. The article raised questions earnestly debated in the wake of Harvard's loss: the merits of the "Harvard" or "American" style of rowing over that of Oxford; whether there was in fact a distinctive American style; and the "moral" shortcoming of the Harvard crew in not saving their strength for the final moments of the race. Nine prints of the International University Boat Race illustrated the article. "The Start, at Putney" set forth spectator-jammed steamers and guard boats, the competing crews, and on the shore identifying buildings, waving pennants, and the soft summer forms of trees. One of the images of the race underway, "Barnes Bridge" (Figure 22), shows the boats about to pass under the bridge as spectators at all points strain to follow their progress. In "The Finish, at Mortlake" the racing craft are shown parallel to the plane of the image in order to dramatize the victory of Oxford over Harvard by half a length; in the background on the river are small boats, barges, sailboats, and even a steamer; and on the shore are the houses and inns at the finish line with pennants and flags, trees, and spectators who crowd every conceivable space.

Other images accompanying the article focused not on the university race, but on the events that preceded it: an exhibition by the London Rowing Club and a single scull race between the American professional oarsman Walter Brown and the English champion James Renforth. In "The Picked Crew of the London Rowing Club" (Figure 23), which demonstates the ex-

[25] *Harper's New Monthly Magazine* (vol. 40), December 1869), pp. 49-67. So important to the general boating public was this race that Currier and Ives devoted their second rowing print to it, "The Great International University Boat Race" (1869).

hibition form of these rowers, the shell sits in the water at a slight diagonal to the viewer, its length sweeping from one edge of the image almost to the other with a slight space on the left giving it "moving room." On the same page with that image is a careful drawing of the boat by American builder Elliott which the Harvard crew had brought to England especially for the race. In Figure 24, the former professional champion Harry Kelley (a grand old figure in English rowing who had only recently lost his title to Renforth) poses in his scull in a moment of relaxation, his oars resting lightly on the water. The bow and stern of the long shell are overlapped by the edge of the engraving; the image is close to the viewer, but as in the "Picked Crew of the London Rowing Club," the shell is in a position to move away from the foreground on a diagonal. In Figure 28 the American Walter Brown poses on the thwart of his shell in a favorite portrait format for rowers (one which appeared frequently in rowing almanacs in the years 1871-1875), reaching forward in the style with which he characteristically began his stroke—hands well beyond feet, legs flexed, wrists poised.[26]

The entire repertoire of Eakins' nineteen rowing images is contained in this article and in the Currier and Ives rowing print. In his portrait of Max Schmitt, as he was to do throughout his career, Eakins adopted this visual vocabulary of his times and applied it incisively to his work in Philadelphia.

And this work, in the case of Max Schmitt, was to celebrate a champion. Prints of the Schuylkill River and of the Fairmount Water Works, located on the river, and possibly painted views as well, had featured rowing crews as part of the detail as early as 1835 (Figure 26).[27] Yet so unusual in Philadelphia was a rowing portrait as a subject for a painting of local life that on seeing the painting of Schmitt exhibited in 1871 a local critic felt compelled to note the peculiarity of the subject.[28] It was unusual in France, too, where

[26] For portrait photographs, some famous crews posed in their street clothes. Individual champions, like Brown, often posed in racing trunks or knickers, seated on a shell thwart in the studio. A popular photographer of rowing portraits recommended in rowing periodicals was John O'Neill of New York, an oarsman himself. See *Aquatic Monthly*, September 1872, p. 313, and *Turf, Field and Farm*, December 15, 1871, p. 375.

[27] A number of artists exhibited paintings in mid-century in Philadelphia that focused on local scenery; the exhibition at the Pennsylvania Academy of the Fine Arts in 1861, for instance, included E. Moran, *Evening on the Schuylkill*, E. L. Williams, *Sketch on the Schuylkill*, A. Z. Schendler, *View from above the Falls of the Schuylkill* (now all unlocated).

[28] The painting was reviewed in the Philadelphia *Inquirer* on April 27, 1871, by a writer who identified the painting as a "river scene" and went on to note: "While manifesting marked ability, especially in the painting of the rower in the foreground, the whole effect is scarcely satisfactory. The light on the water, on the rower, and on the trees lining the bank

rowing began to develop even later than in America; in 1875 Gérôme gave Eakins a requested critique on one of his rowing studies with the accompanying comment that he didn't know if the subject would be saleable.[29] Whereas painted rowing portraits were not unheard of in England,[30] in the United States the few scenes of rowers seem to have been done in the Boston area. One early such scene, that by A. A. Lawrence (Figure 27), was stimulated by the first Harvard/Yale race of 1852; another, George D. Hopkins' *Scull Race, Boston Bay*, 1856 (Peabody Museum of Salem), depicted some of the first single scull races in Boston. Eakins was perhaps the earliest artist in Philadelphia—and, as Figure 27 reveals, certainly the first American artist of his capability—to paint portraits of scullers at work, to follow the lead of the early printmakers and the photographers and commit the activity to a strong assertion of its importance: to put it on canvas.[31]

indicate that the sun is blazing fiercely, but on looking upward one perceives a curiously dull leaden sky." The reviewer for the *Philadelphia Evening Bulletin*, writing on the same day, was more complimentary: "[Thomas Eakins] who has lately returned from Europe and the influence of Gerome, has also [in addition to a portrait, now lost] a picture entitled *The Champion Single Sculls* (no. 137), which though peculiar, has more than ordinary interest. The artist, in dealing so boldly and broadly with the commonplace in nature, is working upon well-supported theories, and, despite somewhat scattered effect, gives promise of a conspicuous future. A walnut frame would greatly improve the present work." Eakins may have seen rowing paintings in New York exhibitions in the early 1870s: in his letter to Earl Shinn of Good Friday, 1875 (Friends Historical Library of Swarthmore College), he comments that aspects of the movement of a rowing painting he had just finished (probably *The Schreiber Brothers*, 1874, Collection of Mrs. John Hay Whitney) were "all better expressed than I see any New Yorkers doing." On the other hand, he may have been making a general technical comparison between his ability to catch particular details and that of his rivals in New York.

[29] Gérôme to Eakins in 1873, Lloyd Goodrich, *Thomas Eakins*, 2 vols. (Cambridge, Mass.: Harvard University Press, 1982), I, 116. Before long, however, rowing and regattas would appear in works by French artists: James Tissot painted the *Henley Regatta* ca. 1877 (private collection) illustrated in James Laver, "*Vulgar Society*"; *The Romantic Career of James Tissot, 1836-1902* (London: Constable and Co., Ltd., 1936), pl. 17. Henri Michel-Lévy painted *The Regattas*, ca. 1878 (location unknown, illustrated in Theodore Reff, *Degas: The Artist's Mind*, London: Thames and Hudson, 1976). An early example by E. Morin, "Les Régates du Rowing-Club," was engraved by Marais for the *Paris Guide*, vol. 2 (Paris: Librarie International, 1867), p. 1511. Paul Hayes Tucker in *Monet at Argenteuil* (New Haven and London: Yale University Press, 1982), pp. 89-120 discusses the rise of boating in France, with Argenteuil as a major center, as reflected in the paintings of Monet.

[30] Several prints of champions were made from these paintings. The print of "Henry Clasper, Champion of the North" published by Hodgetts, c. 1860, is noted as being from a painting by J. H. Make; the print *A Boat Race on the River Isis, Oxford*, was engraved after a painting by John Thomas Serres.

[31] He was also one of the few artists ever

The Champion Single Sculls reestablished Eakins in his home territory, asserting the continuity between what he had known and done before his specialized studies and what he wanted to paint now, as an artist, and it proclaimed what he had written his friend Emily from Paris—that he was proud to be a Philadelphian.

For *The Champion Single Sculls* is a partisan image. Currier and Ives had celebrated professional rowing and, in 1869, college rowing—themes appropriate for their national audience—but they had not focused on the rowing of amateurs, who were regional heroes. Images in the periodicals of important races in America showed racers on the Hudson, on Lake Saratoga, in Boston, in Ontario, in Pittsburgh—but not in Philadelphia.[32] Despite the rush to the river in the late 1850s and early 1860s of novices like the Eakins family, Max Schmitt, and many Philadelphia professional men, in 1870 Philadelphia had not yet attracted the national spotlight as the site of huge regattas and brilliant professional races. Yet the Schuylkill River was eminently suitable for fine rowing and was praised as such in the national press.[33] The foliaged banks of Fairmount Park on both sides of the river gave it in the summer an oft-cited "emerald" peacefulness. Above the dam, the river was smooth, broad, and fairly straight. The gentle flow of the river downstream gave a pleasant variety to rowing the course upstream and downstream. It was also eminent for spectatorship: it had just enough of a curve to make watching a race an adventure. (See Figure 28, "The Rowing Courses Used on the Schuylkill River".) At no one vantage point could spectators see the entire race, but either above or below the bend of the river strained to catch sight of the leading boat as it shot around the turn.

Although rowing had taken place on the Schuylkill as early as the 1830s, and a regatta "of some importance" had been held in 1835, heavy barges (two-seated open boats) without outriggers had dominated Schuylkill rowing until the 1860s.[34] One professional race did take place on the Schuylkill—in

to do so, a phenomenon that suggests not only his individuality but the rapid changes that characterized the evolution of rowing after Eakins abandoned the subject.

[32] For example, *Harper's Weekly* had covered rowing events in Pittsburgh on November 23, 1867; Ottawa on October 19, 1867; West Point, June 27, 1868; and Boston on July 3, 1869.

[33] Even the editor of the New York jour-

nal, *Turf, Field and Farm* praised the Schuylkill, stating flatly that it had the best water anywhere for comfortable boating: June 1, 1867, p. 342.

[34] Engelhardt, *Rowing Almanac*, 1873, pp. 115-116, reconstructs what was known of Schuylkill rowing after the regatta of 1835. His records of the races of each year specify type of boat and length of course, so that one can assess the character of the sport. Also see

1862 the professional single scullers Joshua Ward and James Hammill rowed on two successive days and established the racecourses that became official on the Schuylkill[35]—but thereafter, professional rowing languished until the 1870s. The Schuylkill was too far from New York, the home of most of the professional rowers. Official college racing, which stimulated the spread of amateur rowing in the New England centers, did not begin on the Schuylkill until after 1878.

Moreover, Philadelphians were slow to take up single sculling. Whereas citizens in most rowing centers were actively single sculling by 1860, not until 1866 were the first amateur single shell races recorded in Philadelphia, and these were unofficial, with only two rowers participating.[36] In a letter published in one of the influential American sporting journals a correspondent from Albany wrote disdainfully in June 1867 that Philadelphians were still racing in gunwale barges and heavy outriggers as though the Schuylkill had just come into existence. They had not even taken up four-oared shells, the correspondent charged, and single shells were virtually unknown. His parting shot was that Philadelphians ought to "keep up with the times."[37]

Max Schmitt was among the Philadelphians to respond to this challenge. When the Schuylkill Navy began the season of 1867 with a new commodore who announced that Philadelphia would "make a bold struggle for boating supremacy in our country," the subsequent three-day regatta drew immense crowds and the flattering notice of leading sports periodicals in New York. Noting that Fairmount, the site of the racecourse on the Schuylkill, "is to Quakerdom what the Central Park is to Gotham," they reported that lady equestrians, the Liberty Cornet Band, and "a surging mass of anxious humanity, men, women, and children" jammed the river banks, shores, and bridges, while "the bosom of the river [was] dotted . . . with innumerable craft gaily decorated with flags and streamers."[38] The regatta opened on June

Charles A. Peverelly, *The Book of American Pastimes* (New York: published by the author, 1866), pp. 201, 204.

[35] They rowed a five-mile race and then a three-mile race. See reports in *Spirit of the Times*, August 23, 1862, p. 388, and in Engelhardt, *Rowing Almanac*, 1873, p. 31. The *Spirit of the Times* noted that Philadelphians did not give the race proper attention—that indeed, the main reason the competitors chose the Schuylkill was that it was generally free of craft of all kinds.

[36] See Engelhardt, *Rowing Almanac*, 1873, p. 117. There were two races this year (1866).

[37] *Turf, Field and Farm*, June 1, 1867, p. 343.

[38] The commodore was Charles Vezin, described by the *Spirit of the Times* as "a boatman of some years' standing" and "a gentleman of ample means," June 22, 1867 (vol. 16), p. 308. For a report on the regatta see also *New York Clipper* (vol. 15, no. 12) June 29, 1867, p. 92.

10 with the race for the first single scull championship of the Schuylkill Navy. Max Schmitt won it.[39]

Between the time of that victory and July 1870, when Eakins returned from Paris, Schmitt raced in most of the regattas.[40] The race of 1867 had secured the single scull championship as an event, and over the next few seasons Schmitt lost the title, won it back, and then lost it again. In Paris, Eakins kept track. His sister Frances wrote him of Schmitt's victory in June 1869. "I've got your letter announcing Max's victory. I am glad he beat & you give him my congratulations next time you see him," Eakins wrote. "Who was that Clark that run against him?"[41] Clark won the title back from Schmitt that fall.

When Eakins returned from Paris in the summer of 1870, Schmitt was ready to try for the championship again. This race, held on October 5 with a huge crowd in attendance, provoked even more interest than the first championship, for it drew four competitors.[42] This was the first time in the three years of competition that more than two scullers had entered the event, and it raised considerable pride in the healthy spread of single sculling among Philadelphia rowers. The three-mile course for this race ran from Turtle Rock (Figure 28) to Columbia Bridge and back. Although the competitors, all members of the Pennsylvania Barge Club, seemed to be evenly matched, Schmitt won handily. By the time he reached the stake boat halfway through the race, two of his colleagues had already fouled twice and he was three full lengths ahead. As the *Spirit of the Times* reported on October 15, after Schmitt turned the stake he "had no trouble in maintaining the advantage he had gained," and he finished with the very fast time of twenty minutes.

[39] Schmitt's opponent was Austin Street, his fellow club member in the Pennsylvania Barge Club. According to the *Clipper*, the contestants pulled bow and bow for half a mile, and then Schmitt pulled ahead to win by 25 seconds, in a total time of 24:49. The race was also recorded in Engelhardt, *Rowing Almanac*, 1873, pp. 117-118, who reports that the water was "very rough."

[40] His participation can be followed in Engelhardt, *Rowing Almanac*, 1873, p. 119-121.

[41] Eakins to Fanny, July 8, 1869, Archives of American Art.

[42] The race of October 5, 1870 is recorded in Engelhardt, *Rowing Almanac*, 1873, p. 121;

the *Philadelphia Evening Bulletin* covered it on October 6; it was reported succinctly in *The New York Clipper* (vol. 18, no. 28), October 15, 1870, p. 220; and in great detail in *The Spirit of the Times* (vol. 23, p. 135), October 15, 1870. This last report also included a summary of the history of the single scull championship on the Schuylkill in which Schmitt's early and continuing role in that championship was cited. The race is also discussed as definitive for single scull racing on the Schuylkill by Louis Heiland, *History of the Schuylkill Navy of Philadelphia* (Philadelphia: Drake Press, 1938), p. 134.

His prizes were the championship belt and a pair of silver-mounted sculls, and well-earned publicity as well: one of the earliest coverages of rowing activity in the Philadelphia *Evening Bulletin* and stories in the New York sporting journals.

This is the victory that Eakins memorialized and documented in his portrait: Schmitt had been the first, and now he was again, the "champion" of the "single sculls" of the Schuylkill Navy. Just as Schmitt's achievement as a single sculler capped the evolution of rowing, and specifically rowing on the Schuylkill, so did Eakins' tribute bring to full expression the tradition of rowing imagery and tie that tradition to Philadelphia.

In the first place, *The Champion Single Sculls*, like the prints and illustrations that celebrated rowing's progress, celebrates a particular victory. Although Schmitt first won the championship in 1867, it was the race of October 5, 1870 that Eakins saw; and the double-portrait format of the painting testifies to this expert witness. In the place of the margin-filling texts of the rowing prints, Eakins conveyed with pictorial details the main facts of this championship race. The foliage reports the fall season; the houses and double bridges mark the location not only as the Schuylkill, but, more specifically, the particular three-mile amateur course on the Schuylkill that Schmitt rowed in this race: from Turtle Rock, through the double bridges to Columbia Bridge, and return.[43] The late-afternoon sunlight reports the time of the race: lasting 22 minutes, it began at 5 p.m. Schmitt rowed in the craft "Josie," made by the famous boatbuilder Judge Elliott of Long Island, and Eakins suggests the dimensions faithfully: 33-1/2 feet long, 13 inches wide, 40 pounds. He portrays Schmitt's slim physique, noted in the journal account as 5 feet, 11 inches, 135 pounds.[44]

Secondly, like its precedents in prints, especially the Currier and Ives prints, the painting celebrates more than a specific victory. It establishes that

[43] The alternative three-mile amateur course with turn that Schmitt could have rowed began just above Columbia Bridge (see Figure 28), extended north to the Reading Railroad Bridge and returned to Columbia Bridge. On this course, the rower would not have passed through the Girard and Connecting Bridges. The third amateur course, the straightaway (which is now the course commonly used) ran from just below Falls Bridge (see star on map) all the way to Turtle Rock (see star on map), near the boathouses.

[44] Schmitt's age (28), weight, and height, and the specifications of his boat *Josie* (which apparently belonged to the Pennsylvania Barge Club of which he was a member) are reported in the *New York Clipper* (vol. 18, no. 28), October 15, 1870, p. 220. The report claims that the course was actually not quite three miles in length, which would account for Schmitt's extraordinarily fast time.

Philadelphia rowing had matured. Here is the Schuylkill's "Champion, Single Sculls" barely three years after Philadelphians had been taken to task for not rowing singly at all. What is more, four other single scullers ply the river with the champion. The only other craft on the river—besides the steamboat—is a double scull, another notably "modern" craft. In the event any viewer unacquainted with Philadelphia's bridges misses the point, the crew wears Quaker dress, placing the scene unmistakably in America's Quaker city.

Through its celebration of a victory and assertion of civic pride, the painting is, and fundamentally so, a portrait. More explicit than a likeness in bust form, Eakins' image shows his friend—and, not incidentally himself also—in a context of disciplined action that sets forth character. Schmitt is a thoroughgoing amateur, a modern hero who has taken on the mantle of all the virtues associated with rowing. None of these virtues had come to him through aristocratic advantages: both Schmitt and Eakins, in fact, had typically democratic backgrounds: Schmitt's family had immigrated from Germany, Eakins' grandfather was an immigrant from Ireland; both families were hardworking middle-class Philadelphians; both young men were graduates of the egalitarian Central High School.[45] As the painting shows, these young men devote themselves to enlightened leisure activity that combines physical exercise with mental judgment and moral discipline.

In addition to celebrating a champion, a notable pursuit, and Philadelphia "modernity," Eakins' painting marks the quiet, solitary pleasures of rowing. To do so he modified several of the conventions in the print repertory. A central element of many rowing images was spectatorship, and in *The Champion Single Sculls*, despite the amenability of the format to the nature of the occasion being celebrated, there are no spectators. The late afternoon scene, with the last steamboat down the river, records the time after the victory, when everyone has gone home; or perhaps it evokes one of Schmitt's daily practice sessions, with the steamboat on a visitor's tour. With another subtle modification of convention Eakins manages Schmitt's portrait: Schmitt rows on the scene of his championship race, as do Hammill and Brown, and like the champion, Hammill, he interrupts his stroke as though to present him-

[45] Schmitt's background is reported in the *New York Clipper* (vol. 15, no. 26) October 12, 1867, p. 211: he was born in Kaiserlauthern, Bavaria. His name and scholastic record at Central High School, like that of Eakins and all other students, are included in the Annual Reports. He became a lawyer, by which identity he is listed in the Philadelphia Directory from 1870.

self to the viewer. He is as relaxed with his oars as the Englishman Harry Kelley in the *Harper's* image. But Kelley sits in his shell simply to pose; and Hammill's stroke is patently awry for the sake of a clear pattern. Eakins maintains Schmitt's working position, but, by dissociating him from the actual manipulation of the oars, gives him a subtle commanding ease. Even more finely, he preserves his friend's psychological privacy: Schmitt has to turn sharply to look at us. And in yet another delicate effect, Eakins avoids the straight paths of the shells characteristic of the popular prints and places Schmitt's shell on a dynamic curve with carefully arranged clues that the viewer can reconstruct. His is a painting in which movement is almost palpable.

Eakins' transformation of the format of the double portrait that Currier and Ives employ makes a point about his own role in the activity of the painting. Schmitt's head is almost precisely in the middle of the picture, and he is the near rower; Eakins is in the deep middle ground, off center. As in Currier and Ives' contrast between the interrupted pose of the champion and the attention to work of the runner-up, Schmitt relaxes and Eakins (encourager rather than contender) works. Rather than rely on the easy parallelism of the popular image, however, Eakins exploits the curve of the river for a deep space in which to construct a picture of distinctions: one rower works, one relaxes; one moves into deep space, one into the foreground; one moves on a course to the viewer's right, one to the left; one in sunlight, one in partial shade. These distinctions point to the different interests of Eakins and Schmitt as oarsmen. Schmitt is the racing champion; Eakins is the recreationist. Schmitt is a model of the excellence toward which others aspire, but Eakins is no dabbler: he rows intently, and with proper form. He, like many other Americans educated in the discipline, belongs to the large cadre necessary for the excellence of the few to flourish. Eakins, not a competitor, is the authoritative witness to this heroism, a role he was to play all his life.

Not only in compositional subtleties, but also in his palette and painting technique, Eakins gave his portrait of Schmitt a life beyond (and distinct from) printed rowing tributes. His subduing of the bright sky, overlayering of the water with dark fingers of glazing, flat massing of brown areas against the sky—under it all a noticeable gray—evoke the varied uncertainties in human endeavor. The brushwork is deliberately testing, at points awkwardly resigned. Autumn is a season of ambiguity and loss, as things come to an end, even as championships just won recede in importance after the first flush of satisfaction.

Schmitt continued his championship rowing for several years after Eakins painted his tribute to him. In fact he became an authority on racing, recognized beyond the confines of Philadelphia. On a trip to Europe in 1873 he reported to the sporting journal *Turf, Field and Farm* on rowing equipment and styles in France and Germany, finding both countries considerably behind America in physical fitness and in rowing discipline.[46] The year before, in 1872, he had again won the single scull championship of the Schuylkill; with that victory he had set a record for the fastest time.[47] Thereafter, Schmitt's own rowing gradually tapered off. Some regattas would find him on the sidelines; he was away from Philadelphia for some months, and at times he was not in top condition. Soon the pressure of business and the inevitable loss of robustness that came with entering his thirties led him to yield championship rowing to those younger than he and to row merely for recreation.[48] Eakins had given him the painting, and after Schmitt exhibited it in 1871—at the first exhibition of Eakins' paintings in Philadelphia—he kept it in his living room. When Mrs. Eakins got it back in 1930 from Schmitt's widow, it was called simply *Max Schmitt in a Single Scull*, having over sixty years become significant simply as a portrait of the young Schmitt rowing.[49]

After *The Champion Single Sculls*, Eakins moved on to other rowing subjects. Just as he had tested his technique in the first rowing painting, laboring over it here and exulting in it there, so he explored a set of variations in rowing imagery and in techniques. He painted pair-oared rowers (two men rowing, each with an oar) at various moments in races and in their workouts (Figure 29), a crew of four (*Oarsmen on the Schuylkill*, c. 1874, formerly Brooklyn Museum) and close-up portraits of a professional single sculler (Figure 30 and *John Biglin in a Single Scull*, 1873-1874, Yale University Art Gallery). He painted with thick opaque brushwork; he laid in some of his skies with

[46] His letters to the journal are published July 11, 1873, p. 26; July 25, 1873, p. 59; July 29, 1873, p. 138; October 24, 1873, p. 267; October 31, 1873, p. 283. After his return, Schmitt continued his correspondence: his long letter about rowing on the Schuylkill appeared in the issue of May 8, 1874, p. 302; and on December 18, 1874 (p. 432) he wrote an amusing satire on Schuylkill rowing.

[47] His time, according to Engelhardt, *Rowing Almanac*, 1873, p. 122, was 22.30.

[48] For a few years he rowed in the less-demanding four-oared shell competition. In the

fall of 1874, for instance, he rowed for his club in a race of 1½ miles, straightaway, in a position recorded by Engelhardt (*Rowing Almanac*, 1875, p. 65) as immediately behind the stroke oar; thus it must have been the crew for this race that inspired Eakins to begin his *Oarsmen on the Schuylkill*, a painting that he did not complete. Schmitt is the second figure facing the stern of the shell.

[49] The painting entered the collection of the Metropolitan Museum of Art in 1934 with that title.

the palette knife—indeed exulted to a friend that he had shocked Gérôme by doing so in one of his hunting paintings; he experimented with wiping back some of his backgrounds to the weave of the canvas and glazing thinly over the area; he painted in delicate watercolor. He sent several watercolors of the rowing subjects (apparently of single scullers), now lost, to his teacher Gérôme explicitly for critical appraisal and perhaps implicitly to show him an American, and even more specifically, a Philadelphian, subject.[50] Some of the works he did not complete. But in the large rowing paintings that he did finish he continued his partisanship for champions, modernity, and the Schuylkill.[51]

The most enduring of these sculling images focus on the private moments of the activity: *The Champion Single Sculls, The Pair-Oared Shell* or *The Biglin Brothers Practising* (Plate 3), and *John Biglin in a Single Scull* (Figure 30). Although in all the rowing paintings Eakins celebrated what an overwhelming number of his fellow citizens—in Philadelphia and elsewhere—enjoyed and found important, he saw beyond the bright colors, the noise of the crowd, and the rush of the boat through the water to the lonely discipline of doing something well—and to its mutability.

Indeed, the history of rowing itself provides a metaphor for what Eakins saw. Over the century, rowing shells had been refined from ten and eight-oared heavy barges to ever lighter, ever more delicate craft rowed by smaller

[50] Gérôme criticized the first picture Eakins sent of a rower (a watercolor) as being static and urged Eakins to show the rower at the beginning or at the conclusion of his stroke instead of in the middle (Goodrich, *Eakins*, 1982, I, 114); the second picture, with the rower at the end of his stroke, Gérôme liked (Goodrich, I, 116). Eakins wrote Earl Shinn of his amusement that Billy Sartain had reported Gérôme's "fear" that the sky of his painting about "rail shooting" had been "painted with the palette knife" (Eakins to Shinn, March 26, 1875, Friends Historical Library of Swarthmore College). Eakins' earlier rowing image, which Gérôme found lacking in motion, probably reveals his reliance on the conventions of prints and photographs.

[51] Three of them grew from the famous pair-oared professional race on the Schuylkill on May 20, 1872 between the Biglin brothers, John and Barney of New York, and the Coulter/Cavitt team, of Pittsburgh, the first professional pair-oared race in America. The *Philadelphia Press* covered the race in a long article on May 21, 1872; and *The New York Clipper* gave it detailed coverage on June 1, 1872 (vol. 20, no. 9), p. 68. Soon after he painted the Biglins, however, Eakins felt that the works were "clumsy and although pretty well drawn are wanting in distance and some other qualities" (to Earl Shinn, Good Friday, 1875, Friends Historical Library, Swarthmore College). Eakins may also have painted another national champion. Irene Ward Norsen, *The Ward Brothers, Champions of the World* (New York: Vantage Press, 1958), p. 52, claims that Eakins painted a portrait of Joshua Ward which was displayed in Ward's hotel in Cornwall, New York until it was destroyed in a fire.

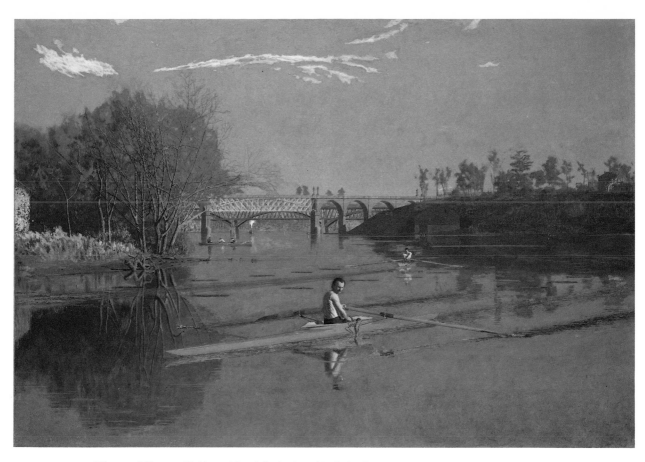

Plate 1. Thomas Eakins, *Max Schmitt in a Single Scull*, or *The Champion Single Sculls*, 1871.

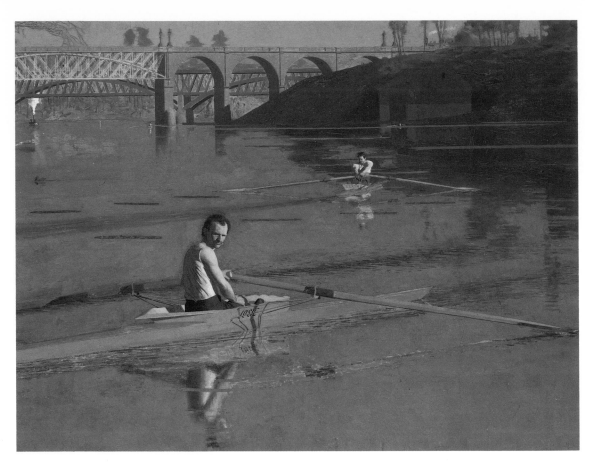

Plate 2. Thomas Eakins, *Max Schmitt in a Single Scull*, or *The Champion Single Sculls*, 1871, detail.

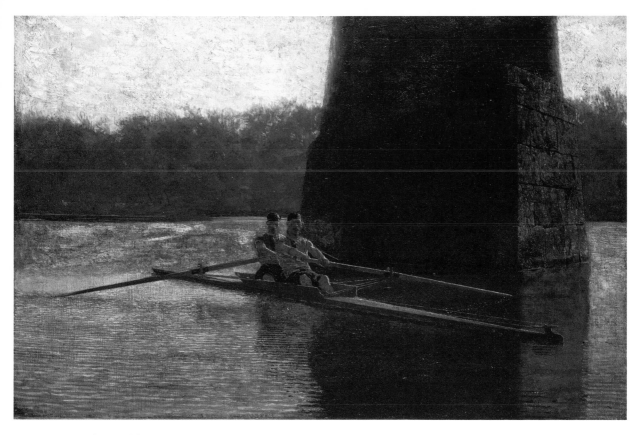

Plate 3. Thomas Eakins, *The Pair-Oared Shell* (originally *The Biglin Brothers Practicing*), 1872.

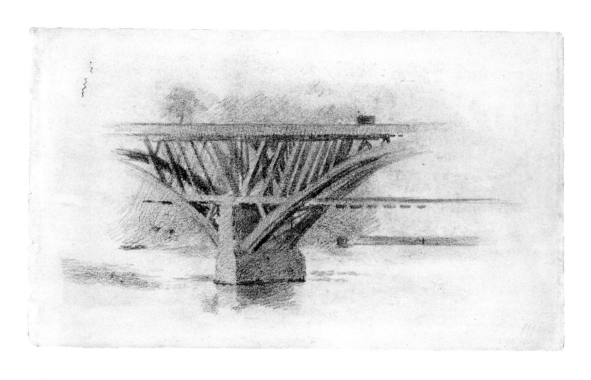

left oar looking out
to the blade

Figure 17. Thomas Eakins, *Drawing of the Girard Avenue Bridge with sketch of an oar the verso*, pencil on paper, c. 1870.

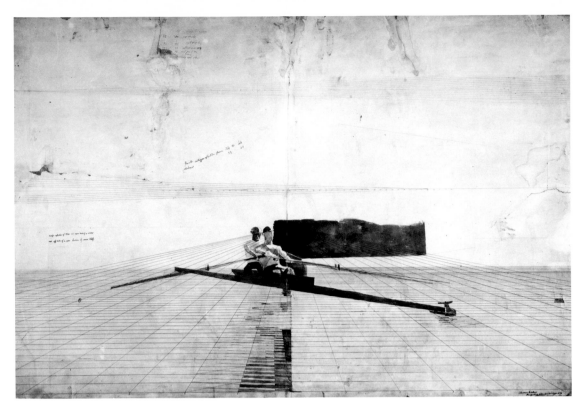

Figure 18. Thomas Eakins, *Perspective Drawing for "The Pair-Oared Shell,"* pencil, ink, and
watercolor on paper, 1872.

Figure 19. *Match Between Eton and Westminster Rowed at Putney, August 1, 1843: The Eton winning
by fourteen boats length*, lithograph by R. F. Thomas, 1843/44.

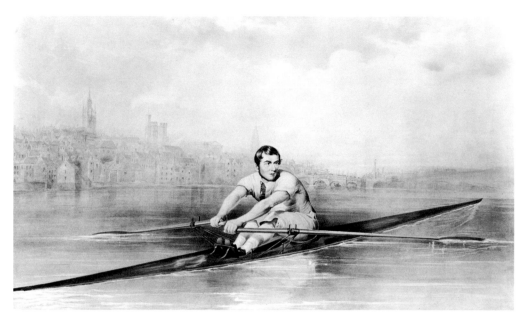

Figure 20. *Henry Clasper, Champion of the North of Derwenthaugh by Newcastle on Tyne*, lithograph by R. M. Hodgretts and E. Walter, c. 1860, after J. H. Make.

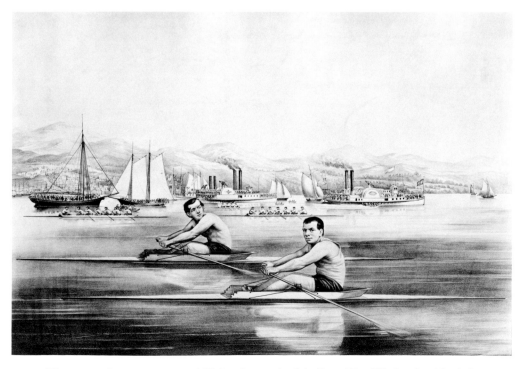

Figure 21. *James Hammill and Walter Brown, in their Great Five Mile Rowing Match for $4000 and the Championship of America*, lithograph by Currier and Ives, 1867.

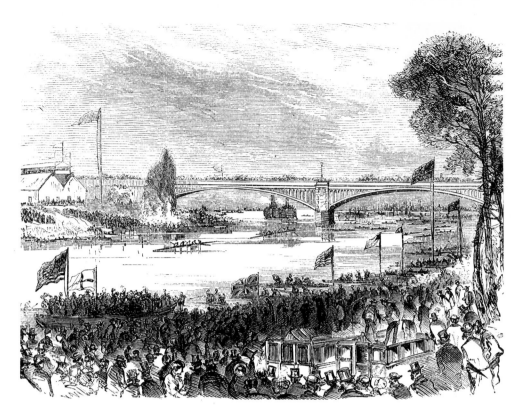

Figure 22. "Barnes Bridge," *Harper's New Monthly Magazine*, December, 1869.

ELLIOTT'S BOAT.

Figure 23. "Picked Crew of London Rowing Club" and "Elliott's Boat," *Harper's New Monthly Magazine*, December, 1869.

Figure 24 (Above). "Harry Kelley," *Harper's New Monthly Magazine*, December, 1869.

Figure 25 (Left). "Walter Brown, American champion," *Harper's New Monthly Magazine*, December, 1869.

Figure 26 (Below). *A View of Fairmount Waterworks with Schuylkill in the Distance Taken from the Mount*, lithograph by John T. Bowen, 1835.

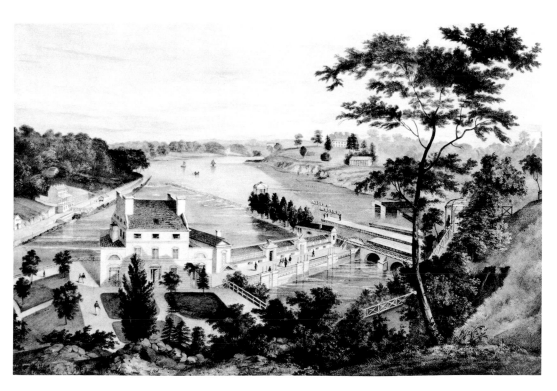

Figure 27. A. A. Lawrence, *Boat Race, Boston Harbor*, 1852.

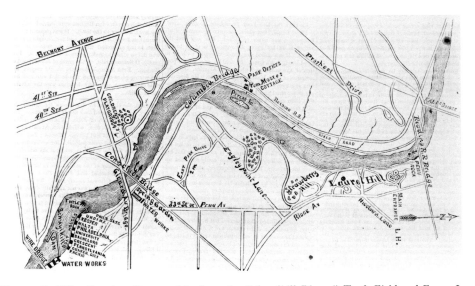

Figure 28. "The Rowing Courses Used on the Schuylkill River," *Turf, Field and Farm*, June 14, 1872. This shows the several courses on the Schuylkill. The professional course was five miles: it ran from just below Reading Railroad Bridge (see spearhead) to Connection Bridge (see bent arrow), where the racers turned, and back to Reading Bridge. The amateur course was three miles: racers could choose either a straightaway course or one with a turn. If they rowed a straightaway course, they began just below Falls Bridge (see star on map) and rowed all the way to Turtle Rock, near the boathouses (see star on map). If on the other hand, they rowed a course with a turn (always more challenging), they would begin just above the Columbia Bridge, row north to the Reading Railroad Bridge, and return to Columbia Bridge. An alternative three-mile turning course ran from Turtle Rock north to Columbia Bridge and back. Waters and Balch, *Annual Illustrated Catalogue*, p. 472, gives a table of distances between various points on the Schuylkill course.

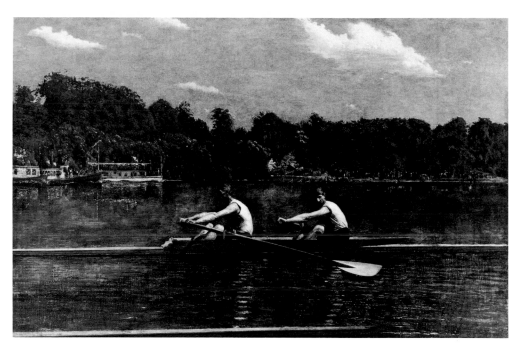

Figure 29. Thomas Eakins, *The Biglin Brothers Racing* (orig. *The Biglin Brothers About to Start the Race*), ca. 1873.

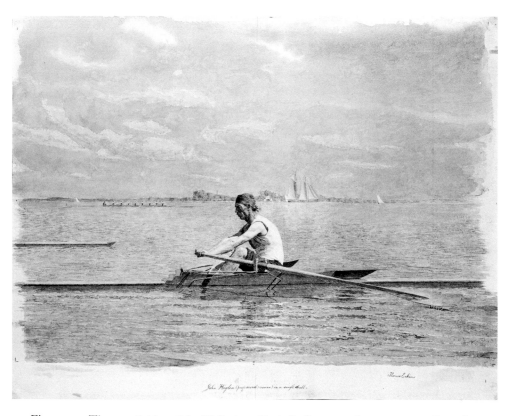

Figure 30. Thomas Eakins, *John Biglin in a Single Scull*, watercolor on paper, 1873-1874.

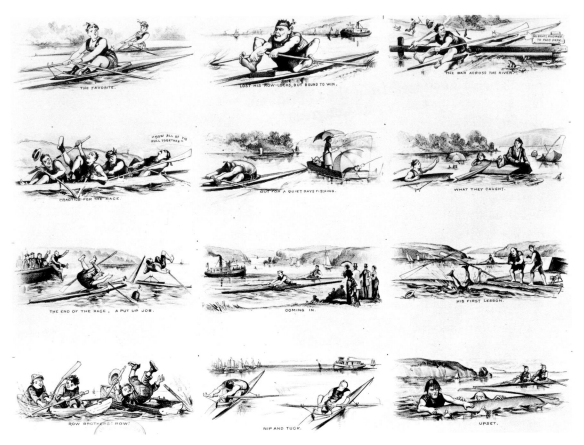

Figure 31. *Bufford's Comic Sheet—No. 419.*

teams, and, finally, by a single man. This single rower alone propelled himself and steered. Like good men in all endeavors, he "rowed within himself," not allowing himself to be swayed by transitory fears of losing or even of falling behind, but demanding of himself loyalty to the measured discipline that he had perfected in his training. Eakins himself, metaphorically, was to be a single sculler all his life.

He did not undertake rowing as a painting subject after 1874; he turned his own leisure before long to other pursuits. Although sailing and hunting were approved of as healthful and relaxing, they did not rest on the same moral underpinnings as had rowing. And boxing, which Eakins was to paint in 1898 and 1899, claimed supporters who found it to be "scientific," but no one called it "moral."[52] Ironically, rowing on the Schuylkill achieved consistent national prominence only after Eakins abandoned the subject: first with the Centennial National Regatta, and then later in the decade when the University of Pennsylvania's involvement in college racing made river life considerably more newsworthy nationally.[53] Eakins celebrated rowing before other painters perceived its potential; he celebrated Philadelphia rowing before other Philadelphians quite recognized what they had.

When he turned permanently to other subjects after 1874, Eakins had exploited most if not all the conventions in rowing imagery. The champions he had admired and painted during the first burst of his painting career grew older and retired from racing, for racing was then considered to be a young man's sport. Schmitt, two years older than Eakins, and John Biglin, six months older than Eakins, were getting too old for it by 1874, when Biglin and Eakins were thirty. Even in 1872, one of Biglin's staunch admirers speculated that he had but one or two seasons more at top form, and then, other rowers' youth would tell in their favor, so that "on some fine sunny day Biglin will realize . . . the sensations and discouragements of the proverbial stern chase."[54]

[52] For the cultural context of boxing, as reported during the period contemporary with Eakins' paintings, see Walter H. Pollock, *Fencing, Boxing, and Wrestling* (Boston: Little and Brown, 1890); and E. B. Mitchell on boxing in *Fencing, Boxing, Wrestling* (London and Bombay: Longmans, Green and Co., 1897), as well as commentary in the sporting journals of the period. Carl S. Smith, "The Boxing Paintings of Thomas Eakins," *Prospects* 4 (1979), 403-420, relies generally on twentieth-century studies rather than firsthand reports.

[53] The first National Amateur Regatta was held on the Schuylkill in June 1872, following the formation of the National Association of Amateur Oarsmen, and it played a major role in increasing Philadelphians' and the nation's enthusiasm for the Schuylkill as a rowing center.

[54] *Aquatic Monthly*, October 1872, p. 369.

Other considerations told deeply, too. There was the difficulty of being simultaneously in top form and an amateur. Max Schmitt felt the tension in his own busy life and saw it in the lives of his fellow clubmen. As he wrote *Turf, Field and Farm* in 1874, near the end of his own racing, "Our men cannot afford to neglect their business engagements for training. In order to be able to attain any distinction in 'open' scull races now-a-days, a man, besides being the possessor of a powerful frame, must be able to give his entire and undivided attention to rowing for at least two months before the race. I know of no one, in the ranks of our scullers, who could, even approximately, have enjoyed these advantages."[55] In addition, the claim that rowing was beneficial to the health was not always true. When he came to America in 1869 to demonstrate his form, the famous English rower James Renforth dropped dead near the finish line of a vigorous race on Lake Saratoga; he was only thirty years old. The American oarsman Walter Brown (of Brown/Hammill fame) died at age thirty-one of a cold caught while trying to practice when the late winter ice still choked the river.[56]

Finally, as Enlightenment values began to lose their hold later in the century, much of the elaborate moral construction built around all sporting activity began to weaken. In the case of rowing, it became clear that successful rowers did break training, that not everyone benefited from rowing, that competition was frequently ungentlemanly. Indeed, by the late 1870s after the first and second generation of professional rowers retired, professional racing came to be dominated by men lacking virtuous public identities.[57] The role of the citizen amateur took back seat to the increasingly exclusive interest in college rowing; and then, in the 1880s, other college

[55] *Turf, Field and Farm*, May 8, 1874, p. 302.

[56] In England an entire book was devoted to countering the argument that rowing was not beneficial to the health: John Edward Morgan, *University Oars, being a critical inquiry into the after health of the men who rowed in the Oxford and Cambridge Boat-Race from 1829 to 1869, based on the experience of the rowers themselves* (London: Macmillan and Co., 1873). Renforth's death is discussed in *Harper's Weekly*, September 9, 1871, p. 845; Brown's in *Turf, Field, and Farm*, March 31, 1871, p. 203.

[57] Actually, there was consistent criticism of rowdyism even early in the rowing literature, which focused on a few professional rowers who acted like "blackguards"; generally James Hammill and Walter Brown received the most disapproval. Contributing to the demise of the sport's respectability was the large amount of gambling that accompanied races. See John R. Betts, *America's Sporting Heritage: 1850-1950* (Reading, Mass.: Addison-Wesley, 1974), p. 133; Thomas C. Mendenhall, *A Short History of American Rowing* (Boston: Charles River Books, 1980), pp. 13-20; Richard A. Glendon and Richard J. Glendon, *Rowing* (Philadelphia: J. B. Lippincott and Co., 1923), p. 61.

athletics began to overshadow rowing.[58] By the late 1870s occasional caricatures of sculling began to appear, with prints that signal the collapse of the rhetoric of the previous two decades (Figure 34). Certainly it had always been the case that rowing was fun, and it became apparent that it need be nothing more.[59]

Eakins, in the meantime, had gone on for his subjects to other, perhaps not so transitory, triumphs of modern life.

[58] Betts, *America's Sporting Heritage*, p. 102, places the phenomenon in perspective: the greatest competitor for the limelight in college athletics was football.

[59] By 1893 John F. Huneker, in an article called "Amateur Rowing," part of a series on athletics for *Lippincott's Magazine*, could describe the advantages of rowing without any reference to discipline: "[It] calls into play all the muscles of the body, it rests the brain, and is a gentlemanly, graceful amusement," p. 719; (June 1893, pp. 712-719). In 1923 Richard A. and Richard J. Glendon wrote in *Rowing*: "After all, a boat race is only a boat race, and eventually becomes only another atom in the list of life's experiences" (p. 20). Yet, for a few, especially in college rowing, the mystique lives on. See Yale rower Stephen Kiesling's *The Shell Game: Reflections on Rowing and the Pursuit of Excellence* (New York: William Morrow & Co., 1982).

CHAPTER THREE

The Gross Clinic, or *Portrait of Professor Gross*

THE EARLY years of the 1870s saw radical changes in the fabric of national life. With economic and psychological recovery from the Civil War hardly resolved, Americans were faced with tides of immigrants, employment in factories that broke up earlier patterns of employee/employer relationships, and national financial uncertainty. Urban growth was so rapid that cities sprawled without direction. Many of the new men in political life were aggressive and uneducated, and in public life the exemplary values that Americans had earlier held in common began to fall by the wayside. But all the changes were not negative. Many members of the middle class enjoyed the material comforts of the new urbanization, and professionals and scientists who had had the opportunity for European training and who had absorbed some of the dynamism of industrial progress surged toward new achievements and higher standards. As the country moved toward the Centennial celebration (with exhibition entries expected from all over the world), citizens became acutely aware of America's stature in comparison with that of Europe. They sought objective evidence that in a variety of fields America was pulling up with and even forging ahead of her counterparts abroad. In Philadelphia, political home of the nation and site of the Centennial, a city heavily industrialized and burgeoning with immigrants, all of these pressures, and hopes, were felt in full. The more thoughtful in the city felt that only the old values—rationality, discipline, and morality—as given a continuing life in the educational, scientific, and professional traditions in the city, would preserve the city as they would wish it to be in the future.

Making his own contribution to celebrating those values, in early 1875 Eakins turned a canvas of rowing studies upside down and covered it with a composition sketch for a portrait of the widely admired Philadelphia surgeon Dr. Samuel D. Gross.[1] Eakins had finished with painting scenes of

[1] A photograph of the X-ray of this composition sketch, revealing the rowing studies, is on p. 173 of Theodor Siegl, *The Thomas* *Eakins Collection* (Philadelphia: Philadelphia Museum of Art, 1978).

46

leisure, even leisure that was morally pursued, and—with the exception of a brief foray years later into boxing and wrestling themes, and one painting about swimming—he would not take up the idea again.[2] Instead, he would record sitters and activities whose power stemmed from what had more endurance as "heroic." And as he had with the oarsmen, he would find this excellence in people and work that he knew, or that, with introductions, he could come to know.

No painting could have announced his resolution more prominently than the large work depicting Dr. Gross (Plate 4). Not only was it imposing in scale—almost ominous in prospect as a blank canvas to be covered—but truly epic in theme. Even when he had barely blocked it in, Eakins expressed confidently that the painting would be "very far better than anything I have ever done."[3]

For Gross's portrait, Eakins joined an elaborate setting and carefully selected details to give full meaning to Gross's work as a surgeon. The details are rich indeed. At the focal point of the painting, Gross holds in his right hand a blood-covered scalpel; he has just turned away from his patient and surgical assistants in order to lecture to his students in the amphitheater. The young patient lies on his right side, his knees pulled up near Gross.[4] His head is at the far end of the table under the anesthesia-soaked gauze, his sock-clad feet at the near end;[5] a long incision has been made in his left thigh

[2] I except from the category "scene of leisure" Eakins' painting of 1879, *A May Morning in the Park*, now called *The Fairman Rogers Four-in-Hand* (Philadelphia Museum of Art). Coaching was not an egalitarian activity, but one pursued by the wealthy; Eakins painted the subject on the commission of coach owner Fairman Rogers, whose intellectual acumen and energy he very much admired, and he developed the painting primarily as a study of motion.

[3] To Shinn, April 13, 1875, Friends Historical Library of Swarthmore College.

[4] Eakins' first reviewer, William J. Clark, criticized this part of the painting as a "decided puzzle" in his review of April 28, 1876, in the Philadelphia *Evening Telegraph*. "The only objection to the picture that can well be made on technical grounds," Clark conceded near the end of his enthusiastic review,

"is in the management of the figure of the patient. The idea of the artist has obviously been to obtrude this figure as little as possible, and in carrying out this idea he has foreshortened it to such an extent, and has so covered it up with the arms and hands of the assisting surgeons, that it is extremely difficult to make it out."

[5] Evidence does not support Hendricks' contention ("Thomas Eakins's *Gross Clinic* in *Art Bulletin* 51 [March 1969], 64) that the bluish-gray socks designate the patient as a "charity" patient. They are simply clothing that did not have to be removed for the operation. It was not until late in the 1880s that clothing was generally perceived as more than an inconvenience in surgery—as, in fact, a source of bacteria, when surgeons adopted aseptic or bacteria-free, operating environments.

from which Dr. Gross is about to remove a piece of dead bone.[6] An anesthesiologist and a team of four surgeons, one of whom is obscured behind the figure of Gross, assist in the surgery.[7] The anesthesiologist, Dr. Joseph W. Hearn, presides over the administration of chloroform;[8] on the middle right the intense figure of Dr. James M. Barton, Gross's Chief of Clinic, bends to his task of absorbing bleeding in the interior of the incision;[9] and at the lower right Dr. Daniel Appel, a new graduate of Jefferson Medical College, holds a retractor in his right hand to secure one side of the incision, while in his other hand he holds an instrument ready for Gross. At the lower left of the table is Dr. Charles S. Briggs, who grips the young man's legs to keep them in position during the surgery; and, obscured behind Dr. Gross, at the upper left side of the table, another member of the assisting team holds a second retractor.

Details on the periphery of this central grouping give further meaning to the scene. In front of Gross, at the lower left of the painting, is a tray of instruments and gauze. Behind him, at the middle left of the painting, the mother of the patient,[10] dressed in black, seems to shrink in her chair and

[6] The surgical operation was specified in the catalogue of the exhibition of the Centennial as "an operation for the removal of dead bone from the femur of a child"; see "Report on the Participation of the War Department in the International Exhibition," in *Report of the U.S. Board on behalf of U.S. Executive Departments at the International Exhibition*, 2 vols. (Washington, D.C.: 1884), p. 137.

[7] Although Clark wrote in his review in 1876 that all the participants were portraits of actual persons, even the witnesses in the audience, identifications were first made in print by Charles Frankenberger, "The Collection of Portraits Belonging to the College," *The Jeffersonian*, 17 (November 1915), 1-10; Frankenberger did not identify any members of the audience. Ellwood C. Parry (in the *Jefferson Medical College Alumni Bulletin* 16 [June 1967], 2-12, and in the *Art Quarterly* 32 [Winter 1969], 373-390), discusses the now somewhat obscure figure behind Gross. The obscurity today is due at least partially to the darkening of the paint and the consequent merging of the dark clothing of this figure with that of Gross; when the painting was

just completed, the figure provoked no critical comment. The tasks in this particular operation make the obscured assistant essential.

[8] Gross discusses his preference of chloroform at his clinics at Jefferson Medical College in his *System of Surgery: Pathological, Diagnostic, Therapeutic, and Operative*, 2 vols. (Philadelphia: Henry C. Lea's Son & Co., 6th ed., 1882), vol. 1, p. 559; and his typical assignments of tasks to assisting surgeons in vol. 1, p. 486. For biographical and professional material on Hearn and on the anesthetist in Eakins' later surgical clinic, *The Agnew Clinic*, see J. E. Eckenhoff, "The anesthetists in Thomas Eakins's 'Clinics,' " *Anesthesiology* 26 (1965), 663-666.

[9] In *System of Surgery* (1882), vol. 1, p. 489, Gross discusses the tourniquet that he used in order to assure that such surgery would be relatively bloodless.

[10] In 1876 Clark identified the woman less specifically as "a female relative." In January, 1918, in a memorial tribute in *The Art World*, "Thomas Eakins," p. 291, William Sartain identified her as the mother.

raises her left arm to shield her eyes from the scene. Above her, at a brightly lit lectern in the first row of the amphitheater, Dr. Franklin West records the clinic proceedings. In the right middle distance of the painting, in the doorway to the amphitheater behind the operating table, stand two figures: in a relaxed posture, Hughey O'Donnell, the college orderly, and in a more intense pose, Gross's son, Dr. Samuel W. Gross, himself a surgeon. In the amphitheater audience, the twenty-one figures are all portraits, but only two have been identified: a young man who later became a poet and writer, Robert C. V. Meyers,[11] leaning forward near the top railing, and Eakins himself, the first figure on the lower right, looking on the scene with pencil and pad in hand.[12]

The scene is dramatic and intense. Gross does not occupy the precise center of the painting, as did Max Schmitt. Instead, he, his patient, and by implication, the operation they are bound up in together, form a large triangle, with the absolute center of the picture falling just off Gross's shoulder above his patient. At that plane the painting has the sharpest focus: from the blurred instruments in the foreground tray the focus clears until it reaches its most precise point in Gross's scalpel and the incision in the patient's leg.[13] The figures seated in the amphitheater fill out the picture but remain subordinate in the dim light. Indeed, lighting is Eakins' most dramatic tool. It sets apart from the dark clothing and dusky room the highlighted forehead and hand of Gross; the white of the bed sheets, anesthesia-soaked gauze, shirt cuffs of the assisting surgeons and thigh of the patient; and the clinic recorder's podium, hand, and notebook. This emotion-charged lighting emphasizes actual conditions in Jefferson's surgical clinics. There as everywhere else surgeons wore dark street clothes to operate until the general acceptance of asepsis in the late 1880s, and they performed surgery under skylights at mid-day on sunny days.[14]

[11] Written on the back of the oil sketch of Meyers is "Study of R.C.V. Meyers, for picture for Centennial Exhibition, painting by Thomas R. Eakins and presented by him to R.C.V.M. Dec. 25, 1875. Sitting of Oct. 10, 1875."

[12] Lloyd Goodrich, *Thomas Eakins*, 2 vols. (Cambridge, Mass.: Harvard University Press, 1982), I, 323, expresses doubt that the figure is a self-portrait. From my own close study of the canvas, I believe that it is. A self-portrait was not without precedent in Eakins' own work, and, as I shall show below, it was a prominent feature of a contemporary group portrait honoring a French surgeon.

[13] Clark described Eakins' intentions as: "The picture being intended for a portrait of Dr. Gross, and not primarily as a representation of a clinic, the artist has taken a point of view sufficiently near to throw out of focus the accessories, and to necessitate the concentration of all his force on the most prominent figure" (*Evening Telegraph*, April 18, 1876).

[14] Edward Louis Bauer, *Doctors Made in*

Although tonal extremes dominate the painting, especially when it is viewed under unfavorable lighting and behind glass, or when it is studied in reproduction, Eakins suffused both lights and darks with a warm, unifying color.[15] The warmth begins with the thin red underpainting with which he prepared the canvas. The red in the doorway and in the depth of the amphitheater brings the distances close, and in the foreground the heads and hands of the participants, their flesh tones built on the underlying red, radiate immediacy and human presence. With direct touches of several local colors Eakins reported the details of the surgical setting. The instrument cases in the left foreground are lined with bright green and blue felt; a warm red layer underneath brings the areas into harmony with the rest of the picture. Pinks, blues and purples describe blood-stained dressings at the very left of the table, and on the right of the table is gauze stained with the reds and pinks of fresh blood. Underneath the end of the operating table are the reds and purples describing the box of sand or sawdust traditionally placed there to catch the blood of the operation.[16] Even in local color, it is red that dominates, drawing the viewer across the painting and into the center: from the red of the pen of Franklin West on the left, across to Eakins' own pen on the right, to the dressings and surgical gauze in the foreground; then, in the center group, to the blood on the shirt cuffs of the assisting surgeons and on Gross's coat, in the incision of the patient, and, climactically, on Gross's hand and scalpel. In the blood-covered scalpel, Eakins brought together his most intense color and his sharpest focus.

America (Philadelphia: J. B. Lippincott and Co., 1963), p. 104, indicates that the amphitheater, torn down in 1877, seated six hundred students. Jefferson Medical College announcements, preserved in the National Library of Medicine, Bethesda, show surgical lectures and clinics to have taken place between 11 and 3; Gross, *System of Surgery* (1882), I, 487, specifying the best time for surgery as between 11 and 3, discusses the need for bright sunlight.

[15] From 1968 to 1982 the painting was displayed at the Alumni Building of the college (by then, Thomas Jefferson University), most of which time it was under a transparent plexiglass cover. (Before that, it had hung unprotected on a staircase landing in the college itself, where it sustained some damage.) The plexiglass cover, added to the installation for security, reflected light so intensely (some of it from an adjoining atrium) that viewers had difficulty seeing more than the highlights in the painting. Since April 1982, the painting has been installed in a separate gallery in Alumni Hall—the Eakins Gallery—where sympathetic lighting and environment serve it well. In the same gallery are Eakins' *Portrait of Professor Rand*, 1874, and *Portrait of William Smith Forbes, M.D.*, 1905.

[16] John Chalmers Da Costa, *Selections from the Papers and Speeches* (Philadelphia: W. B. Saunders Co., 1931), discusses the operating arena and arrangements in "The Old Jefferson Hospital," pp. 204-219, and "Last Surgical Clinic in Old Jefferson Hospital," pp. 334-352.

In brushwork Eakins was no less varied, no less hardworking, than he had been in the rowing paintings. But he was considerably more self-confident. This sureness began with his studies for the painting. The composition study (Figure 32) is quick and deft, laid on with knife and brush to establish the composition as well as the tonal contrasts. He virtually sculpted his study for the head of Gross (Figure 33), painting it with a palette knife and juxtaposing the planes of opaque under-flesh tones to create not a surface but vigorous, even jarring, three-dimensional form. Certainly Dr. Gross did not have much time to pose, and, indeed, Eakins took photographs to complement his posed studies.[17] But in his study of Gross there is no deference to the certainty of a photographed image; there is instead a profound commitment to human bone and flesh, to that which moves and changes and can only be caught by boldness. The same boldness appears in his sketch of a spectator, the only study that survives of what must have been nearly thirty (Figure 34); it is a certainty of quickness, this time not with knife but with thinly loaded brush.

No perspective study for the entire painting exists. Although Eakins probably made one—on the canvas at least—his studies of heads suggest that with his work on this painting, he had passed a major point. From then on it would be the material reality of bone and flesh that would receive the hard work, the planning. Although his work was never to be without plan (to the end of his life, he made perspective studies and, to transfer sketch to canvas, used grids), Eakins was always to show more respect for the body than for abstract space. Indeed, in the portrait of Dr. Gross his preoccupation with the way bodies do things rather than with perfectly measured space led to a noticeable awkwardness in his central grouping around the patient: he had to show the thigh of the patient in order to demonstrate this type of operation; he had to put a surgeon behind Dr. Gross who would logically reciprocate the work of Dr. Appel in the right foreground; and he had to show the location of every hand involved in the surgery. Eakins eclipsed nothing—

[17] Alexander Stirling Calder, in *Thoughts on Art and Life* (New York: privately printed, 1947), p. 6, reports that when he entered a competition in 1894 to execute a standing sculptural portrait of Gross, he went by Eakins' house to get negatives of the "very fine photographs of Dr. Gross [that Eakins had made] for his own use." Calder, who won the competition, sculpted Gross in a pose modeled on Eakins' portrait of Gross in the *Gross Clinic*. The sculpture, originally on the Mall in Washington, D.C. near the Army Medical Museum, is now in the courtyard of the Jefferson Medical College, the Medical Museum having been torn down in 1971 to make way for the Hirshhorn Museum and Sculpture Garden.

indeed, even exaggerated the knee of the surgeon behind Gross: the demands of a real situation took precedence over design, material over grace.

In this painting Eakins continued to explore ways in which he could use the brush. Across the canvas of the *Portrait of Professor Gross* are tight, precise strokes describing Gross's scalpel, opaque build-ups on the highlighted foreheads of the surgical team and of Dr. Gross, thin glazing over cheek hollows and eye cavities, dry brushed wisps of Dr. Gross's hair, sketchy and thin strokes describing the surgeon's costumes, and short brushings scrubbed over the podium and the amphitheater wall. No longer hesitant, with the portrait of Gross Eakins had fully developed his repertory of expressive brushwork.

In his large cast of characters Eakins set forth a range of delicately nuanced expressions that was also new in his work: neither the delicacy nor the range had appeared—nor indeed, had been called for—in his earlier paintings. As the hero of the painting, Gross emanates control, and his arrested pose conveys the thought that he insisted must dominate the physical activity of an operation. His white hair stands around his head like an aura; his eyes are in deep shadow (the pupils, in fact, lost). In this distant look Gross seems larger than life—his personality subordinate to his role. The other figures, in contrast, contribute very personal qualities. At the opposite pole of Gross's self-possession is the emotional surrender of the child's mother. The anesthesiologist almost smiles in his benign look at the face of his patient. Dr. Briggs, the surgeon on the lower left, holds the calves of the young patient with the gentle fatherliness that is consistent with Eakins' rendering of his thinning hair and the aging contour and chin line of his face. The experienced Dr. Barton probes in the incision with scrupulous concentration; and the young surgeon on the right, just graduated from the Medical College, looks up at Dr. Gross with reverence.

The members of the audience—painted with only a few thin strokes—convey the many attitudes of students and witnesses.[18] Some lean forward, some place their elbows on the seat railings behind them, others prop or cross their legs, one grasps the handrail above the entranceway and leans his head against his hands; all focus on the arena with expressions ranging from solemnity to wistfulness. Eakins presents himself as short-haired and young, looking with direct intensity at Dr. Gross. He and the recorder are the only people using writing materials.

Eakins' presence in Gross's audience would seem simply to testify to his

[18] According to Clark, the audience was composed of "students and other lookers-on."

first-hand observation of the material for his painting. Actually, clinic audiences frequently contained members of the general public. Thus on one level Eakins' presence in Gross's clinic, like that of his friend Meyers and perhaps also some of the unidentified members of the audience, reflects this community interest. But it also points to two other phenomena, as did Eakins' presence in *The Champion Single Sculls*: first, he had been familiar with the surgical context for a long time, and second, he was such an expert that he was qualified to paint it.

He had come to a general familiarity with the medical world in high school. There his scientific courses in natural history, chemistry, and physics were taught by physicians who shaped their instruction in the natural sciences to reflect their primary—and medical—interest in the human body. Eakins studied human anatomy in detail in his natural history class, for instance, and in his course in "Mental Sciences" he learned about the physiology of vision and hearing. Students were encouraged to supplement their scientific instruction at the high school by attending anatomical and surgical clinics in the many medical facilities throughout the city; no one assumed that the students would go on to medical training, simply that an educated person should know human anatomy.[19] But the students did learn a special point of view, and they met specialists. Eakins, like his fellow students, absorbed a medical vocabulary of ideas and of words, and an introduction to the wider Philadelphia medical community. More conspicuously than did his friends, however, Eakins drew on it the rest of his life. The physician who taught Eakins chemistry

[19] For a discussion of the medical emphasis at Central High School, with detail about the backgrounds and interests of Eakins' teachers, see Joseph S. Hepburn, "Medical Annals of the Central High School of Philadelphia with a historical sketch of medical education in Philadelphia," *The Barnwell Bulletin* 18, no. 72 (October 1940). The annual reports of the high school set forth the content, texts, and, in several cases, final examinations of courses Eakins took (see, for instance, 41st Annual Report to the Board of Controllers, pp. 129-130; 42nd Annual Report, pp. 141-142, in the Pedagogical Library, Philadelphia). See Edmonds, *History of Central High School*, pp. 164-165, for the reminiscences of Eakins' fellow student T. Guilford Smith, who later became an industrialist, of his visits during his student years to the Philadelphia School of Anatomy (a private dissection facility) and to the hospital surgical clinics. Joseph Boggs Beale noted in his diary (at the Historical Society of Pennsylvania) that he and his brother watched Gross's clinics (October 15, 1864; also, November 5, 1864), and John C. Da Costa remembered his early years of dropping in to Jefferson's clinics before he had any idea of studying surgery, *Selections*, "The Last Surgical Clinic," p. 339. Eakins' subsequent study of anatomy in a medical school and under the tutelage of surgeons perhaps led to the comments by Philadelphians after his death (discussed by Goodrich, *Eakins*, 1982, I, 13 and 315, note 13:12-14) that Eakins had contemplated becoming a surgeon himself.

and physics, B. Howard Rand, M.D., and who left Central High School in 1864 to join Dr. Gross on the Jefferson medical faculty, sat in 1874, in fact—thirteen years after Eakins had graduated from the high school—for Eakins' first seated, formal portrait.[20] It was the work with which he prepared himself to paint Dr. Gross, and he labored over it. Indeed, the painting (Figure 35) was a proving ground for textures, colors, and brushwork that he polished almost without subordination to tell the story of Professor Rand: from the microscope on the extreme left to the bright pink shawl in the right foreground, from the brilliant figured rug on the floor to the dark cat under Dr. Rand's hand. A year later, Eakins was able to order and rank his details.

In 1862, once Eakins had made his decision to become an artist, he was not content with the generalist's knowledge of anatomy that he had absorbed in high school. He became a specialist, and he did so in a manner crucial to his painting of Dr. Gross: he studied anatomy with surgeons. For surgeons, precise anatomical knowledge was of such importance that they learned it through dissection and then reaffirmed it again and again by practicing dissection before each operation. For Eakins' first instruction in anatomy beyond his high school work, he enrolled in the anatomical lectures that accompanied his drawing class at the Pennsylvania Academy of the Fine Arts in 1862; those lectures, although taught by the physician A. R. Thomas, were couched for artists.[21] In 1864 he undertook more strenuous work, enrolling in the anatomy course of the surgeon Joseph Pancoast at Jefferson Medical College; not only was the instruction more rigorous because it was offered for medical students, but it called for dissection by the students. Since the course was preliminary to the students' training as surgeons, they also attended surgical lectures and observed surgical clinics. At Jefferson they could see Dr. Gross lecture on surgery daily at eleven, and at noon on Wednesdays and Saturdays they could observe the two- to three-hour clinics over which he, and occasionally other surgeons, presided. Eakins, even after his study at Jefferson, did not feel he had finished: in Paris, from 1866 to 1869, he

[20] An earlier portrait that may have been a formal image, however, has been lost: at the Union League Art Reception of 1871 (where Schmitt exhibited *The Champion Single Sculls*) a work by Eakins entitled simply "Portrait" was exhibited by M. H. Messhert. Professor Rand retired from the Jefferson faculty in 1873 (disabled, unfortunately, by an accident in his chemical laboratory—see Bauer, *Doctors Made in America*, pp. 153-154); Eakins perhaps painted the portrait as a retirement tribute. Rand accepted the portrait and later gave it to Jefferson.

[21] Beale records that the class had 80 to 100 students, and that for some of the lectures Thomas met the class at a medical amphitheater (Diary, January 16, 1861).

continued anatomical work, taking advantage of the opportunities to dissect and to watch surgical clinics at the Paris hospitals and at the École de Médecine. Finally, after his return from Europe, he attended at least one more series of anatomical lectures and dissections—again at Jefferson Medical College, this time in 1874. There his apprenticeship ended. He had earned the credentials to paint the surgery in *The Portrait of Professor Gross* in 1875; to become the chief preparator/demonstrator in 1876 for the surgeon W. W. Keen, M.D. in Keen's lectures on anatomy at the Pennsylvania Academy of the Fine Arts; and to teach anatomy and dissection himself over many of the next years. He had joined an inner circle of professionals who knew precisely what was beneath the surface of the body, and, more, who could tell from observation of a particular surface what anomalies they would find underneath as well.

Eakins was absolutely clear as to why he had studied anatomy: he was to tell an interviewer a few years later about his practice and teaching of dissection: "No one dissects to quicken his eye for, or his delight in, beauty. He dissects simply to increase his knowledge of how beautiful objects are put together to the end that he may be able to imitate them."[22]

Thus, Eakins was at home in a Jefferson clinic, just as he had been at home on the Schuylkill. In letters to his friend Earl Shinn between 1872 and 1875 he had charted his artistic progress with increasing confidence.[23] But before 1875 he had not undertaken a picture so demanding as his portrait of Gross, and it was the upcoming Centennial exhibition that encouraged him to do so. Entries had been solicited from all over the world, for in one respect at least the exhibition was to be like world's fairs that had begun earlier in the century: it would recognize the international march of progress. But primarily, the Centennial aimed to celebrate progress specifically American, and excellence exclusively American. Since the exhibition was to be in Philadelphia, cradle of so much of the nation's history, Philadelphia exhibitors had a unique chance to emphasize their city's contributions to American life.

Eakins, almost the only artist to do so, seized that chance. For Philadelphia had very early been a major medical center. And in 1875, Dr. Gross, anatomist and surgeon of the top rank, was admired in Philadelphia medical circles, in the sphere of medical practice in America, and even in medical

[22] William C. Brownell, "The Art Schools of Philadelphia," *Scribner's Monthly* 18, no. 5 (September 1879), 745.

[23] To Shinn, Good Friday 1875, and April 13, 1875, especially, Friends Historical Library of Swarthmore College.

centers of Europe. Surgery had become in the nineteenth century a major professional opportunity for heroism.

A review of some of the history of surgery illuminates Eakins' choice of it as a subject and, within that choice, the meaning of the particular operation in which Gross is engaged.

Traditionally, medical practice had been—and, of course in its largest dimensions, is still—divided into two provinces, one the responsibility of the physician, and the other, that of the surgeon. Although the distinction did not become codified until the Middle Ages, even in the classical era there was a line drawn between practice that was essentially internal, pursued by a physician who diagnosed and prescribed medicine for what he could not see, and practice that was primarily external, pursued by a surgeon who cut away cysts, pulled decayed teeth, and set bone fractures. With the establishment of university education in the Middle Ages, medicine—the discipline of the physician—became a liberal art, one which was practiced as an intellectual activity; surgery, on the other hand, was simply a skilled craft that called for manual work. Physicians came to be considered learned and aristocratic; surgeons, uneducated, of low social class. The more complicated surgical procedures, lithotomies and amputations, caused horrible pain, and the instruments associated with them—especially the scalpel—were disdained by the public. Such instruments were distinctively not the province of theory-oriented physicians.

During the Renaissance and thereafter, however, the new respect in all disciplines for the material world and for the process of investigation encouraged surgeons in their efforts to improve their surgical capabilities and to raise the intellectual and social status of their work. They became expert anatomists—dissecting with the scalpel, of course—and arrived at new understandings of the interior of the body. The famous picture by Rembrandt of Dr. Tulp (Figure 36) delivering an anatomy lesson to a group of surgeons shows the new dignity that such guilds enjoyed. By the late eighteenth century, particularly in France, surgeons had come to be respected not only for their anatomical knowledge but for the manual dexterity that had enabled them to make impressive strides toward new operations—progress that was from some points of view more impressive than that made during the same period by physicians.

Then two developments secured the admiration in which surgeons were to bask after about 1800 and throughout most of the nineteenth century: scientific studies by a small group of brilliant surgeons working in Paris

revolutionized both the practice and the teaching of surgery; and the French Revolutionary government proclaimed that both surgeons and physicians would be educated in the university—thus equalizing their status. Informed with new knowledge of how disease spread within the body, surgeons began to undertake operations they had never earlier even contemplated (although not until late in the century were they to operate on the lungs or the abdominal cavity). With a new "clinical" method of instruction they taught students by performing surgery in their presence and then monitoring, again with student audiences, the recovery or decline of the patient. They practiced and taught as "scientific" surgeons, who took no traditional outcome for granted but kept detailed records of the consequences of each procedure. They began to emphasize the effect of surgery on the entire body of the patient and taught their students that a surgeon was fundamentally a physician, concerned with the relationship of a local surgical problem to the general health.

By the 1820s the honor that French surgeons enjoyed was at a height, and students and trained surgeons came to Paris from all over Europe and America to study French surgery and the French method of teaching. There were detractors, of course—the caricatures of Daumier are the best evidence of that—for in the first part of the century even greatly improved surgical procedures, especially before the use of anesthesia, were often brutal.[24] But surgeons mounted an impressive campaign for recognition. Editors of general periodicals featured biographies of surgeons; printmakers issued editions of portraits of surgeons; compilers of collections of engravings of eminent men began to include surgeons along with physicians in their selection of men eminent in medical life; the French government erected public monuments to famous surgeons. Surgeons began to write the history of their discipline and to stipulate the moral as well as the intellectual character that had identified surgeons throughout history.[25] By the 1840s this character could be

[24] For Daumier's caricatures, see Henri Mondor and Jean Adhémar, *Les gens de médecine dans l'oeuvre de Daumier* (Paris: Impr. nationale, 1960). Other caricaturists included Paul Gavarni and the mid-century French lithographer and photographer Etienne Carjat; Carjat's lithographs caricatured the lectures of such eminent surgeons as A. A. Velpeau (1795-1867) and Auguste Nélaton (1807-1873) (in the collection of the Bibliothèque Nationale, Paris).

[25] A leading historian was the surgeon J. F. Malgaigne (1806-1865), who edited the collected writings of Ambroise Paré in 1840, and prefaced his edition with a long biographical study of Paré in which he urged others as well to begin the study of surgical history. Later he followed his own advice and wrote a major study of the history of surgery. See Wallace B. Hamby, *Surgery and Ambroise Paré* (Norman: University of Oklahoma Press, 1965).

read like a litany, in interviews with famous surgeons, in necrologies, even in histories of surgery: surgeons were typically of humble birth, had taught themselves to read, and had worked indefatigably to enter the competition for surgical training; once educated they had operated brilliantly, never lost their rural humility or, what was more important, their piety, and, their social potential fully developed by education and science, they moved easily at all social levels. French surgeons put themselves forward, in short, as the very embodiment of Enlightenment values and egalitarian opportunities taken seriously—as heroes of modern life.[26]

American surgeons were not yet in so fortunate a position. They had had to struggle simply for basic training, and in many areas of the country the distinction between physicians and surgeons was still a luxury. Philadelphia had played a prominent role in the struggle of American medical men for training and recognition, and during Eakins' lifetime it actively cultivated (and indeed, continues to do so) a sense of proprietorship about its early contributions to American medicine. Eakins' painting of Dr. Gross was as rooted in his pride in Philadelphia as was *The Champion Single Sculls*.

Before Philadelphia made its early contribution, medical care in the American colonies had been provided by men trained in the great medical centers of Great Britain and of Holland—notably London, Edinburgh, Dublin, and Leyden—and, as in any rural area, by people without special training who simply developed medical skills. Philadelphia, in its strong position in the mid-eighteenth century as a center of rising wealth, boasted a number of foreign-trained physicians who saw the desirability of providing medical training in the colonies, and they took several steps to develop Philadelphia as a medical center. As early as 1739 a physician returning from study in England delivered a course of anatomical lectures in the city. In 1751, Benjamin Franklin, the physician Thomas Bond, and a group of other dedicated citizens worked together to establish the Pennsylvania Hospital; and then in 1765 a group led by the physician John Morgan founded a medical school that was to become part of the University of Pennsylvania, modeling the educational program of the school, because of the training of the physicians that would teach there, on the system of the University of Edinburgh med-

[26] For examples of this hagiography, an international phenomenon, see Félix Guyon, "Eloge d'Auguste Nélaton," *Bulletin et mémoires de la Société des Chirurgiens de Paris* 2 (1876), 76-95; Francis Dowling, "Some of the former medical giants of France," *Lancet-Clinic* (Cincinnati), 104 (1910), 604-613; and R. J. Mann, "Of Guillaume Dupuytren, who feared nothing but mediocrity," *Mayo Clinic Proceedings* 52, no. 12 (December 1977), 819-822.

ical school. The establishment of medical education in Philadelphia led to a slowly growing cadre of professional men who early in their history encouraged each other to carry out research, first as members of the American Philosophical Society, which sponsored scientific studies, and then within their own professional society, the College of Physicians of Philadelphia, formed in 1787. In this atmosphere of support members of the faculty of the medical college at the University of Pennsylvania made the pioneering publications in America in a variety of fields of medicine: in psychiatry, anatomy, surgery, materia medica, and therapeutics.[27]

Philadelphians were also notable in the establishment of American medical periodicals. Although early publications in medicine had appeared sporadically in New Haven and Boston, and a regular periodical had begun publication in New York in 1797, in 1804 Philadelphia entered the field and soon was contributing a number of journals. One of these, the *Journal of Foreign Medical Science*, played a central role in transmitting to Philadelphians and other readers the advancements in French surgical research. Another, founded in 1820, became as *The American Journal of the Medical Sciences* one of the most distinctive continuing medical journals in the country, and throughout the century kept Philadelphia at the center of American medical publication.

Although as late as 1876 the New York physician Austin Flint credited Philadelphia with maintaining the medical leadership of America it had established so early, by that time the city had long since been joined by Boston and New York, and then New Haven, Charleston, and cities to the west, in offering students and professional colleagues anatomical instruction, medical training, professional societies, and publications.[28] This spread of training and talent to several major medical centers encouraged scientific industry among American medical men, and they began to make original contributions to medicine and surgery. Two of the surgical contributions, conspicuous even in the large framework of Western surgical progress, were particularly important to American surgeons' self-confidence: first, the discovery of anesthesia in Boston in 1846, making possible intricate, time-con-

[27] The work most well known in Europe was that of the Quaker Benjamin Rush (1745-1813) in psychiatry, published in 1813. Particularly notable from Dr. Gross's point of view was the work by Caspar Wistar (1760-1818) in anatomy and Philip Syng Physick (1768-1805) in surgery.

[28] Austin Flint, address to the International Congress of Physicians and Surgeons, published in the *Philadelphia Medical Times* 6 (September 16, 1876), 603.

suming surgery that was unthinkable when the patient was conscious—and that turned European eyes to America for the first time—and second, several pioneering gynecological procedures. Other advances brought American medicine to international attention: the Civil War resulted in American improvements in the treatment of gunshot wounds, the setting up of hospital facilities, and the keeping of records, all of which were studied by European physicians. Finally, the founding after the Civil War of the National Medical Library set an example in bibliographic resources that was emulated in Europe.

Distinctive though the contributions were earlier in the century, American medical progress until considerably after the Civil War was a conscious struggle for autonomy from foreign training and literature. Even major surgical contributions were made in awareness of the domination by the long English and European traditions of American medical training, literature, and research. Americans felt that Englishmen especially, as previous colonial superiors, underestimated the potential of American scientific contributions—indeed, of all American contributions. In 1820 the acerbic Englishman Sydney Smith wrote in the *Edinburgh Review*: "Who reads an American book? or goes to an American play? or looks at an American picture or statue? What does the world yet owe to American physicians or surgeons?" The Philadelphia-based *American Journal of the Medical Sciences* incorporated the last fling of the taunt—"What does the world yet owe to American physicians or surgeons?"—into its title page masthead and kept it there throughout the century.[29] It was a powerful rallying point for American surgeons and physicians, who, with their colleagues across the Atlantic never far from their consciousness, worked vigorously to provide medical training on this continent, to stimulate their colleagues to research and writing, and to participate in American life as professionals meriting the highest social and intellectual respect.

Seminal in the success of their struggle was their turn to the new advances and ideals of French surgery. Perhaps given extra encouragement by an American anti-British sentiment that increased after the war of 1812 and by the stubborn class consciousness that persisted in British surgery, Americans were prominent among the foreigners who flocked to Paris to attend surgical clinics, ward visits, and anatomical and surgical lectures—all available free

[29] E. B. Krumbhaar, in "Early Days of the American Journal of the Medical Sciences," *Medical Life* 36 (1929), 240-256, discusses the effect of the Edinburgh challenge (*Edinburgh Review* 33 [January-May, 1820], 79-80).

to anyone with a passport.³⁰ They brought back the ideal of clinical teaching; they translated French texts for teaching and published French research in their American journals; they celebrated the democratic image of the French surgeon as profoundly appropriate for America. One American surgeon, writing a book in 1843 about his years of study in Paris, found a crowning lesson for aspiring Americans in the career of the great French surgeon Guillaume Dupuytren, who had risen from poverty to a rank in the aristocracy (and whom Gross was to cite as having been without question France's most eminent surgeon): "Had not *Monsieur* Dupuytren been compelled from poverty to trim his student's lamp with oil from the dissecting room, he never would have succeeded in becoming Monsieur le *Baron* Dupuytren."³¹

In emulating the French example, Philadelphia medical men were again distinctive leaders. In 1825, the surgeon George McClellan founded Jefferson Medical College. Establishing it in well-publicized rivalry with the medical college of the University of Pennsylvania (which had been modeled on the medical school at Edinburgh), he proposed that two tenets—French-inspired—would guide the curriculum: equal access to a medical education (he and others claimed that admission to medical training at Pennsylvania depended on "connections") and instruction carried out by the clinical method (at Pennsylvania, students were taught by the more private method of being assigned to follow the practice of one physician or surgeon). Taking the French ideal as Jefferson's guide, McClellan claimed that basic training for surgeons and physicians would be the same, that the practice of medicine was founded on fundamental principles common to both its branches.

Dr. Gross was in one of the earliest classes of students at the new college. When he entered in 1826, he had already pursued an introductory medical education despite discouraging difficulties. Born in 1805 near Easton, Pennsylvania, to highly moral, hardworking and humble German-speaking parents, Gross had had what he later called "the strongest desire" to be a "doctor" since early childhood. His father died when Gross was only nine, and his education was primarily at his own direction; after teaching himself

³⁰ For the American excitement with the new ways and the opportunities in Paris, see August K. Gardner, *Old Wine in New Bottles: or Spare Hours of a Student in Paris* (New York, 1848). *Galignani's New Paris Guide for 1868* (Paris: A. and W. Galignani and Co.), pp. 131-133, stressed the open nature of hospitals and clinics for visitors.

³¹ F. Campbell Stewart, *Hospitals and Surgeons of Paris* (Philadelphia: Carey and Hart, 1843), pp. 214-215. Among the Philadelphians who studied in Paris were Dr. Gross's own teacher at Jefferson, Thomas Dent Mütter, and William W. Keen, with whom Eakins worked as his demonstrator of anatomy.

mathematics, Greek, Latin, and English, he began medical study but went from one preceptor to another, disillusioned with their ignorance of classical and foreign languages and lack of scientific knowledge. Finally, on the recommendation of his last preceptor, he went to Philadelphia. There, in the fall of 1826, stimulated by the reputation of Professor McClellan for "brilliant achievements" in surgery, he enrolled at Jefferson Medical College. Two years later, after clinical course work in anatomy and surgery, which he complemented with long hours of dissection, and courses in therapeutics, Gross received his medical degree.

He embarked on a career that fulfilled every dimension of the ideal surgeon. In his first two years of practice he translated four European texts and published the results of his own substantial original research on bone diseases. Over the next twenty-five years he taught at medical colleges in Cincinnati, Louisville, and New York, published a text on pathological anatomy, and conducted and published research on wounds of the intestines that was to prove invaluable in the treatment of Civil War wounded. In 1856, at age fifty-one already a man of national reputation, Gross was elected to the Professorship of Surgery at Jefferson Medical College and returned to Philadelphia. For the next twenty-six years, until he retired in 1882, he continued to work in many dimensions. He taught and operated brilliantly, dissecting almost daily; he edited and wrote for a major medical journal; he published voluminously, from short articles to major addresses to his two-volume *System of Surgery* that went through six editions; he maintained a large office for private practice. His writings and texts were known abroad; and he was honored with foreign degrees. In person Gross was both authoritative and compassionate, always conscious of his responsibilities as a human being; all his life he spoke of himself not as a surgeon, but as a physician. On his death a colleague wrote, "Dr. Gross's majestic form and dignified presence, his broad brow and intelligent eye, his deep mellow voice, and benignant smile, his genial manner . . . remain indelibly impressed upon the memory of all who knew him. . . . It is safe to say that no previous medical teacher or author on this continent exercised such a widespread and commanding influence as did Professor Gross."[32]

[32] I. M. Hays, M.D., quoted in "Memoir" to *Autobiography of Samuel D. Gross, M.D.*, 2 vols., ed. Samuel W. Gross and A. Haller Gross (Philadelphia: George Barrie, Publisher, 1887, rpt. New York: Arno Press, Inc., 1972), vol. 1, p. xxix. Gross stated his ideals eloquently in his *The Glory and Hardships of the Medical Life, being the valedictory address delivered . . . March 11, 1875, before the trustees, faculty, and students of the Jefferson Medical College, at its 49th commencement* (Philadelphia: P. Madeira, 1875).

In choosing Dr. Gross as his sitter, Eakins selected a surgeon ideal not just in Philadelphia eyes but also by international standards: a man of humble origins, trained in the French clinical—the scientific—tradition, an untiring worker, and a brilliant researcher and writer. Dr. Gross was at the center of a community—a community of people, of values, of techniques, of history. Eakins' picture about that community rose through specific detail to make a general statement about Gross, Philadelphia and America, and modern surgery.

Eakins built his picture of Gross to illustrate the principles by which Gross and his community had worked: principles that Gross never took for granted but enumerated before his students in clinical sessions and formal addresses and put down for his reader in his *Autobiography*.

The first involved the fundamental role of clinical instruction in the training at Jefferson Medical College. In his inaugural address as newly appointed Professor of Surgery in 1856, Gross traced the heritage of the Jefferson clinics directly to those established in France. Not only was he proud that the Jefferson clinics, like those in Vienna, Padua, Berlin, and Edinburgh, had sprung from the very source of the clinical method, but he exulted that Jefferson in turn had become a model: that the many hospital clinics in existence in Philadelphia by 1856 had been formed on the example of Jefferson, so that "there is no city in the world, Paris and Vienna not excepted, where the young aspirant after the doctorate may prosecute his studies with more facility or advantage than in this."[33]

And clinical instruction as Jefferson offered it, according to Gross, provided for the best possible training of the future physician or surgeon. Advantageous as were the "hospital clinics" elsewhere in Philadelphia and throughout Paris in rounding out the student's familiarity with severe medical and surgical problems, it was also the case that hospital patients usually suffered from such grave problems that the student was unlikely to encounter them in general practice. Further, the acute condition of the hospital patient often prevented doctors from transporting him to the hospital amphitheater where large numbers of students could study the symptoms or observe the surgery. If the attending physicians carried out the examination and surgery in the hospital wards, at the patient's bedside, only the three or

[33] Gross, *An inaugural address introductory to the course on surgery in the Jefferson Medical College of Philadelphia, delivered Oct. 17, 1856* (Philadelphia: J. M. Wilson, 1856), pp. 25, 30. The clinic in the form in which Gross and his contemporaries practiced it had been established in 1841.

63

four students nearest the bed could actually learn from the procedure. Thus the "college clinic"—that offered at Jefferson—was best; first, because the patients were usually ambulatory, so that the student saw "every variety of chronic disease, both medical and surgical," and second, because the student could see the professor conduct a preliminary examination, diagnose, and prescribe. If the professor performed an operation, the student could see "the disposition and functions of the assistants, the arrangement of the instruments, the position of the patient, and the different steps of the procedure, from its commencement to its termination, including the dressings, and the replacement of the sufferer in his bed." Even though the college clinic specialized in common medical and surgical problems, Jefferson students saw their share of serious problems, too. Next door to the amphitheater, and connected to it with a passageway, were rooms in which care could be provided for as many as fifteen patients. If a relative could not stay around the clock to care for a patient, the professors and students of the college did.[34]

Another principle that underlay Gross's career—indeed had made it possible—and one that Gross reminded his students of frequently, was that Jefferson Medical College was the champion of the ordinary citizen. This was no idealistic claim. By the beginning of the Civil War, Jefferson had become the largest medical school in America, graduating more than one-fourth of the medical students in the country.[35] It attracted students from all states of the Union, from Mexico, and from Canada. In his first address in 1871 as president of the newly formed Jefferson Alumni Association, Gross celebrated with his fellow alumni the college's historically egalitarian character: "[Jefferson Medical College] has been emphatically the school of the people and of the profession at large, dependent upon no clique, combination of interests, or hereditary prestige for support and countenance. She has been, in every sense of the term, a self-made institution. . . . she rose from

[34] *An inaugural address*, pp. 31, 29. Da Costa, *Selections*, "The Old Jefferson Hospital," p. 214.

[35] See John S. Billings, "Literature and Institutions," in *A Century of American Medicine, 1776-1876*, ed. Edward H. Clarke (Philadelphia, 1876; rpt. New York: Lenox Hill Publishing and Distributing Co., 1971), p. 359. By 1876 Jefferson had graduated 6668 students, the University of Pennsylvania Medical School 8845; the two schools led the country. Between 1850 and 1860 Jefferson graduated more students than the University of Pennsylvania, with a high point of 269 graduates in 1854. For comments by Gross, see *An address delivered before the Alumni Association of the Jefferson Medical College of Philadelphia, at its first anniversary, March 11, 1871* (Philadelphia: Collins, printer, 1872), p. 9.

humble beginnings by rapid strides to gigantic proportions, outstripping, in the number of her pupils, every school of the kind in the country."[36]

Two of Gross's ideals were more personal. One was the importance to him of being a surgeon who taught. He noted that the most distinguished surgeons in recent history had almost inevitably held teaching positions, and that teaching usually made a researcher a better writer.[37] Even more important to him was the range of influence that the teacher of surgery had. He could inculcate into his students basic medical principles, and Gross matter-of-factly praised himself as a teacher who insisted that students know the principles underlying whatever particular instance they were dealing with. He taught his students to have a profound respect for knowledge, but only that which had been verified; and he set down his testimony in his *Autobiography*: "I never dealt in hypothesis, conjecture, or speculation." But the most important aspect of his influence as a teacher, Gross felt, was on the lives of the patients his students would treat. Writing of the poise with which he had addressed thousands of students in clinics over his career, Gross asked his reader: "Who would not, inspired by the occasion, be eloquent when he is addressing himself to a body of ingenuous students, in quest of knowledge designed to heal the sick, to open the eyes of the blind, to make the deaf hear, to enable the lame to walk, and to loose the tongue of the dumb? I never enter the lecture-room without a deep sense of the responsibility of my office—without a feeling that I have a solemn duty to perform—and that upon what I may utter during the hour may depend the happiness or misery of hundreds, if not thousands, of human beings."[38]

For Gross, neither the process nor the teaching of surgery was a performance. During the first part of the century, before the introduction of anesthesia, surgeons performed amputations and other operations with a haste that kept the acute suffering of the patient to a minimum; in clinical sessions many surgeons openly yielded to the temptation to make this haste as dramatic as possible—and with calculated gestures they won applause and cheers from the colleagues and students who were their witnesses.[39] Reminiscences

[36] Gross, *An address delivered before the Alumni Association*, p. 8.

[37] Gross, *History of American Medical Literature from 1776 to the Present Time* (Philadelphia: Collins, printer, 1876), p. 61.

[38] Gross, *Autobiography*, vol. 1, pp. 161, 160-161.

[39] See H. E. Sigerist, "Surgery at the Time of the Introduction of Antisepsis," *Journal of the Missouri State Medical Association* 32 (May 1935), 169.

and contemporary accounts of surgery in the Jefferson clinics in the 1860s and 1870s show that the taste for drama was not lost even then. Such clinics, in which surgeons took turns at performing three or four spectacular operations, each surgeon introducing the next as the "hero" of the upcoming demonstration, were held at the beginning of the college term when medical institutions were competing with each other for enrollments, or when famous surgeons from other cities or from abroad were visiting.[40] But Dr. Gross was not dramatic, and he would not permit such an atmosphere in his clinic. He wrote in his autobiography: "Nothing was more offensive to me than applause as I entered the amphitheater, and I never permitted it after the first lecture. I always said, 'Gentlemen, such a noise is more befitting the pit of a theatre or a circus than a temple dedicated, not to Aesculapius, but to Almighty God, for the study of disease and accident, and your preparation for the great duties of your profession. There is something awfully solemn in a profession which deals with life and death; and I desire at the very threshold of this course of lectures to impress upon your minds its sacred and responsible character.' "[41]

On this ideal he was as insistent to his colleagues as he had been to his students. In his *System of Surgery* he spelled out the proper atmosphere for a surgical undertaking: "The operation is proceeded with, slowly, deliberately, and in the most orderly, quiet, and dignified manner. All display as such, is studiously avoided; ever remembering, in the language of Desault, that the simplicity of an operation is the measure of its perfection. No talking or whispering should be permitted on the part of the assistants, and as to laughter, nothing could be in worse taste, or more deserving of rebuke. Every important operation should be looked on as a solemn undertaking, which may be followed in an instant by the death of a human being, whose life, on such an occasion, is often literally suspended by a thread, which the most trivial accident may serve to snap asunder."[42]

Gross's pride in Jefferson, his sense of the origin and the superior contribution of clinical instruction, his celebration of democratic opportunity in surgery—each of these found its way into Eakins' image. Trained in the teaching tradition with such an important heritage, born not to privilege but to discipline and hard work, Gross was not only shaped by Jefferson but in

[40] John Chalmers Da Costa discusses these clinics in "The Old Jefferson Hospital," pp. 204-291, and "Last Surgical Clinic in Old Jefferson Hospital," pp. 334-352, in *Selec-* *tions*.

[41] Gross, *Autobiography*, vol. 1, p. 162.

[42] Gross, *System of Surgery* (1882), vol. 1, p. 488.

66

return gave its ideals their fullest confirmation. Thus Eakins showed him in the Jefferson surgical clinic, surrounded by students, who will rise to prominence in the very way Gross did, by hard work. Gross is assisted by an operating team several of whom were Jefferson graduates. The presence of the clinic recorder emphasizes the scientific modernity of the work: there is no authoritative anatomical text, as in the format of the anatomy lesson (typified by Rembrandt's *Anatomy Lesson of Dr. Tulp*, Figure 36, where the text is open at the feet of the cadaver), but a record to be passed on to the future. And Eakins sets forth Gross's more personal ideals, too: Gross considered his role as a teacher to subsume his work as surgeon; and Eakins shows Gross about to lecture on what he is doing, his act of explanation and interpretation being larger than his act of doing. And secondly, in the painting the operating amphitheater over which Gross presides is indeed like a temple of healing hushed by a respectful, even reverent, quiet. From the point of view of the student, before whom Gross was so anxious to have everything laid out, the painting leaves nothing unclear: the disposition of the presiding surgeon, of the assistants, the arrangement of the patient, the location and display of the surgical instruments—precisely what each person is doing and with what. (Figure 37, a photograph of a surgical operating team in the 1850s, also sets forth meticulously the persons and equipment necessary for the procedure.)

And Eakins makes very clear what the operation is. Like everything else in the painting, Eakins chose it to pay tribute to a particular quality of Dr. Gross.

One further principle was fundamental to Gross's practice, and that was his sense of the history of surgery. His clinical and formal lectures were dotted with references to past surgeons and techniques.[43] He wrote historical essays about surgeons, focusing early in his career on American surgeons who he thought deserved recognition; then turning his attention to the great sixteenth-century surgeon Ambroise Paré, who was honored then as now as the father of French—and in many ways—of modern surgery; and finally, during the months when Eakins was painting his portrait, writing two ex-

[43] These references may be found in the numerous reports of Gross's clinics published in the *North American Medico-Chirurgical Review*, 1856-1861, and in the *Philadelphia Medical Times* in the 1870s. The manuscript clinic reports of John Roberts, "Reports of the Surgical Clinics of Professor S. D. Gross in the Jefferson Medical College, for the term commencing Oct. 6th, and ending Dec. 30th, 1874," located at the College of Physicians of Philadelphia, are rich in historical references.

tended essays that have become landmarks in the history of American medical literature. One of these was a history of medical literature in America, the other, a history of American surgery.

With a wide knowledge of the character of surgical procedures that extended even to those recorded by classical authorities, Gross was acutely sensitive to the rapid changes being made in surgery during his lifetime. In 1867 he exulted that recent progress in surgery had been "without a parallel in any age. . . . It would almost seem as if the millennium were actually close at hand. Look where we may, progress, rapid and brilliant, nay, absolutely bewildering, literally stares us in the face, and challenges our respect and admiration."[44] Yet while Gross, like his colleagues, exulted in the new surgical procedures that scientific work in anesthesia, pathology, and medical instrumentation was permitting surgeons to perform, he also identified "conservative" surgery as one of the profession's most important recent developments.[45] Not a particular operation, but a philosophical approach to surgery, "conservative" surgery derived from the conviction that to amputate, so long as there was any other option, was to admit failure as a surgeon. The practice of conservative surgery applied primarily to diseases in the limbs; it often involved a long period of waiting for nature to take a positive course before the surgeon took drastic action. But the conservative attitude could illuminate the general practice of the surgeon; and in the mid-century years across Europe as well as in America conservative surgeons occasionally accused their colleagues of being impatient, of being "too fond of the knife."[46]

In Eakins' portrait of him, Dr. Gross is performing conservative surgery. The operation underway, for the removal of a piece of dead bone from the thigh, is the last stage of Gross's treatment of his patient for osteomyelitis, or infection of the bone. A problem virtually eradicated by the introduction of sulfonamides and antibiotics in the 1930s, osteomyelitis was characterized by infection of the longer bones of the body, such as the femur, tibia, and humerus, to which few people but the young between the ages of five and twenty-two were susceptible.[47] Infection usually set in after a sudden chill,

[44] Gross, *Then and Now: A Discourse introductory to the 43rd course of lectures in the Jefferson Medical College of Philadelphia* (Philadelphia: Collins, 1867), p. 4.

[45] *Then and Now*, pp. 18-19.

[46] American medical literature, particularly, was dotted with such accusations. See: *North American Medico-Chirurgical Review* 1, no.

2 (March 1857), 316 and 211; and for an English point of view, Samson Gamgee, "Present state of surgery in Paris," *Lancet* (London), 1867, articles beginning on pp. 273, 295, 392, 483.

[47] Acute osteomyelitis (the term from the roots "osteo" for bone, "myelon" for marrow, and "itis" for infection) resulted in necrosis,

causing the patient to experience high fever and excruciating pain. Until the late eighteenth century surgeons would respond to osteomyelitis with a matter-of-fact amputation of the limb just above the infection. However, through dissections and observation of ongoing cases, English surgeons discovered that the infected part of the bone, if left alone, would simply die and then slowly separate itself from the bone shaft (often penetrating the skin), leaving intact a shaft that would regenerate itself and resume its normal function. If the separation process proved too long, surgeons could intervene with resection and cut the diseased portion away from the healthy shaft. In either case, amputation would not be necessary. For his own competence in the procedure, Gross had drawn most notably on the work of the American surgeon Nathan Smith, who in the 1830s wrote a seminal paper on the subject that described his own long experience.[48]

Although his colleagues and many lay admirers esteemed Gross for the brilliance and tact of his lithotomies and complicated amputations, Gross himself felt his work on bone diseases to have been of superior importance. Whereas lithotomies and amputations were standard surgical procedures, in each instance of osteomyelitis the problem was slightly different, and solving it appealed to Gross's pride in being a physician. Gross had studied osteomyelitis for his first original publication, in fact, and in his *Elements of Surgery* of 1859, he set forth in detail careful procedures for treatment of the disease in its various manifestations.[49] In his clinics at Jefferson during the 1860s and 1870s, the treatment of diseased or dead bone occupied him more than did any other single surgical procedure.[50]

The problem demanded a great deal of patience: the surgeon did not dispatch his patient quickly as he would if he had removed a cyst or performed

or death of the diseased area. A recent discussion that places the treatment of osteomyelitis in historical perspective is that of Richard H. Meade, *An Introduction to the History of General Surgery* (Philadelphia: W. B. Saunders Co., 1968), p. 34. For discussions contemporary with Gross, see Gross himself, in *System of Surgery*.

[48] "Observations on the Pathology and Treatment of Necrosis," in Nathan R. Smith, ed., *Medical and Surgical Memoirs, by Nathan Smith* (Baltimore: William A. Francis, 1831), pp. 97-127. Gross praised Smith in his *Autobiography*, vol. 2, pp. 208-209; and in *The*

History of American Medical Literature, pp. 35-36.

[49] *The Anatomy, Physiology, and Diseases of the Bones and Joints* (Philadelphia: J. Grigg, 1830). He discussed it in detail in his *Elements of Pathological Anatomy* (Boston: Marsh, Capen, Lyon & Webb, 1839); and then in *System of Surgery*, 1859 and subsequent editions.

[50] This may be ascertained by following clinic reports in the *Philadelphia Medical Times* and in the Jefferson Medical College archives (the archives record begins in 1877, with the opening of the new hospital).

an amputation. For instance, the *Philadelphia Medical Times* reported on December 17, 1872 the successful conclusion of the necrosis of the humerus of a young patient Gross had been treating at the Jefferson clinic for a year and a half. During this time the boy had visited Gross's clinic "a number of times," and Gross waited for nature's own work on the disease to make it possible for his surgery to be most successful. From time to time, the report notes, Gross had removed small pieces of dead bone, "but did not find the necrosed portion sufficiently separated, or the involucrum [new, living bone] strong enough to maintain the shape and usefulness of the arm after an operation." On the clinic day reported, Gross determined that the healthy bone was at last sufficiently strong, and the reporter quotes Gross's lecture as he performed the surgery: "The patient being well influenced [by the anesthesia], we will enlarge this opening [made by nature on the surface of the skin, through which a piece of protruding dead bone would eventually pass] down to the bone and remove the necrosed portion. We will then carefully scrape out the cavity to remove all the carious particles of bone and unhealthy granulations that would interfere with the reparative process."[51] Such a procedure, such an explanation—except that the bone being treated is the femur, in the thigh—is taking place in Eakins' painting.

Although surgery for the removal of dead bone was tedious, it was not life-threatening. As early as 1830 Gross's authority Nathan Smith had written, on the basis of his years of experience with this type of surgery, "[even in the most advanced stages of osteomyelitis when the surgery demanded was some of] the most laborious and tedious, both to myself and the patient, which I have ever performed, yet I have never known any untoward circumstances to follow such operations, of which I have performed a great many."[52]

And surgery for the removal of dead bone did not create what Gross's faculty colleagues called a "show" clinic. Because Eakins was so attentive to the principles on which Gross conducted his work, his picture takes a remarkable place in the history of images about surgeons.

A standard early point of comparison, of course, is Rembrandt's *The Anatomy Lesson of Dr. Tulp* (Figure 36).[53] A group portrait with Dr. Tulp as the

[51] *Philadelphia Medical Times* 2 (December 7, 1872), 151-152.

[52] Nathan Smith, ed., *Medical and Surgical Memoirs*, pp. 120-121. The postoperative record for amputations, on the other hand, was grim: in his *System of Surgery* (1882), p. 546,

Gross reported the calculation by James R. Lane that the mortality rate for 6,000 cases was 36.92 per cent.

[53] In reproduction, the image of *The Anatomy Lesson of Dr. Tulp* was well known to Philadelphians. It was printed on the gradu-

most important figure, the painting is certainly not too removed from Eakins' intentions in that respect. Rembrandt was careful to show, as was Eakins two and a half centuries later, the precise nature of the procedure underway: the demonstration of certain muscles of the arm by a master surgeon to other surgeons. But what is being taught in Rembrandt's image, of course, is anatomy, not surgery. The standard anatomical text is open in the foreground to guide the instruction. And in 1632 there was no awareness that one could use that instruction for the performance of a particular operation. What the image celebrates is not healing but empirical investigation. And earlier, less imposing images had also set forth scenes of investigation: images of private dissections are found in manuscripts in the Romanesque period; and the well-known woodcut by van Calcar of Vesalius performing a public dissection in the amphitheater at Padua in 1543, which served as the frontispiece for Vesalius's famous work on anatomy, *On the Fabric of the Human Body*, was one of many such images in the Renaissance.

In the early nineteenth century, with the well-publicized advances in French surgery and the rise of the French surgeon to prominence, French artists began to explore ways in which surgeons might be depicted, both in history paintings and in portrait formats. An early subject was the surgeon Guillaume Dupuytren (whose career was admired by Americans), who won considerable renown for his operation for cataracts. In 1820 an anonymous artist pictured him in the hospital ward with one of his successes after cataract surgery (Figure 38); Charles X, who had made him a baron in recognition of his achievements, is shown on a visit to the ward to see the removal of the bandages of one of Dupuytren's patients. The patient, a woman, throws up her hands in delight that she can see; Dupuytren, the proud surgeon, stands modestly near her. Another image, part of a historicizing portrait, appeared in 1843 in the *Plutarque Française* (Figure 39); this one honored the surgeon-pathologist M.-F.X. Bichat, whose research in the dissection laboratory on the character of disease (which cost him his life at age thirty-one) had made the single most significant early contribution to French surgical progress. The artist chose to show Bichat posed in a Napoleonic stance by

ation certificate of the Philadelphia School of Anatomy (one such certificate is filed in the Medical History section of the Library of the College of Physicians of Philadelphia); and Eakins' friend Will Sartain wrote his father from Paris that he thought Philadelphians would subscribe to another copy of the painting by Bonnat, who had just made one for the National Museum of Copies in Paris (Sartain Collection, Historical Society of Pennsylvania, August 31, 1872).

a dissection table, the cadaver modestly covered, texts nearby to show that Bichat's research had led to a substantial increase in knowledge. These images of Dupuytren and of Bichat show the environment and the results of the surgeons' work; but they do not show that work in process.

With the revival of interest in Rembrandt in the 1840s, artists turned to the format of the anatomy lesson, both for historicizing paintings and for compliments to living surgeons. The Belgian painter Edouard Hamman chose the theme for his widely admired historical tributes to the anatomist Vesalius: one showing Vesalius delivering a famous public lecture in Padua in 1546 (Figure 40), the other showing Vesalius about to undertake private anatomical study (engraved by Wisener, Bibliothèque Nationale).[54] Anatomy lessons also honored contemporaries. Among the portrait medallions, allegorical scenes, and landscapes several Parisian artists did in 1859 for the all-purpose lounge of the interns at Charity Hospital was an anatomy lesson with each participant a member of the professional or intern staff of the hospital (Figure 41).[55] Articles in journals informed the public about hospital life and often included wood engravings of dissections or anatomical teaching. Even at the Salons, artists occasionally exhibited scenes of autopsies.[56]

From the point of view of Eakins' achievement, the most pertinent image in the format of the anatomy lesson was a painting by F.-N.-A. Feyen-Perrin exhibited at the Salon in 1864 (Figure 42). With this painting the artist honored one of Paris's most famous surgeons, Armand Velpeau, the chief surgeon at Charity Hospital. As Eakins had done in Philadelphia at Jefferson (and in Paris, perhaps at Charity Hospital), Feyen-Perrin had attended dis-

[54] The Flemish Vesalius was a source of pride to Belgian surgeons and physicians during the period of historical consciousness in early and mid century. The image of Vesalius in his dissection room emphasizes the anatomical text (which represents the authority of the classical anatomist Galen that Vesalius successfully challenged), and a crucifix on the wall provides assurance that Vesalius was not impious in his researches—a charge that nineteenth-century anatomists and surgeons also had to fight on occasion.

[55] For a discussion of the Charity Hospital "salle de garde," as this lounge was called, as well as those at several other Paris hospitals, see Augustin Cabanes, La salle de garde, ed.

Dewambez (Paris: Chez Montagu, 1917), an affectionate remembrance long after the salle de garde had been closed; Leon Binet and Pierre Vallery-Radot, Médecine et art: de la Renaissance à nos jours (Paris: Expansion Scientifique Française, 1968), pp. 181-183 lists the paintings at Charity specifically.

[56] These articles, usually undated, are filed in the Cabinet des Estampes under the codes for the various hospitals. Henri Gervex exhibited at the Salon in 1876 a painting that depicted the daily activity of autopsy that took place in medical training at the Hôtel-Dieu (engraving in the Bibliothèque Nationale, Paris).

sections and clinics at Charity Hospital.[57] Thus Feyen-Perrin drew on his own experience to show Velpeau presiding at a dissection surrounded by a number of onlookers. A lithograph (collection of the National Library of Medicine) with identifications of the onlookers shows the company to have been a diverse one: other surgeons on the staff of Charity Hospital, medical students, poets, and artists—including Feyen-Perrin himself. Although Velpeau presides over the dissection with grandeur, dissecting is an activity that is not as central to his identity in 1864 as a surgeon as it had been to that in 1632 of Dr. Tulp. Of course anatomical knowledge of the most detailed kind was absolutely essential for the nineteenth-century surgeon, but what defined the modern surgeon's essential achievement, and especially that of Velpeau, was his pioneering and brilliant role in actual operations and his teaching in surgical clinics. Yet Feyen-Perrin chose to present Velpeau in the role of an anatomist, even with a text in evidence, and, what is more, to show him before an unblemished cadaver before the dissection has even begun. Even more noticeable is that nowhere in evidence in the painting is the anatomist's and the surgeon's tool, the scalpel. Classically balanced, discreetly lighted, the painting is a decorous one. But in defining the essence of modern surgery—the heroism of modern surgery—it serves as little more than a group portrait.

The French artist Louis Matout did face the issue of what a surgeon does as a surgeon rather than as an anatomist. Significantly, however, he was not dealing with a modern surgeon, but with a historical figure. Moreover, he had been commissioned to paint the work—for installation in the anatomical and surgical amphitheater of the École de Médecine—and the subject was defined for him by the Ministry of Fine Arts in consultation with the medical school faculty (Figure 43).[58] The painting, installed in the amphitheater in

[57] For Feyen-Perrin, see Gabriel P. Weisberg, *The Realist Tradition: French Painting and Drawing 1830-1900* (Cleveland: Cleveland Museum of Art, 1981), pp. 288 and 180 (although note error in dating Eakins' *The Gross Clinic* after the Centennial). Velpeau's texts and clinical lectures were popular in America in translated and annotated editions.

[58] For a description and history of this painting, and of its pendants, with illustrations, see Noë Legrand, *Les collections artistiques de la Faculté de Médecine de Paris* (Paris: Masson, 1911), pp. 315-318. The paintings

are also discussed by Auguste Corlieu, *Centenaire de la Faculté de médecine de Paris (1794-1894)* (Paris: Imprimerie nationale, 1896). Before installation in the amphitheater, the ensemble was exhibited at the Salon in several stages: the central mural, about Paré, in 1853 (for a reaction, see A.-J. du Pays, *L'Illustration*, May 28, 1853, p. 344); the pendants and a sketch of the central mural as an ensemble in 1857 (for a review see Gustave Planche, *Revue des Deux Mondes* (vol. 10, 2nd per., July 15, 1857), pp. 395-396, and Maxime du Camp, *Salon de 1857* (Paris: Librairie Nouvelle, 1857),

1864, was a large mural that set forth the definitive accomplishment of the sixteenth-century surgeon Ambroise Paré; as the central panel of a three-part installation that pointed out the most significant moments in the history of French surgery, it dominated the group. In this painting Matout showed Paré, surgeon to the king, about to close off the arteries after an amputation by tying them rather than by cauterizing them with hot oil. In the middle of a battlefield, the black-clothed Paré stands above a patient whose leg he has just amputated; in the foreground is a brazier with hot irons ready for cauterization of the blood vessels. But Paré has rejected the hot irons, and he holds up the ligaments he will use instead. Several ermine-robed physicians near him raise their hands in surprise and disdain. Across the foreground of the painting are other wounded the surgeon must deal with; there is even a corpse. Paré's triumph in the midst of the chaos is notable. For the future of surgery, Paré's discovery was significant in several respects: tying rather than cauterizing the arteries prevented infection and promoted healing, and it was considerably less painful. Paré's defiance of tradition and of the aristocratic physicians for larger goals was also important. In fact, of all the surgical heroes who were studied, written about, and paid tribute to by nineteenth-century surgeons and imagemakers, Paré—for this rich variety of reasons—was the favorite. His life exemplified every ideal: he had risen from poverty to be the king's surgeon; he had worked indefatigably; researched, written, taught. And he was pious: his motto, in fact, was "I dress the wound, God heals it."

In the arrangement and scale of the paintings in the medical school amphitheater, Paré was the very embodiment of the French tradition. On each side of the large painting were narrow pendants: the one on the left, showing a professor lecturing to a group of students, honored the Italian anatomist and surgeon who had first lectured on anatomy at the University of Paris in the twelfth century; the one on the right, showing a surgeon demonstrating a surgical invention to students gathered around a patient's bed, honored the professor who had introduced the clinical method into French medical teach-

pp. 12-18. Also see Ernst Menaut, in *L'Annee Illustrée*, no. 18, 1868, p. 278, who was sharply critical that the history of medicine was not included in the scheme. The ensemble covered an allegorical frieze painted by Antoine-Esprit Gibelin in 1779 to celebrate Louis XVI's patronage of surgery; at that time, the building was the School of Surgery. Records of the commissioning of the new ensemble, by Matout, are in the Archives Nationale, file F^{21}4397. The paintings burned in a fire in the amphitheater in 1889 and were replaced in 1896 with an allegorical mural by Louis Bourgeois that celebrates both surgery and medicine.

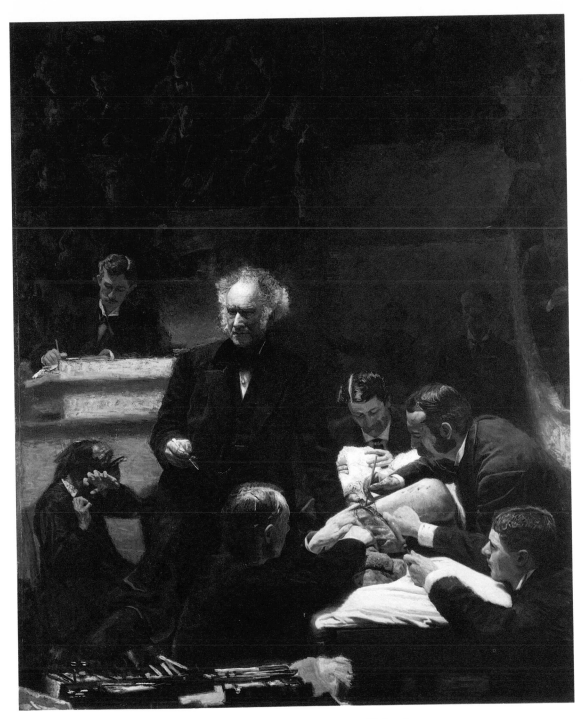

Plate 4. Thomas Eakins, *The Gross Clinic*, 1875.

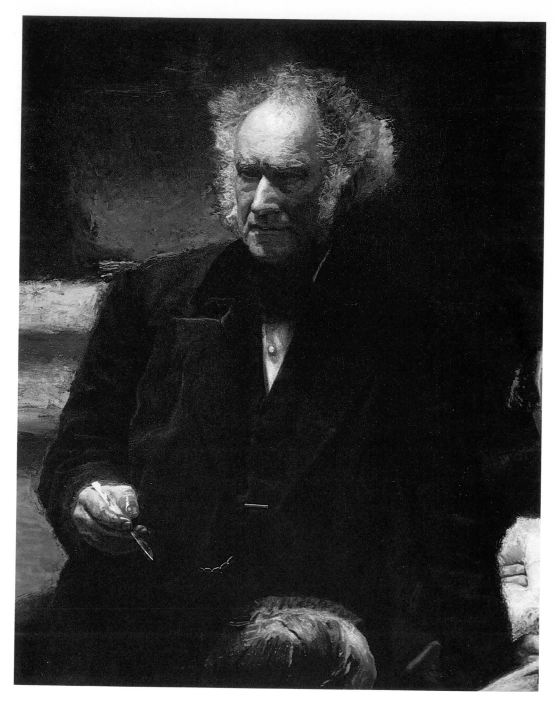

Plate 5. Thomas Eakins, *The Gross Clinic*, 1875, detail.

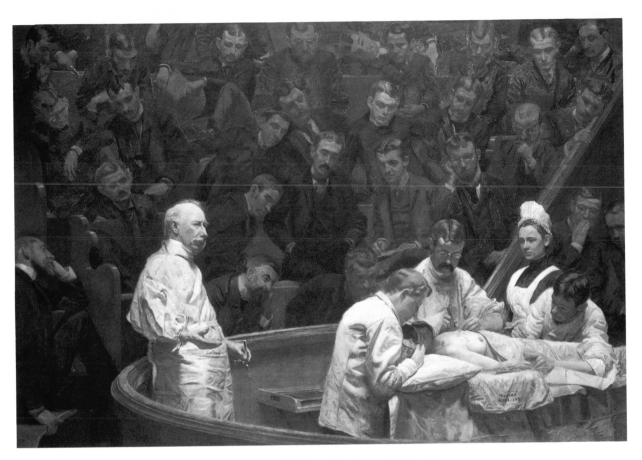

Plate 6. Thomas Eakins, *The Agnew Clinic*, 1889.

Figure 32 (Left). Thomas Eakins, *Composition study for the Portrait of Professor Gross*, 1875.

Figure 33 (Below, left). Thomas Eakins, *Study for the Head of Professor Gross*, 1875.

Figure 34 (Below, right). Thomas Eakins, *Study for spectator (Robert Meyers) in the Gross Clinic*, 1875.

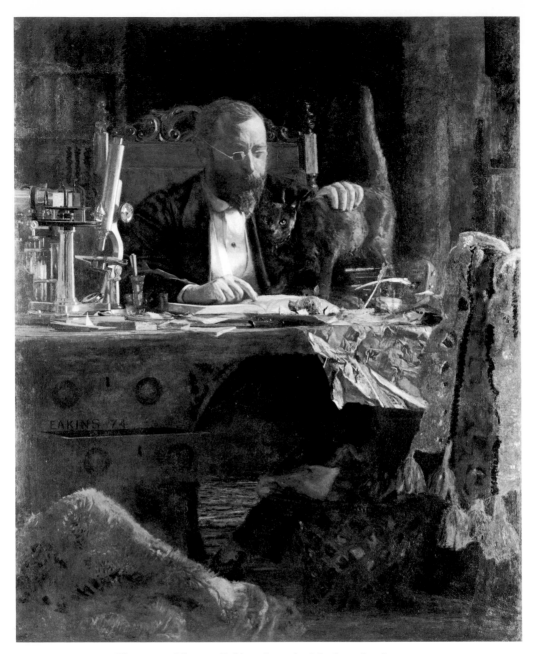

Figure 35. Thomas Eakins, *Portrait of Professor Rand*, 1874.

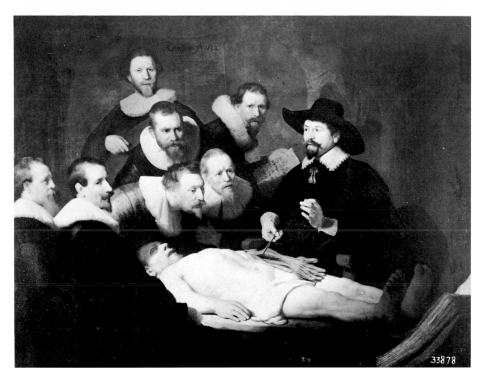

Figure 36. Rembrandt van Rijn, *The Anatomy Lesson of Dr. Nicolaas Tulp*, 1632.

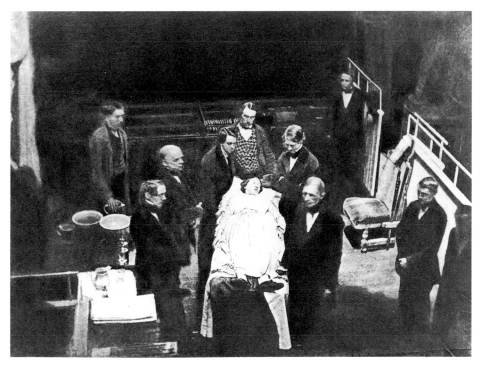

Figure 37. *An operation under ether at Massachusetts General Hospital*,
photograph, ca. 1850.

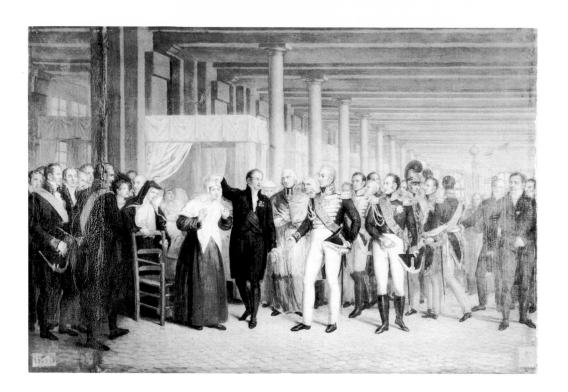

Figure 38. Anon. *Patient in the presence of Charles X after a cataract operation by Dupuytren*, ca. 1820.

Figure 39. *Marie-François Bichat*, engraved 1834 after painting by Emile Béranger.

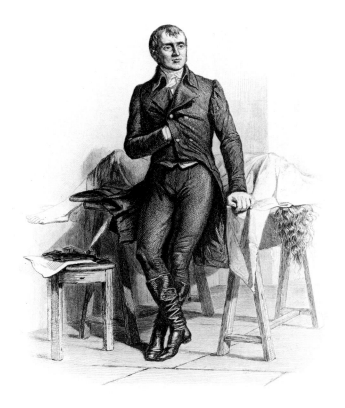

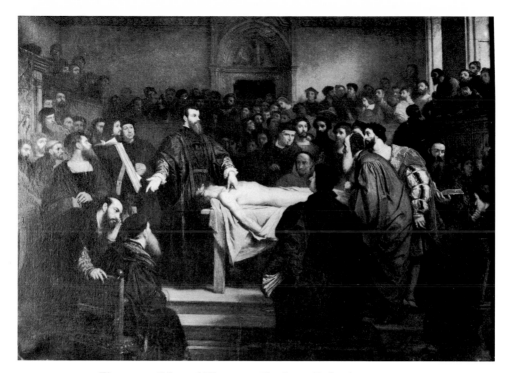

Figure 40. Edouard Hamman, *Vesalius at Padua in 1546*, 1848.

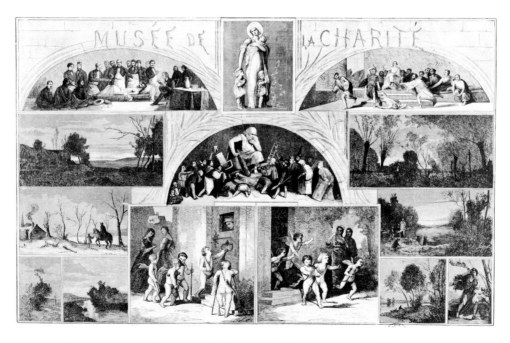

Figure 41. *The Museum of Charity Hospital* (Scenes from the Salle de garde).

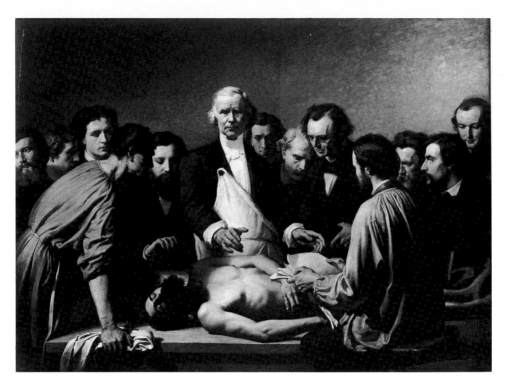

Figure 42. F.-N.-A. Feyen-Perrin. *The Anatomy Lesson of Dr. Velpeau*, 1864.

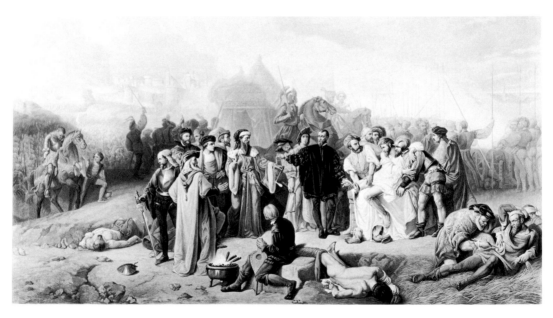

Figure 43. Louis Matout, *Ambroise Paré Applying Ligatures after an Amputation*, installed in the amphitheater, École de Médecine, 1864. Engraving by Goupil.

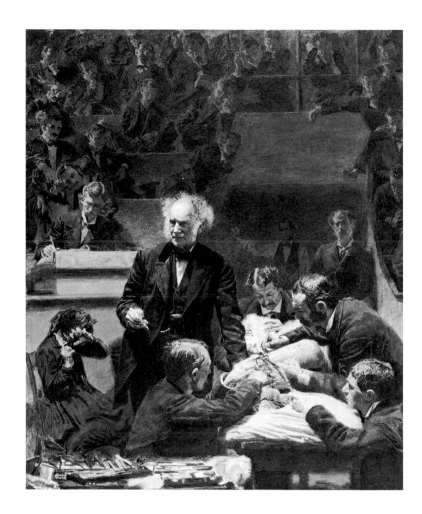

Figure 44. Thomas Eakins, *The Gross Clinic*, India ink wash on cardboard, 1876.

Figure 45. Ward of Model Post Hospital, Medical Department, Philadelphia Centennial Exposition, photograph, 1876, showing installation of *The Gross Clinic*.

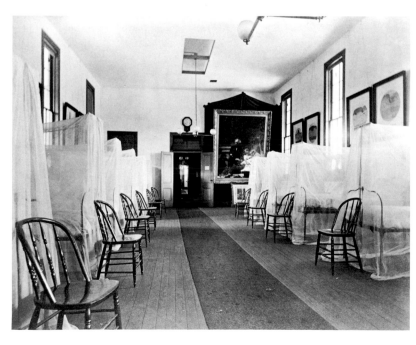

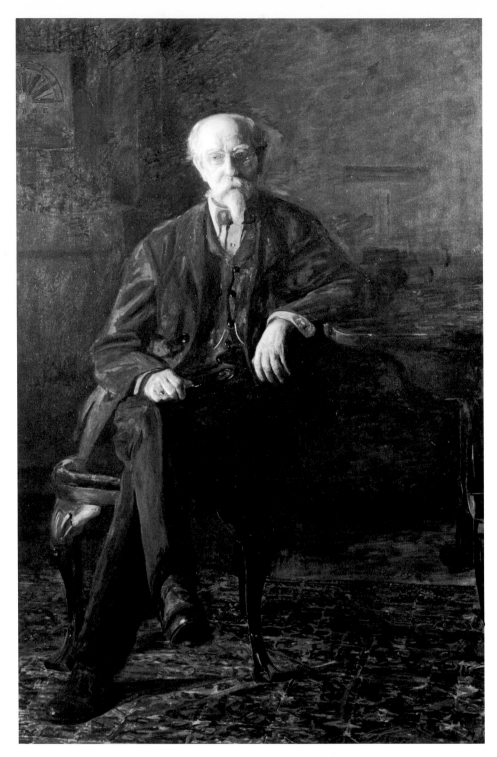

Figure 46. Thomas Eakins, *Dr. William Thomson*, 1907.

ing. In the middle and largest panel, the scene demonstrating Paré's personal courage, his career on the battlefield rather than in the cloistered university or hospital, defined the ideals of French surgical training—whether in lecture or in clinic. It set the highest standards for students.

Against this background, Eakins' image of Gross is direct.

He painted it to no order but his own. As Gross was no mere anatomist, Eakins did not choose an outdated convention to honor him. Gross's place was in the college clinic, performing surgery, where the scalpel and the blood were at the center of the procedure—the scalpel, the tool of investigation and of healing, and the blood, the flag of the living being on the operating table. Moreover, the surgery that defined Gross as a modern surgeon was not the heroic amputation or the bladder-stone removal that had been practiced by earlier surgeons for centuries, but a quiet surgical procedure that in its capacity to improve the life of a patient illustrated incisively the benefits of the evolution of surgery. Including the patient's mother to assure that his audience would not miss the youth of Gross's patient, Eakins makes a point that could be made only with this operation: the happy outcome of the surgery in Gross's clinic is a child with a whole leg instead of a stump. Dr. Gross and other conservative surgeons of the modern community have, in effect, applied to their own work the motto of Paré: "I dress the wound, God heals it."[59]

No American artist had ever painted a work of such intellectual scope, nor of such challenge as a sheer arrangement of figures. Considering what he had painted earlier, and that he was only five years into his painting career, Eakins exercised an impressive authority in carrying out this project: at least six very busy surgeons besides Dr. Gross sat for him, as well as a number of students. Soon after he finished the painting Eakins painted a small black and white watercolor of it (Figure 44) on which to have based an autotype and an edition of prints. Some of these he perhaps gave as mementos to the people who sat for him. Autotypes that survive today are those Eakins autographed and gave away years after the painting was completed: the work remained, in his own estimation as well as that of future generations, one of his finest achievements.[60]

[59] There is a remarkable kinship between the pose of Dr. Gross—with its emphasis on both dexterity and intelligence, action and thought—and that of the sculptor Martinez Montañés in the portrait by Velázquez in the Prado, a point that I developed in a talk at the Annual Meeting of the College Art Association in Washington, D.C. in 1979.

[60] The following autographed presentation copies are in institutional collections: to Jo-

Even during his lifetime Eakins was not alone in his assessment of the work. Although the Centennial jury, offended by the work's directness, refused to hang the painting in the regular art exhibition section—a decision for which we have no recorded reaction from Eakins—under the sponsorship of Gross himself the painting was exhibited in the medical section of the Centennial. There it took a proper place along with other medical exhibits—many of them related to the surgery in the painting—medical texts, and portraits of eminent medical men (Figure 45).[61] Nearly seven hundred physicians and surgeons from other cities and countries, in Philadelphia for an international congress, visited the medical exhibit and saw in Eakins' painting what a Nashville surgeon declared in his major address: "It was as late as 1820 that the taunt was uttered, 'What does the world yet owe to an American physician or surgeon?' [Yet, less than fifty years later] a French surgeon said to an American student, 'You ought to be proud of America, for she wields the sceptre of the whole world's surgery.' "[62] Eakins had caught

seph Leidy II (M.D.), National Library of Medicine; to Florence A. Einstein, Philadelphia Museum of Art; to James Tyson, M.D., College of Physicians of Philadelphia; to Dr. Fenton, Hirshhorn Museum and Sculpture Garden. The presentation dedications are undated, but biographical data indicate that Eakins gave them away considerably after he painted the Gross portrait. Joseph Leidy II was born in 1866; Eakins painted his portrait in 1890, and may have given him the autotype at that time. He painted the portrait of Florence A. Einstein, head of the department of design of the School of Design for Women in Philadelphia, in 1905. No portrait has survived of James Tyson (1841-1919); he may simply have been one of Eakins' friends in the medical community; or the presentation may have coincided with Eakins' friend Samuel Murray's sculpting of a bust of Tyson. Eakins painted Dr. Fenton about 1905. Horace Traubel, *With Walt Whitman in Camden*, Vol. 4 (Philadelphia: University of Pennsylvania Press, 1953), p. 104, reports that Eakins gave Whitman a reproduction; Eakins first met Whitman in 1887.

[61] The Centennial catalogue of the medical exhibition reads: "This room also contains . . . a painting of Prof. Samuel D. Gross, loaned for the Exhibition by that gentleman, viz: No. 15. An oil painting by Eakins, of Philadelphia, representing Professor Gross performing an operation for the removal of dead bone from the femur of a child, in the amphitheater of the Jefferson Medical College. No. 16. A small photograph of the same" (p. 137 in "Report on the Participation of the War Department in the International Exhibition"). Other medical portraits included those of Physick; and texts those of Gross and Paré; see "Report on the Participation," pp. 214, 227, 229 and passim. It is an historical irony that Feyen-Perrin's *Anatomy Lesson of Dr. Velpeau* was exhibited at the Centennial—in the French section—apparently to no objections (indeed, it was not an "objectionable" painting). At least one American reaction was very matter-of-fact: see Robert C. Fletcher, *The Centennial Exhibition of 1876: What We Saw, and How We Saw It* (Philadelphia: S. T. Souder & Co., 1876), pt. I, p. 73.

[62] Nashville surgeon Paul F. Eve's address is recorded in the *Philadelphia Medical Times* 6 (September 16, 1876), 607. The remark

ideals that were crucial to the entire medical community, and in 1878, after a new Jefferson hospital was opened, the Alumni Association of the College bought the painting and hung it in their museum.[63]

Sympathetic critics in the art community also recognized Eakins' achievement and gave it high praise. Eakins first exhibited the autotype of the painting, in fact, at an art exhibition at the Penn Club, founded just earlier to honor distinguished intellectual and professional leaders. The critic who reviewed the exhibition wrote of the image as one "of great learning and great dramatic power" and, later, on the exhibition of the painting itself at Eakins' dealer's, wrote further: "We know of nothing in the line of portraiture that has ever been attempted in this city, or indeed in this country, that in any way approaches it. . . . This portrait of Dr. Gross is a great work—we know of nothing greater that has ever been executed in America."[64]

Yet in other situations, starting with Eakins' submission of the painting to the Centennial jury, the painting was not cordially received.[65] It made people uneasy, even angry. For the first time, Eakins had two publics, "insiders" and "outsiders." These publics were divided not so much on whether they liked his painting as on whether they would acknowledge that a painter could insist that he had responsibilities that were beyond their ken. Eakins took his responsibilities as earnestly and self-consciously as Gross took his and was not swayed from that seriousness even though over the years his public of disgruntled outsiders grew.

And over the years, surgery changed. In fact, in only a very few years progress obscured the earlier modernity of Gross.[66] Within a short time of

"America wields the sceptre" attained a certain currency: in his *Autobiography*, for instance, Gross reported that in 1868 the French surgeon Pierre Marie Chassaignac had told him that "America at this moment wields the surgical sceptre of the world" (vol. 1, p. 319). About the same time, J. E. Erichsen wrote the highly complimentary "Impressions of American Surgery," *Lancet* (London), 2 (1874), 717-720 (reprinted in Gert H. Brieger, ed., *Medical America in the Nineteenth Century*, Baltimore: The Johns Hopkins University Press, 1972).

[63] *Philadelphia Press*, March 9, 1878.

[64] The critic was William J. Clark, writing in the *Daily Evening Telegraph*, first on March

8, 1876, and later on April 28, 1876.

[65] The New York papers the *Herald* and the *Tribune*, for example, reacted very negatively to the painting (March 8, 1879) when Eakins exhibited it there at the second annual exhibition of the Society of American Artists. See Hendricks, "Thomas Eakins's *Gross Clinic*," for quotations. In good-natured recognition of the "objectionable" aspects of the painting, some of Eakins' students parodied it in a tableau about 1876; a photograph of that parody, and another one of a spoof on an anatomy lecture, are in the collection of the Philadelphia Museum of Art. See Siegl, *Eakins Collection* for reproductions.

[66] In fact, Gross was one of the last physi-

his retirement, surgeons had accepted aseptic procedures and were operating in white gowns and with sterile instruments; they were entering the abdominal and lung cavities and making their first probes into the brain.[67] Philadelphia surgeons and physicians had contributed notably to this progress, and Eakins painted many of them over the years in their various medical capacities as scholars, and lecturers, and, simply, as seated human beings (Figure 46).[68] Not until fourteen years after his portrait of Gross did he paint his second, and only other, clinic portrait. In 1889 the medical class graduating from the University of Pennsylvania commissioned him to paint a portrait of Dr. D. Hayes Agnew, who was retiring that year. Agnew and Gross were almost contemporaries, Gross being only thirteen years older than Agnew and retiring only seven years ahead of him. Within the later years of these men's careers, surgery had changed at a breathtaking pace. Gross had

cians of his scope and depth to advocate bloodletting, a procedure that many had abandoned decades earlier. Gross delivered "A discourse on bloodletting considered as a therapeutic agent" at the annual meeting of the American Medical Association in Louisville, Kentucky, on May 5, 1875, printed by Collins, 1875. Public interest in the rapid changes in surgery was notable. See W. W. Keen, "Recent Progress in Surgery," *Harper's New Monthly Magazine* 79 (October 1889), 703.

[67] An overriding surgical problem had been the occurrence of infection after surgery; Joseph Lister (1827-1912), Professor of Surgery at Glasgow, led by the work by Louis Pasteur to reason that surgical infections were caused by bacteria, introduced in 1865 an antiseptic, bacteria-checking, carbolic acid spray to be used over the affected area of the body and throughout the operating room. This spray damaged tissues, however, and in the 1880s surgeons turned to asepsis: rather than check the growth of bacteria already introduced into the operation, they performed surgery with sterilized (and thus nonbacteria introducing) instruments and gowns. Gross respected Lister's motives, but preferred to depend on simple cleanliness to prevent infection. In *Forty Years in the Medical Profession, 1858-1898* (Philadelphia: J. B. Lippincott and

Co., 1900), John Janvier Black, who had studied with and admired Gross, celebrates the rapid advances in medicine that followed Gross's retirement, contrasting explicitly and often the practices of Gross's era with those of 1900.

[68] These include: his portrait in 1876 (Medical Museum of the Armed Forces Institute of Pathology; on loan to the National Gallery of Art) of the surgeon John H. Brinton, editor of the monumental six-volume *Medical and Surgical History of the War of the Rebellion*, sitting in his study; a portrait in 1889 of the neurologist and naturalist Dr. Horatio C. Wood (Figure 110), also in the identity of a scholar; a seated portrait of internist and public hygiene specialist Dr. Joseph Leidy, II in 1890; the standing portraits of medical chemist Dr. James W. Holland (Figure 117) in 1899 and of Professor William Smith Forbes, the surgeon and anatomist, in 1905 (Figure 118); the bust portrait of the radiology pioneer Charles Lester Leonard in 1897; and the seated portrait of the ophthalmologist William Thomson in 1907 (Figure 46); (see Harold D. Barnshaw, "The Portrait of Dr. William Thomson by Thomas Eakins," *Transactions and Studies of the College of Physicians of Philadelphia*, 4th series, 38 [1970], 40-43).

retired before the most outwardly notable of these changes had won general acceptance—the practice of asepsis—but Agnew had adapted to the new ways. Keenly sensitive to these changes, on receipt of the commission Eakins decided not to paint a conventional portrait of Agnew but to enlist the help of assisting surgeons and medical students to show the distinguished surgeon in the context of the newer surgical clinic.[69]

In the *Agnew Clinic* (Plate 6) surgeons wear white; the sterilized instruments are in a covered case; a nurse is prominently in attendance; the pyramidal structure of the Gross clinic scene is transformed into a horizontal format that shows the teamwork more characteristic of recent surgery, which had to some extent replaced the individual heroism of Gross. The painting is much lighter in palette than that of Gross, revealing not only Eakins' generally higher key during these years but the physical circumstance that by 1889 surgery was performed under widely dispersed artificial illumination. And painted in a rush, the work in many areas is thin. *The Agnew Clinic* is larger than the *Portrait of Professor Gross*, but it derives its meaning, in Eakins' career, at least, primarily in its relationship to that earlier painting. It is a relationship grounded in change.

Soon progress that amazed Agnew had been surpassed and, eventually, even the clinic faded into history. Surgeons abandoned it for teaching altogether as they began to appreciate the risk of infection from lecturing during surgery. Nostalgia for the clinic set in and with the passage of time, the interest of the medical community in the portrait of Gross—and the interest of Eakins too—shifted from its focus on the surgical hero to its documenta-

[69] An article in the *Old Penn Weekly Review*, October 30, 1915, named all the participants, even the students in the audience. A historical irony is that Dr. Gross's son, Samuel W. Gross, M.D., had pioneered radical surgery for cancer of the breast, the operation that is underway in the *Agnew Clinic*; the younger Gross died unexpectedly only a few months before Eakins undertook the painting of Agnew's clinic. Da Costa, *Selections*, pp. 341 and 356, praises Samuel W. Gross's stature in the history of this particular surgery. During the interval between Eakins' portrait of Gross in his clinic and this painting of Agnew, the French artist Henri Gervex had painted (and exhibited at the Salon of 1887) a scene show-ing Dr. Louis Péan in a ward, surrounded by his staff, about to perform surgery for breast cancer; Péan had developed an arterial clamp to prevent hemorrhage—protection vital for the success of this surgery. The surgery is about to be performed in a ward rather than in a clinic. Although Eakins may have known of the image, his interest in Agnew and in surgery for breast cancer (a very current concern) needed no specific precedent—as indeed he had been very much to the point without precedent in the *Gross Clinic*. (For Gervex, see *Equivoques: Peintures françaises du XIXᵉ siècle*, Paris: Musée des Arts Décoratifs, 1973.)

tion of the near legendary clinic over which Gross has presided.[70] By 1904, when Eakins exhibited the painting at the Universal Exposition in St. Louis, he was calling it the "Clinic of Professor Gross." After Eakins' death his friend wrote about the painting as "Dr. Gross' Clinic." It was but a short journey from there to the *Gross Clinic*, which the painting has been called ever since.[71]

The confidence with which Gross presided in 1875—the self-conscious heroism of his career as a surgeon—had, in fact, its underside. Gross wrote to one of his favorite students after he had entered professional life himself: "God knows surgery is not a sinecure, but a most corroding, soul-disturbing profession."[72]

Sanford C. Yager, writing in the *Cincinnati Lancet and Observer*, explained why this was the case: "[The medical profession is] the most difficult, obscure, and complicated of all human learning. No other occupation in life involves such varied and minute knowledge, such careful observation of nature, such constant and absorbing study, such heavy responsibilities. The

[70] Nostalgia for the passing of the old clinics is recorded by Black in *Forty Years in the Medical Profession*, especially pages 49-54; as well as by John C. Da Costa in his essays on the old Jefferson clinics. Early agitation for abandoning the surgical amphitheater was put forward by Stephen Smith, "Shall not the operating theatres of hospitals be abolished?" *Sanitarian* 6 (1878), 35. Only twenty years later a retrospective viewpoint was taken by William MacComac, "Operation Rooms, past and present," *Bristol Medical-Chirurgical Journal* 16 (1898), 304. For a comprehensive historical survey, see Owen H. and Sarah D. Wangensteen, "The surgical amphitheatre, history of its origins, functions, and fate," *Surgery* 77, no. 3 (March 1975), 403-418.

[71] From Eakins' exhibition of the autotype and the painting in Philadelphia in 1876, through its exhibition in 1879 in New York at the Society of American Artists and at the Pennsylvania Academy of the Fine Arts, to 1893 at the World's Fair in Chicago, he titled the work *Portrait of Professor Gross* (in Chicago, *Portrait of Dr. Gross*). In 1904, however, he exhibited it in St. Louis as *The Clinic of Professor Gross* (Official Catalogue of Exhibitors,

Department B, Art, No. 222); in 1907, to a request from Professor John Pickard of the University of Missouri that he name his best paintings, Eakins responded with a list headed with the "Clinic of Professor Gross" (Archives of American Art, roll 498, frame 997). In 1901 Sadakichi Hartmann, *A History of American Art* (Boston: L. C. Page), vol. 1, had called the painting "The Operation" (p. 200); in 1907 Charles Caffin, *The Story of American Painting* (New York: Frederick A. Stokes Co.), titled the work "Surgical Clinic" (p. 231). And in his memorial tribute of January, 1918 in *The Art World*, William Sartain called the painting "Dr. Gross' Clinic," p. 291. The catalogues of the memorial exhibitions of 1917 and 1918 in New York and Philadelphia listed the painting as the *Gross Clinic*. Recognizing Eakins' original intentions, in 1969 Hendricks argued strongly in a headnote to his article in the *Art Bulletin* that the painting ought to be known as *Portrait of Professor Gross*. The name of the *Agnew Clinic* underwent a similar transformation.

[72] Black, *Forty Years in the Medical Profession*, p. 94.

principles of other sciences are founded upon inanimate matter, are, therefore, well defined and not subject to change; and can be calculated on with certainty. Medicine, on the contrary, has to do with that which is in continual turmoil, and subject to a thousand varying circumstances and affecting causes. Our science rests upon human life: than which nothing is more uncertain."[73]

This profound respect for the uncertainty of human life was increasingly to characterize Eakins' approach to portraiture. Like the surgeon who had to know what was inside the body in order to understand the meaning of what he saw outside, Eakins knew not only the visible dimensions of the body, but as he matured he became increasingly sensitive to the invisible strains of spirit that moved it. Dr. Gross was inconceivable in his clinic without the blood that showed his full knowledge of and concern for the changing, living body; Eakins was to be inconceivable as a portraitist without the shadows, the slackening skin, the heavy shoulders that revealed his full awareness of the journeying human spirit.

[73] Sanford C. Yager, "The Medical Profession," *Cincinnati Lancet and Observer*, 9 (1866), 592-593.

CHAPTER FOUR

William Rush Carving His Allegorical Figure of the Schuylkill River

ABOUT THE same time that Eakins began his portrait of Dr. Gross, he made preliminary sketches for *William Rush Carving His Allegorical Figure of the Schuylkill River* (Plate 7). It was a work with a strong private dimension, but like the portrait of Dr. Gross, it had a public role to play as well. He was not to finish the painting until 1877, after he had tried at least two approaches to his subject and made rigorous studies in clay for the final version. He invited distraction from the strain of trying to get the work right: while it was in process, he painted other works, including some home scenes—one of his sister Frances's baby daughter (*Baby at Play*, 1876, National Gallery of Art) and one of his father's friends playing chess while his father looked on (*The Chess Players*, 1876, Metropolitan Museum of Art). In addition, perhaps assisted in the necessary introductions by Dr. Gross, he also painted two large, full-length portraits of distinguished citizens: the surgeon and writer John H. Brinton, M.D., a close associate of Gross at Jefferson Medical College, who had just finished editing the lauded *Medical and Surgical History of the War of the Rebellion* (1876, Medical Museum of the Armed Forces Institute of Pathology; on loan to the National Gallery of Art); and Archbishop James Frederick Wood, long a personal friend of Gross, who had just been elevated to the first Catholic Archbishopric of Philadelphia (1877, St. Charles Borromeo Seminary, Philadelphia). Eakins even received and carried out a portrait commission: one that eventually led to disappointment, but seemed at first to promise future success. For the Union League of Philadelphia, he went to Washington in the summer of 1877 to paint a portrait of President of the United States Rutherford B. Hayes.[1]

[1] The members of the Union League apparently objected to the portrait; after a few years, it disappeared and one by another artist took its place. Eakins painted another por-

82

In the context of these and his sporting portraits, Eakins' painting of Rush would seem to have been a radical contrast. For although Rush was a Philadelphian, he had been dead for more than forty years, and Eakins had never known him. Eakins had tapped his community's excitement for modern leisure in his rowing subjects; he had recognized the distinctiveness of modern surgery in his portrait of Dr. Gross. But the sculptor William Rush (1752-1833), who had worked in wood and terra cotta, was definitely out of date, his work a reminder of America's early artistic limitations.

Actually, the painting mixed public and private dimensions of portraiture the way Eakins had done earlier; from the very beginning he had painted not only what was admired by the community but what he knew himself and what he found important to his own life. But with the William Rush there was indeed a difference. Whereas rowing—and sailing and hunting—were a part of Eakins' life, as leisure they were not at the heart of his work as an artist. Surgery, based as Eakins knew it on precise anatomical knowledge and concern for the human being, came closer to his fundamental creed. With his turn to William Rush, however, Eakins created a work about a fellow artist.

Rush was a sculptor rather than a painter, and that, too, had its bearing on his attractiveness to Eakins as a subject for a painting. Until well into the nineteenth century sculptors had most frequently modeled or carved the human form, in full length or simply in the bust. A sculptor knew the body's anatomy, understood the mechanism of its movement, indeed, paid a more profound tribute to the body as nature than did the painter.

Moreover, the content of sculpture most typically was public; if the sculpture was a portrait, it honored a political or religious or cultural hero who embodied virtues admired by an entire group of people. Or if the sculpture was a mythological or allegorical figure it alluded to values of beauty and morality held in common by the community. Eakins painted his subjects with the same assumption that underlay public commission for sculpture: that his sitters were important representatives of an excellence fostered and rejoiced in by the entire community.

But, given the reasonableness of Eakins' interest in painting a sculptor, the questions that remain are large ones: Why did the modern Eakins turn to the past for his sculptor, and, specifically, to Rush?

trait of Hayes in 1912 or 1913 for Thomas B. Clarke. See Lloyd Goodrich, *Thomas Eakins: His Life and Work* (New York: Whitney Museum of American Art, 1933), cat. nos. 473 and 475.

William Rush had lived a long and busy life in Philadelphia, prominently as a sculptor and member of the artist community but also as a public-spirited citizen involved with the often controversial problems of Philadelphia's water supply. As a sculptor, Rush was more specifically a woodcarver; he served an apprenticeship in Philadelphia with an English-trained ship-carver and by 1779 had set up his own workshop. He enjoyed the patronage of shipbuilders during the long years of Philadelphia's domination of shipbuilding and carved allegorical figureheads and ship's scrolls for such well-known shipbuilders as Stephen Girard and Joshua Humphreys, whose ships sailed all over the world and brought Rush's work international admiration.

In 1808, when he was more than fifty years old, Rush began to receive commissions for public sculpture to ornament Philadelphia buildings.[2] In the next twenty years these commissions included figures for the facade of a theater, crucifixes for two churches, and figures for a bridge and for the triumphal arch honoring Lafayette. All, except the crucifixes, were traditionally allegorical. In Eakins' eyes more than half a century later, the most important of these public sculptures were the ones connected with the new water system for the city, particularly a fountain figure of a lightly draped female.

This sculpture had been commissioned to mark a technological advance distinctive to Philadelphia. As a result of the city's terrible fever epidemics of the 1790s, which had been aggravated by an impure water supply, the Philadelphia City Council developed a plan to bring pure water into the city from the Schuylkill River. Benjamin Latrobe designed the entire system and then the neoclassical enginehouse in Centre Square, more than a mile from the river, where the water was to be pumped by steam engine to users across the city. The enginehouse was in service by 1802. In 1809 the Watering Committee of the Council, on which Rush was an active member, engaged Rush to make an ornamental fountain and figure to ornament the site, com-

[2] Linda Bantel points out that one factor influencing Rush to turn to architectural sculpture was an economic slump that depressed shipbuilding; his new direction was also due to the civic pride with which Philadelphians, aware of European parks and architectural sculpture, encouraged him to contribute his untapped talents to new building projects (*William Rush, American Sculptor*, Philadelphia: Pennsylvania Academy of the Fine Arts, 1982, pp. 19-20). A commentator in *Port Folio*, series 3, 8 (July 1812), 145, expressed the opinion that only with such recent work had Rush been sufficiently challenged: "We are much gratified that Mr. Rush begins to employ his chisel, on subjects more durable, and more likely to perpetuate his fame, than those he has in general hitherto executed."

plementing the temple-like enginehouse and symbolizing the bringing of water into the city from the river.

Rush asked Louisa Vanuxem, the daughter of his colleague James Vanuxem on the Watering Committee, to pose for the fountain figure. A lively young woman of twenty-seven who despite numerous suitors did not accept a marriage proposal until 1817 (when she was thirty-five years old), Miss Vanuxem was honored by Rush's choice—her progeny recorded it more than a century later in the family genealogy.[3] Aided by her posing, Rush carved a fountain figure that was lightly draped and slender (although not classically proportioned) with a demure face and that held on her shoulders a bittern (a bird found along the marshy shores of the Schuylkill) through the beak of which Schuylkill water was to spray and fall into the fountain (Figure 47 shows the bronze cast made of the figure in 1872). Although Rush announced no specific allegorical program, the figure was readable enough. In August 1809 he installed the completed "Water Nymph"—painted white to imitate marble—in its fountain basin at Centre Square, on a casual arrangement of rocks among which pipes sprayed water[4] (Figure 48 shows an early view of Centre Square). The effect was cooling and graceful; and around the fountain and the nearby enginehouse city officials made walkways, installed benches, and planted trees so that the area became a noted park. The installation—Philadelphia's first public fountain—brought Rush acclaim and drew forth expressions of civic pride from the press, visitors, and residents, even in years thereafter when the central location of the fountain became only a memory.[5]

[3] Francis Van Uxem, *Notes Concerning the Van Uxem Family*, 1923, pp. 11-15.

[4] *Poulson's American Daily Advertiser*, August 28, 1809, described the statue and fountain in detail but offered no interpretation of the program, and other accounts followed this example.

[5] Besides the congratulations of *Poulson's* and of the *U. S. Gazette for the Country* (September 4, 1809, a reprint of the article in *Poulson's*), a writer for the *Port Folio* series 3, 8 (July 1812), 30, praised Rush for the "well-executed" "figure of the nymph." The *Port Folio* author did quibble, however, that Rush had given the bittern "a peculiar awkward-ness and want of grace . . . in its stiff and formal attitude" (p. 31), a point of view that suggests that the author would certainly have criticized the draped figure itself if he had felt it warranted it. A young Moravian girl who visited Philadelphia in 1810 wanted to see—if nothing else—Peale's Museum and the Waterworks. She recorded in her diary that she saw Rush's "exquisite art creation of a nymph, on a rock, having on her shoulder a bird with water spouting from its beak," p. 358, A. R. Beck, "Notes of a Visit to Philadelphia, made by a Moravian Sister in 1810," *Pennsylvania Magazine of History and Biography* 36 (1912), 346-361. In 1860 Abraham Ritter,

For the city very quickly outgrew the water-supply system of which the fountain and nymph were a symbol; the inefficient steam pump in the enginehouse fell silent in 1815 and no more water was brought into the center of the city. The Watering Committee, after much controversy, decided to abandon the expensive steam operation and build a dam across the river in order to distribute Philadelphia's water with power generated by the dam. By 1822, after the dam was completed, wheelhouses and a new distribution system were ready near the bank of the river at Fairmount. The Watering Committee commissioned Rush to make sculpture to decorate the new installation, and for the tops of the entrances to the new wheelhouses he carved the sculptures *Allegory of the Schuylkill River in its Improved State* (a male rivergod figure) and *Allegory of the Waterworks* (Figure 49, and Figure 50 a view of the Waterworks). Then the committee moved the *Water Nymph and Bittern*, along with her fountain, to Fairmount—to a prominent location next to the forebay. Successfully reinstalled, the nymph once again inspired strollers who admired her beauty and the effect of the Schuylkill water bubbling up around her and spraying out of the bittern's beak (Figure 51).[6]

Besides his woodcarving, Rush was active as an artist in other ways. About 1812 he began to model portrait busts of distinguished Philadelphia citizens—notably, one was the physician Benjamin Rush, another the anatomist Caspar Wistar, and a third the surgeon Philip Syng Physick—and exhibited the busts at the academy. For such fledgling institutional collections as those of the American Philosophical Society, the College of Physicians of Philadelphia, and the Pennsylvania Hospital, he made plaster replicas.[7] In 1814 he conceived his most ambitious portrait: he carved a full-length, life-size George Washington in wood (Figure 52). Although he did not attract any commissions for replicas of the Washington, as he had hoped, the city of Philadelphia did buy the work and from 1824 displayed it in Independence

Philadelphia and Her Merchants, as Constituted Fifty or Seventy Years Ago (Philadelphia: published by the author, 1860), remembered that the figure had been "the admiration of the daily throng" in Centre Square and described its later location in Fairmount as contributing "to the beautiful blending of art with nature," pp. 104-105.

[6] For two discussions of the new installation, see Charles Coleman Sellers, "William Rush at Fairmount," in Fairmount Park Art Association, *Sculpture of a City: Philadelphia's Treasures in Bronze and Stone* (New York: Walker Publishing Co., Inc., 1974), pp. 8-26; and Edwin Wolf 2nd, *Philadelphia: Portrait of an American City* (Harrisburg: Stackpole Books, 1975), p. 160.

[7] Rush carved for Wistar and Physick large anatomical models of parts of the brain and head to be used in teaching; only two are extant (Pennsylvania Academy of the Fine Arts, *Rush*, cat. no. 33).

Hall. There it joined Charles Willson Peale's portraits of eminent citizens in ongoing testimony of Philadelphia's—and America's—heritage.

Rush also participated in the several attempts from 1789 on to establish an art academy in Philadelphia. In these efforts he joined Charles Willson Peale, who actually led the crusades. Although Peale and Rush were anxious to promote patronage for the arts, one of their main objectives was to establish in Philadelphia opportunities for serious study in drawing, painting, and sculpture. Fundamental to such study were life classes, where students could draw from the live model. Peale had known the benefits of such study in his years as a student of Benjamin West in London, from 1767 to 1769; Rush, however, trained in Philadelphia and as a craftsman, had not. After several failures to establish a permanent academy, in 1805 Rush and Peale joined with businessmen and lay members of the community to bring into being the successful Pennsylvania Academy of the Fine Arts where Eakins was to study and then to teach, six and seven decades later.

After Rush's death, memories of his lively participation in Philadelphia life naturally dimmed with the death of his colleagues and the passing of time. But appreciative coverage in John Watson's *Annals of Philadelphia*, first published in 1830 and revised in 1845 and 1857, kept Rush's life as a ship-carver before the public eye.[8] In 1859 Rush was recognized in Simpson's *Eminent Philadelphians* (which focused on Philadelphians of the past) as having been a carver and honored Councils member, and the next year the merchant Abraham Ritter reminisced fondly about Rush's talents as a carver of ship ornaments, the crucifix for St. Augustine's church, and the fountain figure.[9] In 1872 Eakins' friend Earl Shinn wrote a long article in *Lippincott's Magazine* about the early history of the Pennsylvania Academy of the Fine Arts, in which he mentioned both Rush's fountain in its original location and Rush's association with Peale in Philadelphia artists' early efforts to form an academy.[10]

And several of Rush's sculptures continued on public display. When Eakins began his painting in 1875, the *George Washington* was still exhibited in

[8] John Fanning Watson, *Annals of Philadelphia* (Philadelphia: E. L. Carey & A. Hart, 1830), pp. 550-552; edition of 1845, pp. 439, 575-576.

[9] Henry Simpson, *The Lives of Eminent Philadelphians* (Philadelphia: William Brotherhead, 1859), pp. 852-853. Abraham Ritter, *Philadelphia and Her Merchants*, pp. 104-105; although Ritter found Rush's fountain to be beautiful, he admired the representation of the crucifixion Rush carved for St. Augustine's Church as his "chef d'oeuvre."

[10] Earl Shinn, "The First American Art Academy," *Lippincott's Magazine* 9 (February 1872), 143-153.

Independence Hall, the center of Philadelphia's and the nation's history. A bust of Rush himself—a self-portrait (Figure 53)—and replicas of several of his other works were part of the permanent collection of the Academy of the Fine Arts, and busts of Physick, Wistar, Benjamin Rush, Lafayette, and others belonged to institutional collections.[11] The wheelhouse figures, *Allegory of the Schuylkill River in Its Improved State* (*Schuylkill Chained*) and *Allegory of the Waterworks* (*Schuylkill Freed*), and the gazebo ornament *Mercury* (carved slightly later) could be seen at Fairmount, where paths and gardens had turned the area into a public park. *Wisdom* and *Justice*, formerly on the Lafayette Arch, were displayed in the main hall of the enginehouse. And the *Water Nymph and Bittern* ornamented the park in two versions: near the forebay, where the wooden original and its fountain had been moved about 1825; and—in a bronze replica that had been made since Eakins' return from Paris—on a new fountain basin in a grassy area of the park near the Callowhill Street Bridge (Figure 54, made about 1876).

Eakins included three of these sculptures in his painting—the *Water Nymph and Bittern*, the *George Washington*, and the *Allegory of the Waterworks*. A close look at the painting shows his imaginative ordering of these sculptures and other evidence from the past.

On its most apparent level, the painting is at once a tribute to the achievements of a historical figure and an evocation of the dignity of artistic creation. Dominating the painting, Rush's model for the water nymph stands in the middle foreground, her back to us. Although Eakins entitled his painting *William Rush Carving His Allegorical Figure of the Schuylkill River* rather than "William Rush's Model," he gave the sculptor himself and his work in progress a position in the painting decidedly subordinate to that of the model. He placed Rush, in fact, in the dim left background, where, smartly dressed in wielding mallet and chisel, he bends to his task of finishing the fountain figure directly from the model. To the left of the model, in the foreground, is her brilliantly colored clothing draped over a Chippendale chair—white hat with long tie, dark blue jacket with red lining, white dress and petticoat, and blue stockings, with dark green parasol leaned against the chair. Just to the model's right, an older woman sits knitting. Two works Rush was to carve after 1809 are placed in the background: the standing figure of *George Washington*, carved in 1814 (in the right corner), and along the back wall

[11] According to Pennsylvania Academy of the Fine Arts exhibition catalogues in the 1860s, a number of portrait busts attributed to Rush were a part of the permanent collection; they have since disappeared.

behind the fountain figure, the *Allegory of the Waterworks*, the pedimental sculpture for the new wheelhouse that Rush was not to carve until 1825. In the left foreground are parts of two ship's scrolls—the type of work Rush had engaged in from his earliest years as a sculptor and from which he had progressed to create these other more demanding and enduring works of art. Scattered about on the floor are chips of wood, including one in the right foreground on which Eakins signed his authorship of the painting; tools hang on the back wall and rest on the bench along the right wall. Under that bench are two or three large books—perhaps of designs and engravings—and above the bench on the wall is a drawing of a scroll that has been modified for a second version.

The workshop is like a dark box filled with shadows. Across the front of it in a plane of light are the model, her clothing, and her companion. The model, a vivid contrast to the shadowy background, is the most solidly painted form in the picture; indeed, no other part of the painting more clearly reveals Eakins' own sculptural power, fundamental to his achievement as a painter. Bright, direct light falls on the model from the left, and Eakins shows its effect not only along that side of her body, but in such unexpected—and finely detailed—areas as along the front of her right thigh, along her right forearm just to the right of the book spine, and on the tip of her left breast. He gave the body roundedness with a rich gradation of half tones achieved by varyingly dark glazes and, finally, with reflected light along the right contours of her legs and across her lower back. The model is attractive but by no means idealized. Somewhat short-waisted and full-hipped, her body shows other particular qualities: well-shaped but not slender legs, dimpled flesh right above the buttocks, in the small of the back, and along the left ribs; and a delicate shoulder-collar bone area marked by a prominent vertebra. In contour the model's face is young and delicate, her ear is well shaped, and her hair is swept up on her head in an attractive array of wisps and curls held with a blue band.

The clothing near the model sets off other aspects of Eakins' technical capabilities. In lighting, palette, precision of detail, and fineness of brushstroke, these details—the red-seated, richly carved chair, the delicate lace, the intricate ribbing and ruffles—provide abundant testimony of the skills Eakins now commanded. As a still life within a painting, the area is a magnificent contrast to the looseness of the tray of instruments in the *Gross Clinic*—although it is a fitting companion to the precision of the surgical instruments in the hands of the operating team. Moreover, Eakins set these

technical achievements in relief: in contrast to the youth and fullbodiedness of the model, the knitting woman is angular (prominently so in her elbow and in the form of the knee under her dress); and in distinction to the tour de force of the model's bright clothing, the costume of the knitting woman is pale and only sketchily detailed.

And elsewhere in the painting, beyond the brilliantly lit foreground plane, Eakins subdued his effects. Rush and the contents of his studio are like a stage set carefully dimmed to show that the scene is a memory or an evocation of days long past. Yet even though the figure of Rush is in a low key, it is distinct and solid, a solidity Eakins achieved to a large degree with outlining. Careful outlining also defines the forms of the fountain figure Rush is carving, as well as the other sculptures in the studio. And the workshop wall, tools, floor, and scraps of wood are painted with broad, quick strokes that convey the busy atmosphere of a somewhat rough workshop. They contrast in their tentativeness to the firmness of the nude model in the foreground. Eakins made all subordinate to the present and to the living model.

The modest, almost offhand effect of many of the painted areas reflect only their place in Eakins' scheme of meanings, not the depth of investigation with which he prepared for the painting—investigation that had been a part of his normal experience in the case of the rowing paintings and of the *Gross Clinic*. But he had not lived in Rush's world, and to immerse himself in it, he took several steps. He visited a workshop and sketched the scene (1876-1877, Philadelphia Museum of Art); he talked with very old people who remembered Rush's own workshop, long since burned. He studied John F. Krimmel's painting *Centre Square on the Fourth of July*, of 1810-1812 (Figure 55), which shows the fountain figure in its original installation, and inspired by Krimmel's period detail, made studies from it for the clothing of Rush, the model (Figure 56), and the older woman. He photographed Rush's works to use as studies;[12] and following Rush's own three-dimensional creative process, he modeled in wax the works he would include in the painting—the *George Washington*, the *Allegory of the Waterworks*, the *Water Nymph and Bittern*, and the head of Rush himself (Figure 57). He painted a number of studies, including arrangements of the figures that he later discarded (Figure 58, and Farnsworth Museum).[13] He even modeled in wax the figure of the

[12] Susan Eakins mentions the photographs in a letter to Will Sartain September 15, 1917 and in another one dated simply "Friday night, 9:15 p.m.," both in the Sartain Collection, Historical Society of Pennsylvania.

[13] Gordon Hendricks, "Eakins's William Rush Carving His Allegorical Statue of the Schuylkill," *Art Quarterly* 31 (Winter 1968)

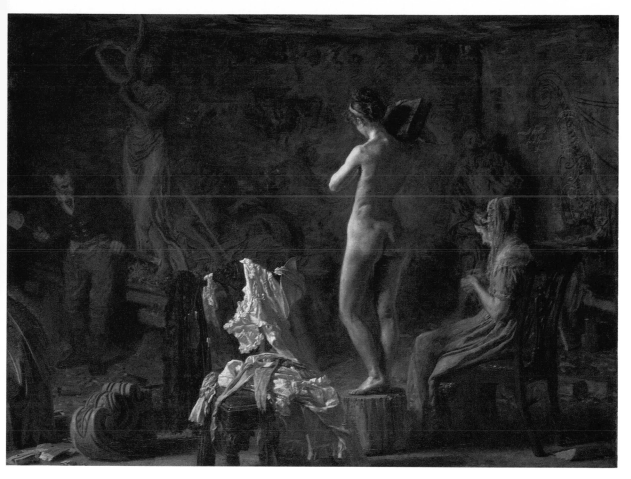

Plate 7. Thomas Eakins, *William Rush Carving His Allegorical Figure of the Schuylkill River*, 1877.

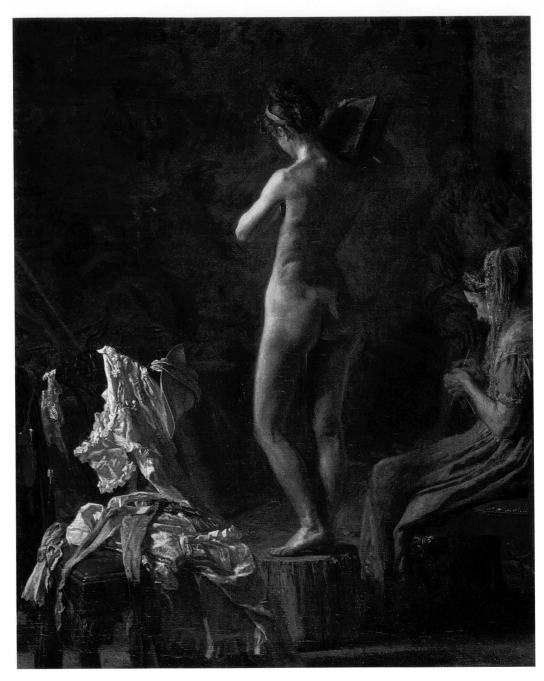

Plate 8. Thomas Eakins, *William Rush Carving His Allegorical Figure of the Schuylkill River*, 1877, detail.

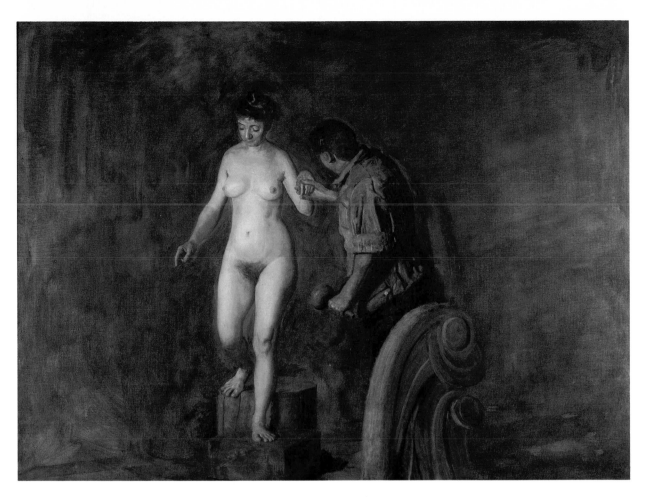

Plate 9. Thomas Eakins, *William Rush and His Model*, 1908.

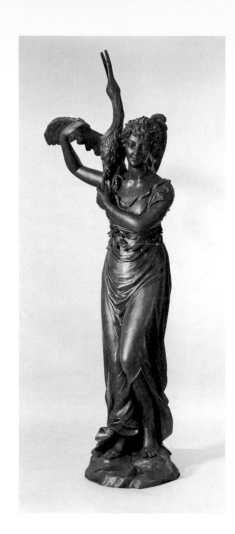

Figure 47. William Rush, *Water Nymph and Bittern* or *Allegorical Figure of the Schuylkill River*, bronze cast of wooden original, 1872.

Figure 48. *Centre Square* (an early view, ca. 1809), engraved by C. Tiebout after John J. Barralet.

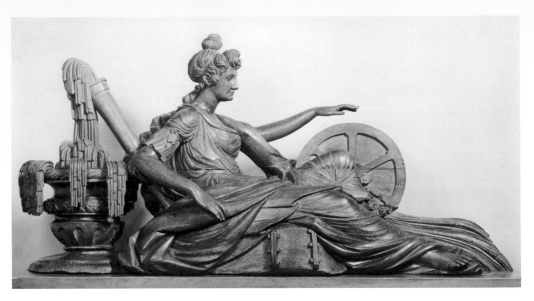

Figure 49. William Rush, *Allegory of the Waterworks (The Schuylkill Freed)*, 1825.

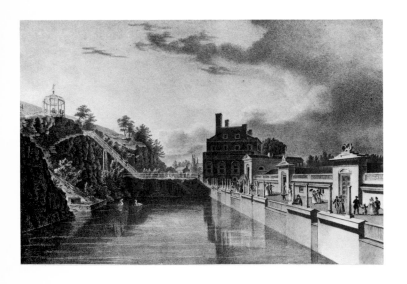

Figure 50. *Fairmount Waterworks, From the Forebay*, lithograph by
Childs and Lehman, 1833.

Figure 51. *Fountain and Stand-Pipe*, engraving by J. W.
Lauderbach after J. D. Woodhouse.

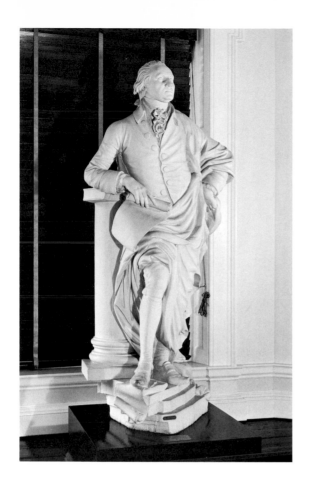

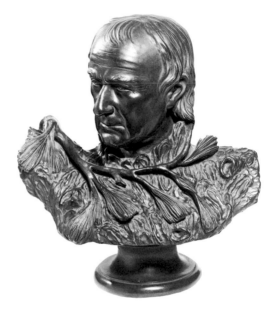

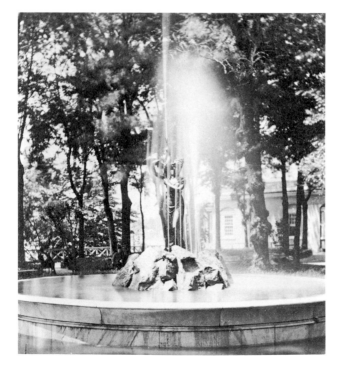

Figure 52 (Above, left). William Rush, *George Washington*, 1814.

Figure 53 (Above, right). William Rush, *Self-Portrait*, ca. 1822.

Figure 54 (Left). *Installation of Rush's Nymph with Bittern in Fairmount Park near the Callowhill Street Bridge*, photograph ca. 1876.

Figure 55 (Above). John L. Krimmel, *Fourth of July in Centre Square*, ca. 1810-1812.

Figure 56 (Left). Thomas Eakins, *Study of Woman with Parasol*, 1875-1876.

Figure 57 (Above, right). Thomas Eakins, *Wax Studies for William Rush Carving His Allegorical Figure of the Schuylkill River*, ca. 1875-1876.

Figure 58 (Right). Thomas Eakins, *Composition Study for William Rush Carving His Allegorical Figure of the Schuylkill River*, ca. 1875-76.

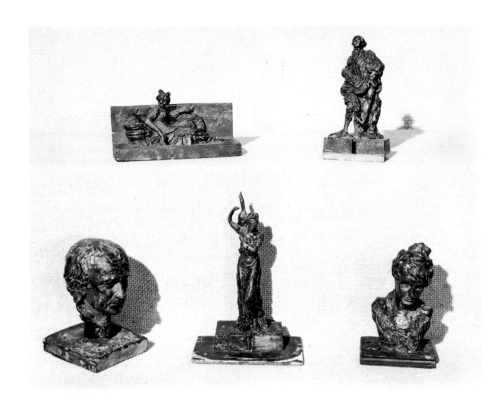

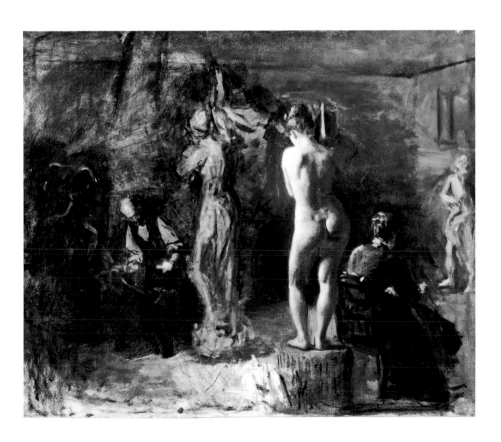

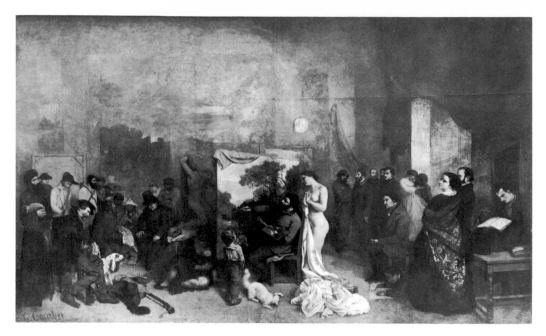

Figure 59. Gustave Courbet, *The Artist's Studio*, 1855.

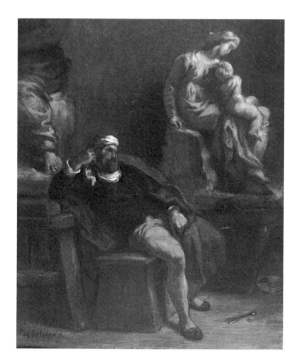

Figure 60. Eugene Delacroix, *Michelangelo in His Studio*, 1852.

Figure 61. J.-L. Gérôme, *Rembrandt Etching a Plate*, 1861, engraving by Goupil.

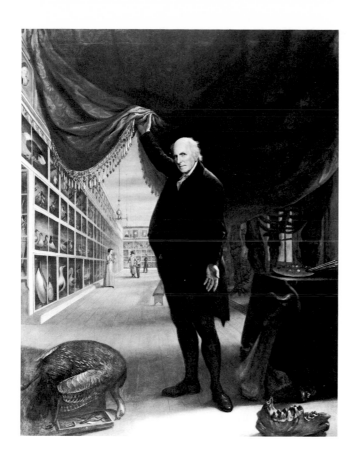

Figure 62. Charles Willson Peale,
The Artist in His Museum, 1822.

Figure 63. William Sidney Mount,
The Painter's Triumph, 1830.

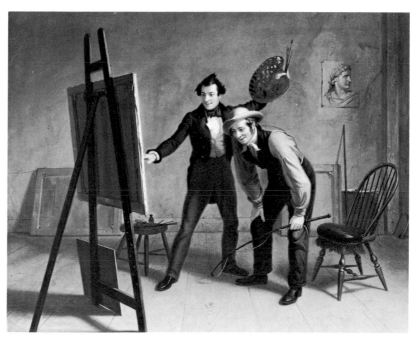

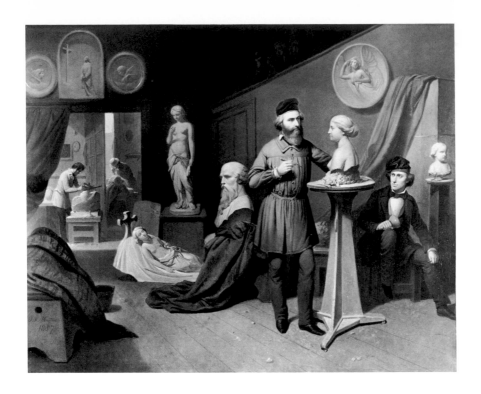

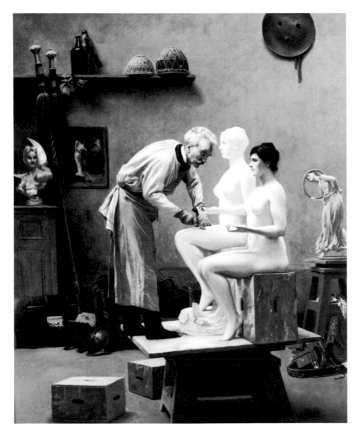

Figure 64 (Above). Tompkins H. Matteson, *Erastus Dow Palmer in His Studio*, 1857.

Figure 65 (Left). J.-L. Gérôme, *The Artist and His Model*, ca. 1890.

Figure 66 (Above, right). L. M. Cochereau, *The Studio of David*, 1814.

Figure 67 (Right). Alice Barber, *Female Life Class*, 1879.

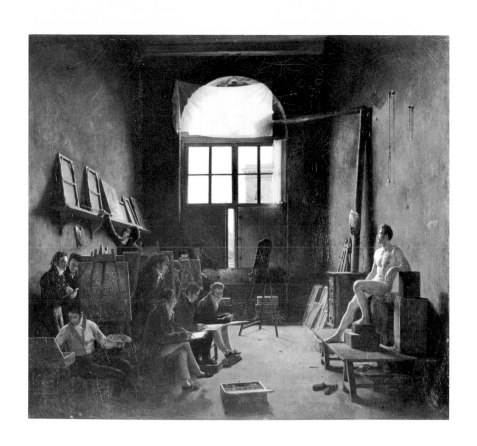

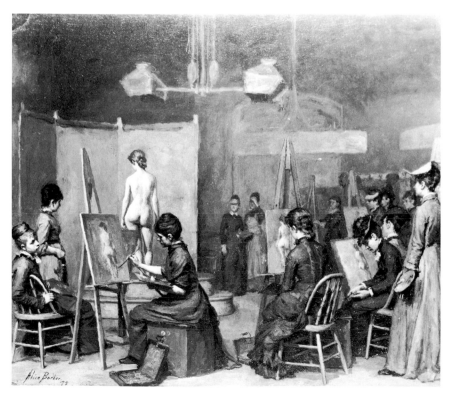

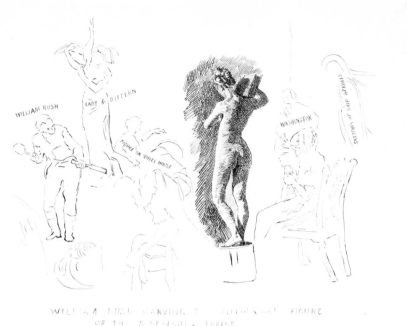

WILLIAM RUSH

LADY & BITTERN

FIGURE ON WHEEL HOUSE

WASHINGTON

SKETCHES OF SHIP SCROLLS

WILLIAM RUSH CARVING THE ALLEGORICAL FIGURE
OF THE SCHUYLKILL. EAKINS.

Figure 68. Thomas Eakins, *Pen and Ink Drawing after William Rush Carving His Allegorical Figure of the Schuylkill River*, 1881.

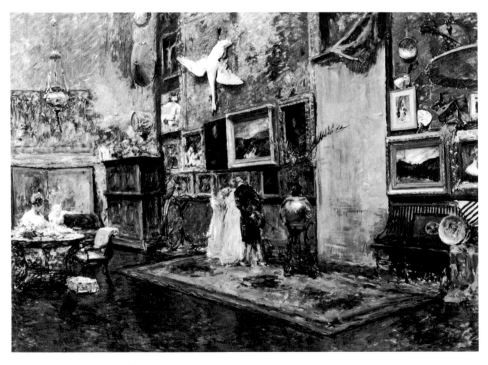

Figure 69. William Merritt Chase, *The Tenth Street Studio*, ca. 1905-1906.

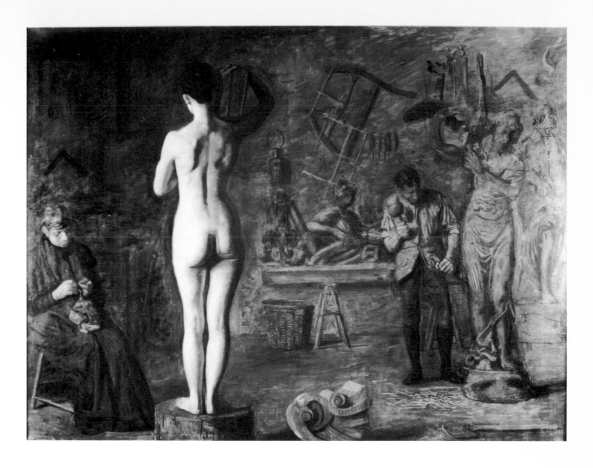

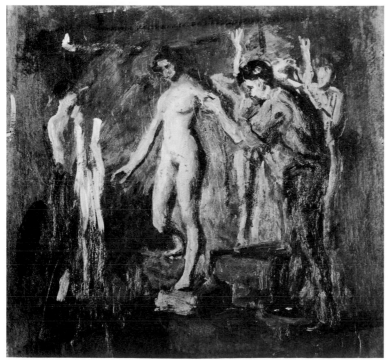

Figure 70. Thomas Eakins, *William Rush Carving His Allegorical Figure of the Schuylkill River*, 1908.

Figure 71. Thomas Eakins, *Sketch for William Rush and His Model*, ca. 1908.

model herself, made studies of her on canvas, and then, as he credited his sculptor-predecessor with having done, he completed the final work directly from the model.

Eakins had not immersed himself in Rush's world in order to paint an incident from history. For the focus of the painting, Rush's work on his sculpture from the nude model, was not literal truth. Indeed, Eakins enabled the viewer to see this discrepancy for himself by facing the nude model with the draped fountain figure. But to say that the work was not historical is not to say that it was not true in a profound sense. It was not new for Eakins to move beyond historical incident: he had painted Dr. Gross in a symbolic operation, performing surgery that represented the highest ideals of his career as surgeon and of the progress of surgery over the century. He painted Rush sculpting from the nude model to pay tribute to the highest ideals of sculpture and of painting, and, not incidentally, of his own painting in particular.

And for such a painting, Eakins drew his conventions from the repertory of the "studio" painting, a subject artists had long since used to set forth important aspects of their practice. A brief review of the tradition of this subject—often called the "artist in his studio"—shows Eakins' bold adaptation of its possibilities.

First explored in breadth in the seventeenth century, the theme of the artist's studio admitted many variations: studios with a general clutter to identify them as a place of hard work; studios full of casts, engravings, completed works, and perhaps work in progress, which identified the tradition in which the artist was working; and scenes of the artist and his model showing the artist's reliance on "nature." Other variations included the self-portrait of the artist in his studio, often with the canvas hidden from view to heighten the mystery of creativity; scenes of relaxation in the studio, with the artist's friends participating in general merrymaking; and scenes of the visit of a patron to the studio, with the artist, perhaps in formal dress, surrounded by representative works of his career. Whatever the specific focus, the general theme of the studio painting served the artist as self-definition: of his working methods, his heritage, his colleagues, his social status, and his patronage.

lists twenty-six studies for the painting but identifies many as "unlisted" and/or "unlocated." According to Theodor Siegl, *The Thomas Eakins Collection* (Philadelphia: Philadelphia Museum of Art, 1978), p. 102, Benjamin Eakins posed for Rush early in Eakins' study process.

Painters turned anew to this theme in the nineteenth century, amidst the radical changes in social and artistic ideals. Some artists focused on the poverty-stricken nature of the artistic life: Octave Tassaert, for example, specialized in that aspect of it, drawing on his own experience. Some focused on friends and visitors whose presence in their studio had an ideological significance like Henri Fantin-Latour in his *Homage to Delacroix* (1865, Louvre) and *Studio in the Batignolles Quarter* (1870, Louvre). Others pictured the studios or working areas of their friends as did Edgar Degas in his *Portrait of James Tissot* (1866, Metropolitan Museum of Art), and Edouard Manet, in an important variation of the type, *Portrait of Zola* (1868, Louvre). Students often submitted to the Salon exhibitions paintings of their teachers in their studios.[14]

Although many of the paintings that are well known today had a limited focus, the subject encouraged artists virtually to inventory the contents of their studio—and many did, showing drawings on the wall, works in progress, casts that served as training for their drawing skills, perhaps a model posing for a work underway, and even visitors. The best known today of such inclusive mid-century paintings is Gustave Courbet's *The Artist's Studio: A Real Allegory Summing Up Seven Years of My Life as an Artist* (Figure 59). Picturing himself seated before a canvas in the middle foreground of the painting, with a nude model nearby and his studio full of people, Courbet set forth an allegory of his artistic subjects, his working methods, and his audience—making it clear that he worked from "nature" and not from the traditional academic nude, took as his models people closest to nature, and was supported by writers and critics who shared his commitment to making art from direct experience.

Out of the general theme of the artist in his studio, pursued vigorously as a definition of artistic creed, artists developed a variation that bore directly on Eakins' painting of Rush: the theme of the Old Master in his studio. They were inspired by the nineteenth-century historicism felt in all areas of endeavor, which in the arts led to a new interest in the lives of the old masters and a rash of biographies of old masters in the popular literature. In this historical spirit, artists painted scenes focusing on an old master engaged in a famous encounter with a patron or rival, creating a famous work, or simply musing in his studio, with one or more of his noted works in the

[14] This is apparent from the catalogues of the Salon exhibitions; for instance Edouard Detaille, *Un coin de l'atelier de M. Meissonier*, Salon of 1867 (No. 483); and Otto Dorr, *Interieur de l'atelier de M. Bonnat*, Salon of 1868 (No. 819).

background providing a quick identification of the master. Like its more general type, the theme of the Old Master in his studio gave artists the opportunity to express in historical disguise their own ideals of practice or hopes for patronage; in an era when allegiances to past styles could be changed quickly, it was an excellent theme by which to pay honor to the artistic heritage with which artists identified their own work.

Early in the century, when neoclassicism was an artistic ideal, Raphael and Poussin were popular subjects, and J.-A.D. Ingres probed the relationship between the artist, his model, and the work of art while paying tribute to Raphael. Eugene Delacroix, somewhat later, fascinated by the complexities of Michelangelo's career and by the analogy of his own theories and difficulties to those of the master, painted Michelangelo pondering in his studio, his *Moses* and the *Medici Virgin and Child* in the background (Figure 60). In the 1830s and 1840s, artists rediscovered the Dutch painters and created a wide range of tributes to Rembrandt and masters of Dutch landscape and still life. Some years later, French painters turned to the Spanish baroque masters. In 1860 Manet, for example, interested in the newly popular Velázquez's palette, technique, and royal patronage, painted the artist at his easel surrounded by courtiers. Although the focus of historicism in artistic taste shifted over the century—and reflected such phenomena as the mid-century rediscovery of artists of the Quattrocento—artists generally paid tribute with the Old Master theme to already established great artists rather than to newly discovered masters like Botticelli whose long forgotten work had just been added to the historical canon.

During the years of Eakins' studies the subject continued to engage artists' attention—both in its general type as the artist in his studio and in its historicizing variation of the Old Master in his studio. It was prominent at the Salons from 1866 to 1869 and at the Universal Exposition of 1867.[15] When Eakins visited the Prado in December, 1869, he saw Velázquez's two brilliant contributions to the theme: Velásquez's portrait of himself painting in the king's apartments (Figure 15), and his portrait of the earlier, distinguished sculptor *Martinez Montañés* (Figure 14) at work modeling the head of

[15] A survey of a few of the lesser known of these works shows their range: Victor Regnault, *Zurburan peignant le moine en prière* (Salon of 1868, No. 1272); Adolph Aze, *Masaccio, peintre florentin de XVᵉ siècle* (Salon of 1868, No. 83); P. Kremer (of Antwerp), *Daniel Seghers, celebrated flower painter, weaving a garland which he intends to paint* (Exposition Universelle, No. 68); J. Ballantyne (English), *Daniel Maclise, R.A., at work on his fresco of the Death of Nelson in the House of Lords* (Exposition Universelle, No. 4).

Philip IV. Eakins' own teacher, Gérôme, painted at least two works on the Old Master variation: *Raphael showing Bramante the Sistine Ceiling* (1880, now lost) and *Rembrandt Etching a Plate* (Figure 61), the latter of which was exhibited at the Universal Exposition in 1867 and also engraved.

In Philadelphia, both American and European examples were popular at exhibitions from the late 1850s into the 1870s.[16] Two of the most conspicuous examples of the subject by Americans, in fact, were in permanent collections in Philadelphia: one was Charles Willson Peale's *The Artist in His Museum* (part of the Joseph Harrison, Jr. collection until 1878, when it entered the collection of the Pennsylvania Academy of the Fine Arts collection; Figure 62), showing the early Philadelphia artist proudly alluding to his working methods (as an artist and as a naturalist), his extensive portrait gallery (all the portraits painted by himself or his sons), and his service to and patronage by the community in the form of his museum and its interested audience. Another prominent studio painting in Philadelphia—again a self-portrait—was William Sidney Mount's *The Painter's Triumph* (Figure 63), long a part of the Henry C. Carey collection, which showed, although good-naturedly, the dependence of the painter on the approval of his fellow citizens.

The paintings by Peale and Mount were both studio subjects, of course, rather than tributes to Old Masters (unless one finds a certain delightful irony in Peale's work). American artists, in fact, chose almost without ex-

[16] See exhibition catalogues of the Pennsylvania Academy of the Fine Arts, then from 1870 (when the academy had no permanent building while its new structure was under construction), catalogues of the Union League Art Receptions. Some of the paintings with this subject were exhibited by the Harrison Earle Gallery, others from private collections like that of Samuel B. Fales. Whereas there is no published study of the specifically American interest in this motif, exhibition catalogues from mid- to late-century show it to have been popular, and the Inventory of American Painting (Smithsonian Institution) lists a number of extant paintings on the theme. The American artist Edwin White painted several scenes of European Old Masters (his *Leonardo da Vinci and His Pupils*, 1867, is in the collection of Mount Holyoke).

Thomas Moran, a Philadelphia artist, painted *Salvator Rosa Sketching the Banditti*, 1860 (art market). The Carey Collection had in the 1870s George P. A. Healy's *Titian's Model—from the Painting in the Louvre* (now unlocated). At least two paintings on the theme featured nude female models: Henry Bebie (1824-1888), a Baltimore painter, painted *Van Dyck in His Studio* (illustrated in *American History* 24, no. 3, 1973) and John Henry Dolph (1835-1903), *Studio in the Time of Louis XVI* (Dartmouth College). But the only scene of an American Old Master—before Eakins' tribute to Rush—seems to be that by the German emigrant to Philadelphia Charles Schmolze, who in 1852 painted *George Washington sitting to Gilbert Stuart* (Pennsylvania Academy of the Fine Arts).

ception to focus on the present in their use of this convention: they painted studio scenes of themselves and their friends that emphasized their modernity. In 1852 Tompkins Matteson, for instance, painted an earnest tribute to the highly successful marble sculptor Erastus Dow Palmer (Figure 64), showing the dignified artist in his studio amidst his assistants and the full range of his works, all of which show his support by patrons. John Ferguson Weir painted his father, Robert F. Weir, in 1864 (Ganz Collection), seated in a studio full of the props, casts, engravings, and works in progress that identified the learned tradition the elder Weir worked in as a painter. In 1857 Daniel Huntington painted Asher B. Durand in his own modern studio—he is seated outdoors in a magnificent landscape, which he records on the easel before him (*Asher Brown Durand*, The Century Association, New York). And by 1860 many Philadelphia artists posed for photographs that served as studio portraits, seated before an easel on which rested a representative painting.[17] In their new nationalism, in their anxiety to be independent of the past, American artists—most of them, that is—considered that art in America had begun with their generation—in the 1830s and 1840s with the rise of neoclassical sculpture, genre painting, and landscape.

Even in Philadelphia, almost alone, Eakins looked to the past. Centennial fervor encouraged retrospection and national pride, and in Eakins' opinion, William Rush deserved patriotic restitution. For despite the fact that the city had had Rush's water nymph cast in bronze in 1872, no celebration of Rush's work as a sculptor had initiated, accompanied, or followed the action. In fact, the city undertook to preserve the decaying wooden figure because it was a "relic" of the old waterworks.[18]

Indeed, in 1875, when Eakins began his painting, virtually no Philadelphian would have identified William Rush as an Old Master. Part of the reason was the simple lapse of time. That year Eakins' friend Earl Shinn noted the effect that his fellow Philadelphians' absorption in the present had on their knowledge of their artistic past. In his book *A Century After: Glimpses*

[17] Several examples of this genre are in the collection of the Library Company of Philadelphia and are illustrated in Kenneth Finkel, *Nineteenth-Century Photography in Philadelphia* (New York: Dover Publications, 1980), figures 28, 31-33.

[18] *Journal of the Select Council of the City of Philadelphia*, Appendix No. 13: "Annual Report of the Chief Engineer of The Water Department for the Year 1872," Philadelphia 1873, p. 22, cited by Bantel in Pennsylvania Academy of the Fine Arts, *Rush*, p. 117. So inconspicuous a position did Rush's nymph have in public awareness that the Fairmount Park Art Association was formed in 1872 to remedy the complete "deficiency" of sculpture in the park.

of Philadelphia, Shinn commented that although the city had "a right to be proud of her record in art," few citizens knew anything of Philadelphia artists before James Hamilton, William Trost Richards, and Peter Rothermel—all painters (two of them landscapists), and all artists currently active.[19] In part to correct that lapse of community memory, three years earlier Shinn had written the long article for Philadelphia's *Lippincott's Magazine* on the history of the Pennsylvania Academy of the Fine Arts. Philadelphians were not necessarily unappreciative of their artists who were working in the older ways; in fact, in 1868 in its first volume *Lippincott's Magazine* had published a long appreciation of the just-deceased Philadelphia portraitist John Neagle.[20] But modern concerns eclipsed the past quickly.

And in the case of Rush, a number of other factors contributed to his decline. The first was that even by 1860, Rush's wooden figureheads and scrolls had fallen into decay and rotted away, so that examples of the woodcarving that he had created in a career of more than fifty years were simply no longer to be seen. Further, after 1830 the building of transoceanic vessels had shifted away from Philadelphia; few reminders of either the old craft or their successors stirred citizens' recollections.[21] Third, several of Rush's public and architectural sculptures were no longer in place: the crucifixes had been burned in the anti-Catholic riots of 1844, the *Agriculture* and *Commerce* on the Market Street Bridge had just been destroyed in a fire in 1875, the theater sculptures had been removed to a private institution (the Edwin Forrest Home for actors) after the building was destroyed in 1855; even the fountain with the *Water Nymph and Bittern* had been moved from its location in the center of the city to a point on its periphery. The most powerful cause of the demise of Rush's reputation, however, was Americans' sense of the "progress" of sculpture in America in the nineteenth century. By 1875 they confidently assumed the history of their nation's sculpture to have begun with American sculptors' earliest work in marble.

That assessment of sculpture had not always prevailed. During his lifetime Rush had been warmly supported by his fellow citizens. But as the history of American art was written over the several decades from 1830 to 1875,

[19] Earl Shinn, *A Century After: Picturesque Glimpses of Philadelphia and Pennsylvania* (Philadelphia: Allen, Lane & Scott & J. W. Lauderbach, 1875), in the chapter "Arts and Sciences," p. 4.

[20] Thomas Fitzgerald, "John Neagle, the Artist," *Lippincott's Magazine* 1, no. 5 (May 1868), 477-491.

[21] See Marion V. Brewington, "Maritime Philadelphia 1609-1837," *Pennsylvania Magazine of History and Biography* 63, no. 2 (1939), 93-117 for an early review of Philadelphia maritime history.

Rush, in his earliest work a mere figurehead carver and throughout his career a worker in wood, slowly lost his place in it.

It was a telling of history that Eakins challenged.

Rush's early recognition had been of two kinds, each notably partisan. In 1830 historian-compiler John Watson gave Rush enthusiastic notice in his *Annals of Philadelphia* in his identity as shipcarver: "Few citizens of Philadelphia are more deserving of commendation for their excellence in their profession than this gentleman, as a shipcarver."[22] Associating Rush with Philadelphia's prominence in shipbuilding, Watson did not describe him as a sculptor and indeed noted virtually no other of Rush's achievements beyond shipcarving. Four years later, the New York artist and historian William Dunlap reversed this emphasis. Discussing Rush in his *History of the Arts of Design in the U.S.*, Dunlap gave play to his own bias as a patriotic historian of American art.[23] Conscious of European standards against which American achievement could be measured, Dunlap ignored Rush's place in the context of the local color and civic pride in Philadelphia that had interested Watson and limited his discussion to Rush's figures and modeled busts. Dunlap deferred even the mention of Rush's work as a shipcarver until more than halfway through his biographical notice. Attributing to Rush working habits eminently respectable by European and academic standards—a neoplatonic attitude toward form within the block and a close observation of the human figure—Dunlap told his readers that Rush encouraged his students to carve hands using their own as models.

These partisan analyses marked Rush's first appearances in surveys of American culture and art. They also marked his last, for some time. Dunlap's apologetic comment, "[Rush's] time would never permit, or he would have attempted marble," identifies the reason.

After Dunlap, historians did not admit that there had been any sculpture created by an American before 1830. They took the position of the dour

[22] Watson, *Annals of Philadelphia*, 1845, vol. 1, p. 575. Although Watson's *Annals* were enlarged and revised in 1845, 1857, and 1879, no substantive changes were made in the notice of Rush until the revision of 1879. In 1887 Watson's successor Willis P. Hazard enlarged the *Annals* to three volumes.

[23] William Dunlap, *History of the Rise and Progress of the Arts of Design in the United States* (New York: George P. Scott and Company, 1834; rpt. Dover, 1969), vol. 1, pp. 315-316. Actually, as William Gerdts has pointed out in his essay "William Rush: Sculptural Genius or Inspired Artisan?" in Pennsylvania Academy of the Fine Arts, *Rush*, p. 198, note 18, Dunlap was relying on correspondence from Rush's son, who by 1833 would have been very much aware that his father's medium was old-fashioned.

John Neal who, after spending a great deal of time in Philadelphia in the mid-teens, wrote an assessment of American sculpture in 1823 that matched the acid contempt of Sydney Smith for early American surgery: "No—we have no 'dramatists'—no 'architects'—no 'sculptors' in America . . . we have not even a pretender to sculpture."[24]

Americans like Horatio Greenough and Hiram Powers who had begun to go to Italy in the 1820s and 1830s to study carving in marble seemed to historians to have founded the very practice of sculpture in America. In 1854, although Hannah Lee drew on Dunlap for the American section of her *Familiar Sketches of Sculpture and Sculptors*, she omitted Rush and began her survey with stonecarvers John Frazee (1790-1852) and Horatio Greenough.[25] Subsequent writers followed suit: in 1861, the New York landscape painter and academician T. Addison Richards wrote that "of our native sculptors, perhaps the first who gave indications of talent above the humblest mediocrity, was John Frazee."[26] James Jackson Jarves pronounced in 1864 that "such sculpture as we possess is the work of the present generation,"[27] and Henry Tuckerman, in 1867—while he did mention Rush—paid the bulk of his attention to the careers of America's first stonecarvers.[28] As the Centennial approached, books appeared surveying various aspects of America's history and progress, and of the few that even included a section on the country's artistic history, the names of Greenough, Powers, Crawford, and others—all workers in marble—were those identified as "names of which any country might be proud."[29]

For Eakins, however, the name of William Rush was also one of which a country, a city, and an artist successor might be proud. As Susan Eakins was to write later, her husband took it as his mission to "call attention to"

[24] John Neal in vol. 2, pp. 202-203 of *Randolph*; quoted in Harold E. Dickson, ed., *Observations on American Art: Selections from the Writings of John Neal* (State College, Pa.: Pennsylvania State College, 1943), pp. 24-25.

[25] Hannah Lee, *Familiar Sketches of Sculpture and Sculptors*, 2 vols. (Boston: Crosby, Nichols, & Co., 1854). John Frazee had begun his career carving tombstones, but in 1824 began to make marble portrait busts.

[26] T. Addison Richards, "Arts of Design," in *The First Eighty Years of National Existence*, reprinted in *First Century of National Existence* (Hartford: L. Stebbins, 1872), p. 326.

[27] James Jackson Jarves, *The Art-Idea* (New York: Hurd and Houghton, 1864), p. 209.

[28] Henry T. Tuckerman, *Book of the Artists* (New York: G. P. Putnam & Sons, 1867), p. 572.

[29] These include S. S. Conant, "Progress of the Fine Arts," in *The First Century of the Republic: A Review of American Progress* (New York: Harper and Bros., 1876), p. 413; and, source of the quotation, *Our Country Past and Prospective* (Hartford: L. Stebbins, 1878), p. 222.

the "intelligent and refined work" of "the old sculptor," whose "attitude in art he greatly respected."[30] Attentive to the beauty in his own city and willing to act as gadfly to his fellow citizens, Eakins set about to resurrect Rush's reputation. His format was one with which countless contemporaries and earlier nineteenth-century artists in Europe, including his teacher Gérôme, had honored their artistic heritage. Unlike his European counterparts, however, Eakins painted an Old Master who was in virtually no one's canon but his own.

Neither guided nor restricted by popular biographies of Rush, Eakins cut his central focus in the painting from the whole cloth. Although he could be credited with having translated quite literally Dunlap's comment that Rush worked from nature, his painting was, on a higher level, a symbolic recreation that would direct the attention of Philadelphians to their artistic past, anchor the figural tradition—that of working from the nude model—of the Pennsylvania Academy of the Fine Arts to a time near the origins of the academy, and embody Eakins' own artistic principles. Like history-conscious rowers, like historically sensitive surgeons, Eakins wanted to reach back to a time before his own, to root his "modernity" in what had gone before.

Drawing on the conventions of the studio and Old Master themes, Eakins directed his audience's attention to his convictions quite clearly.

In the first place, Rush's studio is a place of work. The littered floor, the layers of sketches on the wall, the ship's scroll in progress—all indicate that Rush's studio is not a neat showroom to impress a potential patron but a private place of diligent, searching activity. Indeed no patrons invade his privacy; no furniture is set in a corner for conversation. And appropriately, Rush is at work—like Velázquez, like Montañés in Velázquez's tribute to him at work, and like Rembrandt in Gérôme's painting, Rush is intently absorbed in the work underway.

Although no patrons or sociable visitors crowd the workshop, there is, of course, one person in the studio in addition to the sculptor and his model: the knitting woman. In the study process Eakins changed her position to reflect her importance as an onlooker: from a position in which she has her back to the model to one in which, as witness, she seems to be a full participant. Eakins' reviewers and friends identified the knitting woman as the model's mother. Although Louisa Vanuxem's mother had in fact died sud-

[30] Susan Eakins to Will Sartain, September 15, 1917, and letter dated "Friday night, 9:15 p.m." (Sartain collection, Historical Society of Pennsylvania).

denly in the summer of 1808, the year before Rush worked on the fountain, the presence in the workshop of an older woman, whether relative or family servant, associates the scene with Eakins' own attitudes toward models—and with those of his future academy constituency. He was to tell the Committee on Instruction in 1877, soon after he began to teach life classes, that even though "professional models" needed no recommendation (and therefore were easy to obtain), the best models for the academy students were amateurs; and the participation of these models in the artistic enterprise warranted the full approval of their mother or other female relative—even their presence in the modeling session. Miss Vanuxem's companion thus establishes both the quality of Rush's model and the family's approval of the project.[31] She represents the third party in the artist's work: the supportive community of family, friends, and viewers and ultimately, of course—because of Miss Vanuxem's father's role in the commission—of patrons.

And in this context of community support for his work, Rush's dress is significant. In contrast to the disarray in his workshop, Rush's dress is elegant, not literally appropriate to the messy aspect of his studio in general or the carving that is underway. His dress, too, was an aspect of the composition that Eakins changed during the study process. At first, he depicted Rush wearing craftsman's clothing. On second thought, he modeled Rush's dress after a more formal costume in the painting of 1812 by Krimmel. With that change, he gave the painting a specific tie to a well-known local painting that featured the very work on which Rush was carving. More important, with gentlemanly dress and a graceful bearing Eakins linked Rush to the aristocratic tradition of Velázquez in his studio paintings at the Prado. Eakins created a sculptor who was no mere ships' figurehead carver, but in his very workshop identity an important citizen.

The period clothing for the model and the knitting woman root the painting in a local past from which it could speak so eloquently to the present.

[31] A chaperone figure occasionally appears in earlier versions of the studio theme by other artists: in, for example, the gouache by P. A. Baudouin, *La Modèle Honnête*, 1769 in the Ian Woodner Collection, New York (reproduced in William H. Schab Gallery, Inc., New York, "Master Prints and Drawings 15th-20th Centuries," 1972, p. 74). In the the nineteenth-century Robert-Fleury's lithograph *Atelier de Rembrandt* (lith. Eugene de Roux, collection Bibliothèque Nationale) shows a draped model accompanied by an older woman. With such a cast of characters the potential exists for innuendo, and it is exploited by Felix de Vigne in *The Sleeping Chaperone*, 1830 (Musée Moderne, Musées Royaux des Beaux-Arts, Brussels). In Philadelphia, however, "professional models" were prostitutes, who modeled without family supervision, and Eakins deliberately undercut erotic associations in his tribute to Rush by including the older woman as chaperone.

In addition, the cast-off clothes of the model give the scene a vivid immedi-acy, emphasizing the model's nudity. The brilliant red, white, and blue fabrics contribute a patriotic touch. And the technical brilliance with which Eakins painted the fabrics and laces permitted him to avow his own skill as painter: in this scene of figure, atmosphere, and "stuffs," Eakins proved his range to be as broad as that of Rush as sculptor in the varied evidence in his workshop.

The several works of Rush in the studio show the accomplishments of his career that, once called to their attention, Philadelphians would have recog-nized. Eakins paid no attention to chronology in including them: in the back-ground are the *George Washington*, carved in 1814, and the *Allegory of the Waterworks*, carved in 1825—both works done considerably after the *Water Nymph and Bittern*. The foreground scrolls, while not attributable to specific works, are typical of Rush's ornamental shipcarving. All of the other works are "public sculpture" and thus show Rush's patronage by the community—by the ancestors of Eakins' audience. The evolution of sculptures in Rush's workshop shows the parallels between Eakins' and Rush's careers: just as Rush had moved beyond shipcarving into the more demanding realm of sculpture, so Eakins had moved on after several years of writing and teaching ornamental script to become a professional artist.

With the crux of the picture—Rush's work on the fountain sculpture—Eakins celebrated the artistic principle that undergirded all else.

The fountain sculpture itself had been Rush's most prominently displayed commission: designed for the very center of the city, where it was comple-mented by an elaborate park, even in its more remote location after 1825 in Fairmount Park it continued to provide viewers with refreshing beauty. After 1872, the bronze replica gave the image renewed life and two installations graced Fairmount. Further, the figure had an allegorical reference inspired specifically by Philadelphia, unlike Rush's more generally allegorical figures.

But most important, the figure of the nymph gave Eakins the opportunity to show Rush engaged in a process basic to the academic tradition that he had helped to establish in Philadelphia. At first, of course, that academic tradition had existed mainly as potential. The founding artists in 1805 and others who joined the group over the next few years had to struggle to bring into actuality at the academy facilities for modeling from the nude, for ana-tomical study, even for dependable annual exhibitions—advantages long standard in European academies. By the time of Eakins' study at the acad-emy in the early 1860s these advantages were an actual, although not always

regular, part of the curriculum; and during his tenure in the late 1870s and through the 1880s to 1886 as instructor at the academy, Eakins insured that they were fundamental to the program.

That Eakins depicted Rush modeling the "Water Nymph" from the nude figures was audacious. It was bold from the point of view of conditions in Philadelphia in 1876 and bold from the point of view of conditions in Philadelphia in 1809. For it was not in the least likely that Rush modeled any of his figures from the nude: the practice had not yet been established in the city. In 1809, in fact, Rush and his fellow artists were still struggling even to establish the first life classes in drawing, and it was a goal they were not to realize for several years.[32] One can imagine the shock the Rush and Vanuxem descendants felt in 1881 when they saw Eakins' license with "history."[33] It was necessary for him to be so bold, however, to establish the fundamental principle of his painting—which was not literal history. He found in Rush's work a respect for and knowledge of the human body; it was the academic tradition that nourished and guarded these principles. Thus in his painting Rush's model is nude, and she holds a highly typical academic pose. Eakins proceeded with much the same reasoning in painting Dr. Gross at work; he chose an operation that best set forth Gross's—and his fellow surgeons'—essential creed. To demonstrate his meaning in that painting he showed quite clearly the incision in the patient's leg and the blood on the sheets, Dr. Gross's scalpel, and his hands. Shocking or not, in the painting of William Rush, the nude was essential.

Courageous in Philadelphia as was Eakins' transcendence of literal history with symbol, in the context of European studio paintings it was also unusual, but for different reasons. Eakins' teacher Gérôme later painted a number of scenes of the nude model and sculptor. Some were self-portraits; one a Pygmalion and Galatea (Figure 65, Gérôme's *The Artist and His Model* combines

[32] Except for C. W. Peale's aborted attempt to hold a life-class in 1795, the first life-classes in Philadelphia were held in 1813. Over the next several decades, they were held only irregularly.

[33] That is the year the painting was first exhibited in Philadelphia (see below). As far as I know, there are no written accounts of reactions to Eakins' painting beyond those of the critical reviewers (for which, see Note 43). Eakins did pay a wry tribute to one tradition about Rush's model (that of her long years of turning down suitors) with his painting *Courtship* (Fine Arts Museums of San Francisco), which he did right after he finished the *William Rush Carving His Allegorical Figure*. Nannie Williams, Eakins' model for the much-wooed Miss Vanuxem, also posed for the young lady in *Courtship*, and wore the costume draped on the chair in the earlier painting.

the ideas: the painting *Pygmalion and Galatea* hangs on the studio wall). However, most of the European tributes to Old Masters in the 1850s and 1860s focused on an aspect of their work that did not involve nudity: a Renaissance artist painting the Virgin, for instance, or a seventeenth-century Dutch landscapist outside with his sketch book—the former a conservative image but the latter an aspect of the history of art that had a new importance to artists in the 1850s and 1860s. Contemporary studio paintings also tended to show motifs fundamental to artists' "modernity": Japanese prints on the wall, copies of Spanish works, or important friends gathered in the studio. Of course the antiquity of the academic tradition of studying from the nude was not an issue in mid-nineteenth-century France, where the academy had been established in 1648, or in England, where the Royal Academy had been established in 1768. And as European painters of the 1860s and 1870s turned to "modern" life for their subjects—to the outdoors and to urban scenes—they did not want to assert an identity with an academic tradition, one that would tie them to the past. Indeed, many explicitly rejected it. Courbet, for example, did just that with his *Studio* painting (Figure 59): the nude (she is even decidedly unacademic in form) stands to one side as Courbet paints a "modern" landscape. Eakins, on the other hand, did want to assert an identity with an academic tradition—for himself, for Philadelphia, and for Rush. For Eakins, one could never surpass the modernity of the human form.

Thus, in one sense, Eakins' focus on the nude model finds its proper context in studio pictures from earlier times—in the company, for example, of Johann Zoffany's *The Academicians of the Royal Academy*, of 1770-1771 (The Queen's Collection, Buckingham Palace), which shows the academicians, including the first president, Sir Joshua Reynolds, and Zoffany himself, in their newly established academy engaged in the proper academic study of the nude. Another appropriate comparison is the painting by Léon Mathieu Cochereau in 1814 of his teacher Jacques Louis David's studio (Figure 66), which shows that David's students drew directly from the model and not from casts—a principle that David put forth vigorously.[34] And Eakins himself, a little more than a year after he finished his painting of Rush, had his students illustrate an article in *Scribner's Monthly* about art training in Philadelphia with scenes of the life class at the academy: one student painted the

[34] A much earlier example is Michael Sweerts, *Pupils Drawing from a Nude Model*, c. 1660 (Franz Hals Museum, Haarlem), showing young students beginning their instruction properly, by drawing from the nude. All three instances, however—the Zoffany, Cochereau, and Sweerts—feature a male model.

women's class painting directly from the nude model (Figure 67), another showed the men's class painting directly from the nude (Pennsylvania Academy of the Fine Arts).[35]

After Eakins finished the painting of Rush, he wrote on cardboard a statement calling attention to Rush as a historical figure which was to be exhibited with the painting.[36] He did not allude to the nudity of the model. Instead, he set forth a brief biography of Rush and a notice of several of his achievements, and he specified the iconography of the water nymph.

The work had come to be called—when referred to at all—"Leda and the Swan." Early in its years at Centre Square the sculpture was known as the "Nymph."[37] But gradually people began carelessly to refer to the delicately proportioned bittern as a swan, especially after increasing traffic on the Schuylkill River drove the bittern away, and then they associated the swan with Leda, so that even Eakins' art critic friend Shinn wrote of the sculpture in 1875 as "Leda and the Swan."[38] But Eakins had studied the work closely, and to correct the inaccuracy of a title inappropriate to Philadelphia's physical as well as her artistic legacy Eakins named the work Rush's "Allegorical Figure of the Schuylkill River."

Eakins' statement about Rush—direct, precise, and sensitively written—provided the fullest explication of Rush's work yet written:

William Rush was a celebrated Sculptor and Ship Carver of Philadelphia. His works were finished in wood, and consisted of figure heads and scrolls for vessels, ornamental statues and tobacco signs called Pompeys. When after the Revolution, American ships began to go to London, crowds visited the wharves there to see the works of this Sculptor.

[35] William C. Brownell, "The Art Schools of Philadelphia," *Scribner's Monthly* 18, no. 5 (September 1879), 737-750.

[36] Lloyd Goodrich, *Thomas Eakins*, 2 vols. (Cambridge, Mass.: Harvard University Press, 1982), I, note on p. 324.

[37] *Poulson's American Daily Advertiser*, August 28, 1809, and *Port Folio*, series 3, 8 (July 1812), p. 30.

[38] *The Stranger's Guide to . . . the City of Philadelphia* (Philadelphia: George S. Appleton, 1845), p. 26, refers to the figure as "a fine statue of a woman holding a swan, from whose mouth issues a beautiful jet of water." Ritter, *Philadelphia and Her Merchants*, in 1860, p. 104, calls it a "female figure with her spouting swan." Thompson Westcott, *Philadelphia Illustrated* (Philadelphia: Porter and Coates, 1877), p. 74, mentions the "Leda-and-the-Swan fountain, wooden figures, by Rush, on the rocks of the forebay, and the same figures in bronze." Finally, Shinn, in "America's First Art Academy," p. 151, and in *A Century After*, p. 26, refers to the work as "Leda and the Swan."

When Philadelphia established its Water-works to supply Schuylkill water to the inhabitants, William Rush then a member of the water committee of Councils, was asked to carve a suitable statue to commemorate the inauguration of the system. He made a female figure of wood to adorn Centre Square at Broad Street and Market, the site of the water works, the Schuylkill water coming to that place through wooden logs. The figure was afterwards removed to the forebay at Fairmount where it still stands. Some years ago a bronze copy was made and placed in old Fairmount near the Callowhill Street bridge. This copy enables the present generation to see the elegance and beauty of the statue, for the original wooden statue had been painted and sanded each year to preserve it. The bronze founders burned and removed the accumulation of paint before moulding. This done, and the bronze successfully poured, the original was again painted and restored to the forebay.

Rush chose for his model, the daughter of his friend and colleague in the water committee, Mr. James Vanuxem an esteemed merchant.

The statue is an allegorical representation of the Schuylkill River. The woman holds aloft a bittern, a bird loving and much frequenting the quiet dark wooded river of those days. A withe of willow encircles her head, and willow binds her waist, and the wavelets of the wind sheltered stream are shown in the delicate thin drapery much after the manner of the French artists of that day whose influence was powerful in America. The idle and unobserving have called this statue Leda and the Swan and it is now generally so miscalled.

The shop of William Rush was on Front Street just below Callowhill and I found several very old people who still remembered it and described it. The scrolls and the drawings on the wall are from sketches in an original sketch book of William Rush preserved by an apprentice and left to another ship carver.

The figure of Washington seen in the background is in Independence Hall. Rush was a personal friend of Washington, and served in the Revolution.

Another figure of Rush's in the background now adorns the wheel house at Fairmount. It also is allegorical. A female figure seated on a piece of machinery turns with her hand a water wheel, and a pipe behind her pours water into a Greek vase.

Thomas Eakins

105

(A paper written by Thomas Eakins after he finished his picture called "William Rush carving his allegorical figure of the Schuylkill River")[39]

Whether the document was in fact exhibited with the painting, or whether Eakins hoped to be able to publish the text in full, is not known. Eakins did draw catalogue text from it, however, to inform his audience. And in his choice of that audience Eakins was as purposeful as he had been in composing his text. First, in 1878, he sent the painting to the exhibition in January of the Boston Art Club. Then he exhibited it in New York, at the First Annual Exhibition of the newly formed Society of American Artists. There he had to condense his text for the catalogue to a few brief words: "William Rush, ship carver, was called on to make a statue for a fountain at Central Square, on the completion of the first Water Works of Philadelphia. A celebrated belle consented to pose for him, and the wooden statue he made, now stands in Fairmount Park, one of the earliest and best of American statues."[40]

From New York the painting went to Brooklyn, to be seen in the April 1878 exhibition of the Brooklyn Art Association. At the earliest appropriate time, Eakins exhibited the painting on his home ground. That was in 1881, when the painting was seen at the Pennsylvania Academy of the Fine Arts in a large exhibition devoted to works by American artists working in Europe as well as in America. In Philadelphia, Eakins was able to run a long entry about Rush in the catalogue and to include an outline engraving of the painting that identified each important part (Figure 68). To the information in his original statement he added that the academy owned casts of several of Rush's portrait busts and that the Krimmel painting, also in the possession of the academy, showed the original location of the sculpture and fountain.[41] With

[39] In manuscript in the Sartain collection, Historical Society of Pennsylvania. Eakins may have observed the cleaning of the wooden figure and the casting of the bronze version; he writes knowledgeably about the process.

[40] *Catalogue of the First Exhibition of the Society of American Artists*, Kurtz Galleries, New York, March 6-April 6, 1878. Eakins' painting of William Rush was No. 8. The painting by New York artist Robert C. Minor (1839-1904) of *The Studio of Corot* (No. 5)—an outdoor scene honoring the tradition in which

Minor had recently been studying in Europe—shows effectively how unusual Eakins was in looking to the past, and particularly, to the American past for a studio subject. For the Boston exhibition, see Goodrich, *Eakins*, 1982, I, 324.

[41] The Brooklyn catalogue (No. 313) listed only the title of the painting. Eakins' text in the Philadelphia catalogue, *Special Exhibition of Paintings by American Artists at Home and in Europe*, Pennsylvania Academy of the Fine Arts, November 7-December 26, 1881, which

the phrase "earliest and best" Eakins summarized Rush's importance for both his New York and his Philadelphia audiences: in New York, he wrote that the allegorical figure was "one of the earliest and best of American statues"; in Philadelphia, that "William Rush, the Ship Carver, was the earliest and one of the best American sculptors."

Despite his textual precision about Rush's allegorical intentions, Eakins was not able to prevent the "idle and unobserving" American public from continuing to misidentify Rush's nymph as Leda. Even his friends were guilty.[42] But he did succeed—and magnificently—in re-establishing Rush's place in the history of American art.

includes the error put forward by Watson in 1830 that Rush's *George Washington* had originally been a ship's figurehead, is pointedly instructive for Philadelphians:

William Rush, the Ship Carver, was the earliest and one of the best American sculptors.

At the completion of the first Philadelphia waterworks at Centre Square, which is now occupied by the Public Buildings, he undertook a wooden statue to adorn the square, which statue was afterwards removed to the forebay at Fairmount, where it still remains, though very frail. Some years ago a cast of it was made in bronze for the fountain near the Callowhill Street Bridge.

The statue represents the River Schuylkill under the form of a woman. The drapery is very thin, to show by its numerous and tiny folds the character of the waves of the hill-surrounded stream. Her head and waist are bound with leafy withes of the willow—so common to the Schuylkill—and she holds on her shoulder a bittern, a bird loving its quiet shady banks.

This statue, often miscalled the Lady and the Swan, or Leda and the Swan, is Rush's best work, and a Philadelphia beauty is said to have consented to be his model.

The painting shows, among other things, a full-length statue of Washing-ton, intended for a ship's figure-head; a female figure, personating the water-power; and some old-fashioned ship scrolls of the time. The Washington is now in Independence Hall, and the female figure is on the wheel-house at Fairmount.

The Academy owns casts of several of William Rush's portrait busts; among them a portrait of himself.

A picture in the Academy, by Krimmel, an early Philadelphia painter, shows the original position of the forebay statue in Centre Square.

Some public discussion of the original location of Rush's fountain may have been stirred in 1874 when construction was begun on the site for the City Hall—what Eakins refers to above as the "Public Buildings." As was the case in the New York exhibition three years earlier, another studio painting in the Philadelphia exhibition with Eakins' *William Rush Carving His Allegorical Figure* would seem by its title to have made a significant contrast: *The Studio, Spanish interior*, by F. L. Kirkpatrick. (And interesting from the point of view of the *Gross Clinic*, in this exhibition the painter Milne Ramsey (1846-1915) working in Paris, exhibited a painting called *Lesson on Anatomy*, now unlocated.)

[42] Eakins' disdain for people who had confused the iconography of the nymph, evident in his terms "idle and unobserving," is characteristic of his insistence that one should get

As he undoubtedly expected, when New York and Philadelphia critics reviewed the painting in 1878 and 1881 they seemed not to know much of the old sculptor.[43] Soon, however, Eakins' painting and catalogue entries took effect.

The first evidence of Eakins' success came quickly, in the book his friend William J. Clark in 1878 wrote about American sculpture. Obviously having written most of the book before Eakins called his attention to Rush, Clark wrote a special section on Rush at the end of his chapter on Philadelphia sculptors. Giving the sculptor generous coverage, Clark emphasized his "study of nature," his self-taught genius, and his gift to Philadelphia of a "genuine masterpiece" in the nymph.[44]

The next year Watson's *Annals* were revised. Expanding substantially the notice on Rush, the editor combined the *Annals'* earlier focus on Rush as a shipcarver with praise for the Rush that Eakins had celebrated. Noting that Rush's "figures are generally fine, and if he had lived at a time when there was a chance for a statuary to make a living by his art, he would doubtless have attained a high reputation," the editor went on to list as Rush's achievements his theater figures, wheelhouse figures, several of his allegorical figures, his *George Washington*, and "the well-known figure of the Naiad with a Swan [!], once used as a fountain at Centre Square, and now at Fairmount."[45]

things right. In 1884, J. Thomas Scharf and Thompson Westcott, *History of Philadelphia, 1609-1884*, 3 vols. (Philadelphia: L. H. Everts & Co., 1884), vol. 3, p. 1853, called the sculpture "Nymph and Swan." In 1917 Susan Eakins scolded Will Sartain for so miscalling the sculpture: "You do not know the statue. If you had seen it you would laugh at the title 'Leda and the Swan.' The bird is a small graceful and delicate creation and she holds it on her shoulder" (July 5, 1917, Sartain Collection, Historical Society of Pennsylvania). That same year Horace Mather Lippincott, *Early Philadelphia* (Philadelphia: J. B. Lippincott and Co., 1917), describing the old Centre Square Waterworks, called Rush's statue "Leda and the Swan," p. 107. And preserved in the Pennsylvania Academy of the Fine Arts Archives is a letter from T. Rumford Samuel to Eakins, written on April 25, 1911, thanking him for answering with a detailed personal letter Samuel's re-

quest for "very explicit explanations of the Lady and the Swan Fountain" (on film in the Archives of American Art, roll P14).

[43] In New York reviewers paid a great deal of attention to the nude as an example of figure painting, some liking it, others finding it inferior. Reviews, newspapers, and dates are cited in Hendricks, "Eakins' William Rush Carving." On December 2, 1881, the critic for the *Philadelphia Press* liked the "earnest restraint" in the painting, approving that Eakins had shown that the participants in the scene care "more for what they are doing than for displaying themselves while doing it." Of Rush's place in Philadelphia history no notice was given.

[44] William J. Clark, Jr., *Great American Sculptures* (Philadelphia: Gebbie & Barrie, Publishers, 1878), pp. 107-110.

[45] Watson, *Annals of Philadelphia*, 1879, p. 444.

Soon after Clark's and Watson's work, general histories of American art began to include Rush. Although the first historians were cautious—as was S.G.W. Benjamin who praised Rush as "undoubtedly a man of genius" in 1880—their debt to Eakins is clear.

In only twenty years Eakins was quoted almost exactly. Sadakichi Hartmann stated categorically that Rush began America's sculptural tradition, and then described the fountain figure as support for his assertion: "[Rush's] wooden allegorical statue of the Schuylkill River, for which a celebrated belle of the time consented to pose, standing still near the water-works in Fairmount Park, Philadelphia, is one of the earliest and best of our American statues." The last line of Hartmann's comments confirms Eakins' role in the resurrection of Rush's reputation: "Thomas Eakins has painted a picture of Rush modeling this statue."[46]

In restoring Rush to the canon of the history of American sculpture—indeed, in effectively challenging the terms on which that canon had been selected—Eakins acted with the artistic authority that characterized his decisions throughout his entire career. He never doubted that he saw through the accidents of time and nature, and often the ignorance of his fellow citizens, to essential principles. He was to find, however, that his vision of what was worth pointing out would not typically bring the assent in his audience that his recognition of William Rush had inspired.

And the curious result of this phenomenon was that later, because of the painting of 1877, Eakins' identity and that of Rush slowly merged—first in the public eye, and later in Eakins' own symbolic vision. Eakins' methods of instruction at the academy provided the starting point. His insistence that all students study from the human figure began to disturb the Philadelphia academy community during Eakins' tenure as Director of Instruction after 1879. Members of the academy board were anxious to make the instruction self-sustaining and were responsive to the occasional complaints of parents and of academy students that Eakins' rigid prescriptions were too inflexible for the casual student. A certain amount of sexual reserve dominated the public life of the community, giving for some critics a prurient cast to Ea-

[46] S.G.W. Benjamin, *Art in America: A Critical and Historical Sketch* (New York: Harper & Brothers, 1880), p. 137. Sadakichi Hartmann, "American Sculpture," in *A History of American Art*, Vol. 2 (Boston: L. C. Page, 1901), p. 16. In addition, Lorado Taft, in *The History of American Sculpture* (New York: Macmillan, 1903), gave Rush high praise, pp. 20-24. Even later, Edward H. Coates, director of the Pennsylvania Academy, drew on Eakins' work for his talk about 1911 on William Rush (Pennsylvania Academy of the Fine Arts Archives; on film in the Archives of American Art, roll P78).

kins' matter-of-fact use of models of both sexes for students of both sexes. After increasing tension, in 1886 the board insisted that Eakins resign from his post. The action hurt Eakins deeply, for it was directed not only at him but at principles that he felt to be of unquestionable importance.

With this event the merging of Rush's and Eakins' identities began. An early newspaper clipping in the Vanuxem files at the Historical Society of Pennsylvania alludes to criticism Rush had aroused among his fellow Philadelphians of 1809 with his fountain figure. But the author of the article, as subsequent historians have elaborated, ties the criticism not to the sculpture but to Rush's advocacy of the controversial water system designed by Latrobe.[47] That Rush was criticized has a historical foundation; but the community understanding of what had caused that early criticism was to change its character totally after 1886. In 1893 the author of a Philadelphia magazine article purporting to reestablish the reputation of the forgotten Rush mentioned that when Rush installed the fountain the nymph had been "denounced as immodest."[48] Five years later, a newspaper writer put the case more strongly, although again qualifying it as hearsay: "It is said that when [the fountain sculpture] was first placed in the Square many nice and fastidious persons were shocked in contemplating the female figure."[49] By 1937 the notion that Rush had scandalized his audience with the sculpture had achieved such persuasiveness that Henri Marceau, the author of the catalogue of the first exhibition devoted to the works of Rush, wrote that it would be superfluous to air the scandal in detail.[50] Just earlier, in 1933, Eakins' biographer Lloyd Goodrich had suggested that Eakins painted the scene of Rush because he felt bound to the sculptor by their common rejection by the Philadelphia community for working from the nude.[51]

[47] The clipping is filed under FCVa Van Uxem. Nelson M. Blake, throughout, notes the antagonism Rush occasionally aroused with his early support for the Latrobe plan, the engines for which failed miserably (*Water for the Cities* [Syracuse: Syracuse University Press, 1956]). As Note 9 (above) indicates, community response to the sculpture itself was warmly appreciative.

[48] E. Leslie Gilliams, *Lippincott's Monthly Magazine*, August 1893, pp. 249-253 (p. 251).

[49] July 26, 1898 unsourced newspaper clipping, Archives of the Philadelphia Museum of Art.

[50] William Marceau, *William Rush 1756-1833: The First American Sculptor* (Philadelphia: Pennsylvania Museum of Art, 1937), pp. 28, 29.

[51] Goodrich, 1933, pp. 59-60. See his later note on the matter in *Eakins*, 1982, I, 325. Until Bantel (Pennsylvania Academy of the Fine Arts, *William Rush*), succeeding scholars, even on Rush, followed Goodrich; as did, for example, Wayne Craven, in *Sculpture in America* (New York: Thomas Y. Crowell Company, 1968), p. 23. However, Hendricks, "Eakins' William Rush," p. 386, demurred, stating that for the socially prominent young belle to have posed at all would have caused sufficient scandal to start innuendos.

In fact, the "tradition" that William Rush worked from the nude was Thomas Eakins' invention, and the "tradition" that William Rush had caused a scandal by doing so was the invention of the Philadelphia community in the late nineteenth century after Thomas Eakins caused—in his insistence on working and teaching from the nude—a scandal. When Susan Eakins assessed the painting the year after Eakins' death as one of his most important works, she explained to Will Sartain that Eakins had painted it to call attention to Rush's elegant and refined work.[52] Through the years of Susan's and Eakins' marriage—which began two years before Eakins was fired from the academy—the painting hung in their home. In neither Susan's correspondence nor comments by associates is there evidence that Eakins conceived of Rush's career as troubled.

But increasingly Eakins felt his own career to be troubled, and he retreated into more solitary ways and assumed an independent judgment of the worth of his paintings. Many years later, in 1908, he returned to the theme of William Rush as a subject. He perhaps was stimulated in part to do so by the call printed in the *Pennsylvania Magazine* for more biographical details about Rush's life.[53] And poignantly, only a few years earlier the hopelessly decayed wooden nymph had been removed from her fountain in the forebay at Fairmount and stored away in an attic.[54] In the years after 1900 Eakins had paid more attention to his own sculptural interests, modeling portrait figures in his studio at the same time as he and his sculptor-friend Samuel Murray were working together on portrait subjects.[55] And what had been

[52] Susan Eakins to Will Sartain, letters of September 17 and "Friday night, 9:15 p.m." (Sartain Collection, Historical Society of Pennsylvania). Sartain himself, having spent his career in New York, had come to consider the nudity historically accurate. He wrote about the painting in his memorial essay on Eakins, explaining that "the daughter of one of the Board consented to pose nude for the statue," in "Thomas Eakins," *The Art World*, January 1918, p. 292.

[53] Letter from Charles Henry Hart, *Pennsylvania Magazine of History and Biography* 31 (1907), 381-382.

[54] This took place about 1900, when, according to Marceau (*William Rush*, p. 28), the figure was stored in the attic of the Assembly Room of the Waterworks. Soon thereafter John S. Wurts (1876-1958), Louisa Vanux-

em's great-great-nephew, preserved what was left—the head—and had two bronze casts made.

[55] For Samuel Murray, see Michael W. Panhorst, *Samuel Murray*, exhibition catalogue (Washington, D.C.: Hirshhorn Museum and Sculpture Garden, Smithsonian Institution, 1982); and Mariah Chamberlin-Hellman, "Samuel Murray, Thomas Eakins, and the Witherspoon Prophets," *Arts Magazine* 53, no. 9 (May 1979), 134-139. Two late paintings by Susan Eakins show Eakins working as a sculptor: one, called *Artist and Model*, shows Eakins between about 1900 and 1910 working at a sculpture on a pedestal; the other, *Sculptor and Model*, 1924 (Joslyn Art Museum, Omaha) is a memorial portrait. Even before 1900, in the 1890s, in fact, Eakins worked on sculpture, helping his student

true about Eakins' principles as an artist in 1877 was still true in 1908: he worked simply, straightforwardly, in the very private hard work of the workshop. Indeed, in conversation Eakins pointedly noted to friends that the fashionable portraitist William Merritt Chase painted in an atelier, but he himself worked in a workshop (see Figure 69, one of Chase's several paintings of his own studio).[56]

Most important, however, was that between 1877 and 1908 Eakins had come to share another bond with Rush: the goals he had established for his painting early in his career and had pursued for forty years without faltering had become old-fashioned. In 1908 Philadelphians still liked portraits, but they did not like portraits—even of, and in some instances, particularly of, eminent persons—unless they were graceful or gave easily read signs of the sitter's power. Eakins' work did not have these qualities. By the late 1880s critics had begun to declare that Eakins was one of the "old school," a "nativist" painter; and although they were often impressed by his draftsmanship, his careful observation, and the strength of his work, they were just as often distressed by the effects of these qualities. Occasionally they could hardly even "fit" Eakins' work into histories of American painting.[57] In 1908,

Samuel Murray with commissions for architectural sculpture, and working with the sculptor William Donovan for relief sculpture that would ornament the Soldiers and Sailors Memorial Arch, Brooklyn. In the flush of these interests, Eakins did sketches about 1890 for a painting of another sculptor from the past, *Phidias Studying for the Frieze of the Parthenon* (Goodrich, *Eakins*, 1933, cat. no. 255). One of the sketches shows two nude youths on horses, perhaps tying the work to his own modeling of horses in high relief for the Brooklyn Memorial Arch (Goodrich, *Eakins*, 1933, cat. no. 509).

[56] Goodrich quotes this remark, *Eakins*, 1982, II, 8. And indeed, while Chase had elaborate studios (at one time in the famous Tenth Street Studio Building in New York— see Nicolai Cikovsky, Jr., "William Merritt Chase's Tenth Street Studio," *Archives of American Art Journal* 16, no. 2 [1976], 2-14) to impress potential patrons, Eakins worked in a plain, cluttered interior. His first studio was on the top floor of the family home; after his

marriage he maintained a studio downtown on Chestnut Street; finally, after 1900 he moved his studio back to his home.

[57] S.W.G. Benjamin, for instance, praised Eakins in 1880 as an "admirable draughtsman" (*Art in America*, p. 208), even saying that he had "very few equals in the country in drawing of the figure" (p. 210). As time passed, however, Eakins was harshly appraised—by Samuel Isham, *The History of American Painting* (New York: MacMillan Co., 1905), pp. 525-526, who thought he ignored beauty altogether and laid on his paint inelegantly, and who compared Eakins' portraiture unfavorably with that of Carroll Beckwith, who had studied with Carolus-Duran instead of with Gérôme; or ignored, as by George W. Sheldon, *Recent Ideals of American Art* (New York and London: D. Appleton & Co., 1888); by Clarence Cook, *Art and Artists of our Time*, 3 vols. (New York: Selmar Hess, c. 1888); and by Alfred Trumble, *Representative Works of Contemporary American Artists* (New York: C. Scribner's Sons, 1887). Charles

in short, Eakins found himself in the same position that William Rush had been in years earlier when Eakins had determined to rescue him from obscurity: he was an artist whose work was considered out of style, even primitive.

Eakins explored the Rush theme in 1908 with more experimentation than he had thirty years earlier. He apparently worked with two models: one youthfully slender and somewhat tall, who appears in four works or studies (Brooklyn Museum, Hirshhorn Museum and Sculpture Garden [2], and Philadelphia Museum of Art), and the other older, plainer, and a little chunky (Hirshhorn Museum and Sculpture Garden and Honolulu Academy of Arts). He dressed Rush in craftsman's clothing rather than formal attire and in two paintings portrayed the chaperone as a black woman (Brooklyn Museum and Hirshhorn Museum and Sculpture Garden), a servant of his own household. In the largest, most finished work (Figure 70)—a painting much larger than Eakins' final version of 1877—the model dominates the foreground stunningly, but the tools hanging in profusion on the back wall and the other sculptures spread out regularly across the painting disperse the impact. The viewer does not seem to peer into the past. In two other works, small, quick studies, Eakins introduced the idea of the model finishing her session (Figure 71, and Hirshhorn Museum and Sculpture Garden), being handed down from the podium by the sculptor himself, stepping into clothing being held out by another model.[58]

In what was perhaps his last version of Rush and his model Eakins seems to have come finally to link himself explicitly with his predecessor (Plate 9). The canvas is large—most of it space, given a vitality, but also an ominous emptiness, with large sweeping brushstrokes. Although a scroll marks the foreground, and the atmosphere is that of a carver's workshop, the artist—his back to us—seems to be Eakins himself. Rush's slight build has been replaced by Eakins' more substantial one—a girth that he had taken on over

Caffin, in *The Story of American Painting* (New York: Frederick A. Stokes Co., 1907; rpt. New York: Johnson Reprint Corporation, 1970), praised the work of Gari Melchers as carefully observed like that of Eakins, but also much better in that Melchers had "essentially a modern point of view" (p. 347). Sadakichi Hartmann, *A History of American Art*, 2 vols. (Boston: L. C. Page, 1901), was able to praise rather than condemn Eakins as nativist and manly, and assessed his work as "nearer to great art than almost anything we can see in America" (vol. 1, p. 204). In 1901 Hartmann's was a lone voice.

[58] Van Deren Coke, *The Painter and the Photograph* (Albuquerque: University of New Mexico Press, 1964), pp. 162-165, suggests that Eakins derived this idea from a series of photographs by Eadweard Muybridge of a nude woman descending stairs, a scarf pulled over her shoulder.

the years—and Rush's narrow head by Eakins' blocky one. The model, frontally nude, is ungainly and not young. The artist helps her down from the stand.

The modeling session is over. At this time Eakins was sixty-four; he had only two painting years left. The motif of the artist and model ending their session was a pendant to the painting of thirty-one years earlier, the painting in which a younger, more confident Eakins had set forth his creed with a work that honored a predecessor whose excellence had been forgotten.

Ironically, Eakins, too, would enter the canon only posthumously.

CHAPTER FIVE

The Concert Singer

FROM HIS earliest years Eakins had been drawn to music, the most fleeting and intangible of experiences. Throughout a career that brought him perhaps more than his share of public affronts, and no common measure of private griefs (including the early deaths of his mother and a favorite sister), music was vital to him. He lived among music makers, in fact, although he did not play an instrument himself. When he was young, his sisters studied the piano and filled the house with the sounds of their music. His wife Susan, whom he married in 1884, was an accomplished pianist and made their home the scene of many musical evenings. And Eakins also sought out music's effects as a concert goer. From the Pasdeloup concerts and the opera in Paris to chamber music and singing society concerts in Philadelphia, he submitted himself to, and was buoyed and comforted by, music's spell. Friends remembered that when he listened, especially to chamber music, tears often ran down his face.

Music formed the subject of nineteen of his paintings, from the beginning of his career to near the end. The paintings are grounded in musical experience peculiar to his city and attitudes characteristic of the late nineteenth century; and like his rowing and surgical portraits and his tribute to William Rush, they show Eakins' thoughtful assessment of the fundamental meaning of the activity. Displaying a musical authority that is both sensitive and powerful, Eakins' portraits of musicians provide a counterpoint to the worldly heroism he celebrated in his rowing portraits, surgical clinics, and William Rush paintings—heroism that was associated with reason, action, and control.

Eakins shared with many other artists his attraction to music in contemporary life. Mary Cassatt, for instance, painted glimpses into the loge at the Opéra, Manet of a group of listeners at the concerts in the Tuileries, Sargent caught the sweep of Pasdeloup's orchestra at the Cirque d'Hiver (Figure 72), and Degas looked with humor into the cluster of players in the orchestra at

the Opéra (Figure 73). But casual scenes did not interest Eakins, nor did the color or the movement of large musical gatherings. His paintings stand distinctly apart: they are portraits, and they are at the same time investigations into certain qualities of music itself. And in his own work, paintings of fellow citizens involved in music making also form a separate group.

On the one hand, it is true and important that Eakins' portraits of musicians playing their instruments range over a spectrum of musical life in Philadelphia much as the body of all his portraits includes citizens devoted to widely varying pursuits. Eakins carried his early confidence that a few basic principles lay at the root of all experience into friendships that led to portraits of zither players, a cellist, an oboist, a violinist, organists, banjo players and guitarists, singers, even a collector of musical instruments. These portraits range from music associated with the classical tradition to that of the folk tradition; some of the paintings are small and jewel-like in technique, others are large and relatively loose. They form a virtual portrait gallery of modern music making in Philadelphia.

On the other hand, Eakins' portraits of musicians show a relationship between man and activity that is different from the themes prominent in his portraits of other professionals at work. In the rowing paintings, Eakins held up the oarsmen to admiration because of the command with which they executed their delicate but demanding task. Dr. Gross in his clinic, and Dr. Agnew in his, exercised with both physical dexterity and intellectual acumen impressive authority in the discipline of surgery. William Rush confidently put the final touches on his sculpture. But in the music paintings, as one can see in the pliant stance of Eakins' *Concert Singer* as she makes music, the sitters take up no poses of easy command; they pretend to no intellectual distance from the music they are making. They seem intentionally, in fact, to have surrendered their separateness to the spell of what they are doing.

Eakins began to explore this submerging of individuality as early as his first musical portraits in the sequence of paintings of his sisters and of a family friend at the piano that he painted in the early 1870s (Figures 77, 78, 79, 80). That he painted pianists as the first of his interior portraits shows that, as he had done with rowing, he was starting his career with experience that he knew well. But playing the piano, like rowing the shell, had a special place in nineteenth-century middle-class life, and Eakins' attention to it shows the extent to which, despite his independent response, he shared the concerns of his contemporaries.

Virtually no activity of Eakins' sisters more clearly identified them, and

the Eakins family, with commended, "modern" middle-class pursuits than playing the piano. Descended from the harpsichord, the piano had been gradually modified until by about 1840 it had reached the form in which Eakins' sisters knew it. By mid-century, manufactured in quantity by English, American, French, and German firms, it had no rival as the ideal parlor instrument. It was a moral and entertainment center of the home, and families sacrificed to buy one and to pay for their children's instruction on it—especially that of their daughters. Imagery as early as that of St. Cecilia had shown the keyboard to be the province of women. And throughout the nineteenth century, despite the fact that the great piano virtuosi in public life were men, artists showed women at the keyboard at home to compliment their cultivation and that of their families.[1] Only rarely in these scenes did artists show the attentiveness of the sitter to the actual making of music. In America George Hollingsworth, in his group portrait of the Hollingsworth family (Figure 74) demonstrated the cultural status of his sitters—just as did J.-A.D. Ingres in his drawing made in Rome of the exiled family of Lucien de Bonaparte (1815, Fogg Art Museum, Harvard University)—by showing a daughter seated at (but not playing) the keyboard. In his painting *At the Piano* of 1859 (Figure 75), J.A.M. Whistler did show the mother of the Haden family in London playing the piano, and the daughter (presumably in training to carry on the tradition of being the musical center of the household) listening dreamily to her, but he also revealed that as a sheer possession the family's piano dominated the parlor. It had even organized the decorative scheme on the wall above it. Degas, too, painted women at the piano, their musicianship an accomplishment particularly flattering to and worthy of their womanhood; typical, for instance, is his tribute to Mlle. Dihau (Figure 76), as she looks around from her position on the piano bench. Behind her we see suggestions of the printed music from which she is playing, but Degas, intent on showing the candid surprise of her glance, only hints at the piano keyboard and the position of her hands.

Eakins, on the other hand, gave the making of music first place, subordi-

[1] There were indeed some paintings, however, that focused on the dramatic presence of the great piano virtuosi (as well as on their instrument and their patrons): one well-known such image is the painting by Joseph Danhauser, *Liszt at the Piano* (1840, National Galerie der Stiftung Preussischer Kulturbesitz, Berlin)—a parlor scene in which Liszt is en- thralling an audience that includes George Sand, Victor Hugo, and Paganini. Another is *Liszt playing a grand piano by Ludwig Bösendorfer before Franz Josef in Budapest*, 1872 (unknown artist, private collection, illustrated in *The New Dictionary of Music and Musicians*, ed. Stanley Sadie [London: Macmillan Publishers Ltd., 1980], vol. 14, p. 713).

nating to that imperative specific moments and even individual likeness. In only one of his four images of young women at the piano—*Home Scene* (Figure 77)—is the instrument a mute possession. In that quiet painting, Eakins' sister Margaret turns from her position on the piano bench to observe their sister Caroline on the floor; her maternal look conveys the sweet affection that the presence of the piano in the home was felt to promise and hints at the transmission of music from older to younger. The viewer realizes with a shock that at the time Margaret was only sixteen or seventeen years old, her image in this painting an early indication of the liberty Eakins later took with his sitters' appearances when it served his purpose.

The other three of Eakins' paintings of music making on the piano form a sequence in which he explored the subtle relationship between technique and music making.

By 1870 technique had become virtually an obsession with both amateur and professional musicians. Although there had certainly been fine musicians in centuries past—and many whose technical brilliance seems still to live in the first-hand reports of letter writers and diarists—the *sine qua non* of musicianship in earlier times had not been so temptingly close to fast, brilliant, dramatic playing as it was to become in the century of progress. Well-educated classes had matter-of-factly played instruments as amateurs, both in ensembles and for private pleasure, focusing not so much on technique as on the moods of gaiety or calm or even melancholy that they could evoke with capable playing. That modest approach to technical control was to change with the modification of instruments, with the new demanding compositions, with the huge musical audiences who craved virtuosity, and with the individual concert performers who were only too willing to make themselves famous by supplying it.

Neither the piano nor the other newly developed or "improved" nineteenth-century instruments could be mastered quickly. The vast mechanical resources of the piano, particularly, made playing it well both a challenge and a responsibility: its strings stretched under high tension, the piano produced a rich sound that could approach either bombast or delicacy. The amateur could play simple music on the piano to good effect only if he sensibly handled the instrument; and the player who wished to call upon all its resources had to spend years of study in developing the physical capability. Composers like Mendelssohn, Chopin, Schumann, Schubert, and others now forgotten composed groups of short, satisfying, and relatively easy pieces for the new players, but with other compositions they pushed virtuosity to its limits with music that was extraordinarily demanding. Scores and then

hundreds of piano method books flooded the market offering authoritative—and often conflicting—advice on how to curve the fingers, hold the wrists, use the elbows, play octaves, manage running sixths and thirds, and use the pedals in order to give this new music—and this new instrument—its due. Technique assumed so important a place in playing the instrument impressively that some teachers compelled their students to work on nothing but technique for years.[2] These circumstances prevailed for other instruments as well—the cello, the oboe, the flute—all of those instruments, in other words, that had been associated for centuries with ensemble playing (and thus with fairly easy adaptability to amateur musicianship). In the case of the piano, even physicians contributed to the mania for technical virtuosity: Eakins' sitter Dr. Forbes (Figure 118) was one of them, inventing a special operation to free the ring finger from its tendon so that the pianist could lift it an extra one-quarter to one inch and strike the keys with more force.[3]

Sensitive critics and musicians, however, knew that no one relying exclusively on technique could play profound music. The best pianists—and the best instrumentalists on all instruments—strove to incorporate impressive technique into a larger ideal of musicianship in which virtuosity was merely a means to bring into being music that flowed autonomously. Pianists worked to achieve in their own playing the ideal that critics found in the playing of Anton Rubenstein: "With Rubenstein [the piano] absolutely gives up all semblance of being a machine at all and becomes a living agent, interpenetrated by and responsive to the spirit of the master. Under his wonderful fingers it sings or thunders, murmurs or tingles, laughs or weeps, in apparent freedom from all physical law but that which puts it in immediate relation with the soul of the performer."[4]

This—the transcendence of technique (parallel, indeed, to Dr. Gross's

[2] See the account of Eakins and his sister's exchange on the subject, below. The strain after technique often resulted in loud, vigorous playing unceremoniously called "pounding" by offended listeners. Oliver Wendell Holmes satirized the phenomenon in "Music Pounding," which was reprinted in the Philadelphia publication *Amateur* 2, no. 10 (June 1872), 157. Eakins himself wrote home from Paris about the painful piano playing of Mrs. F. de Berg Richards, the wife of a Philadelphia painter and photographer who had accompanied her husband to Paris: "Her practice has given her a confidence and horse power of execution. . . . [She hits] as hard and as fast as she can from beginning to end" (to Fanny, November 1, 1867, Archives of American Art, Smithsonian Institution, Washington, D.C.).

[3] See Forbes's reflection on his use of the procedure, which dated from considerably earlier, in his "Liberation of the Ring-Finger," *Philadelphia Medical Journal*, 1898, and separately published pamphlet (Archives, Jefferson Medical College).

[4] *Scribner's Monthly* 5, no. 1 (November 1872), 130.

subordination of "show" surgery for quietly effective procedures)—was the ideal toward which Eakins showed his pianists striving. In the first painting of the sequence (Figure 78), his sister Frances bends forward slightly from a tense, careful position on the piano stool, paying close attention to the music on the rack before her as she plays a series of octaves, or perhaps sixths. She seems to monitor every muscle in deliberate, even nervous attention to what she is doing. Her dress, white with a bright scarlet sash, highlights the disparity between her girlish, gay costume and the mature musical discipline she has set for herself.

Two years earlier, before Eakins returned from Paris, she had written him in discouragement with her progress in her piano studies, and he had responded with a remarkable letter, advising her emphatically not to concentrate on technical exercises unless they aided her to play specific passages in pieces of music. He even drew her a graph to show that, because perfection of every detail was humanly impossible, she should aim for a larger scope of mastery; as an example he called her attention to the silliness of working for months to perfect her trill technique when trills lasted for such a short time in a piece of music. He knew what he was talking about, he assured her: "Don't think that you are the only one that has been down hearted. I have often wanted to die & I feel now plain it was my stupidity. I was playing my trills drawing from plaster casts."[5]

Encouraged by her brother, Frances soon went beyond her early preoccupation with achieving technical command. And in the second of Eakins' sequence of piano paintings (Figure 79), he showed her relaxing at the keyboard, so much more the master of the instrument, in fact, that her sister Margaret leans on the piano listening raptly. Creating a mood of reverie, Frances seems with her right hand to shape the phrase of a melody; she is perhaps playing one of the many melancholy pieces popular at the time, like "The Dying Poet" or "Last Hope" by Louis Moreau Gottschalk, that pointed the attention of player and listener alike beyond technique to the world of emotions. The reflectiveness of these young women is echoed by the somber tones of their dresses—Frances's a dark red and Margaret's a deep black.

Three years later Eakins turned to a musician beyond his immediate family to create a work that would be his last painting in the piano group, *Elizabeth at the Piano* (Figure 80). His sister Frances had married and was busy as a new mother; the pianist in this painting is her husband's sister,

[5] Eakins to Fanny, November 13, 1867, Archives of American Art.

Elizabeth Crowell.[6] The canvas is much larger than the earlier piano canvases, Eakins' techniques more varied and confident. With brilliant red touches against a cool background, set off with discreet light flowing in from the left, the work is a technical and an emotional climax to the series. As she plays, Elizabeth looks down from the score, the notes of the music so absorbed into her consciousness that she watches her hands and yields them to the flow of the music. Her left thumb visible under her right hand, she is performing a piece that called for one hand to hover over the other. Popular as far back as the eighteenth century on the harpsichord, such music demanded that the player know the score intellectually and emotionally. In contrast to the cautious technique of Frances in the first painting, and to the simple melancholy of the second, in this painting Elizabeth's music making is a totally integrated union of body and mind: the score assimilated, the technique mastered, she has given herself to the ongoing power of the music. Of the several paintings in the sequence, this was the one Eakins chose to exhibit, and he did so for years.[7]

After he painted *Elizabeth at the Piano*, Eakins did not again focus exclusively on the making of music at the piano.[8] Having rehearsed the aspects of piano playing—and, in the larger context, of music making—until he found the one that best expressed the relationship between technique and music making, he turned to explore musicianship on other instruments.

The first such painting is *Professionals at Rehearsal* (Plate 11), a small oil painting that Eakins painted on commission for collector Thomas B. Clarke.[9] The "Professionals" in the painting are a zither player and a guitarist, playing in ensemble. Their very music is a phenomenon of modern life: the small zither had been an Alpine folk instrument until the 1830s, when it was taken

[6] Elizabeth Crowell's brother, William (Billy) Crowell, was Eakins' classmate at Central High School.

[7] Eakins exhibited *Elizabeth at the Piano* as "Lady's Portrait" at the Centennial, 1876. He wrote his former student John L. Wallace in 1887 of his disappointment that the Chicago Art Institute had rejected his "big picture of the girl at the piano" the year before because they didn't want portraits (June 23, 1887, Archives of American Art).

[8] He did paint Susan Macdowell, later to be his wife, at the piano, but she plays an accompaniment in the painting *The Pathetic Song* of 1881 (Figure 93); and Samuel Myers, in the painting *Music* of 1903, plays at the piano as Hedda van der Beemt plays the violin (Figure 84).

[9] Eakins painted *Professionals at Rehearsal* after he had painted the watercolor *The Zither Player*. Presumably Clarke, who commissioned the oil painting, chose the subject. Eakins' models for the oil painting, discussed by Theodor Siegl, *The Thomas Eakins* Collection (Philadelphia: Philadelphia Museum of Art, 1978), p. 105, were J. Laurie Wallace on the zither and a Canadian student, George Agnew Reid, on the guitar.

onto the German concert stage and then brought by German immigrants to America. Music for the zither consisted of folk and art songs and, in large number, transcriptions of favorite operatic arias. In the 1870s enthusiasm for the instrument was just beginning to develop in Philadelphia, and Eakins' friends were early to appreciate its potential.[10] They sit at a round-top table in the Eakins' family parlor, a wine bottle and two partially filled glasses on the table identifying the convivial, and the private, nature of the rehearsal. Stacks of music on the floor suggest the musicians' official repertory, although in the painting they play without music. The zither rests on the table; the performer bends over it in intense concentration. His left-hand fingers press the strings on the melody board, his right reach out to pluck the long accompaniment strings, while the plectrum on his thumb sounds the melody notes. He is so physically involved in the music making that even his left leg, wrapped around the chair leg, and his foot, braced against the floor, express the channeled tension. In proper technique, he is a veritable illustration out of a method book.[11] And yet, the painting is not an exposition of the proper zither technique. The other ensemble player, the guitarist, looks toward his fellow musician. He seems lost in the musical atmosphere. Light falls across the scene from the right, revealing the zither player as the chief figure; even so, half his face is in shadow, and the guitarist, even further from the light, sits in a warm dusk. On the table Eakins presents the surfaces and weight of a still life—the metal, wood, and cord of the tuning hammer and the corkscrew; the metal of the thumb ring worn by the zither player; and the wine bottle and glasses with their clear reflecting

[10] In 1856 *The Philadelphia Musical Journal and Review* noted that the zither was practically unknown in America (vol. 1, no. 2 March 26, 1856, p. 19). For its rapid growth in popularity, see *North's Philadelphia Musical Journal* 4, no. 3 (March 1889), 33, and 4, no. 4 (April 1889), 7. In using the term "Professional" to describe his zither player and guitarist, Eakins probably meant to compliment their standards of performance rather than to designate that music making was their livelihood. There were in Philadelphia, however, zither teachers and performers (notably, Henry Meyers, see *Philadelphia Musical Journal* passim, and Scrapbooks of Thomas A'Beckett, Jr., Library of Congress) to whom work on the zither brought a major part of their livelihood.

[11] *Winner's Eureka Method for the Zither*, Philadelphia, n.d., illustrates a player performing with the proper technique, p. 16. That Eakins met cultural rather than necessarily personal expectations with his fidelity to the zither player's technique is apparent from the approval the *Philadelphia Musical Journal* gave to the accuracy of a painting of a zither player on exhibition in the Earle galleries (by an unspecified artist) in 1889: "The position is true to life, even to the 'crooked' fingers, showing the result of imperfect tuition; another natural feature is the stringing of the instrument, the end dangling from the 'pin' even as some players of to-day betray the same carelessness in putting strings on their zithers," 4, no. 9 (September 1889), 35.

light. Across the painting details of color give the scene additional discreet life: on the stack of music in the left a blue cover and a red one; and over in the lower right corner, one in orange. Throughout the scene the light softens and folds the precise detail into a mood that conveys the otherness of the music. It is a quiet, personal world to which Eakins' friends have given themselves and into which they draw their audience.

The "otherness" of music could also prevail in public performance, and Eakins saw it in the professional musicianship of the cello player Rudolf Hennig (Plate 12). The violincello in late nineteenth-century life was at the opposite end of the spectrum from the zither. A formal rather than folk instrument, it had been associated with ensembles for centuries, for a long time as the viola da gamba that provided the bass line for singers and for instrumental ensembles, and then, after its evolution in the eighteenth century, as violincello in the expanding symphony orchestra and in new types of smaller ensembles. In the nineteenth century, boosted like the piano by a series of structural changes that gave it brilliance and sonority, the cello entered the ranks of the virtuoso solo instruments. This was the tradition in which Rudolf Hennig, Eakins' sitter, had been trained. Born into a family active in the influential German school of virtuoso cello playing, after his training in the late 1850s and early 1860s Hennig had immigrated to Philadelphia. There for more than thirty years he contributed indefatigably to the community musical life: as a teacher, performer in ensembles, orchestra member (most notably of the orchestra that performed regularly at the Pennsylvania Academy of the Fine Arts), and soloist.[12] In 1896, in recognition of his musicianship, the Symphony Society of Philadelphia broke with their tradition of inviting only outside soloists and chose Hennig to be the featured concerto soloist for the second concert of their season. Performing a work from the German tradition of virtuoso composition, Hennig earned enthusiastic reviews that also expressed appreciation for his long career in the city.[13] Eakins, much as he had commemorated Max Schmitt's recognition by the community, painted Hennig's portrait.

[12] For details of Hennig's life (1845-1904), see the *Philadelphia Musical Journal* 4, no. 11 (November 1889), 4-5. Hennig's many musical activities in Philadelphia are reported in Robert A. Gerson, *Music in Philadelphia* (Philadelphia: Theodore Presser Co., 1940), with indexed references, and detailed in the *Philadelphia Musical Journal*, passim, and in Philadelphia newspapers throughout the 1880s and 1890s. Programs in the Scrapbooks of Thomas A'Beckett, Jr. are evidence of Hennig's frequent appearances in chamber concerts in homes as well as in public performances of all kinds.

[13] In announcing Hennig's upcoming performance, the Philadelphia *Ledger* referred to Hennig as "the distinguished violincello virtuoso" (April 26, 1896, p. 29), and in its re-

Like *The Gross Clinic*, *The Cello Player* is a large painting. To convey the warmth and liveliness of Hennig's music making, Eakins chose a palette of warm browns, blacks, and grays, and placed the life-sized image of Hennig against a ground of broad many-directional brushstrokes. For the combination of man and cello, Eakins chose a distinctive format. The cello, admittedly an awkward instrument to play, had traditionally presented a dilemma to the portraitist.[14] In the late eighteenth century Gainsborough (Figure 7) had placed Carl Frederic Abel's instrument discreetly to his side, giving him an identity associated with but not confined to his instrument. Only a few years later, Pompeo Batoni in Italy painted the virtuoso cellist and composer Luigi Boccherini (Figure 81) with different intention: Boccherini was the great founder of the new school of cello playing, a developer of the more resonant cello, and a composer of music that exploited the instrument's new capabilities. Thus, although with almost inevitably awkward results, Batoni showed all three dimensions of Boccherini's achievement: he preserved a full-face likeness, demonstrated the dimensions of Boccherini's cello, and gave an idea of Boccherini's playing technique. A half-century later, Degas avoided the clumsiness of this kind of presentation in order to show that his friend the fine cellist Pillet was successor to a long tradition of excellent cellists (Figure 82). Thus he presented Pillet sitting at his desk (we seem to catch him unawares, as we did Mlle. Mihau), his cello nearby, the group of eminent cellists in the imaginary lithograph on the wall behind Pillet turned to pay him homage.[15] By 1870, virtuoso cellists posed for concert photographs

view on May 8 (the concert was May 7) complimented Hennig on his "exquisite tone—a 'golden tone' one might almost call it—[and] sympathy of treatment." Hennig played the Concerto in A minor, Opus 14 by the German virtuoso Georg Eduard Goltermann (b. 1824) (while the music is no longer performed, the score is in the Free Library of Philadelphia), and the "Recitative and Andante" by the famous Dutch performer Louis Lübeck (b. 1838). Eakins' study for the painting is in the Hecksher Museum, Huntington, L.I., New York.

[14] Edward S. J. van der Straeten provides an excellent survey of images of players of the viola da gamba and the cello, *History of the Violincello, the Viol da Gamba, Their Precursors and Collatoral Instruments, with Biographies*, 2 vols. (London: William Reeves, 1915; rpt. New York: AMS Press, 1976). Others may be found in photograph collections in the Library of Congress. For photographic portraits of cellists after about 1865, see the portrait of Eliza de Try (by Carjat, 1865), in Bernard Marbot, *After Daguerre: Masterworks of French Photography (1848-1900) from the Bibliothèque Nationale* (New York: The Metropolitan Museum of Art, 1980), fig. 36; and of Alfredo Piatti (1822-1901) in *The New Grove Dictionary*, vol. 14, p. 717.

[15] Theodore Reff, in *Degas: The Artist's Mind* (London: Thames and Hudson, 1976), pp. 121-125, discusses Degas's fanciful use of the "eminent cellists" motif for a picture within a picture to honor Pillet.

seated with, but not playing, their instruments (Figure 83). It was this up-to-date type of format, rather than the format of Gainsborough and Degas, that inspired Eakins' choice. Like contemporary photographers he turned the cellist's chair at a slight diagonal and lit the work from the left. However, he portrayed his musician actually performing.

But he did not make Hennig a proud virtuoso presiding over his instrument. In fact, there is no sense in Eakins' tribute of a separation between man and cello. The cello is not in front of Hennig, but almost part of him: its sound box is nestled behind Hennig's right leg, its neck, close to Hennig's shoulder, disappears behind his head. The light falling across Hennig and his instrument picks up high points and leaves small areas of darkness as though the two were one form.

And in this singleness man and instrument are servants to the music. Hennig sits near the edge of his chair, presses the string in the higher registers of his instrument, and pushes his bow across it. The vein along his temple stands out in his full concentration. The cello string vibrates intensely. A music lover who knew both Hennig and Eakins was later to write that Eakins' portrait was "a true delineation of character. . . . [Hennig was a gentle man remembered with] affection and respect by those who knew him. . . . [Eakins' rendering of the turn of his head was] intensely characteristic of the sitter when playing, as though listening intently to the quality of the tone, the justness of the pitch, which was always faultless."[16]

Cellist, zither player and guitarist, pianists, and, as will be discussed later in this chapter, singers—the differences in their instruments and repertory, the diversity of their personal backgrounds, were, for Eakins, insignificant beside their great common enterprise, the making of music.

Just how unusual Eakins was among image makers in his subordination of man and instrument to music he himself made clear in one of his last por-

[16] Helen Henderson, *Pennsylvania Academy of the Fine Arts* (Boston, L. C. Page & Co., 1911), p. 136. Winslow Homer painted a cellist performing in a studio (*The Cellist* 1867, Baltimore Museum of Art) and then in another painting added a violinist to make an ensemble (*Amateur Musicians*, Metropolitan Museum of Art, exhibited at the Third Art Reception of the Union League in Philadelphia in 1871); both works are very small and in spirit are more genre than portraiture, but they do reveal a respect for the seriousness of the activity that is like that of Eakins. Eakins' interest in showing the portrait subject actually performing was a harbinger of the future direction in portrait photography of musicians: in recent decades photographs have come to focus even more closely on the working of the musician—the hands of the cellist Pablo Casals, for instance, the fingers of the pianist Vladimir Horowitz, the lips of the flute virtuoso Jean-Pierre Rampal.

traits of instrumentalists. In the painting called *Music* (Figure 84), in which the violinist Hedda van der Beemt and the pianist Samuel Myers play in ensemble, the violinist gives his entire attention to playing the instrument.[17] His head is turned down, much as is Hennig's. His eyes seem to be fixed on some point that will free him from a merely physical preoccupation with playing the notes. On the wall behind him Eakins painted an image of Whistler's portrait of the violin virtuoso Pablo Sarasate (Figure 85). Sarasate holds his silent instrument under his arm and looks out at the viewer, frankly posing. The paintings and the ideals of musicianship held up for emulation by the artists could hardly be further apart.

Although music was a distinctively "modern" and progressive aspect of life on both sides of the Atlantic, it was also much more, and it was that "more" that Eakins consistently evoked. The qualities of music that distinguished it from all other pursuits—its sensuous and transitory existence, its primary appeal to the emotions, its demand that performer and listener intuit rather than analyze its laws—allied it with the realm of the timeless more than any other activity of modern life. Indeed, music seemed to be a corrective to misleading, ultimately disappointing, material experience. It pulled man out of a preoccupation with activity into the simple contemplation of being.

For many observers of the character of music, it was this ideal quality that made music so essential to modern life. Eakins' admirer Mrs. Marianna Griswold van Rensselaer evaluated the phenomenon thoughtfully: "This our nineteenth century is commonly esteemed a prosaic, a material, an unimaginative age. Compared with foregoing periods, it is called blind to beauty and careless of ideals. Its amusements are frivolous or sordid, and what mental activity it spares from the making of money it devotes to science and not to art. These strictures . . . have certainly much truth to back them. But leaving out of sight many minor facts which tell in the contrary direction, there is one great opposing fact of such importance that by itself alone it calls for at least a partial reversal of the verdict we pass upon ourselves as children of a nonartistic time. This fact is the place that music—most nonpractical, most unprosaic, most ideal of the arts—has held in nineteenth-century life."[18]

[17] The unfinished painting *The Violinist*, which Eakins began as a gift to van der Beemt for posing for *Music*, is in the Hirshhorn Museum and Sculpture Garden. See Phyllis D. Rosenzweig, *The Eakins Collection of the Hirsh-* *horn Museum and Sculpture Garden* (Washington, D.C.: Smithsonian Institution Press, 1977), p. 190, for biographical information about van der Beemt.

[18] *Harper's New Monthly Magazine* 66 (1883),

At the same time that musicians celebrated the contemporaneity of music and its great advance in compositional forms and virtuosity of performance since the time of Bach, they theorized about its origins in primitive times. Indisputable as it seemed that music was more sophisticated than it had ever been, it was just as obvious that music was as old as man. Historians disagreed as to whether the first music had come from a rhythmic impulse or from man's need to speak in highly charged emotional tones (and thus to sing), or whether perhaps man had discovered music in playful curiosity about phenomena in nature, like reeds that could be blown through and strings that could be stretched and plucked. But disagree as they did about the specific origin of music, historians agreed that music created a spell that the sophisticated and the unsophisticated alike were almost powerless to resist. Back into antiquity, in fact, images about music had suggested that spell, and had identified it with two distinct kinds of experiences: the Dionysian and the Apollonian, or music that incited one to revelry (and even sensual orgy) and, at the other pole, music that induced thoughtful reverie. The pipes of Pan generally evoked wild Dionysian revels, and the harp, associated with Apollo, suggested music's capacity to calm the disordered spirit. When musical images were revived in secular painting in the Renaissance, the Renaissance successors to the old instruments—the lute and the flute particularly—did not always have the same clear-cut meanings, and often scenes of music making had complex overtones of both melancholy and erotic longing. But regardless of the emotional associations, such scenes evoked a past of simpler pleasures for which men yearned.

In the nineteenth century as an almost inevitable reaction to the uncomfortable pressures of material life, artists and musicians turned for some of their material to the ideal simplicity of pastoral life that they associated with antiquity. Musicians extended the earlier pastoral tradition in music into parts of the larger nineteenth-century compositional forms; groups of artists left Paris and New York and Rome to live in and paint landscapes that had antique associations, or old associations, at least.

Historians of music gave new life to the pastoral ideal of Arcadia, for it provided a metaphor for their perceptions of the place of music in modern life. They followed Polybius in assessing the Arcadians as an "originally rigid and austere" people who had been educated into "piety, humanity, and hospitality" solely by the agent of music; and as a people who, once set apart

540. Perhaps the most noted late nineteenth-century exponent of the ideality of music was Arthur Schopenhauer, in *The World as Will and Idea*.

127

from their primitive state, yearned for the irretrievable innocence they had lost and used music to express that yearning.[19] Publishers, writers, and organizers of musical groups used the term "Arcadia" to name their enterprises: in America, the first journal in New York devoted exclusively to the arts, published from 1872-1878, was called *The Arcadian*. In New York as well as in Philadelphia, singing societies named themselves "The Arcadians."[20]

Even artists who stayed in the city were caught up in the general nostalgia, and began about mid-century to paint idealized Arcadian landscapes that ranged from uninhabited gentle forests to scenes of nymphs and fauns, often playing such instruments as the panpipe and the aulos. As photography became increasingly popular as a study for painting, artists photographed nude models in landscapes, many of them holding imitations of such antique instruments, and painted from these studies scenes that they called "En Arcadie," and "Arcadia" (Figure 86).[21]

His own thoughts about the effect of music developed over most of his life—in 1883 Eakins, too, undertook an Arcadian series, although he himself never gave it a title. His work on the series, for which he made photographs, oil studies, and sculptural reliefs, provides a contrast to his portraits.[22] But

[19] In Philadelphia, for instance, a writer discussed this in *North's Philadelphia Musical Journal* 2, no. 7 (July 1887), 25. In *Etude* 8, no. 1 (January 1890), Annetta J. Halliday wrote, "Man remembers all that he is and might have been, and mourns—as the dwellers in Arcadia mourned over their exile—for his better nature lost," p. 208.

[20] The program of the first concert of the Philadelphia Arcadian Club, January 9, 1880, is in the Thomas A'Beckett Scrapbooks. Philadelphia music companies sold "Sardinian Shepherd's Pipes" and Philadelphia composer Joseph H. Porter even wrote an Arcadian "galop" for the piano, published in 1869.

[21] Of course, the Arcadian tradition in landscape had been a long one, with Giorgione's *Champêtre* at its head in the Renaissance. The theme appeared in Philadelphia during Eakins' era in several guises. At the Third Art Reception of the Union League of Philadelphia in April, 1871, when Eakins ex-

hibited his portrait of Max Schmitt, Bouguereau's *Arcadia* (owned by J. L. Claghorn) was exhibited (No. 153), as was *Arcadia* by Corot (owned by J. G. Fell) (No. 62). Fortuny's *The Piping Shepherd* was engraved in *Scribner's Magazine* 18, no. 6 (October 1879), 825 (Figure 86). Philadelphia painter Alexander Harrison's *In Arcadia*, featuring photographically realistic nudes in a landscape, was engraved in Mrs. van Rensselaer's *American Figure Painters* (Philadelphia: J. P. Lippincott and Co., 1880), and later exhibited at the International Exposition in Chicago in 1893 (No. 522). The Philadelphia painter Anna Lea Merritt's *Piping Shepherd*—a later contribution to the theme, painted in 1896—is in the collection of the Pennsylvania Academy of the Fine Arts (fig. 10 in the Pennsylvania Academy of the Fine Arts, *The Pennsylvania Academy and Its Women*, Philadelphia, 1974).

[22] Lloyd Goodrich, *Thomas Eakins*, 2 vols. (Cambridge, Mass.: Harvard University Press, 1982), I, 236, indicates that the only work he

it shows no deviation whatsoever from Eakins' ongoing investigation of the meaning of the activities of modern life.

For his works on the theme of Arcadia, Eakins made photographic and oil studies at his sister Frances Eakins Crowell's farm showing his students and a young nephew playing the panpipes and the aulos (Figures 87, 88). Although in antiquity the aulos (or double flute) was generally associated with passion, in pastoral scenes neither Eakins nor his contemporaries distinguished between associations with the panpipes and the aulos: they treated both as old instruments on which one played music that was simple, pure, and gently evocative. Eakins painted at least two scenes based on the photographs, with the male subjects nude (Figure 89) and the females draped Grecian style, and then he sculpted two reliefs (Figure 90 and *A Youth Playing the Pipes*, 1883, Hirshhorn Museum and Sculpture Garden). In each scene, the figures in the landscape make or listen to music that holds them in thrall.

It was the sculptural relief called *Arcadia* (Figure 90) that seems to have most completely satisfied Eakins. It is small, with tiny strips and pieces of clay modifying every area. Across the relief stand six figures and a dog, who all attend to the music played on the aulos by the nude youth at the right. The youth, in turn, seems to be very much aware that he has them in his command. His first auditor is a dog—a beast, even though a domesticated one—who just in front of him looks up with devotion. Behind the dog is the lightly draped figure of a mature woman; with one arm resting on the hand of the other and her chin resting on that arm, she too seems to be spellbound. Behind her, two draped female figures stand together in friendship; the nearer one places her arm on the far shoulder of her companion. An old man behind the two women leans forward on his cane and cups one hand to his ear to catch every note of the music. Last, a young female nude, her breast modestly covered and her glance averted, assumes a meditative posture. One by one, each seems mesmerized by the music. It is a scene that gently evokes other old truths about human life. The human relationships suggest solitude, friendship and passion. And the youth and his lover, right and left, who frame the scheme, the maternal figure of the draped woman behind the dog, and the old man leaning on his cane, suggest the three ages of man. The

entered in his record books, the relief *Arcadia*, was listed as "pastoral sculpture." The oil studies are *Boy Reclining* (Hirshhorn Museum and Sculpture Garden), Study for *An Arcadian* (Hirshhorn); the paintings are *Arcadia* (Metropolitan Museum of Art), *An Arcadian* (private collection); the sculpture reliefs are *a Youth Playing the Pipes* (Hirshhorn and Philadelphia Museum of Art) and *Arcadia* (Hirshhorn, Philadelphia Museum of Art, and

surface quality of the relief is tentative, worked over, fragile: the artist's hand is practically still at work on it. Eakins placed the relief on the wall in his studio, where it appears in photographs. In the background of his portrait of Susan Eakins in 1886, it pays a tender compliment to her own powers as a musician (Figure 91). In its basic idea—music removed from the ephemeral trappings of contemporary life—*Arcadia* parallels Eakins' increasingly direct expression in his bust portraits (as will be discussed in the final chapter) of the human condition that underlay activity, costume, and environment.

Whereas music played by instruments could do no more than suggest emotions—the rest was up to the responsive listener—music created by the voice could specify them. Language gave music an explicit quality: it made the singing of a song a communication from singer to auditor, and if performed by a group, a communal declaration. A few music lovers in the late nineteenth century did argue that this specific communicative nature restricted the expressiveness of music, but most agreed that language detracted nothing from the expressive qualities of pure sound and in fact enlarged them, giving music an additional—and prized—level of meaning.[23] It is because of this added musical dimension that I have set apart Eakins' portraits of singers to be discussed last.

In his attraction to the singer for musical subjects, Eakins was not alone. Singers of opera were among the most popular musical heroes and heroines of the period, and in England, France, Germany, and America photographers assiduously sought their business for photographic portraits that could be reproduced and sold in the thousands.[24] Of painted images, the most

private collection). Photographs on the theme are in the collection of the Philadelphia Museum of Art and the Hirshhorn Museum and Sculpture Garden. For discussions see John G. Lamb, Jr., "Eakins and the Arcadian Themes," in William I. Homer et al., *Eakins at Avondale* and *Thomas Eakins: A Personal Collection* (Chadds Ford, Penn.: Brandywine River Museum, 1980); and *Yale Bulletin* 36, no. 1 (Fall 1976). In my own discussion, I differ from Goodrich (*Eakins*, 1982, I, 234) in identifying the figure on the far left in the relief *Arcadia* as female.

[23] Hugh Clarke, *Music and the Comrade Arts* (Boston and New York: Burdett, Silver & Co., 1889), pp. 106ff., states a point of view popular throughout the 1880s. Appointed in 1875 to the first Professorship of Music at the University of Pennsylvania (and currently with an appointment at Harvard, the first in the United States), Hugh Clarke was an organist, composer, and music historian. About 1893, according to Goodrich (1933, cat. no. 480), Eakins painted his portrait. That portrait does not survive, but a portrait of Clarke in 1911 by Benedict A. Osnic is in the collection of the University of Pennsylvania (see Agnes Addison, ed., *Portraits at the University of Pennsylvania*, Philadelphia: University of Pennsylvania Press, 1940, fig. 69).

[24] In addition to works mentioned in the Bibliographic Essay, reproductions of por-

memorable by Eakins' contemporaries are those of French café singers; these are distinctively from the world of entertainment. And in tone, many of those images are, if not cynical, disjunctive: Degas' café singers, for instance, garishly lit, seen from an unusual point of view, point up the disparity between the ostensible glamour of the role and the ordinary person underneath (Figure 92). Daumier savaged his performers, stripping the roles of their glamour.

Eakins, however, admired the song that was sung not in the café but in the parlor, not on the opera stage but on the concert stage. His preference is evidence not only of his devotion to activities generally thought of as of high "moral" seriousness but of a major difference between this aspect of public life in Philadelphia and public life in Paris.

In fact, Eakins' attention to the parlor and concert singer had virtually a national bias. In America, the voice, earnestly cultivated, was seen as the most democratic, the most modern of "instruments." Although the piano, the small instruments like the guitar and banjo, and the violin attracted middle-class players in large numbers, after 1850 more citizens studied the voice than any other musical instrument.[25]

Several factors contributed to this phenomenon. One was economic. By natural endowment, everyone—or almost everyone—had a voice. A piano was a major investment; other instruments, although less expensive, also required a degree of financial comfort. And unlike the piano, the voice was portable. The singer could make music at home—in the family parlor—and alone; or he could join singing societies, where with other devotees he enjoyed the great heritage of choral music from the past.

Perhaps the most important quality of the voice in its favor was that it directly expressed emotion. Indeed, throughout a century that prided itself on the emotional structure of its music, the special qualities of the human voice were commended as the ultimate measure of the beauty of a musical

trait photographs of singers are found in Daniel Blum, *A Pictorial Treasury of Opera in America* (New York: Grosset and Dunlap, 1954); and James Camner, ed., *The Great Opera Stars in Historic Photographs* (New York: Dover Publications, Inc., 1978). *American Art Journal*, *Philadelphia Musical Journal*, and others featured on the front page of every issue engravings or photogravures of famous singers and instrumentalists.

[25] See Loesser's rueful acknowledgment (in *Men, Women, and Pianos*, New York: Simon and Schuster, 1954) of the popularity of the song over even the piano, p. 546. Through the latter one-third of the century, such periodicals as the *Philadelphia Musical Journal*, *American Art Journal*, and even the *Atlantic Monthly*, reflect the national obsession with singing.

performance. The highest compliment one could give a pianist—a laborer on that most mechanical of instruments—was to say that he made his instrument sing. Mendelssohn, in fact, called entire groups of works that he composed for the piano "Songs without Words." The best zither player coaxed a human lament out of his small instrument.[26] Those who loved the guitar described it as a channel of human emotion, its vibrating strings the closest possible equivalent to the sensitive human voice.[27] Concert violinists and cellists were praised for the "singing" tone of their playing. Flutists, oboists, even conductors of orchestras strove to give their music the range of feeling, and the singing tone, of the human voice.

Although the string player could approximate the course of that emotion with sensitive bowing, the wind instrument player with careful blowing, and the pianist even more remotely with gradations of touch, all these techniques were, in the final analysis, translations. In contrast, the singer gave direct expression to emotions—to man's deepest fears and hopes—with the very instrument used to communicate them in speech.

For many lovers of music it was this sheer physical nature of the voice, a sound produced by man's own body, that gave it its power as a musical instrument. For these theorists, especially, the ideal singer was a woman. They held the voice to be the most transparent of instruments, and the woman, more likely than the man to be pure in character and particularly obvious in her emotional reactions, to possess the ideal singing instrument.[28]

For other lovers of the voice, the music derived its fundamental power from language. Songwriters developed texts that magnified the emotional content of music: texts that told tales of sorrow, of loss, and of regret. From composers like Schubert, of art songs, to composers of less demanding songs for the "mass market," writers cultivated in the song the broad range of melancholic experience and feeling.

The song, by its very nature, was perhaps best fitted to enhance, to relieve the tensions of, and to reflect the complexity of modern life. It was democratic, it was old and yet new, and it encouraged the expression of emotion.

[26] *North's Philadelphia Musical Journal* 4, no. 1 (January 1889), 12.

[27] Frederic V. Grunfeld, *The Art and Times of the Guitar* (New York, Macmillan, 1969), p. 174, quoting *The Giulianiad, or Guitarist's Magazine* (London), 8 (1833), 19.

[28] See especially Fanny Raymond Ritter, "Woman as a Musician: An Art-historical Study," published as a separate paper by William Reeves, London; presented at the Centennial in Philadelphia in 1876; and Arthur Elson, *Women's Work in Music* (Boston: L. C. Page & Co., 1904).

From young woman to physician, from student to clergyman, modern citizens, including Eakins himself, studied to become singers. Music publishing houses in America, England, and Germany produced more music for the voice than for all other categories of musical performance put together. In one character or another, the voice dominated public musical life—on the opera stage, in the concert hall, in the parlor, around campfires on the open range of the American West.

Eakins, who was not to achieve success as a singer himself,[29] painted singers in three of those situations: in the parlor, in the American West, and in the concert hall.

The Eakins household, in fact, was the scene of many musical gatherings that involved singing, and Eakins' painting of 1881, *The Pathetic Song* (Figure 93), conveys the earnest devotion to music making and the profound respect for the song that characterized these gatherings.[30] The painting is a large canvas, with portraits of three musicians. In the foreground the singer, Margaret Harrison (a student of Eakins), stands with a gentle attentiveness to the moment, totally given to the responsibilities of her singing; she holds the music before her at waist level and looks out to her hearers—who sit in our space as we study the picture—to convey the emotion of the song. She is a woman no longer very young; thirty years old (and due to be married later that year), Margaret Harrison had lived long enough to have the experience that gave the emotion in her song depth and conviction. Behind her, Susan Macdowell at the piano and C. F. Stolte[31] on the cello pay close attention to their supporting roles as accompanists: the pianist turns slightly toward the singer, sensitive to the slightest pause or change of dynamic level that would call for her mirroring it in her accompaniment, and the cellist focuses intently on the score of his obligato (a melodic line that paralleled or compli-

[29] According to Goodrich, *Eakins*, 1982, II, 83, Eakins' singing teacher gave up in despair.

[30] For a brief article on this painting, see *The Metropolitan Museum Bulletin* 37, no. 4 (Spring 1980), 40. The Museum owns a watercolor of the painting that Eakins did after he finished the oil and presented it to Margaret Harrison for posing. Also, see Rosenzweig, *Eakins Collection of the Hirshhorn Museum*, pp. 93-94; the oil study for the painting is at the Hirshhorn. A letter in the archives at the Corcoran Gallery of Art discusses Margaret Harrison's forthcoming marriage. Her brothers were the painters Alexander and Birge Harrison, who after their training in Paris, stayed there to work.

[31] Mr. Stolte, who died in 1888 at the age of 77, was a long-standing Philadelphia musician. For years he had been a cello instructor, and had taught, among many others, Charles M. Schmitz, who went on to become a conductor, cellist, and singer—and the teacher of Weda Cook, Eakins' concert singer. See *North's Philadelphia Musical Journal* 3, no. 7 (July 1888), 4.

mented that of the singer), the fingers of his left hand stopping notes high in the register of the strings, the fingers of his right hand holding the bow with precision.[32] Light falls across the scene from the left, bringing almost all its power to the central part of the painting: emphasizing the singer and her music score—although leaving part of her in shadow—picking up a touch of the music on the piano, and catching the cellist's white hair, his collar, and his part of his right hand. Subdued touches of color contribute to the soft dignity of the atmosphere: the violet dress of the singer, the oriental rug, the yellow-green vase in the background, the ornate picture frame. A late-afternoon duskiness, achieved with broad brushstrokes and dabs for the wallpaper, unifies the picture—and the music making.

Eakins' particular devotion to the unity of the ensemble that creates the song is emphasized by comparing his painting with the French artist Henry Lerolle's *A Rehearsal in the Choir Loft* (Figure 94), a painting that entered the collection of the Metropolitan Museum in 1887. In showing his two musicians making music, Lerolle was interested in the vast space of the church, in the gathering of listeners, one of whom turns toward us as though caught by a photograph, the incidental detail of books and sheets of music on the floor. Not only is the singer turned away from the viewer, projecting her music to auditors who do not occupy our space, but the musicians themselves—singer and organist—exist in totally separate worlds; the organist, in fact, has his own audience (although she may also be serving as a page turner). In Eakins' picture, on the other hand, there is no such dispersion of interest, no willingness to distract our attention from the making of music with incidental details. The singer is brought close to the viewer; the other musicians are her accomplices; the singing of the song, the making of the music, is his single focus. Indeed, when he first exhibited the painting, he called it *Singing a Pathetic Song*.[33]

With the title of his painting, Eakins specified that he was celebrating the

[32] Eakins' observation of the turn of the head of the supportive pianist is very much like that of Adolph von Menzel in his drawing of Clara Schumann accompanying Joseph Joachim, the violinist. Staattsbibliothek, Berlin, 1854 (See Helen Rice Hollis, *The Piano: A Pictorial Account of Its Ancestry and Development*, London: David and Charles, 1975, Plate 79).

[33] Eakins first exhibited the work at the 4th annual exhibition of the Society of American Artists (no. 21) as "Lady Singing a Pathetic Song"; on October 23, 1882, the painting was seen in exhibition at the Pennsylvania Academy of the Fine Arts as "Singing a Pathetic Song." The *American Art Review 2*, 2nd div. (1881), 72-73, reviewed the painting as a "quiet but effective domestic scene in this artist's happiest vein."

rendition of a particular type of song. The several types of texts that had strong appeal for American singers were distinguished by a dominant theme, such as mourning, remembrance, patriotic fervor, love, and pathos. Throughout the 1860s and 1870s the most popular theme was pathos, and the most popular type of song the "pathetic song"—one that told a poignant tale of loss or regret. Constructed of several verses and a repeating chorus, the pathetic song typically featured a text that today would be considered maudlin: a story of a child who saw visions that were premonitions of his death (which occurred at the end of the song), or of a street urchin who starved to death, or of a woman who died in a nunnery after her lover abandoned her.[34] Although many of the texts of the pathetic songs suggest that the audience had a high degree of sympathy for the unfortunate classes, the songs more properly permitted listener and singer alike to grieve publicly for private, unacknowledgeable sorrows. The singer narrated the story, often as though it had happened to her; this first-person telling moved the audience to profound sympathy. The accompaniment both strengthened and distanced the pathos: while a cello might play an affecting obligato, the piano part—even though the harmony was sentimental—would provide a steady rhythm that drove the song to its conclusion. Music at its best could move one to tears, and the pathetic song was popular because it dependably did so—providing a release from the tensions of striving, of rationality, and of control that marked the era.

[34] The term "pathetic" had roots in eighteenth-century aesthetic theory where it denoted the capacity of a work of art (gently) to arouse feelings. By the time of the Civil War in America, when the song known as "pathetic" was at its height in popularity, its means were anything but subtle. Many songs known as pathetic are preserved in the Free Library of Philadelphia. Periodicals, newspapers, and concert programs of the period show the particular popularity of the songs "Birdie in Heaven" by H. P. Danks, about a dead child (who is the "bird" of the title), advertised in *Amateur* 5, no. 2 (October 1874), as a "beautiful song appealing to the better feelings"; Eastburn, "Died in the Streets," about a child who "Died for the want of a crust of bread, with no one to pity or care" (advertised as a "very pathetic ballad, founded on a sad incident"); George W. Persley, "Not a Crust; or the Beggar Boy," advertised in *Amateur* 1, no. 7 (March, 1871) as "a song for the hearts of the people;" Louis Brewster, "The Dying Nun," first printed in 1865; and G. Braga, "Angel's Serenade," 1877 (published with a cello obligato), about a child who sings to her mother of her own approaching death. The all-time favorite song—although it was not restrictively a pathetic song—was apparently H. P. Danks' "Silver Threads Among the Gold," first issued in 1873 (the first line to which is "Darling, I am growing old"); the music was so popular that it was arranged for trombone and piano; brass band; orchestra; guitar and banjo ensembles; and the words "Jesus, Lover of my soul" were set to it.

Sorrow just under the surface awaiting release was a characteristic of nine-teenth-century life that Eakins was to pursue in his other singing portraits as well.

For three of these, Eakins drew on his experiences in the Dakota territory in the summer of 1887. His friend Dr. Horatio Wood (Figure 110), recognizing Eakins' emotional exhaustion in the aftermath of his forced resignation from the Pennsylvania Academy of the Fine Arts, had recommended that to recover, Eakins spend several weeks on a ranch in the northwestern part of the territory. Essential to the cure was that he sleep and eat outdoors—"on the line" with the cowboys—and he followed Wood's instructions to the letter, staying two months and bringing back with him memorabilia that included a cowboy suit, saddle, and two horses. After he returned to Philadelphia, Eakins painted images of the cowboy in a role that artists before him, attracted to the riding and roping skills of the cowboy, ignored: that of music maker (Figures 95 and 96).[35]

Cowboy music was just then developing the distinctive qualities for which it has since become known. It sprang up in the tradition of the personal lament, reflecting the physical roughness and the loneliness of cowboy life: when cowboys were on the "line," or in what Theodore Roosevelt called the "great dreary solitudes" of the vast ranges—which was most of the time—they had to endure sleeping on the hard ground, an unvarying diet, waves of heat and cold and dust, and sudden violent storms.[36] The animals they protected were for long stretches of time their only companions. Often cowboys sang at night to soothe the cattle and to keep themselves awake at their guard post, playing along on a treasured banjo or guitar. Their texts—sung to simple melodic lines shaped into stanzas, with repeated choruses—focused on the loneliness of their lives, on their shy hopes for their future (once they had earned a "stake"), on loves they had lost, and—in a territory where natural and man-made violence were rampant—on death. Some of the songs were lightened with occasional humor, but throughout them all lay the dark undercurrent of melancholy. Among them were such songs as "The Ram-

[35] See Archie Green, writing on cowboy music and images in the *John Edwards Memorial Foundation Quarterly* 8, pt. 1 (Spring 1972), no. 25, pp. 196-202.

[36] Theodore Roosevelt's series of articles on Dakota life made the cowboy a topic of national conversation. Published in *Century Magazine* in 1888, they were entitled "Ranch Life and the Far West" (February); "The Home Ranch" (March); "The Round-Up" (April); "Sheriff's Work on a Ranch" (May); "The Ranchman's Rifle on Crag and Prairie" (June); and "Frontier Types" (October).

bling Cowboy," the lament of a cowboy whose woman has deserted him; "The Dying Cowboy," still a favorite, the first line of which is "Oh bury me not on the lone prairie"; "The Melancholy Cowboy," and "The Old-Time Cowboy," regretting the old ways being left behind. These were the songs that cowboys improvised, brought back to the comfort of the ranch after weeks on the line, shared, and taught to visitors from back East. These were the songs that Eakins evoked in his paintings of the cowboy singing.

He chose as his model his student Franklin Schenck, an individualist and sensitive singer, guitarist and banjo player himself.[37] Although in all three images Eakins painted Schenck seated in a chair, conveying the setting of the ranch rather than the campfire, in two images (one a watercolor, the other an oil), in which Schenck sings and accompanies himself on the banjo, the light background wash simply locates him on a ground plane. In both of these images, however, the mood is sufficiently established without a background: Schenck is practically lost in his singing, his gentle melancholy a contrast to his rugged costume and gun.

The third painting (Figure 96), showing the cowboy musician in a complete setting, is a kind of companion to the *Pathetic Song*. In *Home Ranch*, the singer, this time playing a guitar, holds forth in what is his parlor when he comes off the line: the ranch kitchen. Instead of the oriental vase and stylish furnishings of a parlor, *Home Ranch* reveals the plain table of a ranch kitchen, the guns and hats of tough outdoorsmen leaning against the walls, and a listener (another one of Eakins' students) sitting at a table bluntly holding a fork.[38] In the dark warmth of the ranch kitchen, the source of companionship as much as of nourishment, the cowboy—like the parlor singer—has a haven. There he can share his fears, there his solitude enters community life.

The cowboy's themes of loneliness, of anxiety were those of which Easterners sang, too, but less directly—often, in fact, in disguise.

But if Easterners could not quite approach the directness of the cowboy song (until, much later, when such songs became quite fashionable), as city dwellers they had a source of strength in another aspect of the song: in its

[37] Years later Nelson C. White wrote of Schenck's distinctively individual life after he left Philadelphia, one of solitude and harmony with nature on Long Island. "Franklin L. Schenck," *Art in America* 19, no. 2 (February 1931), 85-86. In 1890 to 1892, when Eakins painted Schenck, the sitter, born in 1856, was in his mid-thirties—his face just achieving the kind of look that interested Eakins.

[38] The student holding the fork is Samuel Murray; the gesture, like that of Mrs. Frishmuth in *Antiquated Music* (Philadelphia Museum of Art) is blunt and startling—but certainly to the point.

popularity for choral groups. And the most distinctive choral life of the song in mid- and late-nineteenth-century music making was in the oratorio. Eakins tapped this lode of community experience with his painting the *Concert Singer*.[39] A work imposing in scale and in idea, the painting is the climactic expression of musical themes that absorbed Eakins throughout his life.

The career of his singer, Weda Cook, demonstrated—as ideally, a singer's career should—the democratic opportunities in music making. From a large family in Camden who lived in humble circumstances, Cook had had to struggle to study and in doing so had received the encouragement of several established members of the community.[40] One of those was her teacher, the well-respected Philadelphia musician Charles Schmitz; others included journal and newspaper critics who praised her publicly. Still another was Eakins himself, who undertook her portrait in recognition of her hard work and success.

Cook had been singing publicly in Philadelphia as early aas 1887, when she was a young woman of twenty. The reviewer of her concert that year assessed her talent as powerful and promising: "The event of the evening was the appearance of Miss Weda Cook, of Camden (one of Conductor Schmitz's pupils), whose powerful contralto voice, unassuming manner and thorough training won the most enthusiastic tributes from the critical assemblage. Miss Cook's voice is undoubtedly phenomenal, and, should she decide upon a stage career, she seems destined to make a sensation one of these days. . . . Mr. Schmitz was highly elated over the clever appearance and strong impression made by Miss Cook, and well may he feel proud of her as she is a very capable pupil."[41] Cook's career over the next three years justified these expressions of confidence. She performed in Camden and Philadelphia, and in many capacities: in concert with the St. Paul Choral Society

[39] The Philadelphia Museum of Art owns Eakins' oil sketch for the painting. For a discussion of the finished portrait, see Siegl, *Eakins Collection*, pp. 126-129; and Synnove Haughom, "Thomas Eakins' *The Concert Singer*," *Antiques* 108, no. 6 (December 1975), 1182-1184. These authors are among those who speculate what syllable she must be singing, taking their cue from Goodrich's report (*Thomas Eakins: His Life and Work*, New York: Whitney Museum of American Art, 1933, p. 144) that Eakins watched Cook's mouth and throat "as if under a microscope."

[40] This information can be gathered from newspaper and journal reports of Cook's appearances, as well as from correspondence in a private collection.

[41] *North's Philadelphia Musical Journal* 3, no. 1 (January 1888), 7 (reporting a concert on December 18, 1887). According to Goodrich, *Eakins*, II, 84, Cook had made a formal debut at the Philadelphia Academy of Music when she was sixteen.

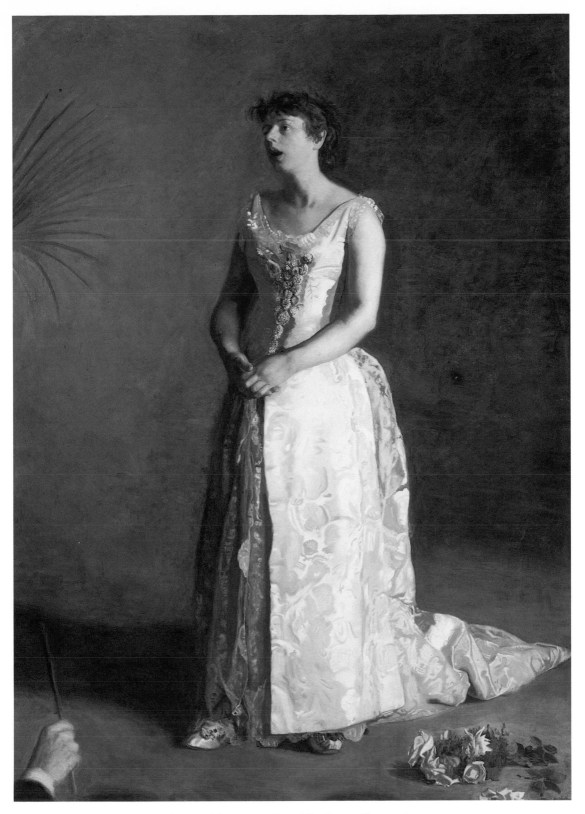

Plate 10. Thomas Eakins, *The Concert Singer*, 1892.

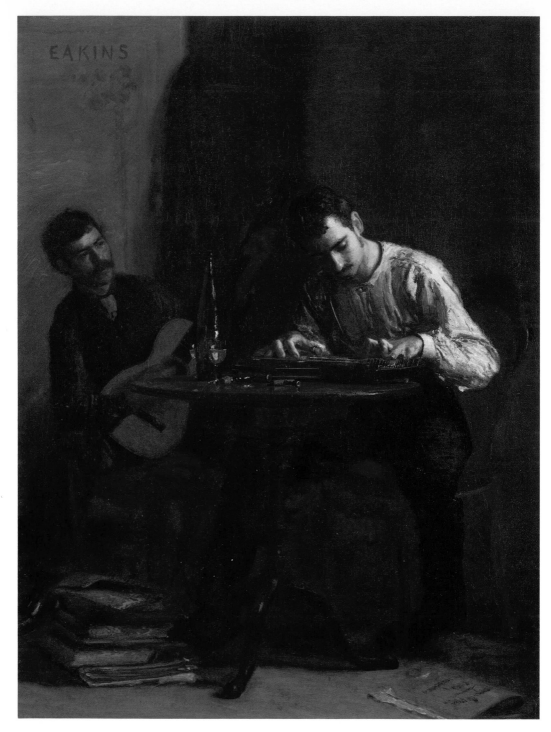

Plate 11. Thomas Eakins, *Professionals at Rehearsal*, 1883.

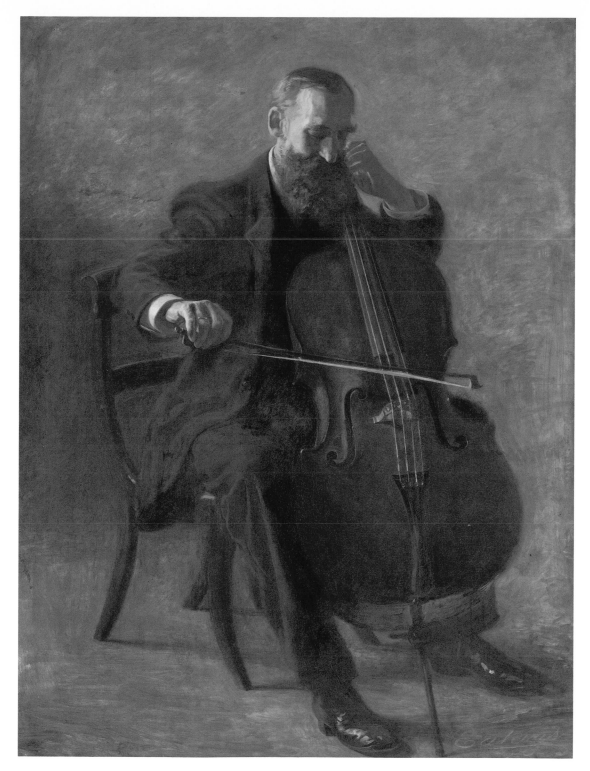

Plate 12. Thomas Eakins, *The Cello Player*, 1896.

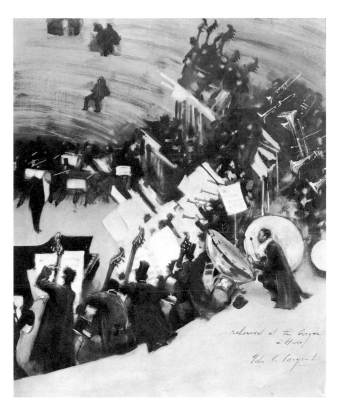

Figure 72. John Singer Sargent,
*Rehearsal of the Pasdeloup
Orchestra at the Cirque
d'Hiver*, ca. 1870.

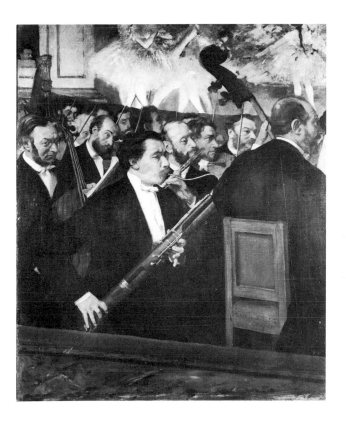

Figure 73. Edgar Degas,
*The Orchestra at the
Opéra*, ca. 1869.

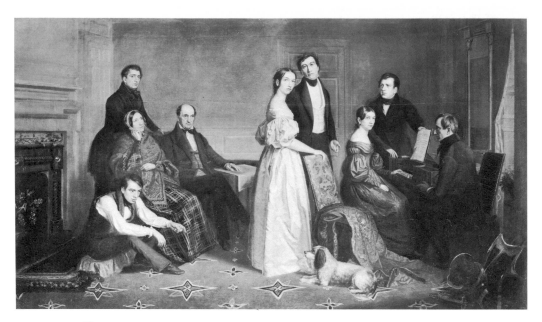

Figure 74. George Hollingsworth, *The Hollingsworth Family*, ca. 1840.

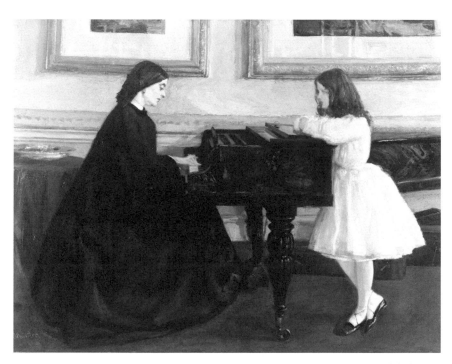

Figure 75. J. M. Whistler, *At the Piano*, 1859.

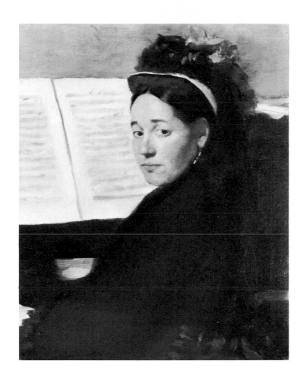

Figure 76. Edgar Degas, *Mlle. Dihau at the Piano*, ca. 1869.

Figure 77. Thomas Eakins, *Home Scene*, ca. 1871.

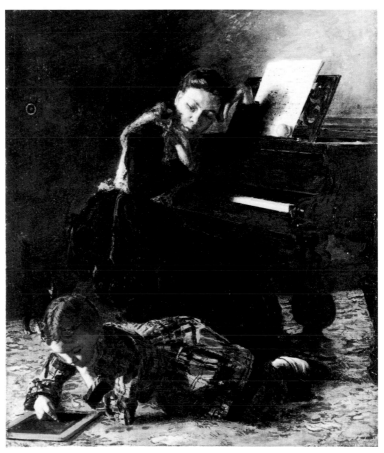

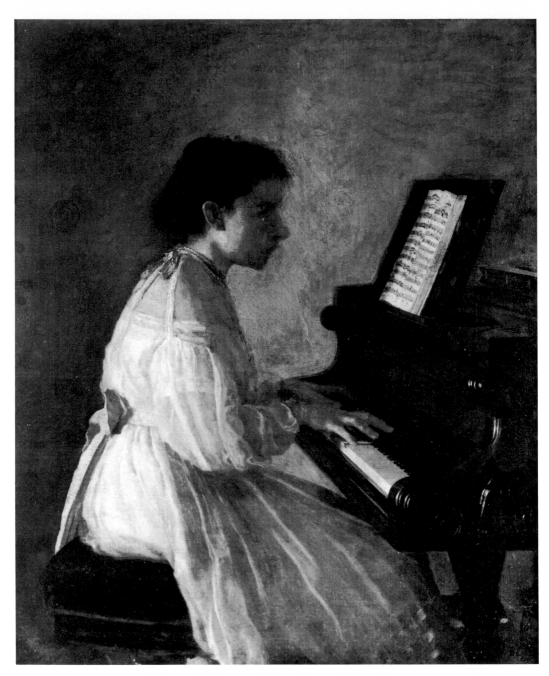

Figure 78. Thomas Eakins, *Frances Eakins*, 1870.

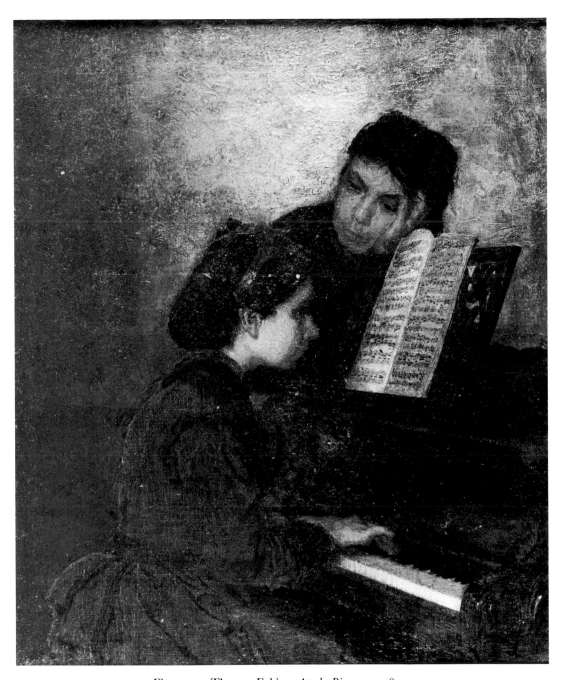

Figure 79. Thomas Eakins, *At the Piano*, ca. 1872.

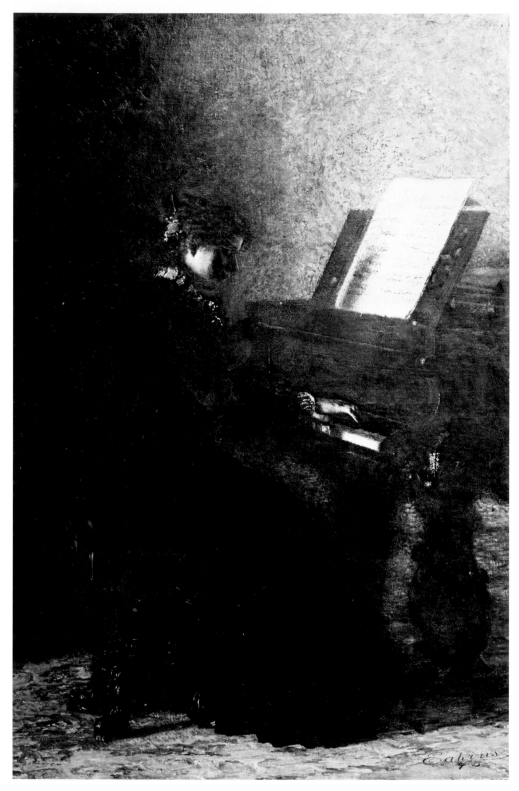

Figure 80. Thomas Eakins, *Elizabeth at the Piano*, 1875.

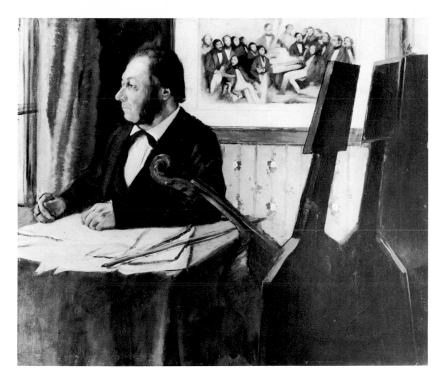

Figure 82. Edgar Degas, *The Cellist Pillet*, ca. 1869.

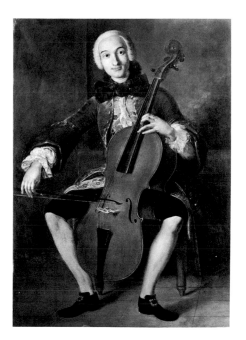

Figure 81. Pompeo Batoni, *Luigi
Boccherini*, 1800.

Figure 83. *F. A. Kummer*,
photograph, ca. 1865.

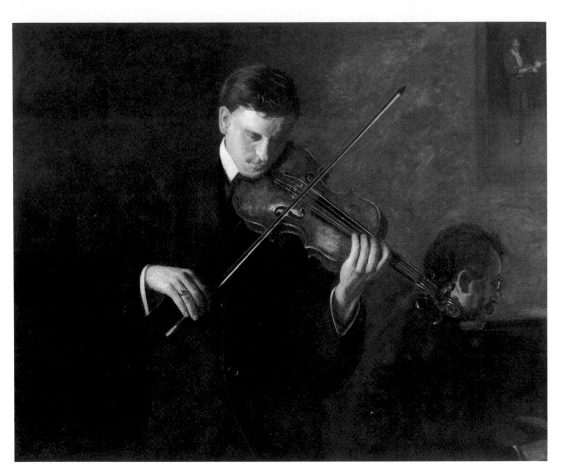

Figure 84. Thomas Eakins, *Music*, 1904.

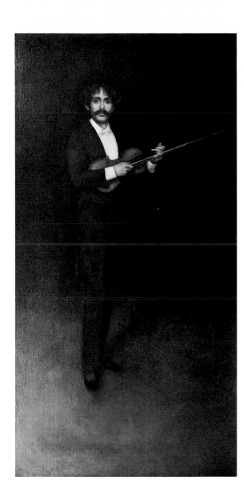

Figure 85. J. M. Whistler, *Arrangement in Black: Pablo de Sarasate*, 1884.

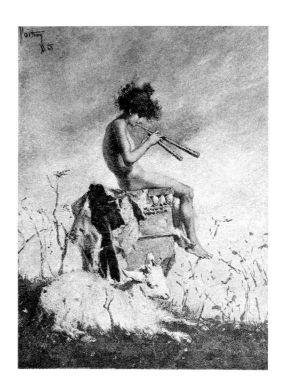

Figure 86. *The Piping Shepherd*, wood engraving after Fortuny, *Scribner's Magazine* October 1879.

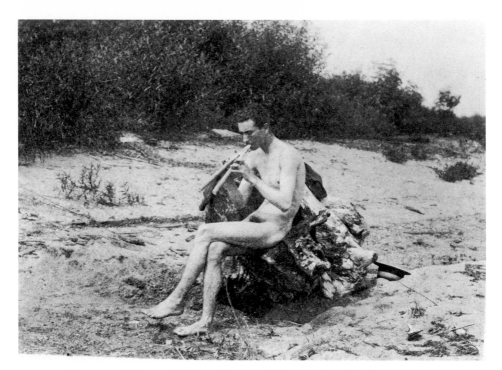

Figure 87. Thomas Eakins, *Photograph of J. Laurie Wallace Seated on Rock, Study for Arcadia Relief*, 1883.

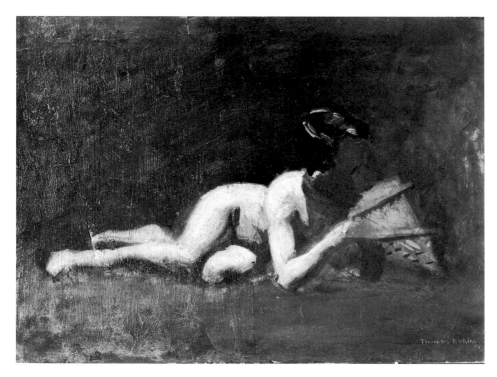

Figure 88. Thomas Eakins, *Study of Ben Crowell for Arcadia*, 1883.

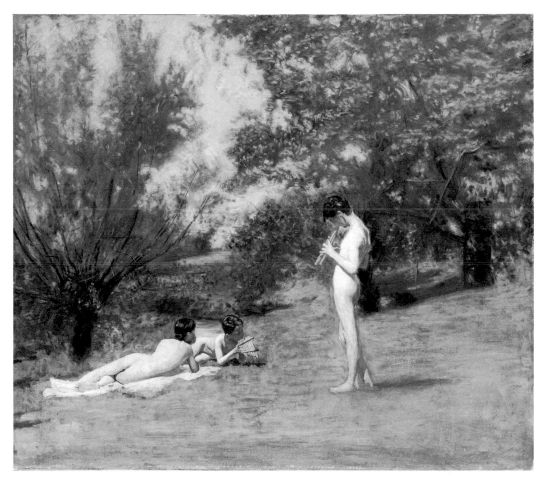

Figure 89. Thomas Eakins, *Arcadia*, oil on canvas, 1883.

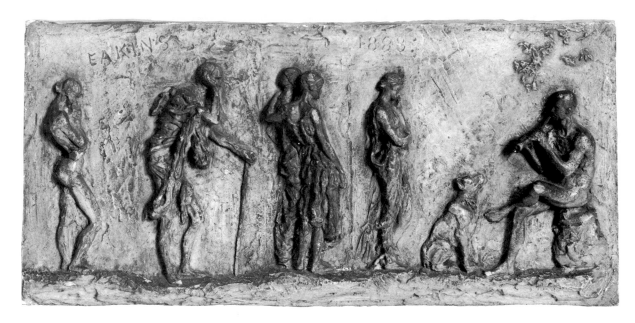

Figure 90. Thomas Eakins, *Arcadia*, plaster relief, 1883.

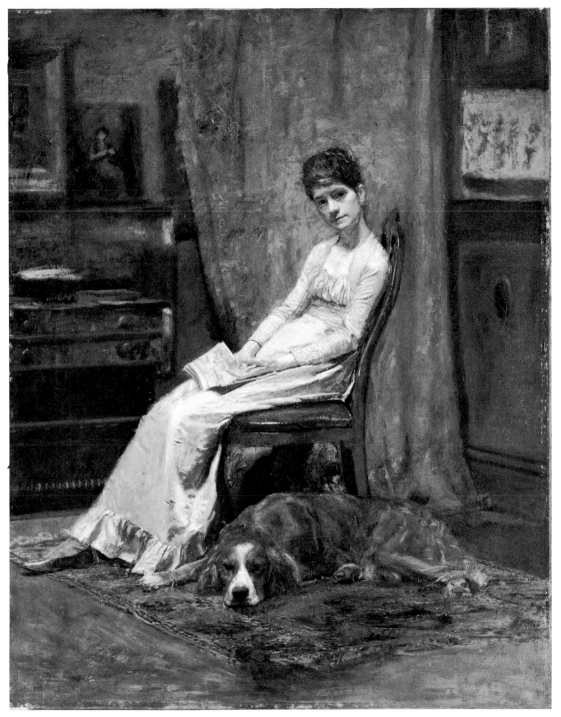

Figure 91. Thomas Eakins, *Portrait of a Lady with a Setter Dog* (Susan Eakins), ca. 1885.

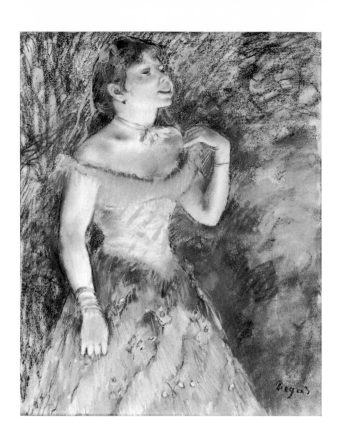

Figure 92. Edgar Degas,
The Singer in Green, pastel,
ca. 1885.

Figure 94. Henry Lerolle, *A Rehearsal in the Choir Loft*, 1887.

Figure 93. Thomas Eakins, *The Pathetic Song*, 1881.

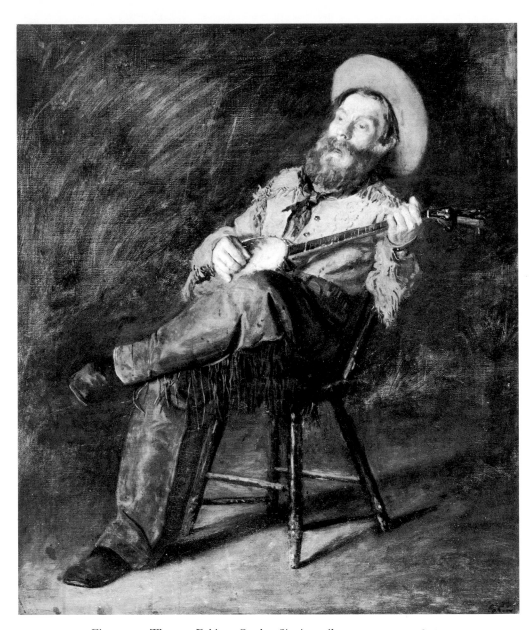

Figure 95. Thomas Eakins, *Cowboy Singing*, oil on canvas, ca. 1890.

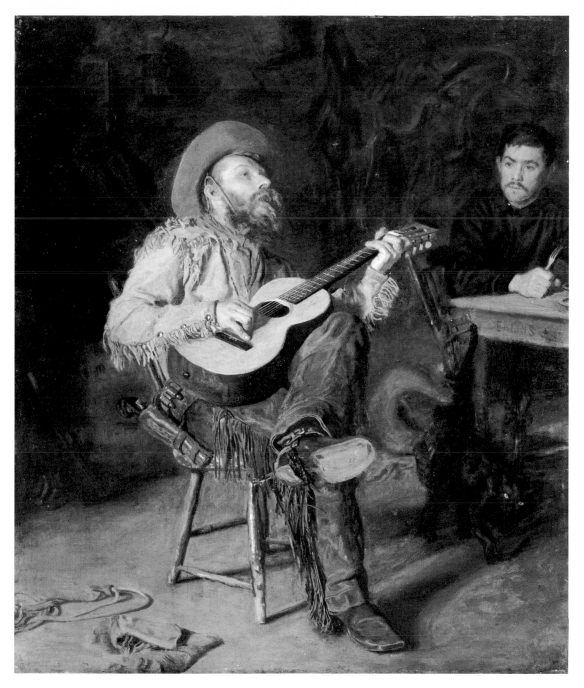

Figure 96. Thomas Eakins, *Home Ranch*, ca. 1892.

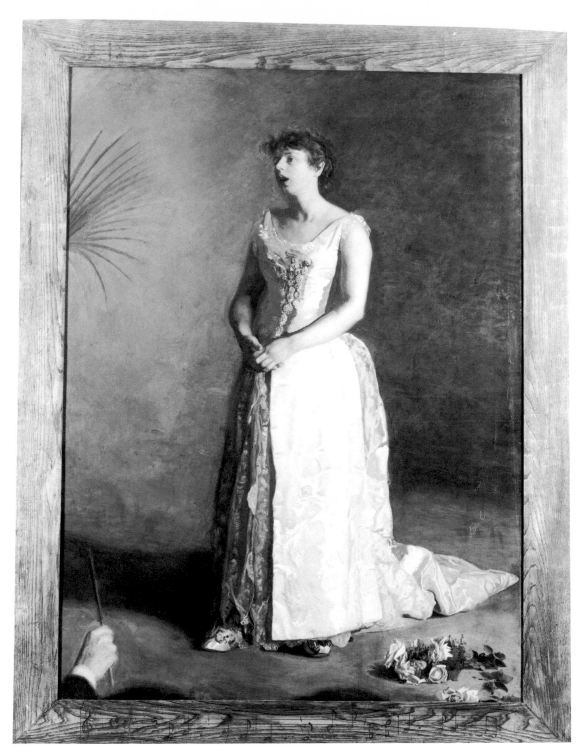

Figure 97. Thomas Eakins, *The Concert Singer*, 1892.

Figure 98. Photograph of Clara Louise Kellogg as Aïda.

Figure 99. Paul Weber, *Portrait of an Opera Singer*, 1839.

Figure 100. *Parepa Rosa Reynolds*, engraved frontispiece to *North's Philadelphia Musical Journal*, July 1887.

of Camden, as soloist at three churches in Philadelphia, in small musicales and in general recitals. In a very short time she became a well-loved singer throughout the area.[42] Eakins, introduced to her by mutual friends, asked her to come to his studio to pose. She did so, for almost two years.

For the portrait Eakins used one of his most unusual palettes—a light one dominated by greens and pinks—to capture the freshness of Weda Cook's youth and her devotion to the making of music. She sings on a concert stage, her head tilted in concentration and chin lifted to project her voice, and her hands clasped in front of her in calm self-possession. In the lower foreground, Eakins painted dark shadows to suggest the hoods of footlights, and in the upper left, a solitary frond, to convey the presence of an ornamental palm. Weda Cook's teacher holds the baton, though only his hand is visible, as he conducts the performance. On the floor near the singer's feet lies a floral bouquet. Across the lower part of the frame that Eakins made for the painting, he completed his tribute to Weda Cook with one more significant detail: he carved into it the opening phrase of Mendelssohn's aria "O Rest in the Lord," from the oratorio *Elijah*.

In the type of image Eakins chose to impart the public nature of Cook's music making (as opposed to the Hausmusik tradition of the *Pathetic Song*), he drew on the repertory of portrait photographs of opera and concert singers. Typically showing the singer in costume and on stage these photographic portraits flattered the singer posed in her best concert form (Figure 98). Her chin might be lifted, her arms dramatically tensed, but she would not actually be singing. As singers were usually renowned for one particular role, portraits typically alluded to that role with a costume, or a stage property (the spinning wheel from Gounod's *Faust* was popular), or even a conspicuous piece of music. A plain setting of palms, and occasionally also of a half column, depicted the stage on which a concert singer performed. Philadelphia painter Paul Weber, for instance, painted an opera singer particularly identified for her role as Iphigenia in Christoph Gluck's two operas on

[42] See A. A. DuBois, *Directory of Organists and Church Choirs in the City of Philadelphia*, 1891-1892; programs in the Scrapbooks of Thomas A'Beckett (February 18, 1887; January 17, 1890; May 29, 1894; May 13, 1897); program preserved in the Camden County Historical Society, New Jersey, of a concert at St. Paul's Church, Camden, January 14, 1886; reports in the Camden newspapers of concerts in Camden in which Weda Cook participated (in the *Camden Daily Courier*, for example, on May 23, 1889; January 11, 1890; and April 19, 1890; in the *Camden Post* on January 15, 1886; February 4, 1891; and others). On several of these occasions Cook sang works by Mendelssohn; on others, works in the repertory of the pathetic ballads, particularly Braga's "Angel Serenade."

the theme, with a piece of music rolled up in her hand that featured an identifying text (Figure 99). And the popular concert singer Parepa Rosa Reynolds, famous for her rendition of "Home, Sweet Home," was photographed late in the century holding a copy of music adorned in large letters with the name of that song; as a wood engraving, the image adorned the front page of the *Philadelphia Musical Journal* (Figure 100).

Eakins made his own adjustments to those conventions. First, as he conceived of the musician and his music making as an entity, he showed Weda Cook, like the pianists, like the zither player, the cello player, and the violinist—even though it was definitely not "done" in the repertory of images of concert singers—in the midst of making music. Second, he included significant props. On the left, the palm frond identifies her performance—in the absence of any set—as that of a concert rather than an opera. And third, he painted the hand of her teacher Charles Schmitz as the conductor to place the singer in the context of support from an important member of the community.[43] The bouquet testifies to the community's appreciation.[44] And Eakins carefully specified Weda Cook's best role, with his carving on the frame of the opening phrase of the aria by Mendelssohn. He was to write later that the very phrase embodied, for those who knew it, the "expression of the face and pose of the figure."[45]

As was true of the pathetic song, the oratorio—and particularly Mendelssohn's *Elijah*—had a special importance in late nineteenth-century life.

Although Handel's treatment of the oratorio form in the eighteenth century had first brought the oratorio to wide public popularity in English-speaking countries, its history before Handel determined its continuing character. The oratorio had originated in the Counter-Reformation, as one of several art forms sponsored by church leadership to combat waning religious belief. To attract and affect the average listener, the form combined religious and secular elements—stories from the Scriptures, and dramatic line and

[43] Since Weda Cook sang with the St. Paul Choral Society in Camden, she did not ordinarily sing under Schmitz's conducting except when he took the place of the St. Paul's conductor (for such an occasion, see the *Camden Daily Courier*, May 23, 1889).

[44] Only about mid-century had the custom developed to place floral tributes at the feet of the concert artist. See Nicolas Sloninsky, "The Plush Era in American Concert Life,"

in Paul Henry Lang, ed., *One Hundred Years of Music in America* (New York: G. Schirmer, Inc., 1961), pp. 109-127.

[45] Letter to Professor Rowland, October 4, 1897, Addison Gallery of American Art. Gordon Hendricks' assertion (*The Life and Work of Thomas Eakins*, New York: Grossman Publishers, 1974, p. 193) that Eakins carved the phrase inaccurately is not correct.

varied musical forms from the opera. Most typically the text was taken from the Old Testament; it traced the struggle of a prophet or of a group of people against evil, destruction, and despair, with the drama culminating triumphantly in God's rescue of the individual or restoration of his chosen people. Although the drama was not acted out literally, the musical exchange was lively and gripping. Soloists sang the roles of protagonists, antagonists, the narrator, and sometimes God's messengers. The chorus, and small sections of it, voiced the inner doubts of the leading characters and expressed the responses of the protagonist's or antagonist's community to the ongoing action.

In the nineteenth century newly popular singing societies made the oratorio one of the basic elements of their repertory. Although these societies originated in England and Germany, they also sprang up across France and America, and by 1860 on both sides of the Atlantic societies of hundreds of voices were performing the oratorio repertory in public concerts in churches, concert halls, even outdoors. Acting vicariously for the audience, the soloists and chorus were a veritable cross section of social levels. Indeed, the comingled secular and sacred elements of the oratorio satisfied in the nineteenth century the very impulses for which it had originally been devised: in an era when faith was on the decline, the oratorio affirmed that the material world had dependable underpinnings. If the chorus and audience of the late nineteenth century could no longer assent unanimously that these foundations were religious, they could agree that they were moral, at least.

Mendelssohn was the composer who seemed to many nineteenth-century music lovers to bring the potential of the oratorio to full expression. His music in general was both carefully structured and expressive of feeling; indeed, its nuances were so pure and understated that it was generally called—with complete approval—feminine. Almost immediately after his first oratorio, *St. Paul*, was performed—in 1836—singing societies took it into their repertory with such commitment that soon it rivaled all previous oratorios in popularity, eclipsing even the all-time favorite by Handel, *Israel in Egypt*. Twelve years later, Mendelssohn's *Elijah* in turn carried off the laurels and was performed in every major city in Europe and America.

Philadelphia singing societies did not perform the work so early as did their New York rivals, but once they began they repeated it devotedly. In the late 1880s and 1890s it could be heard in performance by singing societies and church choirs at least once a year and, occasionally, as many as three and four times in a season. Solos and choruses from it were staples in the

141

repertory of soloists and church choirs. The Philadelphia musical publication the *Amateur* found it to be almost a national expression: "No man ever wrote more in the presence of his public and less in the seclusion of his study than Mendelssohn, and in no other work has he so finely calculated the capacities of the ordinary music-loving mind, and so richly poured forth treasures which the most experienced musician will find if not inexhaustible, yet always perfect."[46]

Underlying *Elijah*'s appeal for a late nineteenth-century audience was the eminent adaptability of its major religious conflict to one of a less specific but nonetheless spiritual nature. The drama traces a confrontation between the prophet Elijah and the rebellious king and people of Israel. In the oratorio Elijah calls King Ahab and the Israelites to penitence; he succeeds in converting them; but then they fall away. God does not punish them for their defection and Elijah feels God has deserted him; he sees his efforts as having been fruitless, his righteousness unappreciated. At the point of his greatest despair, God's messenger, the contralto, comes to him to sing quietly: "O rest in the Lord; wait patiently for Him, then He shall give thee thy heart's desires. Commit thy way unto Him, and trust in Him, and fret not thyself because of evil doers." From the messenger's words, Elijah takes comfort, and not long after, even though the Israelites remain unrepentant, he is carried to heaven.

Late nineteenth-century singers and listeners found deeply satisfying the oratorio's assurance that though discouragement and disillusionment were man's lot—even God's prophet had suffered them—and the world seemed to be dominated by evil forces, moral order would prevail. The contralto soloist, as the angel who sang "O rest in the Lord," was the bearer of that welcome reassurance.

The text of the aria is simple, built on the repetition of only a few phrases that set forth the ideas of "rest," of "waiting," of "patience," and of "trust." It is a text in which the circumstances that prevent man from putting his trust in an invisible power are frankly acknowledged, and man is urged to persist, to endure.

The music, too, is simple and unostentatious. It supports the emphasis of the text on the key ideas of "rest" and "wait." The metric pattern is elemental; the melody has subtle repetition and a delicately contrasting middle section. About mid-way through the contrasting section the opening phrase

[46] *Amateur* 2, no. 6 (February 1872), 88.

returns unexpectedly to surprise the listener, encouraging him that comfort, too, may arrive unexpectedly. A simple coda, emphasizing the word "wait," brings the song of assurance to a close.

The very opposite of virtuosity, an expression more communal than the narrative pathetic song and the personal lament of the cowboy, "O Rest in the Lord" was a universal favorite. Sung within or separately from the oratorio, in situations secular as well as sacred, the aria was uppermost in the repertory of every concert and church singer. Its text reinforced by its music offered assurance that an eternal order underlay material life, that suffering was inevitable but not final, and that man's spirit would eventually be sustained.

And in his very work on the portrait—in his celebration of those convictions—Eakins was to need that sustenance. Cook, acting on the report that the artist had contributed to the insanity and suicide of his niece with sexual improprieties, stopped posing before he had completed the portrait. He finished it without her. The informant later retracted the accusation, and Cook returned to Eakins and posed for a bust portrait.[47] Years later, she wrote him that she would like to have the large portrait. Eakins responded, however, by writing that because of the mingled memories, happy and sad, which the picture held for him, he could not part with it.[48] It was one of the many portraits that would stay in his studio all of his life.

Music, whether of the resonant piano or the simple zither, the virtuoso cello or the rich contralto voice, came from beneath the rational surface of contemporary life and the apparatus of progress to pull man out of his materiality, to give expression to—whether directly or indirectly—the loneliness and the anxiety, and to reassure the dubious that even in modern life there could be found sustenance in the ideal. Music was the verso of worldly heroism, and, toward the end of the century, a consolation for its failures. And in Eakins' portraiture, it claimed its proper place.

[47] Goodrich, *Eakins*, 1982, II, 136, reports the separation. The later portrait is in the Columbus Gallery of Fine Arts. It was perhaps a companion to the bust portrait Eakins painted of Stanley Addicks in 1895, the year after Addicks and Cook were married.

[48] Quoted in Haughom, "Thomas Eakins' *The Concert Singer*," p. 1184.

Walt Whitman

IN 1887 EAKINS' friend the Philadelphia journalist Talcott Williams took him to meet Walt Whitman at Whitman's house in Camden. The poet later reminisced about the introduction—and its consequences—to the young Horace Traubel. " '[Eakins] came over with Talcott Williams: seemed careless, negligent, indifferent, quiet: you would not say retiring, but amounting to that.' They left. Nothing was heard from them for two or three weeks. 'Then Eakins turned up again—came alone: carried a black canvas under his arm: said he had understood I was willing he should paint me: he had come to start the job. I laughed: told him I was content to have him go ahead: so he set to: painted like a fury. After that he came often—at intervals, for short stretches.' "[1] The portrait (Plate 13) became Whitman's favorite, and Eakins a man whom he admired.[2]

[1] Horace Traubel, *With Walt Whitman in Camden*, Vol. 4 (Philadelphia: University of Pennsylvania Press, 1953), 155 (February 15, 1889). Eakins painted Talcott Williams about 1890 (private collection). Williams, a writer, was a stolid Whitman supporter (to which, as a member of the editorial staff, he contributed the efforts of the *Philadelphia Press*), world traveler, collector, and amateur archeologist and orientalist. His wife, anxious to belong to the proper "Salon" circuit in Philadelphia society, took offense to Eakins' portrait of her in mid-process—he wanted her to pose unaffectedly, while she had in mind something more grand—and stopped her sittings (Philadelphia Museum of Art).

[2] Traubel, *With Walt Whitman*, vol. 4, pp. 104, 227; Vol. 5 (Carbondale, Ill.: Southern Illinois University Press, 1964), 413. A large number of painters, sculptors, and photographers came to Mickle Street during Whit-

man's old age. The phenomenon was of great interest in Philadelphia: *North's Philadelphia Musical Journal* 2, no. 9 (September 1887), 7, reported: "Walt Whitman, the venerable Camden poet, has become a favorite subject for artists. During the last six months J. W. Alexander, of Pittsburgh, has completed a life-size study in crayon; Mr. Mone, the Boston sculptor, has modeled a head and a statuette of the poet in his chair; Hubert H. Gilchrist, of England, has finished a portrait in oils; Augustus St. Gaudens is planning a trip to Camden to take studies for a bust; and Thomas Eakins has begun work on a portrait." Eakins' study for his portrait of Whitman is in the Museum of Fine Arts, Boston. He reworked the finished painting in the area over Whitman's head and changed the date; under the "7" of "1887" is a "9," which apparently had covered an earlier "7."

When Eakins painted Whitman, the poet was sixty-eight years old. Although he had virtually stopped writing new poems for *Leaves of Grass*, Whitman had not stopped writing altogether; the next year, in fact, he was to publish the stunning essay, "A Backward Glance O'er Travel'd Roads." But after his stroke of 1873 he had led a retired life. During his earlier years, in contrast, he had been vigorous, energetic, always on the move.

Despite the awkwardness of their introductory meeting, Eakins and Whitman were drawn to each other almost immediately. For one thing, they had a similar personal manner. Whitman was never one to observe the stiff formalities of "cultivated society," and Eakins wasn't either. In fact, Whitman was impressed by the almost brash quality with which Eakins met strangers. After Whitman had known Eakins for several years, he complimented him to Traubel as being "no usual man"; claiming that while Eakins lacked "parlor gallantries," he had "something vastly better," including "the graces of friendship."[3]

Whitman and Eakins also felt a bond in the difficult relationships they had with their public. The problems they experienced were complex in cause. Whereas Whitman had angered a few readers with the sexual fervor of parts of his work, on the vast majority of the reading public he had made no impression at all. It is true that Emerson pronounced the 1855 version of *Leaves of Grass* as "the most extraordinary piece of wit and wisdom that America has yet contributed" and hailed Whitman "at the beginning of a great career," but it is also true that Emerson was very quiet after that initial encouragement.[4] Throughout the 1860s, 1870s, and 1880s anthologies of

[3] Traubel, *With Walt Whitman*, vol. 4, p. 156.

[4] Actually, when Emerson wrote Whitman a letter in 1855 complimenting him on *Leaves of Grass*, Whitman was a total stranger to him. Whitman, without consulting Emerson, stamped a particularly enthusiastic phrase from the letter as an imprimatur on the spine of the cover of the poem's next edition ("I greet you at the beginning of a great career"), and then at the end of the book printed the entire letter. Emerson was not pleased. Earlier, on May 6, 1856 (before the second edition of *Leaves of Grass* appeared), he had written Thomas Carlyle: "One book, last summer, came out in New York, a nondescript monster which yet had terrible eyes and buffalo strength, and was indisputably American,—which I thought to send you; but the book throve so badly with the few to whom I showed it, and wanted good morals so much, that I never did. Yet I believe now again, I shall. It is called *Leaves of Grass*—was written and printed by a journeyman printer in Brooklyn, New York, named Walter Whitman; and after you have looked into it, if you think, as you may, that it is only an auctioneer's inventory of a warehouse, you can light your pipe with it." Quoted Stephen E. Whicher, ed., *Selections from Ralph Waldo Emerson* (Boston: Houghton Mifflin Company, 1960), p. 363.

American poetry rolled off the press; only occasionally was Whitman's work included.[5] To his friends and to strangers Whitman complained frequently that he was neglected both by the critics and by the American public and he was generally right. In his later years, however, after his retirement to Camden, he was the center of a select coterie, some who came to him as strangers, who devoted themselves to his care and to his authority. These men—journalists, a physician, businessmen, with ties to New York or Philadelphia—saw to it that Whitman was materially comfortable; they nurtured the Whitman legend that was to blossom fully after his death.

Eakins, too, had known neglect, and after he met Whitman it was to intensify. Although like Whitman, Eakins did have friends and a number of sympathetic patrons who gave him support over his career, he suffered discouragement from several sources. More than a few of his sitters simply did not like the way he portrayed them; and while many were discreet about their discomfort, avoiding direct rudeness by conveniently "forgetting" to take their portraits from his studio, others were caustic.[6] Eakins could, and often did, lay such lack of success to the idiosyncrasy of his sitters; but public critical notice of his work—and the lack of critical notice—had an authority he could not easily ignore.

Even early in his career Eakins had found himself out of step with critics, dealers, and exhibition juries who determined what would be regarded as

[5] Although the belief that only Whitman's "O Captain! My Captain!" was anthologized in his lifetime is frequently repeated (for instance, by Justin Kaplan, *Walt Whitman, A Life*, New York: Simon and Schuster, 1980, p. 309), it is a misapprehension. R. H. Stoddard enlarged Griswold's *The Poets and Poetry of America* in 1871 with a selection from "Song of Myself" (pp. 626-627), and Charles A. Dana's *The Household Book of Poetry* (New York, 1882; rpt. Freeport, N.Y.: Books for Library Press, 1970) included six poems, none of which was "O Captain!" In 1885 Edmund Clarence Stedman gave Whitman a generous critical assessment in an entire chapter (one among twelve) in *Poets of America* (Boston and New York: Houghton, Mifflin & Co.). These are notable instances of recognition Whitman did receive in his lifetime. Nonetheless, they serve as exceptions to the general truth that his role was on the periphery of American letters until after his death.

[6] Generally, the Eakins collection at the Philadelphia Museum of Art, composed of paintings that Susan Eakins gave to the museum in 1929, represents paintings that sitters refused to take home (the identity of almost all such paintings can be determined by noting in Lloyd Goodrich's catalogue of 1933 that they were still in Mrs. Eakins' possession, *Thomas Eakins: His Life and Work*, New York: Whitney Museum of American Art). Among paintings that sitters abandoned midway are *Mrs. Joseph H. Drexel, Mrs. Elizabeth Duane Gillespie*, and *The Black Fan*, the portrait of Mrs. Talcott Williams (all three are at the Philadelphia Museum of Art).

[7] Eakins discusses these strategies with Earl Shinn in a letter of April 1, 1874 (Friends Historical Library of Swarthmore College).

"good," successful painting: in the early 1870s, proud of his rapid growth as a painter since his return from Europe, he had taken some of his works on the rounds of New York dealers, and he had sent others to be exhibited at the National Academy of Design in New York.[7] When first the dealers, and then the jury committee of the National Academy of Design, were not enthusiastic about his work and, indeed, rejected it, he was jarred into realizing that things might be difficult—that he perhaps could not make a living "anywhere in America."[8] Only a few years later critics began commenting on Eakins in the national and the Philadelphia press as one of the "native" school of American painters who was stubbornly unreceptive to the lessons modern French painters had to offer both in subjects and in techniques. To this public, his work seemed to grow more and more old-fashioned. And thus over the length of his career, while he did occasionally win medals for individual paintings,[9] Eakins was never promoted by critics and general writers—as were Homer and other American painters—as a painter "worthy of prominent notice."

In his role as teacher, in which he exhorted students to follow the principles so important in his own painting—with a passion like that with which Gross taught surgery—he was not long a success, either. Although he enjoyed the compliment of an admiring exposition of his teaching techniques in the New York-based *Scribner's Monthly* in 1879[10] the pertinacity with which he insisted that the Pennsylvania Academy of the Fine Arts center all its instruction on those techniques lost him a crucial following in the Academy Board, and he then suffered the sharp and permanently stinging rebuke of having the board demand his resignation. After that—which had occurred right before he met Whitman—Eakins stirred about as little attention in national artistic life and in Philadelphia public life as had Whitman in the years of his passionate work.

Eakins knew, however, as he proudly told a correspondent, that in the context of contemporary portraitists his work had been "divergent in char-

[8] Persuaded that there was nothing wrong with his work, he wrote Shinn that those who judged it were either "incapable of judging or jealous" (March 26, 1875, Friends Historical Library of Swarthmore College).

[9] Lloyd Goodrich, *Thomas Eakins*, 2 vols. (Cambridge, Mass.: Harvard University Press, 1982), II, 330, lists these awards. Many of them were won at international expositions (the World's Fair in Chicago in 1893, the Pan-American Exposition in Buffalo, 1901, the Louisiana Purchase Exposition, St. Louis, 1904), where, in recognition of the celebratory character of an exposition, a large number of prizes were typically awarded.

[10] William C. Brownell, "The Art Schools of Philadelphia," *Scribner's Monthly* 18, no. 5 (September 1879), 737-750.

acter."[11] Generally, he fought self-pity in order to go on about that work in his own way.

Occasionally, however, his disdain for the gap between public recognition of painters and what he knew to be good work got the upper hand in his temperament, and he expressed his reaction vigorously. In 1892, for instance, when changing fashions in painting had led the ostensibly "democratic" Society of American Artists to reject Eakins' submission for three years in a row, climaxing with their rejection of the *Agnew Clinic*, he resigned from the society with the words "while in my opinion there are qualities in my work which entitle it to rank with the best in your Society, your Society's opinion must be that it ranks below much that I consider frivolous and superficial. These opinions are irreconcilable."[12]

In 1894 he wrote a brief autobiography at the request of the new director of the academy, Harrison Morris, in which he summarized his artistic life in four lines, the first two devoted to his birth and training. "I was born in Philadelphia July 15th, 1844. I had many instructors, the principal ones Gérôme, Dumont (Sculptor), Bonnat. I taught in the Academy from the opening of the schools until I was turned out, a period much longer than I should have permitted myself to remain there. My honors are misunderstanding, persecution, & neglect, enhanced because unsought."[13] The letter reveals an underlying sadness, even bitterness. But more important, it shows that Eakins had the philosophical clarity that Whitman had brought to his own situation: he was undeservedly out of the mainstream of recognition only if one failed to note that the frivolous quality of what was in the mainstream of "good taste" revealed the public's hopeless incapacity for judgment. Eakins could hardly have set himself off more clearly from the fatuous nature of some of this recognition when he appeared at the academy awards ceremony in 1904 in bicycle costume to accept the Temple Award, the first official recognition the academy had offered him.[14] He then conspicuously took the medal to the mint to have it melted down.

It was the potentially offensive, and ultimately the sophisticated, character of their work that doomed Eakins and Whitman to the misapprehension of their fellow citizens. And in the basic impulse that underlay that character,

[11] In a letter of 1904, quoted in Goodrich, *Eakins*, 1982, II, 230.

[12] Goodrich, *Eakins*, 1982, II, 51.

[13] April 23, 1894, Archives, Pennsylvania Academy of the Fine Arts.

[14] This award was for his portrait of *Archbishop William Henry Elder*, painted in 1903 (Cincinnati Museum of Art); it is a stunning painting, but not because it flatters the archbishop.

the two men shared another fundamental kinship. Both Whitman and Eakins were cataloguers: they conferred recognition on deserving people and activities and with that recognition they set forth their vision of the nature of their times. In *Leaves of Grass* Whitman meticulously enumerated types of persons, occupations, experiences, natural creatures, and places—all named, all specific—in democratic America. Added to over so many years, the long poem was a gallery of the diversity in America: indeed, Whitman even used the term "picture gallery" in 1880 (in his poem "The Picture-Gallery") to decribe his accumulation. And on canvas, over his long career, Eakins documented and memorialized his selection of diversity—of rowers, scientists, musicians, artists, collectors, teachers—people and work that were admirable in modern life. Whitman declared that his own voice was the artistic center of his work; and Eakins, in quietly selecting the sitters for his gallery, was the seer at the center of his life work. And although with only a few exceptions Eakins limited his portrait gallery to Philadelphia, and Whitman strained to encompass all of America, Eakins' gallery grew increasingly to be a microcosm of American achievement.

In fact, his forced resignation from the academy seems actually to have strengthened the inclusiveness of his gallery.[15] By 1886, he had painted rowers in the flush of modern, disciplined leisure; hunters, sailors, fishermen, two baseball players from Philadelphia's new team, swimmers, a four-in-hand coach and its occupants and driver (the latest version of a series of such equipages enjoyed by the wealthy); pianists, zither players-experts on a new import from Germany, a chamber trio, and groups of Arcadian musicians; several surgeons and physicians—all of them distinguished in Philadelphia medical history—including a surgical clinic showing surgeons at work; a forgotten Philadelphia sculptor in his workshop and several other scenes evocative of the "olden times" in Philadelphia; a writing master (Figure 101, a personal hero certainly—the writing master was his father—and also a reminder of earlier times); several artists (Figure 102); a religious leader—the first archbishop in Philadelphia; a military leader famous for his Civil War service; a prominent physicist and an engineer on the faculty of the University of Pennsylvania; and the President of the United States. He had even painted a crucifixion. Several of these subjects were notably "democratic," inspired, one might think, by the sheer joy in human beings that guided

[15] Although Eakins did teach after 1886 at the Art Students League in Philadelphia and in Brooklyn, and at a few other institutions, it was only for limited periods of time. Eventually he stopped teaching altogether.

Whitman: the fishermen, the hunters, the baseball players, and the swimmers. Most of them, however, evoked the standards of discipline, intellect, and morality that guided Eakins in his own life and that were celebrated in public discourse.

After 1886, Eakins' focus on his role as a painter was sharpened by the elimination from his life of his teaching responsibilities, and he added breadth and depth to his portrait gallery. He painted Whitman, cowboys, and a more modern surgical clinic, more physicians and scientists—including several on the frontier of exploration (Figure 103), more artists, several more musicians: a guitarist and banjoist, a cellist, a violinist, an oboist, a concert singer, pianists; anthropologists—they, too, in the front of the advance of scientific knowledge (Plate 14), a journalist, publisher, educators (Figure 104), more military leaders (Figure 105), mathematicians, cultural leaders in Philadelphia, boxers and wrestlers (Figure 106); critics; collectors (Figure 107); curators and art dealers; business men; lawyers; actresses (Figure 108); prelates of the Catholic Church (Figure 109). He accompanied his young student Samuel Murray on his sessions for sculpture commissions and even added some of Murray's sitters and associates in Philadelphia to his gallery.[16] In its range and size this collection of portraits is an astonishing group. It is a collection of eminent Philadelphians, of eminent men and women, that reveals the vast expansion of modern life, that picks up the tradition where Peale, and then Sully, and then Neagle, left it; it is a life work that rivals in its diversity the printed collections throughout the century. At its center was a man remarkably sensitive to, and appreciative of, achievement in many forms.

And in his mission to honor eminent citizens Eakins did achieve a certain success, for by the end of his career, a number of works hung in institutions and carried Eakins' tributes into public life: at Jefferson Medical College, the portraits of Dr. Rand, Dr. Gross, and Dr. Forbes; at the University of Pennsylvania, the portrait of Dr. Agnew in his clinic and of Frank Hamilton Cushing enacting a Zuñi ritual; at the American Philosophical Society, the portrait of the ethnologist Daniel H. Brinton; at Central High School, the portrait of former principal John S. Hart; at The Girls' Normal School in Philadelphia, the portrait of Principal George W. Fetter; at the Pennsylvania Museum School of Industrial Art, the portrait of Mrs. Elizabeth Duane Gillespie; at Villanova College, the portrait of former president the Very Rev.

[16] For an introduction to Murray's career and work, see Michael W. Panhorst, *Samuel Murray* (Washington, D.C.: Smithsonian Institution Press, 1982), an exhibition catalogue for The Hirshhorn Museum and Sculpture Garden.

John J. Fedigan; at the Catholic University of America (in Washington), the portrait of His Eminence Sebastiano Cardinal Martinelli (now owned by the Armand Hammer Foundation); at the American Catholic Historical Society in Philadelphia, the portrait of the Rt. Rev. Mgr. Hugh T. Henry, called *The Translator*; at the Fidelity Trust Company, Philadelphia, the portrait of officer and president John B. Gest; at the Mutual Assurance Company, Philadelphia, the portrait of Gen. George Cadwalader. In 1897 the Pennsylvania Academy of the Fine Arts had purchased for their permanent collection the portrait of Rudolf Hennig (*The Cello Player*), and, in 1917, although not from Eakins and too late for him to rejoice in it, the portrait of Walt Whitman.[17]

The very nature of Eakins' success—granted that it was limited—points to an important difference that, despite the affinities in his and Whitman's work, distinguished their missions.

Both men had been caught up in the investigation of heroism that had come to the foreground in Europe and America early in the century. Informed by ideals of the Enlightenment and by the newly emerging faith in egalitarianism, heroism was associated with qualities that ranged from intellectual discipline and scientific achievement, to moral firmness, and eventually, to simple-hearted persistence at one's daily task. The portrait galleries of eminent men and women that were produced over the century descended from the early convictions that specific intellectual, aesthetic, or moral achievements made one heroic. The paintings of hardworking peasants or farmers in France, Germany, England, and America in the 1840s through the 1860s were inspired by later heroic ideals that were egalitarian, even anti-intellectual.

[17] Eakins was commissioned to paint the portrait of John S. Hart, certainly an irony considering the contempt for the man he had revealed in his mocking letter from Paris. Hart had died in 1877 and Eakins, probably the only graduate of the school during Hart's tenure who was also a portraitist, painted the work from a photograph. Several other of his works in institutions had been commissioned: that of Fetter, Cadwalader, Brinton (see the affection Dr. James W. Holland expressed for Eakins in accepting the painting for the society; *A Catalogue of Portaits and Other Works of Art in the Possession of the American Philosophical Society*, Philadelphia, 1961, p. 12), and Gest. Generally, though, Eakins secured public installation of his portraits by giving them away. He certainly had the last word with Mrs. E. D. Gillespie by presenting her unfinished portrait to the Museum School (of the Pennsylvania School of Industrial Art, now the Philadelphia Museum of Art and the Philadelphia College of Art) and noting in the inscription that the painting was unfinished. See Theodor Siegl, *The Thomas Eakins Collection* (Philadelphia: Philadelphia Museum of Art, 1978), pp. 141-143. Mrs. Gillespie, the great-granddaughter of Benjamin Franklin and an energetic worker for charitable causes, omitted in her autobiography her encounter with Eakins: *A Book of Remembrance* (Philadelphia: J. B. Lippincott and Co., 1901).

Eakins and Whitman devoted their careers to explorations of different kinds of heroism. Whitman made no demands of his heroes: he required neither intellect, discipline, nor achievement. His poetic creed held that "to be is as important as to perceive or to tell"; his personal creed led him to profess love for all men and women; and he filled his picture gallery with prostitutes, mine-workers, duck-shooters, escaped slaves, women giving birth, young men swimming—with, in short, the common man. Eakins was devoted, on the other hand, to the uncommon man. His ideals of heroism were informed by an earlier creed, one that championed discipline and recognizable achievement. Thus he painted not one "ordinary" person for his picture gallery: no peasants, no street urchins, no audiences—unless the watchers were students—no casual activities. Even for his intimate portraits Eakins cast his sitters into roles notable in public life: his father, for instance, was *The Writing Master*; one of his students, *The Veteran* (Yale University). For Whitman, it seems, heroism consisted simply in being; for Eakins, in doing.

This relationship suggests that although Eakins was one generation younger than Whitman, he was the conservative artist. The background and training of the two men support this distinction: Eakins, raised in a literate, cultivated family devoted to high moral principles; educated in a high school that vigorously promoted the creed of earning merit by achievement; trained in an artistic system—the École des Beaux-Arts—the very purpose of which was to transmit the best of the past; pursuing his career in a small city, with notable achievements in its recent past; and determining with that career to identify himself with the best that was currently being spoken and done in his city. Whitman was another matter: raised in a semiliterate family of the laboring class, barely educated and then sent off to earn his own living in his young teens; introduced to life in a city teeming with commercial and cultural activity and general "bustle," its best achievements before and not behind it; teaching himself the craft of poetry by reading and writing in a journal and at last deciding, with no strictures of upbringing or education or social class having taught him to the contrary, that his imagination did not need to function in the old channels, that he could carry out a mission new in the history of letters.

Whitman abandoned the literary resources of the past: high themes, high characters, high language, meter, rhyme, structured form. He ignored the very assumptions on which these resources had flourished in order to sing in his art the praise of the new democratic man. Eakins, on the other hand, chose with the portrait one of painting's oldest subjects. He employed tra-

ditional painting techniques. He did not wish to turn his back on the past but to extend its hierarchies into his own era and place.

There were some ways of thinking, however, that passed out of the canon over the latter years of the century, and Eakins, especially in the years after he met Whitman, was attuned to new judgments and perceptions. And in the result of that he was distinctly not conservative. For at the juncture of Whitman's and Eakins' lives in 1887, the poet was in his old age, the painter in his mid-forties. Ideas that did not influence Whitman, and material change the effects of which the poet did not live to feel, played their role in Eakins' work.

Eakins did disturb his audience—as Whitman did his—and it was not because, as the critics suggested, his work was old-fashioned or "nativist." It was because he very matter-of-factly continued to convey in his paintings of men and women (as in his portraits of Schmitt, Gross, Rush, and Cook) the best serious contemporary thinking about human life and activity. Whether it was appropriate to the traditional function of portraiture was a separate question—one that concerned him little.

In the company of the many portraitists among whom he worked, Eakins became more and more estranged. That was a large company, for although landscape and city scenes, visionary works and melancholic interiors—painted with styles ranging from late Impressionist to Symbolist—seem in retrospect to have dominated exhibitions on both sides of the Atlantic, and (more important for historians) to have determined the direction of painting in the early twentieth century, the late nineteenth century was in fact in many ways an age of portraiture.

This was certainly the case in Philadelphia where the portrait continued to exercise its long appeal. Critics gave portraits separate and detailed reviews in exhibition commentaries; Philadelphia artists sent portraits to out-of-town exhibitions to demonstrate the best of their work.[18] The general interest in history and historical figures increased so intensely that in 1887 the academy gathered from local institutional and private collections nearly

[18] In 1903, for instance, the *Philadelphia Press* on January 18 featured an article on the annual exhibition at the Pennsylvania Academy of the Fine Arts that called portraits the "feature" of the exhibition and reproduced portraits by Cecilia Beaux, Whistler, William Merritt Chase, E. C. Tarbell, and John White Alexander. The *World's Columbian Exposition* Official Catalogue Part X, Fine Arts (Chicago: W. B. Gonkey Co., 1893), reveals that the majority of Philadelphia artists sent portraits—and many of them sent only portraits. Eakins sent seven portraits, and also his *Crucifixion* and *Home Ranch* (listed in the catalogue as "Cowboys at Home Ranch").

five hundred portraits of eminent contributors to Philadelphia history and held a spectacular loan exhibition of historical portraits.[19] In subsequent years, the academy encouraged popular local and international portraitists to continue that recognition of great men and women with portraits of renowned contemporaries, and bought a number of such paintings for the permanent collection.[20] The culmination of that mission was the establishment by the board in 1904 of a Gallery of National Portraiture within the academy collection.[21]

On the international scene, portraitists like Eakins' former teacher Léon Bonnat (1833-1922) in France, John Singer Sargent (1856-1925) and James McNeil Whistler (1834-1903) in England and America, and William Merritt Chase (1849-1916) and Cecilia Beaux (1855-1942) in America—and many more—had spectacular careers as portraitists of the successful.[22] Across Europe and in America photographic portraiture of musicians, actors and actresses, sportsmen, scientific leaders, and political leaders flourished in the

[19] *Catalogue of the Loan Exhibition of Historical Portraits*, Pennsylvania Academy of the Fine Arts, 1887, Archives of Pennsylvania Academy of the Fine Arts and on film at the Archives of American Art, Smithsonian Institution, Washington, D.C.

[20] See varied correspondence in the Pennsylvania Academy of the Fine Arts archives and curatorial files. John McLure Hamilton, for instance, born in Philadelphia but very much a traveler during his long career, painted at his own initiative several portraits of eminent British citizens; the academy bought or encouraged the gift of his pastel of Henry Cardinal Manning, William E. Gladstone, and the novelist George Meredith. Hamilton shared with Eakins a wish to commemorate worthy men, but he undertook a much narrower gallery of portraits. His *Men I Have Painted* (London: T. Fisher Unwin Ltd., 1921), records some of his experiences.

[21] See Elisabeth Luther Cary, "The gallery of national portraiture in the PAFA," *The Scrip* 2 (1907), 363-366. Cary singles out for prominent notice the work of, among others, Stuart, Sully, Peale, Neagle, John McLure Hamilton, and Sargent.

[22] In the 1890s and into the early years of the century there was so much demand in America for stylish portraiture that the European portraitists Raimundo de Madrazo y Garreta, Théobald Chartran, Giovanni Boldini, Anders Zorn, and Carolus-Duran, among others, came and enjoyed healthy patronage. Goodrich, *Eakins*, 1982, II, 230, cites Eakins' investigation in 1904 into the prices of Madrazo and Chartran ($6,000 for full-length portraits), who were painting in New York. Portraiture was so much an international topic of reflection that Edith Wharton, who lived in New England, New York, and then France, and spent a great deal of time in England, wrote a number of stories in the first decade of the century about artists who compromised their talent to have highly successful careers as portraitists of the wealthy and undiscriminating (see, notably, her "The Potboiler" and "The Verdict," both 1908). Whether or not we would agree with Wharton's bias, our continuing uncertainty about just what relationship commissioned portraiture bears to "art" is typified by the title of a recent exhibition of the nonportrait work of John Singer Sargent, *John Singer Sargent: His Own Work* (New York: Coe Kerr Gallery and Wittenborn Art Books, 1980).

hands of studio entrepreneurs. And the publication of portrait and biographical collections of eminent men and women that was so popular earlier in the century not only continued but accelerated, as illustrated periodicals, illustrated newspapers, and specialized journals sponsored and recommended to their readers virtually every type of achiever. In fact, collections of eminent people began to be limited to specialties, to focus on eminent scholars, or eminent scientists, or eminent composers, or eminent women.

And in this tendency toward specialization the premises with which Eakins carried out his original mission lost their currency. For he had assumed from the very beginning that he could penetrate to the heart of any activity, that he could understand its basic principles and appreciate the work of the professional who pursued it. This confidence had accompanied him as he persuaded athletes, physicists, even orchestra players to sit for him.

Intellectual specialization, however, made it less and less likely that an artist, even a highly intelligent, well-educated artist, could confidently feel himself to be at the center of modern intellectual life.[23] Physicists by the very nature of their work became less accessible to the "public" as heroes; with their new scientific studies physicians and surgeons moved beyond the veil that separated for the uninitiated the visible from the invisible world; musicians developed ever more arcane theories of music and composed works that were difficult to appreciate on first hearing. As intellectual and aesthetic heroism became almost impossible to comprehend—and thus to celebrate— popular heroism took other forms.

In periodical literature, in novels, and in popular imagery, heroism adapted itself to the visible world and became identified with material success.[24] And this phenomenon separated Eakins' work from the portraiture of his contem-

[23] Eakins expressed this humility himself in his opening remarks to the scientists (and scientific amateurs) at the Academy of Natural Sciences of Philadelphia in 1894, when he presented a paper on a subject he had researched thoroughly, and for years, on the differential action of the muscles of a horse's leg. See Elizabeth Johns, " 'I, a Painter': Thomas Eakins at the ANSP," *Frontiers*, Annual of the Academy of Natural Sciences of Philadelphia, Vol. 3, 1981-1982, pp. 43-51.

[24] A transition in Philadelphia in bound collections of portrait prints and biographies of noteworthy citizens is apparent as early as the year of the Centennial, when W. Curtis Taylor of Broadbent and Taylor published *Representative Men of Philadelphia*, eighty-seven portraits of Philadelphians who represented the "Industry, Enterprise and Intellect" of the city—merchants and philanthropists. By 1900 the transition was complete: *Philadelphia and Popular Philadelphians*, published in Philadelphia by The North American Press in 1891, paid tribute to men successful in commerce; in 1902 Moses King's *Philadelphia and Notable Philadelphians* (New York: M. King) honored with portraits and biographical sketches 1560 of the city's banking and commercial heroes.

poraries who specialized in it. Eakins' public heroes were the self-made in-
tellects, the middle-class citizens who exemplified the earlier ideals of hero-
ism. In appearance and clothing they were often awkward; they were distinctly
not "society." The "public" sitters of other portraitists—the new heroes of
modern life—were a different breed. They were the giants of the new capi-
talism: railroad presidents, bank presidents, insurance entrepreneurs, and
powerful politicians.[25] Although some of these men too were self-made, their
achievements were not intellectual: their code of self-discipline was often
not, by traditional standards, moral. The heroes of commerce and business
did not even sit comfortably amidst the community; by their every act they
separated themselves from it: in success, in power, even in such details as
the expensive, peripatetic nature of their daily lives. The new heroes, unlike
their predecessors, could urge society to emulation only in the making of
money.

The artists who devoted themselves to recognizing these heroes were a far
cry from Eakins in the roles they perceived for themselves as artists. Indeed,
their very upbringing and education were different from those of Eakins. As
artists they became businessmen. They lived on the edge of, and sometimes
solidly in the midst of, a moneyed rather than an intellectual class. Their
clientele was international, or at least, widely dispersed; they were tied to
no community, to no past. The portraits these newly successful people com-
manded, and Sargent and other successful portraitists painted, revealed their
power. But it was not the power specifically of intellect, but of possessions;
not necessarily of character, but of poise. The famous international portrai-
tists ignored whatever they might have seen in their sitters that was unflat-
tering to this power. Other portraitists, working more locally in Boston or
New York or Philadelphia, where the sitters had expectations shaped by the
work of the mobile international set, followed their lead.[26]

[25] Whereas many of Eakins' sitters were
known only in their limited circles in Phila-
delphia, the nationally admired sitters for the
international portraitists included Whistler's
patron and sitter George Washington Van-
derbilt (National Gallery of Art, Washing-
ton); Chase's sitter the Philadelphia financier
Jay Cooke (United States Treasury Depart-
ment); Sargent's John D. Rockefeller (1917,
private collection), railroad magnate Alex-
ander J. Cassatt (1903, Pennsylvania Railway
Company, Philadelphia), influential politi-
cian Henry Cabot Lodge (1890, National
Portrait Gallery), and powerful journalist Jo-
seph Pulitzer (1905, Joseph Pulitzer Collec-
tion, St. Louis); Léon-Joseph F. Bonnat's sit-
ter Marshall Field (1903, Field Enterprises);
and Anders Zorn's sitter Andrew Carnegie
(1911, Museum of Art, Carnegie Institute).

[26] In Philadelphia these included portrai-
tists like Robert William Vonnoh (1858-1933),
Albert Bernhard Uhle (1847-1930) [Uhle
actually taught portrait painting at the Penn-
sylvania Academy of the Fine Arts from 1886-

But Eakins had begun his career as a portraitist of a modern heroism of intellect, morality, and discipline and he continued it to the end. What this meant was that from the beginning of his career he assumed the authority to depict the highest heroic ideals, and he never surrendered that power. This was the crux of his difficulty, and this the glory of his achievement. Increasingly it became clear that what he would specify as heroic had changed: while intellectual specialization was fragmenting men one from another, at the same time the scientific study of man himself—of his brain, of his culture—was placing all men in the same company. After 1890 Eakins painted fewer and fewer sitters with environments that defined what they "did" in order to paint them in bust form to show what they "were": physical human creatures. What men shared in the new scientific view was not Whitman's democratic "being"—an almost childlike creaturehood of nature; it was the capacity for endurance—and the strains of that endurance—of material creatures who had inhabited the world for a very long time.

Early in the century, studies of the age of the earth and of the succeeding eras of plant and animal life on it had pushed the origins of the earth, and of man, farther and farther back into time. Then Darwin's major publications, the first in 1859 and the second in 1871, established that the animal world had evolved through the agency of natural forces and that man, too,

1890], Margaret Lesley Bush-Brown (1857-1944), Hugh H. Breckenridge (1870-1937), Albert Rosenthal, and Eakins' students Frank B. A. Linton and Adolph E. Borie. There was a coterie of art-collecting businessmen and citizens in Philadelphia—men like William Bement, James Claghorn, and others (see Frank H. Goodyear, Jr.'s exhibition catalogue, *The Beneficent Connoisseurs*, Pennsylvania Academy of the Fine Arts, 1974)—who conferred on appropriate artists institutional and private commissions. Eakins did not earn the support of this group—with the exception of that of Fairman Rogers. But these men had not evidenced the kind of heroism that attracted Eakins in the first place. Another indication of the discrepancy between Eakins' ideals and those of many community leaders is that the Penn Club, founded in 1875 to honor with receptions "men or women distinguished in art, literature, science or politics, and other kindred means," honored over

Eakins' lifetime the following artists (but never Eakins): Thomas Hovenden, F.O.C. Darley, Anna Lea Merritt, John Sartain, Cecelia Beaux, and Emily Sartain. See Cortlandt van Dyke Hubbard, *History of The Penn Club* (Philadelphia: The Winchell Co., 1976). After 1886, in fact, Eakins was not conspicuous in official art life in Philadelphia. In 1888, two years after his rupture from the academy, he was apparently not present—he was certainly not mentioned—at the semi-centennial celebration of Central High School; chairman of the celebration John F. Lewis, active in the academy and elsewhere across Philadelphia, cited the most prominent artists to have graduated from the school as "Bispham, the animal painter, Bensell, Knight, William Sartain, Hamilton, the marine painter, Sword, and Richards the marine and landscape painter," Philadelphia Central High School, *SemiCentennial Celebration* Philadelphia Semi-Centennial Committee, 1883, p. 36.

was simply a natural creature subject to these physical forces. Darwin's work, so shocking from the perspective of the eighteenth century, was fairly easily absorbed into late nineteenth-century thinking: by 1871 materialist points of view in many areas of endeavor had simply crowded out the deference to the transcendent that in earlier times would have made Darwin's conclusions unacceptable.

In Philadelphia, several men whom Eakins knew and painted carried these materialist premises of the natural scientists into studies in anthropology and psychology that affected his very conception of human nature and his rendering of it in the portrait.

The field of anthropology had been defined since its origins by its devotion to studying man's rootedness in the material world. Seeking out man in primitive cultures, anthropologists analyzed his language, pottery, costumes, methods of hunting, domestic arrangements—all to understand him as a creature defined by a certain "material" culture. Early anthropologists were concerned primarily to determine what constituted cultural development so that they could place the different varieties of primitive man on a scale that would culminate with the achievement of modern "Western" civilization. But later anthropologists began to see parallels in languages, religions, and domestic rituals, and to suggest that culture was a relative phenomenon. They began to propose that men shared a basic, physical, nature.

Eakins painted two early anthropologists, one (the painting is now lost), Stewart Culin, prominent in the life of the University of Pennsylvania. The other, Frank Hamilton Cushing (Plate 14), was one of the most important, although enigmatic, figures of the time. When Eakins met Cushing, the scientist had spent a number of years in the tribe of the Zuñi Indians in New Mexico, studying their pottery, language, and rituals; he wrote about them in *Century Magazine* and *Popular Science Monthly* for an American audience eager to learn about primitive man.[27] In his character as anthropologist Cushing took an unusual step, one that was highly symbolic. He joined the Zuñi tribe. Thereafter, as a reporter of tribal life—as a student seeking understanding—he was both within and without the group. He brought the sympathy and secret knowledge of the insider to his task, the objectivity and points of comparison of the outsider: in exchange for the Zuñis' confidences of their beliefs, he confided those of his own "tribe," that of "Western"

[27] My Adventures in Zuñi," *Century Magazine*, 25 (1882), 191-207 and 500-511; 26 (1883) 28-47. "The Zuñi Social, Mythic, and Religious Systems," *Popular Science Monthly* 21 (1882), 186-192.

civilization in Pennsylvania and New York. The first anthropologist to use the term "culture" in the plural, Cushing as anthropologist was no longer a representative of the "superior" civilization studying the "primitive" civilization: he existed equally in both worlds.

When Cushing came to Philadelphia for a rest, Eakins asked him to sit for him. Cushing built in Eakins' studio a ritual environment as it would have been built in a Zuñi tribal dwelling, and Eakins painted Cushing in the act of performing a Zuñi ceremony. He then made a frame for the painting that (like the frame of the *Concert Singer*) set forth the symbols essential to understanding the ritual.[28] In their work the two men were profoundly congenial, in fact, alike: the anthropologist had simply extended into a broader realm the commitment with which Eakins had come to know the ways of modern urban life in Philadelphia—in 1871, among oarsmen on the Schuylkill, in 1875 in Dr. Gross's clinic, and in 1890 in the audience comforted by Mendelssohn's music. Cushing was Carlyle's heroic poet singing of the heroic warrior, and Eakins was close behind him, testifying with his portraits to his expert witness of—even his actual participation in—the world of his sitters.

Like their colleagues the anthropologists, the psychologists Eakins knew studied man's rootedness in the physical world. Their predecessors—physicians and scientists earlier in the century—had begun to investigate the forces that affected man's behavior by examining not so much normal functioning as abnormal functioning. Many of their studies focused on such spectacular abnormalities as hysteria, while others focused on less noticeable but considerably more widespread malfunctions, such as depression, exhaustion, and early physical decay. Some, who laid the groundwork for Freud, concentrated on unusual patterns in thought and imaginative processes as explanations for these phenomena and developed functional explanations—that is, they proposed that behavior could not be attributed to specific physical causes but to mental energies. Other psychologists were neurologists: believing that physical causes determined all mental phenomena, they studied the nerves'

[28] The symbols, as Eakins explained to an official of the Smithsonian Bureau of American Ethnology in 1900 (the letter is quoted by Zilczer) when he offered the painting to the institution, represented Cushing's name (a plant), his clan (a macaw bird), and his office (as the original frame has been lost, this symbol is in question; Cushing was a priest of the order of the bow). The Smithsonian failed to accept the painting. Cushing selected the symbols, just as Professor Henry A. Rowland had chosen formulas from mathematics and physics to be carved into the frame of Eakins' portrait of him in 1891 (Addison Gallery of American Art).

reaction to the environment, particularly the physical and social environment of urban, business, and professional life.

Prominent among the latter scientists were some of Eakins' friends: S. Weir Mitchell, M.D., who did not sit for Eakins but gave him congenial support throughout his career, and Horatio C. Wood, M.D., who sent Eakins to the Dakota territory and who later did pose for a portrait (Figure 110). In the theories of these men, the mind was only the brain itself—a limited and vulnerable mechanism. As Wood explained it, the brain was a collection of individual molecules of protoplasm which, like molecules of protoplasm everywhere else in the body, died on completing their task. Thus every thought, every feeling, and every emotional reaction resulted in a small death in the brain, and if the individual did not take regular rest so that the lost protoplasm could be reconstituted, he would fall into a nearly irreversible state of nervous exhaustion.

For Wood and his colleagues, "modern life" was no blessing. Mitchell wrote of "wear and tear" to distinguish between the normal and the abnormal consequences of simply living out one's life: "Wear" was a natural consequence of growing older, and "tear" was the unnatural stress wrought on the body by unrelieved brain work whether in the service of thought or of emotion. Wood warned that the very character of "modern life . . . tends to produce nervous exhaustion."[29] Although the demands of the American business life seemed to these scientists to be particularly hard on the brain, they believed that in the harsh American climate even solitary intellectual work was taxing. Further, according to Wood, expression of the emotions, encouraged in some areas of life—as in overtly Romantic music—played havoc with the protoplasm of the brain, destroying it much faster than the simpler demands of thinking. Thus, Mitchell and Wood, and many like them, taught that to stay healthy the modern individual should repress his emotions and pursue his activities in a state of perpetual calm. The preventives, the antidotes, these men prescribed for nervous exhaustion were completely physical, stressing rest, diet, and extended changes of scenery.[30] In the widespread

[29] Horatio C. Wood, *Brain-Work and Overwork* (Philadelphia: Presley Blakiston, 1880), p. 16.

[30] Mitchell became famous for his "rest cure" (Edith Wharton being perhaps his most renowned patient), which called for the patient's removal from his familiar environment, a long confinement to bed, massage and electrical shock treatments, and heavy eating. Wood was noted for his "camp cure," in which the patient slept and ate outside; he had advised Eakins to spend his time in the Dakota territory living outside with the cowboys. In the prescription of Mitchell, especially, there was a strong moral dimension. He stressed to his patients that they had a moral obligation

preoccupation with avoiding stress, songs like Mendelssohn's "O Rest in the Lord," with calming, reassuring text and gentle musical flow, played not only an aesthetic but a therapeutic role.

The simplicity of the conclusions of anthropologists and psychologists about the nature of man was not so remote from the popular understanding earlier in the century of the nature of "science" itself. Eakins had been taught at Central High School that a few basic principles underlay all of experience, so that the person who examined objects and professions and natural phenomena carefully could understand what he saw. And the *Popular Science Monthly* began publication in 1872 with the creed that a scientific attitude—not specific scientific knowledge—opened all experience and all knowledge to its possessor.[31] The scientific attitude was the democratic attitude, as psychology and anthropology were the democratic sciences. To the sensitive participant in late nineteenth-century intellectual life, the indications of the new sciences of man were clear: that what separated human beings to the eye—language, social class, profession, sex, even age—was negligible, that, fundamentally, all men could be understood in the same terms.

And that is the way Eakins painted them; that is the way he outraged his sitters. He showed a new kind of heroism, one totally alien to the traditional associations with portraiture. He hammered the fact home that men and women were physical creatures, subject to the forces of nature beyond their control. These forces included aging and disease; but they also included the forces of urban life—of "modern life," of disappointment, of competition, of tension. He showed in his sitters' faces not only the aging that was the natural "wear" of the body, but the carefully composed set of the head against "tear"—against emotional outburst, against exhaustion of one's physical, irreplaceable resources. His men and women are waging the battle, and they are vulnerable. Like the earlier ideals of discipline and morality, the heroism of endurance was open to, and ideally, a goal of, all. It was a heroism that Eakins, and the best thinkers of his time, saw as fundamental to modern life.

Eakins' attraction to man's material nature had been evident from the first.

to peers and to family to stay well, indeed, that invalidism was immoral (*Fat and Blood: and How to Make Them*, Philadelphia: J. B. Lippincott and Co., 1878, pp. 45-46). The conviction of Wood and Mitchell that repression of the emotions was desirable was the precise opposite, of course, of the tradition that Freud inherited and made famous, insisting that emotions be unmasked and thereby released.

[31] *Popular Science Monthly* 1, no. 1 (May 1872), 113.

Indeed, in the 1870s he was not unusual in emphasizing man's physical qualities; the century had seen the general "progress" away from the ideal in portraiture, assisted in mid-century by the daguerreotype's spellbinding reportage of the precise physical qualities of the sitter, whether flattering or not. In the rising emphasis after mid-century on the expressive qualities of paint itself, artists used impasto to convey the sense of flesh, to suggest the sharpness of a glance. But in most cases, other than Eakins', that is, the sitter did not seem to be pinioned by such materiality.[32]

Successful portraitists like John Singer Sargent (Figure 111), William Merritt Chase (Figure 112) and Cecilia Beaux (Figure 113), for instance—all of whom Eakins knew—exploited the physical nature of paint with very obvious brushstrokes, but they used the paint and the brushwork to flatter their sitters. Rather than signifying the flesh itself, their paint strokes seemed to float above the bone structure, as though the sitter, even with a head of graying hair, were not really growing old—as though the flesh on his face were not sinking onto the skeletal framework, sagging under the jaw, and wrinkling under the eyes—as though the means of representation had nothing to do with the real nature of the sitter. Instead, the brushwork, free, often flat, confident, seemed to transfer the confident mastery of the painter to the personality of the sitter.

But whereas a close examination of Eakins' paintings shows him to have been remarkably free with his brush, he never detached the means of representation from its direct link to the material world. His brushwork and his paint point directly to the material being of his sitters, not to their personality, and not to his own virtuosity. He knew anatomy and he caught every part of the face from bone structure to fatty tissue to age lines. Even when the brushstrokes do not follow the contour of the face, they are short, and narrow, and they convey the deterioration, the change taking place, all across the head and face.[33] Across his sitters' costumes, brushwork will trail off, or

[32] Eakins was not, however, the only artist to upset his sitters. George F. Watts, with the haunting (and haunted) effects he achieved with pigment in the depiction of his sitters, puzzled several and outraged others—including Carlyle, who said of the portrait that Watts had produced of him: "Decidedly the most insufferable picture that has yet been made of me, a delirious looking mountebank full of violence, awkwardness, atrocity, and stupidity, without recognizable likeness to anything I have ever known in any feature of me" (quoted in National Portrait Gallery, *G. F. Watts The Hall of Fame*, London, 1975, p. 17).

[33] The ready interpretation of what was "wrong" with Eakins' portraits—that he was too honest—was a camouflage for the deeper, more disturbing content of Eakins' portraits. Edwin Austin Abbey's oft-quoted comment (Goodrich, *Eakins*, 1982, II, 77) that he would not let Eakins paint his portrait because he "would bring out all those traits of my character I have been trying to conceal from the public for years" is typical.

pick up a highlight, or simply note an edge, as part of the vast changing panorama of physical experience. The precise detailed passages in the earlier paintings of Gross and Rush have no place in this later collapsing world, although Eakins had hinted at this collapse as early as in his *The Champion Single Sculls*.

Of all the material forces to which human beings were subject, perhaps the most obvious, and painful, was that of age—of "wear"—and Eakins did not hesitate to show a sitter as frankly old. One can see this in his portrait of Whitman himself. Notably, the work is simply a bust. Eakins could have complimented Whitman's work as a poet with an environment that showed him sitting at his desk, something like, perhaps, Manet had used to depict his friend the novelist-critic Emile Zola. But Whitman was the man who had insisted that no real distinctions existed between him and other men and so Eakins showed him in just that way: as an old man, like other old men. In comparing the photographs Eakins made of Whitman at the same time that he painted him—photographs (Figure 114) that show Whitman in his chair, presiding over conversation with and adulation from a circle of admirers, his white-haired head lit poignantly from the window behind him—one sees that for the painting Eakins eliminated most of the photograph. Whitman seems to settle down into the painting—much as he does in his chair in the photographs. He rests into his body the way one does when one is old and tired. The flesh tones on his face are opaque, the glazed shadows on the cheeks and across the forehead break off abruptly, the eyes are veiled. Behind his beard and mustache he seems to be talking, or perhaps chuckling. Few of Whitman's friends liked the portrait. And although Whitman cherished it above all others that had been made of him, he nonetheless thought the painting was a bit too Rabelaisian.[34]

But that was just Eakins' point—not Rabelaisian in the sense of scatalogical, but Rabelaisian in the sense of earthly. In Eakins' painting, Whitman was a creature made of earth, an old creature. And he exaggerated that age to make his point unmistakable.

Nonetheless, Whitman was already old; other sitters were not. But Eakins aged them, too, especially those he painted after about 1890. In 1903 he asked his sitter Walter C. Bryant, for instance, if he could make him look older "to do a fine piece of work as a work of art and not a likeness."[35] Photographs contemporaneous with other sitters' portraits suggest that a room

[34] Traubel, *With Walt Whitman*, Vol. 1 (Boston: Small, Maynard and Co., 1906), I, 39.

[35] Goodrich, *Eakins*, 1982, II, 59.

full of Eakins' portraits is a room full of prematurely older sitters, of paintings almost like Wilde's storied portrait of Dorian Gray, that showed what the living physiognomy did not yet reflect.[36] In fact one of Eakins' portraits was noted by those who saw it frequently as "getting to look more and more like the sitter every year."[37]

In a profound sense Eakins' aging of his sitters is related to the preoccupation of other artists with change and with motion. The implications of motion had absorbed Eakins since his days in Paris, and in one form or another it attracted his contemporaries as well.[38] But whereas the Impressionists were anxious to break motion into discrete parts and to record a moment of such discreteness, whether in color, or in a gesture of movement, Eakins was drawn to the cumulative effect of motion. And he recorded it in his portraits not by arresting a series of movements to look at individual

[36] Among these photographs are those of Amelia Van Buren (Dietrich Collection, Philadelphia, illustrated in Gordon Hendricks, *The Photographs of Thomas Eakins* (New York: Grossman Publishers, 1972), figs. 178, 179), which may be compared with the portrait of approximately the same year in the Phillips Collection; that of Jennie Dean Kershaw, later Mrs. Samuel Murray, (Philadelphia Museum of Art, illustrated in Hendricks, *Photographs*, fig. 228; there are also photographs in the Hirshhorn collection), which may be compared to the portraits in the Baltimore Museum of Art and the University of Nebraska Art Gallery; and that of Suzanne Santje (illustrated in Gordon Hendricks, *The Life and Work of Thomas Eakins*, New York: Grossman Publishers, 1974, fig. 283), to be compared with *The Actress* (Philadelphia Museum of Art). In addition, the membership archives of the College of Physicians of Philadelphia and the Academy of Natural Sciences of Philadelphia contain photographs of Eakins' sitters Rand, Sharp, Da Costa, Nolan, and others which, although dated only approximately, show a contrast between the effect of Eakins' portraits and the freshness, sharpness, and vigor of his sitters as caught by the camera. Eakins also aged his sitters' clothing, requesting Dean Holland, for instance, to wear his old fishing shoes, and Professor Leslie Miller to wear old clothes and "a sack coat."

[37] Goodrich, *Eakins*, 1982, II, 78.

[38] Eakins had painted the *Fairman Rogers Four-in-Hand* in 1879, investigating the horse in motion, and, characteristically, he combined in the group of four horses discrete moments of action that would, if they actually occurred, produce chaos. He had worked with Eadweard Muybridge at the University of Pennsylvania on a project involving stop-motion photography, contributing to that project original research discussed by William Marks in Marks, Harrison Allen, and Francis X. Dercum, *Animal Locomotion: The Muybridge Work at the University of Pennsylvania. The Method and the Result* (Philadelphia: J. B. Lippincott and Co., 1888). And Eakins had posed many of his models in several distinct phases of posture and motion (see *Photographer Thomas Eakins*, Philadelphia: Olympia Galleries, Ltd., 1981, cat. nos. 24-45 for examples), a practice that, common enough among artists in the 1880s, surgeons had used earlier to study patients who had varied degrees of paralysis and deformities. Note, for instance, photographs in the Philadelphia medical periodical *Photographic Review of Medicine and Surgery*, 1870-1872.

moments in process, but by hastening the effect of the accumulation of time, by focusing, that is, on a speculated moment near the ending of the series, an ending that had not yet occurred. Man's nature was that he aged along with the earth, that he too was subject to change and decay, and thus Eakins made aging as characteristic of his portraiture as costumes and setting were of the portraiture of his contemporaries.

As physical creatures, men aged. But more fundamentally, they were vulnerable on every front: to disease, to irrationality, to sorrow. Psychologists, anthropologists, Darwinian biologists revealed what most men knew from experience: that they were not really in control, as men of the Enlightenment had believed. They had not even surrendered themselves to external forces willingly, as did a musician to the spell of music. Eakins pinned down this helplessness, to his sitters' dismay. His peculiar placement of them in space to convey human vulnerability was more upsetting, in fact, than his adding years to their physiognomy.

The objection of Dr. Jacob M. Da Costa (Figure 115) to Eakins' portrait of him shows the fury with which many sitters reacted to what Eakins had done to them—even if they did not know exactly how he had done it. A highly successful physician, confidante of Dr. Gross, leader at Jefferson and prominent writer, Da Costa asked Eakins to destroy his first portrait and paint a second one; then he objected to that.[39] His unhappiness was not without cause. Eakins showed the man straddling a side chair—no arm chair with its history of lending dignity to the sitter—his body facing to the side and humped over slightly. Da Costa's flesh hangs on a delicate skull; his forehead is lined, his cheeks are ravaged, the area under his neck—unrelent-

[39] For an account of the tension between Eakins and Da Costa, with quotation of a letter Eakins wrote Da Costa in indignation when Da Costa asked that he do the portrait again, see Goodrich, *Eakins*, 1982, II, 81. The letter read in part, "I presume my position in art is not second to your own in medicine, and I can hardly imagine myself writing to you a letter like this [:] Dear Doctor, The concurrent testimony of the newspapers and of friends is that your treatment of my case has not been one of your successes. I therefore suggest that you treat me a while with Mrs. Brown's Metaphysical Discovery." In his character other than as Eakins' unhappy sitter, Da Costa was gracious and respected by the community. See M. A. Clarke, "Memoir of J. M. Da Costa," *American Journal of the Medical Sciences* 125 (February 1903), 318-371. Even some of Eakins' fellow artists were not anxious to have Eakins' portraits of them, for quite a few of the works given by Susan Eakins to the Philadelphia Museum are portraits of artists. In 1913 the Philadelphia artist and professor Charles E. Dana gave Eakins' portrait of him to the Pennsylvania Academy of the Fine Arts after writing the director a supercilious letter of inquiry expressing doubt that the academy would want a work so inferior.

ingly apparent in profile—is lumpy. While his eyes radiate an intelligent light, the effect of everything else in the portrait is to underline the man's vulnerability. In the total space of the picture Da Costa is small, and he is further diminished by the flat wash of cadmium orange-red that Eakins put over the entire background. The color comes forward to vie with Da Costa's dark suit, to harden the signs of aging in his face. No commanding physician in this painting, Da Costa is the nervous, apprehensive Everyman of modern professional life.

Robert Vonnoh understood the issue perfectly when he painted Da Costa (Figure 116) the next year: in Vonnoh's portrait, the physician sits in an arm chair, near a side table. He fills his space, with a spread of his elbows from one side of the canvas to the other, and his chair, in which he so assuredly sits, sweeps imposingly from the bottom of the canvas to the top. Da Costa's face reflects almost full light—a slight shadow is barely suggested, for drama— his flesh is firm; the tell-tale area under the chin is impenetrably shadowed. The expression with which Da Costa looks out of the canvas is confident. In every detail—placement in space, light, treatment of flesh—Vonnoh put Da Costa in command, of himself, of his world, of his viewer.

In the standing portrait, a format traditionally associated with power, Eakins was similarly relentless. That had not always been so in his work: Dr. Gross had dominated the surgical clinic; Dr. Agnew had leaned against the amphitheater railing with confidence. But in 1899, in his portrait of Prof. James W. Holland, of Jefferson Medical College (Figure 117), Eakins revealed that under Holland's ample academic robe he was simply a small-boned, fragile man. The viewer has a low point of view—much as would the audience sitting in the auditorium watching Holland call the roll—but instead of emphasizing Holland's power, the point of view shows his delicacy. And even though Eakins has portrayed Holland's eyes and mouth in an expression that suggests the hope and sympathy with which a dean of a medical college calls the roll for commencement, Holland's small head does not countervail the brilliant green of the academic robe. Holland, balanced almost unsurely on his shoes, is a creature of uncertain tenure.[40]

One finds a similar uncertainty in the weight on his feet of Dr. Forbes (Figure 118), whom Eakins painted delivering an anatomy lecture. Tired,

[40] Archival material at the Boston Museum of Fine Arts indicates that Holland was indeed frail and had to beg Eakins for time to rest during his long sittings. See *Museum of Fine Arts Bulletin* 41, no. 246 (1943), 60.

almost used up, Forbes has none of the command of Gross or Agnew, as though in his life he had subjected himself to "tear" very much beyond the capacity of his body to sustain it.

The contrast between these standing figures by Eakins—tentative, racked by fatigue, even shy—and two by Vonnoh and Chase is startling. Vonnoh's standing figure of Da Costa (Figure 119) shows the physician to be solid, substantial, assured. In 1910, when Dr. William W. Keen was a very old man, Chase painted the ultimately tactful standing portrait (Figure 120): discreet in color, so as not to call too much attention to the failing physicality of the subject; steady in background, no flickering brushstroke or uneven wash to suggest the changeability of life; and in pose confident, sturdy, enduring.

One suspects that even when Eakins tried to portray a standing subject as fashionable, in the case of a woman, for instance, because he was so thoroughly absorbed with the human being's essential vulnerability, he found himself unable to do so. In the nearly full-length portrait of Letitia Wilson Jordan (Figure 121) Eakins employed many devices of costume—different textures, colors, even a fan—to suggest Miss Jordan's stylishness, and with opaque, flattering flesh tones laid on rather broadly he presented her face as youthful and fresh. He finished the portrait with a fashionably red, patterned background that should have been the final touch in a compliment to the sitter as a woman of control and of order. And yet, in space, Miss Jordan is not the least bit at ease. She leans forward, not gracefully, but questioningly. She wears too many clothes, and too self-consciously. One has only to see the sure command of space of Chase's *Portrait of Mrs. C.* (or *Lady with the White Shawl*; Figure 112), the calculated relaxed tilt of her head, Chase's easy manipulation of the proportions of floor, wall, and subject, to realize that Eakins simply could not submerge the truths of human experience.

Indeed, women were the more transparent human beings, according to the wisdom of the era, and in Eakins' late portraits he made them devastatingly clear vehicles of the strains of the new heroism. Even when he focused simply on the bust, he showed the repressed emotion, the regret, the ongoing anxiety—even, in a few instances, the carefully reassuring facade—with which women met modern life. Mrs. Mahon (Plate 15) pulls back from an unutterable grief; the actress (Figure 108) collapses on her chair, exhausted from a role far more demanding than that in a theater; Addie (Figure 122) tilts her head and smiles gently to imply that all will be, really, all right; the

young woman in the old-fashioned dress (Figure 123) stares as though she were on the edge of terror. Susan Eakins alone (Plate 16) is virtually unfathomable, and in that lies, we realize, her strength.

Thus Eakins' portraits mark investigations and decisions about the shared nature of man rather than about individual character. They are about humanity—in the costume and in the roles of specific human beings in Philadelphia. In his earlier paintings of men and women engaged in admirable pursuits, and in his later paintings of men and women straining against the subtle ravages of aging and the outright tensions of modern life, Eakins made the portrait the vehicle for his study of man. For Eakins, man was a material being, striving to be heroic and striving to live as an authority, all the while waging an Armageddon against external forces.

Late in his life he advised young artists to peer deep into the heart of American life.[41] That is precisely what, in his own terms, he had done (Figure 124).

IN THE history of nineteenth-century portraiture, and more narrowly that in Philadelphia, Thomas Eakins takes his place. It is a remarkable place. Although he was firmly a Philadelphian, and an American, his career does not illustrate the old adages about American painting. He loved the portrait from the beginning of his career, and he painted it from choice. He was sensitive to images and ideas from the present and from the past. His technique was indirect, occasionally experimental, imprecise, metaphorical. Among his artist colleagues he uniquely registered the ideals of achievement and morality, and of virtue in the democratic life, that were promulgated in the schools, in public discourse, and in journals and newspapers of every persuasion. And he put onto canvas the focus of nineteenth-century science and democracy on the material world, on its past and its changes, with man at its center. Boldly willing to follow the implications of contemporary thought, he was an intellectual in the most profound sense—extremely intelligent, informed, curious, energetic so that he sought out men and women of many disciplines as their equal—indeed, as their master.

In fact, the era that Eakins recorded may just as properly be called "The Age of Eakins" to acknowledge his celebration of the widely touted ideal of the moral, disciplined, self-made man and his courageous record of the un-

[41] Eakins' advice is quoted in Goodrich as "to peer deeper into the heart of American life, rather than to spend their time abroad obtaining a superficial view of the art of the Old World," *Eakins*, 1982, II, 269.

derlying disillusionment and materialism of the end of the century as earlier decades were labeled "The Age of Whitman" by F. O. Matthiessen and other scholars of the 1940s. In the context of Eakins' mission and his persistent courage, the paintings of some of his contemporaries—idealized landscapes, the leisure classes in their gardens and their drawing rooms, Turkish dancers, and antiquarian still life—seem almost beside the point: pleasant distractions, decorations, none of them raising or pointing to the fundamental values, the unanswered questions, in modern life. In Eakins' and Whitman's own time, neither man was seen as representative; we who follow and look back have all the advantage.

Ultimately, the heroism Eakins found in modern life—the honing of one's life on discipline, the perseverance of that discipline through discouraging times and good ones—he lived in his own life. He was Carlyle's poet, who knew the experience of which he sang; Baudelaire's painter, who found out the secrets in human exchange; and Emerson's artist, who saw beneath the material facade, if not to a deity, to a substratum of endurance and courage.

Although Eakins taught a number of students, no immediate successors followed his example. When he died he left a studio full of his testimony. The real successors, perhaps, are those newer citizens of modern life who go to the paintings again and again to experience—and later to bear witness to—Eakins' power.

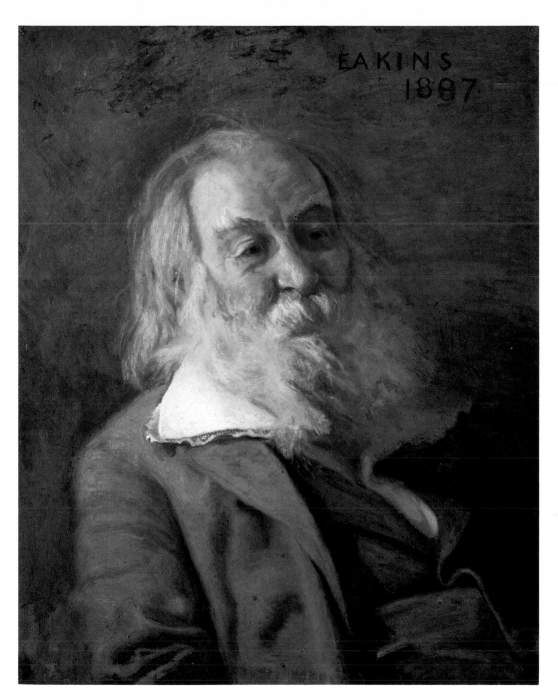

Plate 13. Thomas Eakins, *Walt Whitman*, 1887.

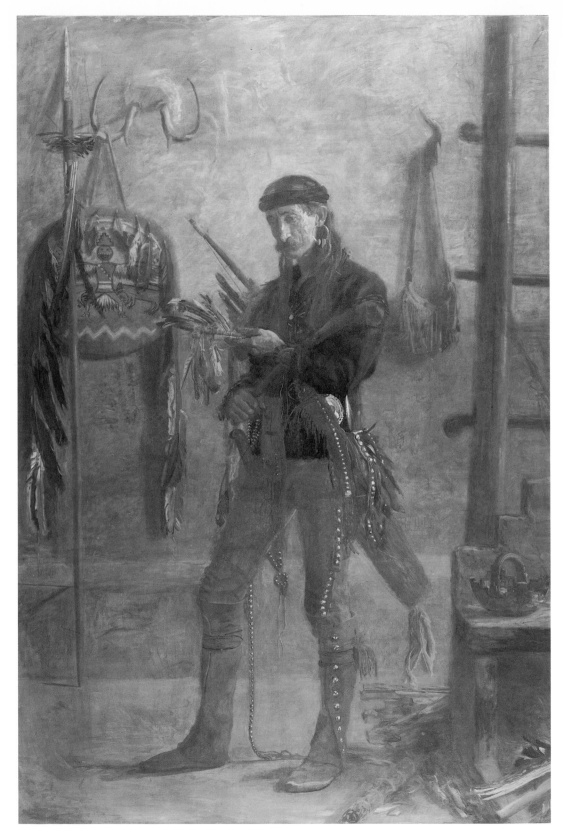

Plate 14. Thomas Eakins, *Frank Hamilton Cushing*, 1895.

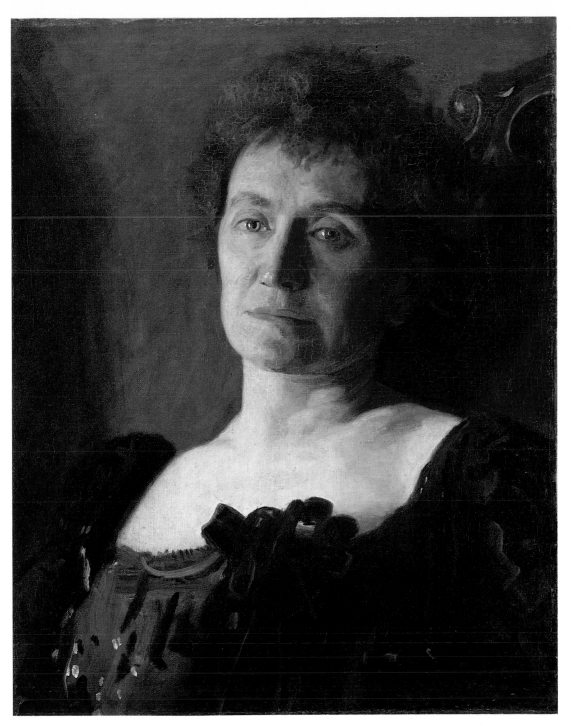

Plate 15. Thomas Eakins, *Mrs. Edith Mahon*, 1904.

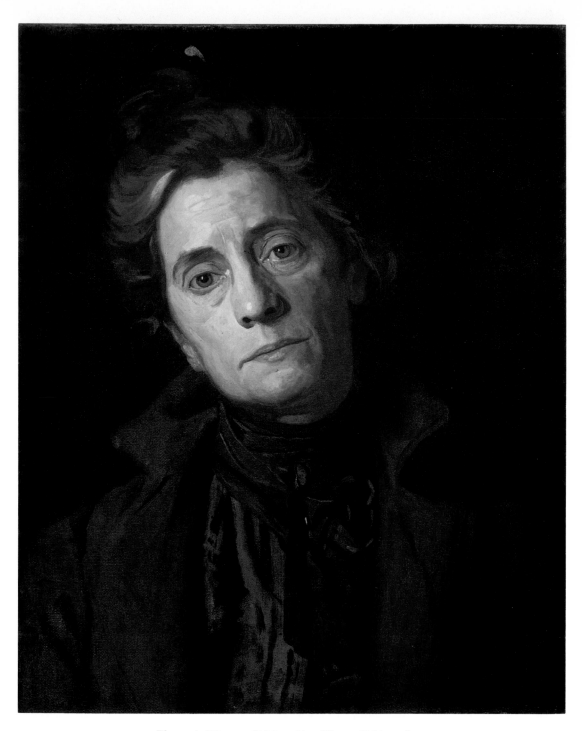

Plate 16. Thomas Eakins, *Mrs. Thomas Eakins*, 1899.

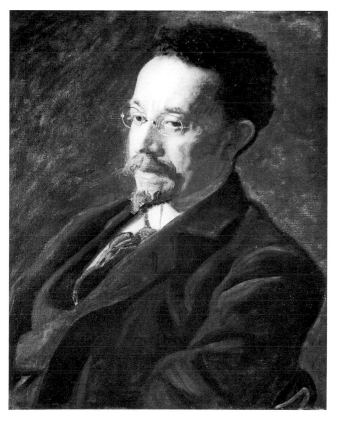

Figure 101. Thomas Eakins,
 The Writing Master, 1882.

Figure 102. Thomas Eakins,
 Henry O. Tanner, 1900.

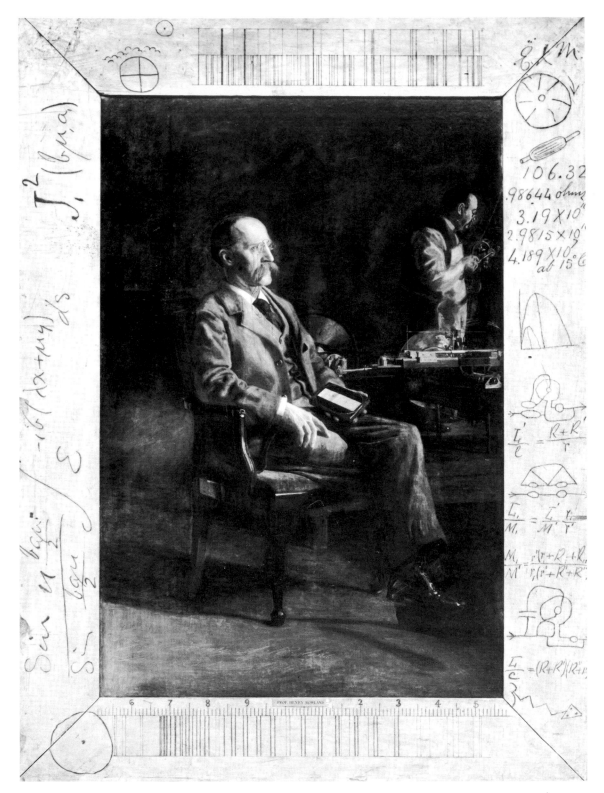

Figure 103. Thomas Eakins, *Professor Henry A. Rowland*, 1891.

Figure 104. Thomas Eakins *Portrait of
Professor Leslie W. Miller*, 1901.

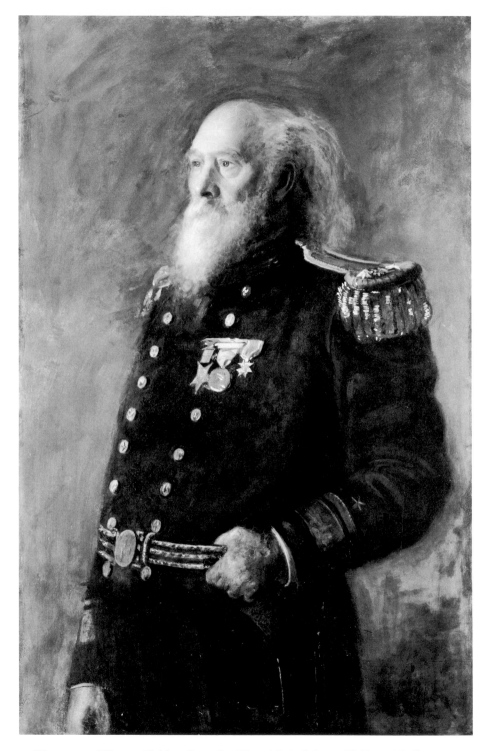

Figure 105. Thomas Eakins, *Portrait of Rear Admiral George Wallace Melville*, 1904.

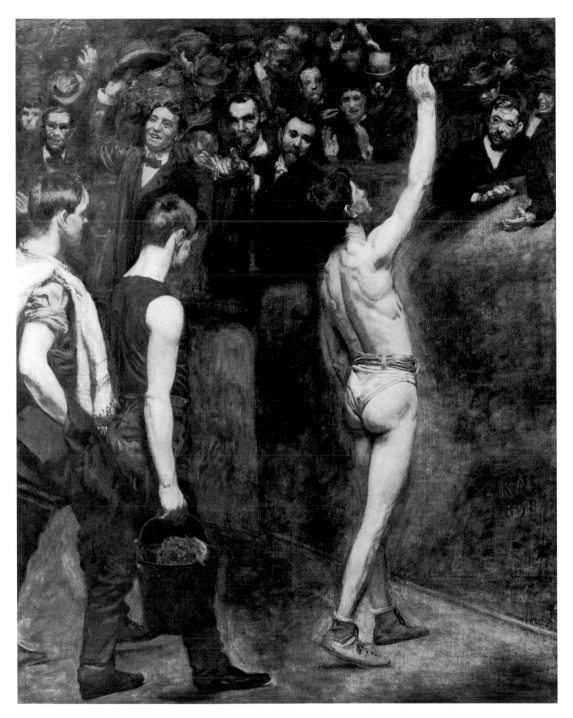

Figure 106. Thomas Eakins, *Salutat*, 1898.

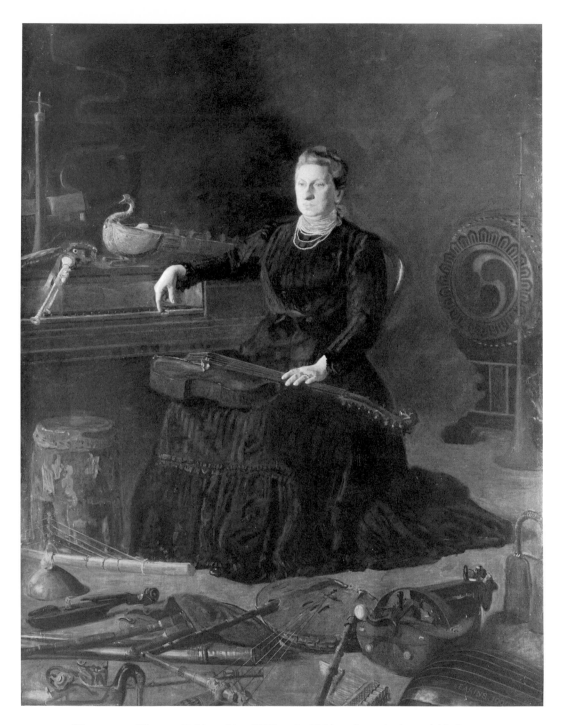

Figure 107. Thomas Eakins, *Mrs. William D. Frishmuth, or Antiquated Music*, 1900.

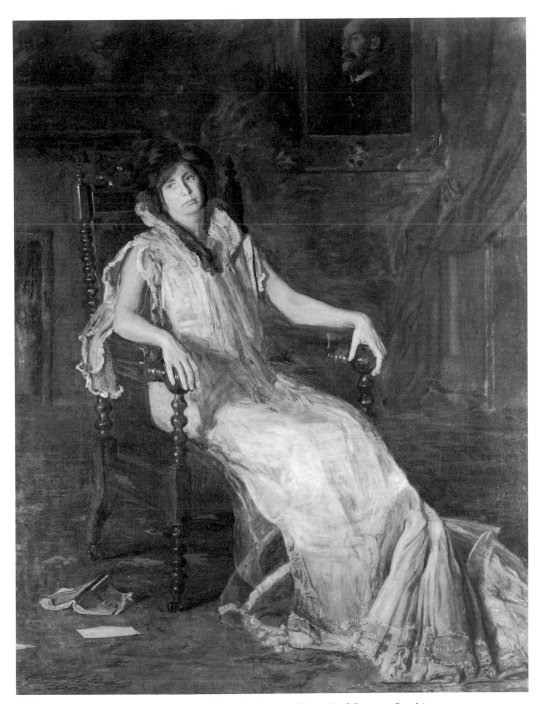

Figure 108. Thomas Eakins, *An Actress (Portrait of Suzanne Santje)*, 1903.

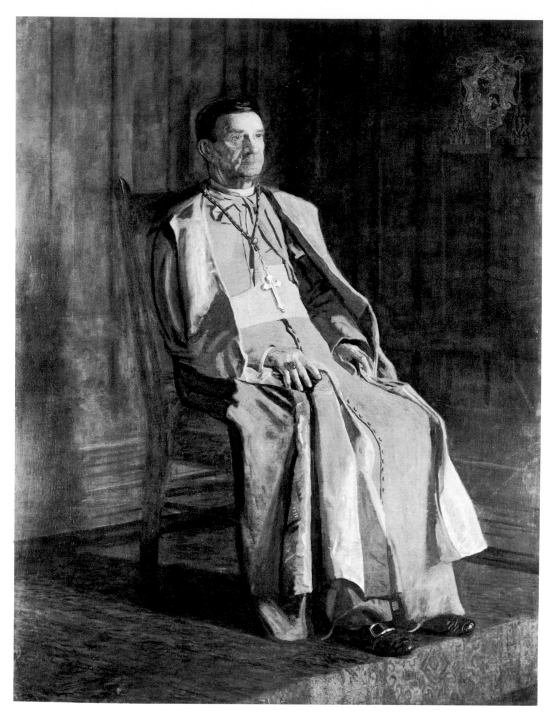

Figure 109. Thomas Eakins, *Portrait of Archbishop Diomede Falconio*, 1905.

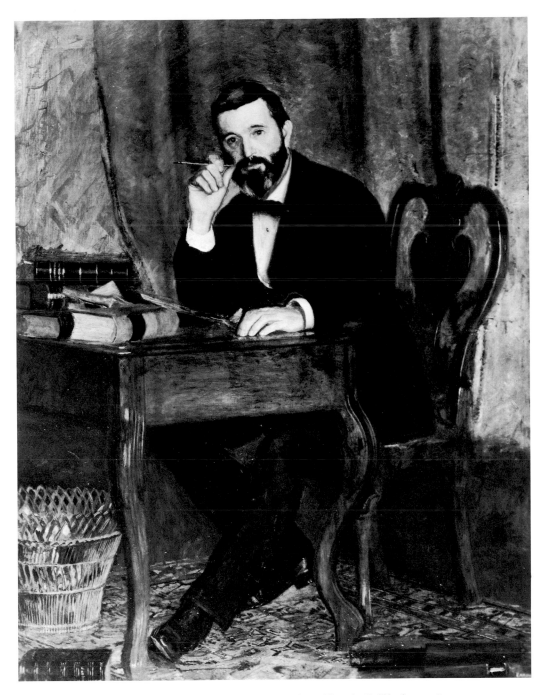

Figure 110. Thomas Eakins, *Portrait of Dr. Horatio C. Wood*, ca. 1890.

Figure 111. John Singer Sargent,
Portrait of Mrs. J. William White, 1903.

Figure 113. Cecilia Beaux, *New England Woman*,
1895.

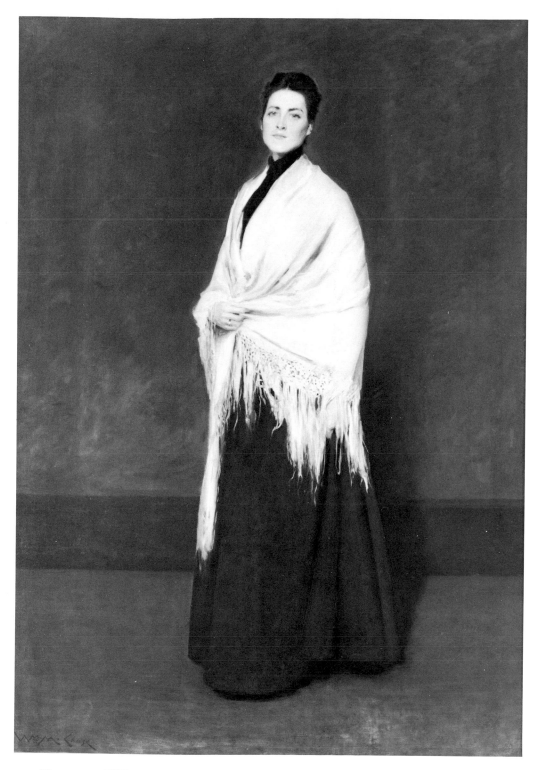

Figure 112. William Merritt Chase, *Portrait of Mrs. C. (Lady with the White Shawl)*, 1893.

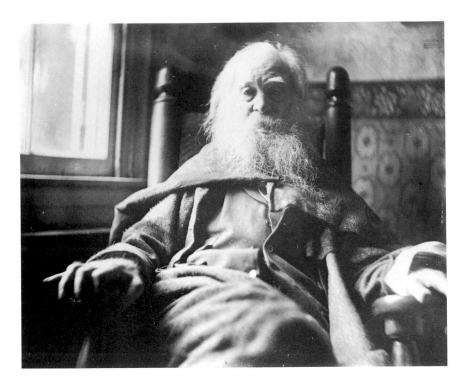

Figure 114. Thomas Eakins,
Photograph of Walt Whitman,
c. 1887.

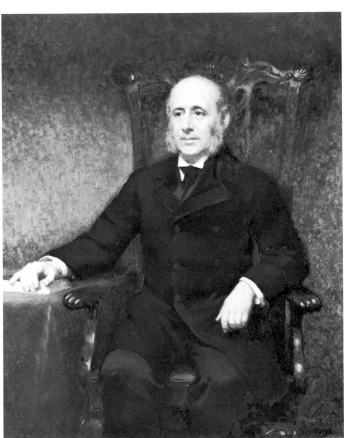

Figure 116. Robert Vonnoh,
*Portrait of Dr. Jacob M.
Da Costa*, 1893.

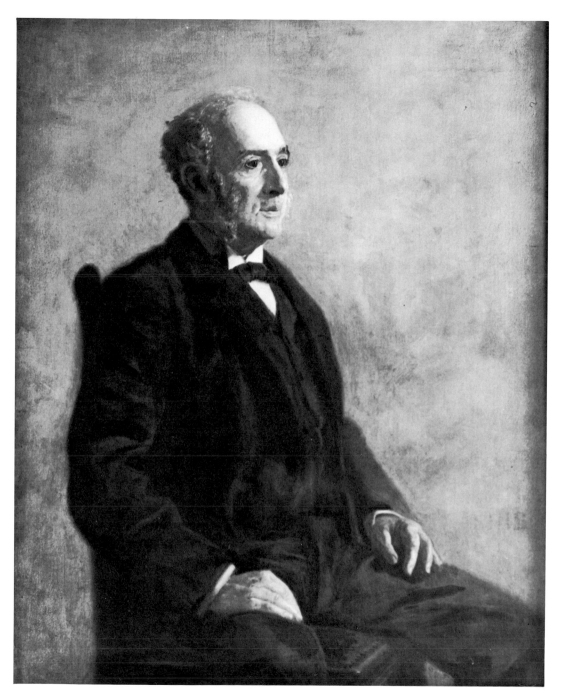

Figure 115. Thomas Eakins, *Portrait of Dr. Jacob M. Da Costa*, 1893.

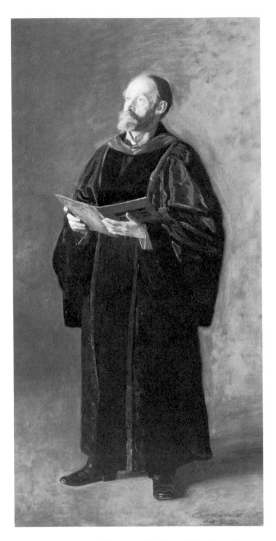

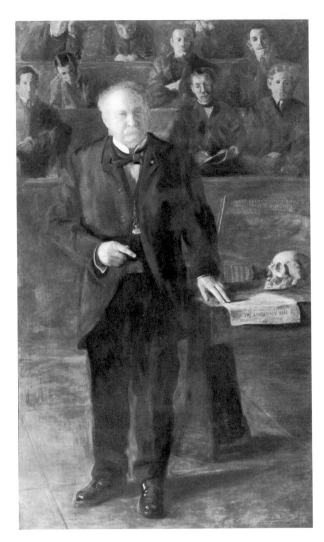

Figure 117. Thomas Eakins, *The Dean's
Roll Call (Portrait of James W. Holland)*,
1899.

Figure 118. Thomas Eakins, *Portrait of
Professor William Smith Forbes*,
1905.

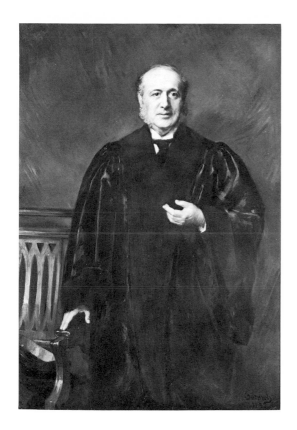

Figure 119. Robert Vonnoh, *Portrait of Dr. Jacob M. Da Costa*, 1893.

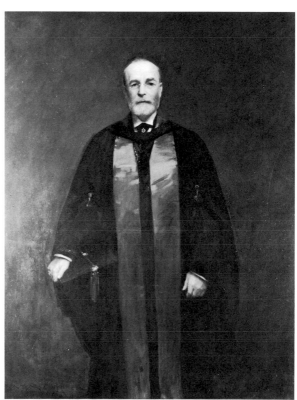

Figure 120. William Merritt Chase, *Portrait of Dr. William W. Keen*, 1910.

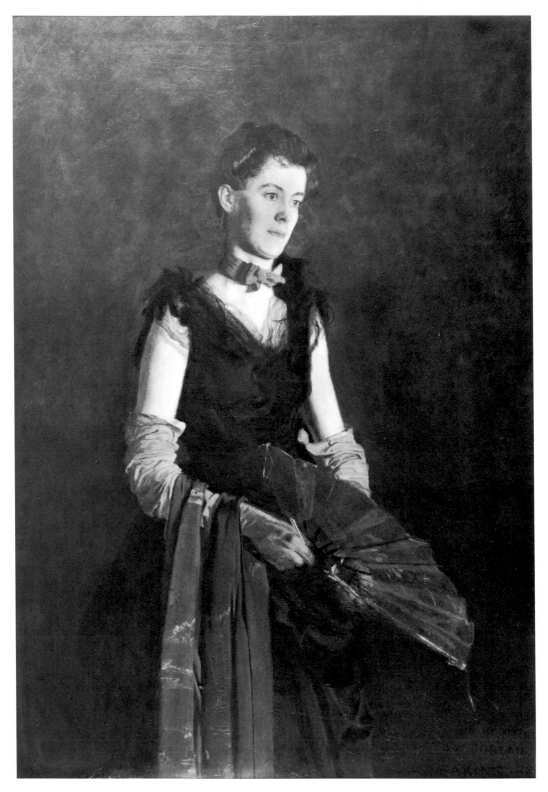

Figure 121. Thomas Eakins, *Portrait of Letitia Wilson Jordan*, 1888.

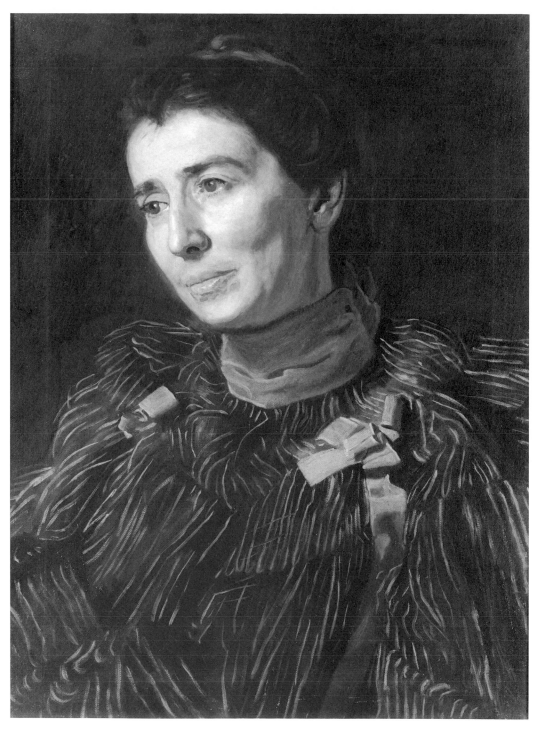

Figure 122. Thomas Eakins, *Portrait of Mary Adeline Williams (Addie)*, c. 1900.

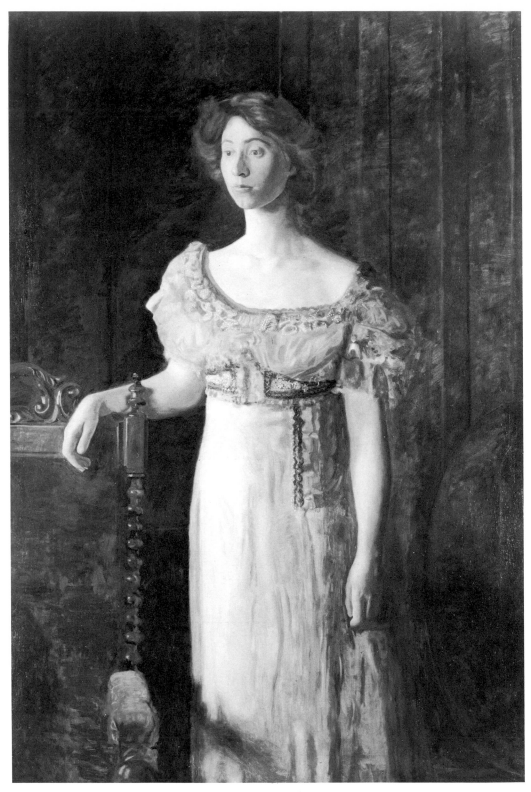

Figure 123. Thomas Eakins, *The Old-Fashioned Dress (Portrait of Helen Parker)*, c. 1908.

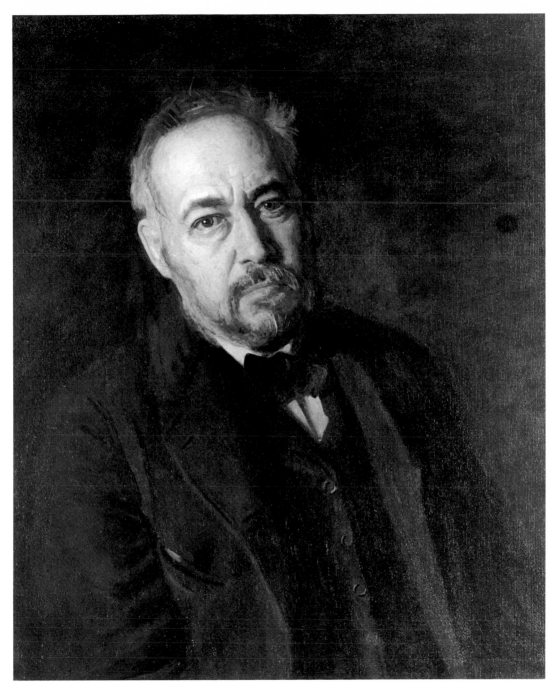

Figure 124. Thomas Eakins, *Self-Portrait*, 1902.

BIBLIOGRAPHIC ESSAY

Preface

The major figure in Eakins scholarship is Lloyd Goodrich, who published his first study of Eakins in 1933, *Thomas Eakins: His Life and Work*, New York: Whitney Museum of American Art; and an expanded, two-volume study in 1982, *Thomas Eakins*, Cambridge, Mass.: Harvard University Press, for the National Gallery of Art, Washington, D.C. Goodrich's early study, a biography and catalogue, climaxed the posthumous championing of Eakins in the 1920s by a number of New York critics who reversed the general neglect of the artist that had prevailed since late in the nineteenth century. Goodrich's enlarged edition draws more fully on the extensive interviews he conducted with Eakins' widow, several of his students, and many of his sitters, and includes an updated bibliography of criticism and scholarship on Eakins.

Scholars after 1933 followed Goodrich's lead to enlarge the canon of biographical data and discuss Eakins' realistic technique. These include Margaret McHenry, *Thomas Eakins, Who Painted*, Oreland, Pa.: privately printed, 1946; Gordon Hendricks, *The Life and Work of Thomas Eakins*, New York: Grossman Publishers, 1974 (almost overwhelming in its detail and speculation); the catalogue by Phyllis D. Rosenzweig, *The Thomas Eakins Collection of the Hirshhorn Museum and Sculpture Garden*, Washington, D.C.: Smithsonian Institution Press, 1977; William Innes Homer et al. in *Eakins at Avondale* and *Thomas Eakins: A Personal Collection*, Chadds Ford, Penn.: Brandywine River Museum, 1980; and Darrel Sewell, *Thomas Eakins: Artist of Philadelphia*, Philadelphia: Philadelphia Museum of Art, 1982 (an exhibition catalogue and essay). A single essay that typifies the approach of historians to Eakins' "exactitude" is Hendricks, "A May Morning in the Park," *The Philadelphia Museum of Art Bulletin* 60 (Spring 1965), 48-64.

Scholars who qualified Goodrich's major emphases but nonetheless treat Eakins as standing apart from his milieu are Fairfield Porter, *Thomas Eakins*, New York: George Braziller, Inc., 1959; Sylvan Schendler, *Eakins*, Boston and Toronto: Little, Brown and Company, 1967; and Theodor Siegl, *The*

Thomas Eakins Collection, Philadelphia: Philadelphia Museum of Art, 1978, with an introduction by Evan H. Turner. Siegl and Turner are particularly sensitive in treating Eakins as a complex person.

With new trends in scholarship, Eakins' sexual nature has become a topic of speculation. Scholars who have offered their opinions include Gordon Hendricks (in his *Life and Work*, 1974), David Sellin (in *The First Pose*, New York: W. W. Norton & Company, Inc., 1976), William Innes Homer (in a paper entitled "Thomas Eakins and Women: A Psycho-Sexual Profile" presented to the annual meeting of the College Art Association in 1981), and Lloyd Goodrich, in his study of 1982.

As an alternative to a biographical approach, a number of historians have focused on Eakins' achievement in specific media. These include Moussa M. Domit, *The Sculpture of Thomas Eakins*, Washington, D.C.: The Corcoran Gallery of Art, 1969; Donelson F. Hoopes, *Eakins Watercolors*, New York: Watson-Guptill, 1971; Gordon Hendricks, *The Photographs of Thomas Eakins*, New York: Grossman Publishers, 1972; William Innes Homer (with J. Talbot), "Eakins, Muybridge and the Motion Picture Process," *The Art Quarterly* 26 (Summer 1963), 194-216; Ellwood C. Parry III and Mariah Chamberlin-Hellman, "Thomas Eakins as an Illustrator, 1878-1881," *American Art Journal* 5 (May 1973), 20-45; and Ellwood C. Parry III, "Thomas Eakins and the Everpresence of Photography," *Arts Magazine* 51 (June 1977), 111-115. An exhibition that studies Eakins' work in relationship to that of his wife and sister-in-law is *Thomas Eakins, Susan Macdowell Eakins, Elizabeth Macdowell Kenton*, exhibition catalogue, text by David Sellin, Roanoke, Va.: North Cross School, 1977.

Very recently, scholars have taken new directions in assessing Eakins' achievement. Two collections of papers demonstrate the increasing variety in this investigation: first, a group of illuminating essays on Eakins' photography, sculpture, student days, late portraits, family relationships, *Crucifixion*, and his only one-man exhibition in Philadelphia, published in *Arts Magazine*, May 1979. The second collection was a session devoted to new approaches to Eakins at the annual meeting of the College Art Association in Philadelphia in 1983 (Abstracts available), which included assessments of his critical reputation, his watercolor technique, problems in attributing his photographs, his participation in the Carnegie International Exhibition, and his fascination with mental activity; many of these papers will be published as articles.

Essays on Eakins' paintings discussed in this book will be cited chapter by chapter, below.

Eakins, Modern Life, and the Portrait

Excellent recent studies analyze the political, economic, and social changes in the nineteenth century that had so fundamental an impact on artists. A cross-Atlantic introduction to the period, with illustrations that show the wide variety of artists' responses, is Asa Briggs, ed., *The Nineteenth Century: The Contradictions of Progress*, London: Thames and Hudson, 1970. A study that focuses on France (and follows the developments into the mid-twentieth century) is Theodore Zeldin, *France, 1848-1945*, 2 vols., Oxford: Clarendon Press, 1973-1977. Ernest L. Woodward, *The Age of Reform 1815-1870*, Oxford: Clarendon Press, 1962 (2nd ed.) examines England during its greatest social upheavals. An excellent starting point for the study of America in this period is Daniel Boorstin, *The Americans: The Democratic Experience*, New York: Random House, 1973, which studies the diffusion of democratic aspirations into all areas of American life and provides an essential bibliography for further investigation.

Of the many works that focus on the latter part of the century in America, several are particularly important. Howard Mumford Jones explores the range of individual experience in *The Age of Energy: Varieties of American Experience 1865-1915*, New York: The Viking Press, 1971. Robert H. Wiebe examines American anxiety about discontinuity in *The Search for Order, 1877-1920*, New York: Hill and Wang, 1967 (a work that might logically be read after Arthur A. Ekirch's study of an optimistic earlier period, *The Idea of Progress in America, 1815-1860*, New York: Columbia University Press, 1944). A specific discussion of the effects of industrialization on American life is Thomas C. Cochran and William Miller, *The Age of Enterprise: A Social History of Industrial America*, rev. ed., New York: Harper and Row, 1961. A group of essays assessing the varied dimensions of culture, business, and politics is collected in H. Wayne Morgan, ed., *The Gilded Age: A Reappraisal*, Syracuse: Syracuse University Press, 1970. Alan Trachtenberg's recent *The Incorporation of America: Culture and Society in the Gilded Age*, New York: Hill and Wang, 1982, with extensive bibliography, is invaluable.

Fundamental primary sources for a close study of the period are the popular periodicals: *Harper's New Monthly Magazine*, *Harper's Weekly*, *Atlantic*

Monthly, Scribner's Monthly, Century Illustrated Monthly Magazine, Lippincott's Magazine (published in Philadelphia), and, more limited in focus but also enjoying a wide audience, *Popular Science Monthly*. Frank Luther Mott, *A History of American Magazines*, 5 vols., Cambridge, Mass.: Harvard University Press, 1930-1968, discusses other periodicals.

A detailed history of Philadelphia as seen from the mid-years of Thomas Eakins' career is that of J. Thomas Scharf and Thompson Westcott, *History of Philadelphia, 1609-1884*, 3 vols., Philadelphia: L. H. Everts & Co., 1884. A recent perspective is provided by Sam Bass Warner, *The Private City*, Philadelphia: University of Pennsylvania Press, 1968, who looks closely at Philadelphia in three separate periods. Specific detail that is valuable for a study of Philadelphia in the Centennial year of 1876 is found in Dennis Clark, ed., *Philadelphia: 1776-2076, A Three Hundred Year View*, Port Washington, N.Y.: Kennikat Press, 1975. E. Digby Baltzell's analysis of the top social level of Philadelphia, *Philadelphia Gentlemen: The Making of a National Upper Class*, Glencoe, Ill.: The Free Press, 1958 (rpt. Chicago 1971), is helpful in placing Eakins in the context of his potential patronage. More recently, Baltzell contrasts the social, professional, and artistic milieus of Philadelphia and Boston in *Puritan Boston and Quaker Philadelphia*, New York: The Free Press, 1979, and includes a bibliography of studies that examine the many facets of Philadelphia life: political, financial, educational, professional, cultural, and religious. A recent article that discusses a phenomenon that the historian of Philadelphia culture must recognize is that by Edwin Wolf 2nd, "The Origins of Philadelphia's Self-Depreciation, 1820-1920," *Pennsylvania Magazine of History and Biography* 104, no. 1 (1980), 58-73.

Surveys of nineteenth-century art show the general artistic context in which Eakins pursued his ambitions. Typifying twentieth-century historians' emphases on the evolution of landscape, genre painting, and modern style in the nineteenth century, these surveys include, for Europe, Fritz Novotny, *Painting and Sculpture in Europe, 1780-1880*, Baltimore: Penguin Books, 1960, and George Heard Hamilton, *Painting and Sculpture in Europe 1880-1940*, Baltimore and New York: Penguin Books, 1967. Two surveys of American painting give sensitive (although, in the broadest outlines, traditional) place to Eakins' work in the context of artists on this side of the Atlantic: Jules D. Prown, *American Painting, From its Beginnings to the Armory Show*, Geneva: Skira, 1969, and New York: Rizzoli, 1980; and John Wilmerding, *American Art*, New York and Baltimore: Penguin Books, 1976. A detailed study of the complex currents in Europe during Eakins' student years is Joseph C.

Sloane, *French Painting Between the Past and the Present: Artists, Critics, and Traditions, from 1848 to 1870*, Princeton: Princeton University Press, 1951. Albert Boime, in *The Academy and French Painting in the Nineteenth Century*, London and New York: Phaidon, 1971, studies the theoretical and practical context in which Eakins actually learned to paint.

For a study of the realist mode in art in the nineteenth century, the more specific current in which Eakins' career takes its place, see the stimulating essay by Linda Nochlin, *Realism*, New York and Baltimore: Penguin Books, 1971. The exhibition *The Triumph of Realism: an Exhibition of European and American Realist Paintings 1850-1910*, Brooklyn: Brooklyn Museum, 1967 examines cross-Atlantic themes and techniques, with some illuminating comparisons. Gabriel P. Weisberg looks closely at French realism in the exhibition *The Realist Tradition: French Painting and Drawing 1830-1900*, Cleveland: Cleveland Museum of Art, 1981. Barbara Novak argues for a specifically American vision and technique in her study *American Painting of the Nineteenth Century: Realism, Idealism, and the American Experience*, New York: Praeger Publishers, 1969. Forming an invaluable illustration and occasional corrective to these studies are the primary documents drawn from several countries in Elizabeth Gilmore Holt, *From the Classicists to the Impressionists* (Vol. 3 of *A Documentary History of Art*), Garden City, N.Y.: Doubleday & Co., Inc., 1966, and *The Triumph of Art for the Public: The Emerging Role of Exhibitions and Critics*, Garden City, N.Y.: Anchor Press/Doubleday, 1979. Providing yet another point of view is the study of popular imagery by Beatrice Farwell in the exhibition *The Cult of Images: Baudelaire and the Nineteenth-Century Media Explosion*, Santa Barbara: University of California Art Museum, 1977.

The classic study of the role of the arts in America in the late nineteenth century is the provocative essay by Lewis Mumford, *The Brown Decades: A Study of the Arts in America 1865-1895*, New York: Harcourt, Brace and Company, 1931 (rpt. Dover, 1955). References to primary sources are a strong contribution of H. Wayne Morgan, *New Muses: Art in American Culture, 1865-1920*, Norman: University of Oklahoma Press, 1978. A variety of documents are reprinted in H. Barbara Weinberg, ed., *The Art Experience in Late Nineteenth Century America*, New York: Garland, 1978, a group of late-century essays which include William J. Clarke, Jr.'s *Great American Sculptures*, 1878, G. W. Sheldon, *Hours with Art and Artists*, 1882, and others.

The art of Philadelphia is explored most thoroughly in the exhibition at the Philadelphia Museum of Art, *Philadelphia: Three Centuries of American Art*, 1976. Studies of significant Philadelphia artists who shaped the tradition that

Eakins inherited include the excellent collection of essays by Edgar P. Richardson, Brooke Hindle, and Lillian B. Miller for the exhibition *Charles Willson Peale and His World*, New York: Harry N. Abrams, Inc., 1982, with a complete bibliography on Peale, and the National Portrait Gallery exhibition on Thomas Sully in 1983 (an earlier exhibition was that at the Pennsylvania Academy of the Fine Arts, *Catalogue of the Memorial Exhibition of Portraits by Thomas Sully*, Philadelphia, 1922). The third major Philadelphia portraitist, John Neagle, was last reviewed in detail in 1925, when the Pennsylvania Academy of the Fine Arts presented an exhibition (*Catalogue of an Exhibition of Portraits by John Neagle*).

The portrait has not received broad emphasis in recent studies of European painting of the nineteenth century. A few studies and catalogues, however, suggest the varied role the portrait played throughout the period. Hugh Honour, in *Neo-classicism*, Baltimore: Penguin Books, 1968, discusses the interest in portraiture of eminent men that was renewed in the Enlightenment and carried into the next century. Essays and individual entries in Peter Fusco and H. W. Janson, *The Romantics to Rodin: French Nineteenth-Century Sculpture from North American Collections*, Los Angeles: Los Angeles County Museum of Art and New York: George Braziller, Inc., 1980, analyze the relationship between cultural ideals and sculpted portraits throughout the century. Beatrice Farwell studies portrait prints in *French Popular Lithographic Imagery*, Vol. 2, *Portraits and Types*, Chicago and London: University of Chicago Press, 1982. Jean Sutherland Boggs, in *Portraits by Degas*, Berkeley and Los Angeles: University of California Press, 1962, analyzes the importance of portraiture to an artist generally associated with other interests. The exhibition catalogue *From Realism to Symbolism: Whistler and His World*, New York and Philadelphia: Columbia University and Philadelphia Museum of Art, 1971, demonstrates the attention slightly later artists, also now associated with different interests, gave to the portrait. The mission of English history painter George Frederick Watts to paint at his own expense a gallery of portraits of the most eminent men of his time is studied in the exhibition catalogue of the National Portrait Gallery, *G. F. Watts: The Hall of Fame*, London, 1975. An English artist (originally German) who pursued a similar goal was Rudolf Lehmann, who recorded his experience in *An Artist's Reminiscences*, London: Smith, Elder & Co., 1894. Much of his work was collected in *Men and Women of the Century* ("being a collection of portraits and sketches by Mr. Rudolf Lehmann"), introduction and biographical notes by H. C. Marillier, London: George Bell and Sons, 1896.

Different historical circumstances—the prominence of the portrait in American painting—have led to a number of essays and exhibitions studying American portraiture that are important in assessing Eakins' role as a portraitist. (The recent date of these studies, however, shows American historians' own earlier emphases on landscape and genre, which followed the focus of historians of European art.) Ellen Miles, ed., *Portrait Painting in America: The Nineteenth Century*, New York: Main Street/Universe Books, 1977, is a collection of essays examining portraiture in various regions of America. William John Hennessey focuses on stylistic changes in American portraiture in *The American Portrait from the Death of Stuart to the Rise of Sargent*, Worcester, Mass.: Worcester Art Museum, 1973. The exhibition *This New Man: A Discourse in Portraits*, National Portrait Gallery, Washington, D.C., 1968, examines nineteenth-century portraits as self-conscious records of the new diversity in American life. The recent exhibition and catalogue by Michael Quick, *American Portraiture in the Grand Manner: 1720-1920*, Los Angeles: Los Angeles County Museum of Art, 1981, probes the development of the formal portrait in America over a range of geography and time.

Important for a study of the role of the portrait in Philadelphia are such institutional collection catalogues as *Catalogue of the National Portraits in Independence Hall, comprising many of the signers of the Declaration of Independence and other distinguished persons*, Philadelphia: John Coates, 1855; *A Catalogue of Portraits and Other Works of Art in the Possession of the American Philosophical Society*, Philadelphia: The American Philosophical Society, 1961; Agnes Addison, ed., *Portraits in the University of Pennsylvania*, Philadelphia: University of Pennsylvania Press, 1940; and Nicholas B. Wainwright, *150 Years of Collecting by the Historical Society of Pennsylvania, 1824-1974*, Philadelphia: Historical Society of Pennsylvania, 1974.

The early role of the portrait print in America is discussed in Harry T. Peters, *America on Stone*, Garden City, N.Y.: Doubleday, Doran & Co., 1931 (rpt. New York: Arno Press, 1976) and Peter C. Marzio, *The Democratic Art: Chromolithography 1840-1900*, Boston: David R. Godine, 1979. Nicholas B. Wainwright points to the place of the portrait print in Philadelphia in *Philadelphia in the Romantic Age of Lithography*, Philadelphia: Historical Society of Pennsylvania, 1958. The most important collections of portrait prints published in Philadelphia, which comprise important primary sources, are Joseph Delaplaine, *Delaplaine's Repository of the Lives and Portraits of Distinguished American Characters*, Philadelphia, 1815-1816; James B. Longacre and James Herring, *The National Portrait Gallery of Distinguished Americans*, 4 vols.,

Philadelphia and New York: M. Bancroft, 1834-1839; Charles Lester Edwards, ed., *The Gallery of Illustrious Americans*, from daguerreotypes by Mathew Brady, New York: d'Avignon Press, 1850; Henry Simpson, *The Lives of Eminent Philadelphians*, Philadelphia: William Brotherhead, 1859; and *The National Portrait Gallery of Distinguished Americans: With Biographical Sketches by Celebrated Authors*, Philadelphia: Rice, Rutter, 1865.

The photographic portrait is examined in the context of the history of photography by Beaumont Newhall in *The History of Photography from 1839 to the Present Day*, rev., New York: Museum of Modern Art, 1964. Newhall narrows his focus to study the photographic portrait in America in *The Daguerreotype in America*, 3rd rev., New York: Dover Publications, 1976. Richard Rudisill, *Mirror Image: The Influence of the Daguerreotype on American Society*, Albuquerque, University of New Mexico Press, 1971 examines the social and aesthetic impact of this early portrait imagery. Elizabeth McCauley probes the conventions across the Atlantic in *Likenesses: Portrait Photography in Europe 1850-1870*, Albuquerque: Art Museum, University of New Mexico, 1980. Ben Maddow surveys the portrait photograph with prominent late nineteenth-century examples in *Faces: A Narrative History of the Portrait in Photography*, Boston: New York Graphic Society, 1977. Two collections of photographs demonstrate the popularity and the conventions of studio photography later in the century: *Victorian Studio Photographs from the Collections of Studio Bassano and Elliott and Fry, London*, Boston: David R. Godine, 1976, and Ben L. Bassham, *The Theatrical Photographs of Napoleon Sarony*, Kent, Ohio: Kent State University Press, 1978. Valuable in assessing the role of the portrait photographer as self-styled documentor of the eminent men of his time are three studies of portrait photographers on both sides of the Atlantic: Nigel Gosling, *Nadar*, New York: Alfred A. Knopf, 1976; National Portrait Gallery, London, *The Herchel Album: an Album of Photographs by Julian Margaret Cameron presented to Sir John Herchel*, 1975; and Dorothy M. Kunhardt and Philip B. Kunhardt, Jr., *Mathew Brady and His World*, Alexandria, Va.: Time-Life Books, 1977.

For the study of portrait photography in Philadelphia, two works are essential: early Philadelphia photographer Marcus A. Root's *The Camera and the Pencil or the Heliographic Art*, Philadelphia: M. A. Root, 1864; and Kenneth Finkel, *Nineteenth-Century Photography in Philadelphia*, New York: Dover Publications, 1980.

A study of heroism as a Western idea should begin with the brilliant work of Sidney Hook, *The Hero in History, a Study in Limitation and Possibility*, New

York: The John Day Co., 1943. Focusing on the development of the idea in the nineteenth century is Benjamin H. Lehman, *Carlyle's Theory of the Hero: Its Sources, Development, History, and Influence on Carlyle's Work; A Study of a Nineteenth-Century Idea*, New York: AMS Press, 1966 (orig. 1928). For Carlyle's own presentation of his theories, see Thomas Carlyle, *On Heroes, Hero-Worship, and the Heroic in History*, New York: AMS Press, 1974; and *The Works of Thomas Carlyle*, edited and introduced by H. D. Traill, New York: AMS Press, 1974. Baudelaire's attention to the idea can be traced in *Art in Paris 1845-1862; Salons and other exhibitions reviewed by Charles Baudelaire*, translated and edited by Jonathan Mayne, London and New York: Phaidon, 1970; and *The Painter of Modern Life, and other essays*, translated and edited by Jonathan Mayne, London and New York: Phaidon, 1970. Emerson's convictions are scattered throughout his *Works*, 12 vols. Cambridge, Mass.: Harvard University Press, 1904, and discussed in detail in his essay entitled "Heroism," in vol. 2, p. 250.

Several studies look at ideals of heroism in America. Henry F. May's *The Enlightenment in America*, New York: Oxford University Press, 1976, discusses the ideals of discipline and morality that informed American intellectual life and ideals during the late eighteenth and early nineteenth centuries, with specific sections on Philadelphia. Two studies specifically focused on heroism consider literary contributions to the ideal: Dixon Wecter, *The Hero in America: a Chronicle of Hero Worship*, New York: Charles Scribner's Sons, 1972; and Marshall William Fishwick, *The Hero, American Style*, New York: D. McKay Co., 1969. Drawing on popular magazines, Theodore P. Greene studies *America's Heroes: The Changing Models of Success in American Magazines*, New York: Oxford University Press, 1970.

Max Schmitt in a Single Scull

American rowing in the nineteenth century is given an immediacy by histories of the sport written during the period, which convey the excitement of rowing's partisans. Charles A. Peverelly, *The Book of American Pastimes*, New York (published by the author), 1866, champions the sport in its context as a leisure activity among many others. Focusing exclusively on rowing, Robert B. Johnson, *A History of Rowing in America*, Milwaukee: Corbitt and Johnson, 1871, includes chapters on its history, on training and health, boatbuilding, biographical sketches of prominent oarsmen, and a glossary of rowing terms. By far the most thorough exposition of rowing and its

implications—much more thorough than similar material in later histories—
is *The Annual Illustrated Catalogue and Oarsman's Manual*, Troy, N.Y.: Waters,
Balch and Company, 1871 (published only in 1871). Waters and Balch dis-
cuss in detail the history of rowing (including rowing in England), various
rowing techniques, boatbuilding techniques (illustrated by a number of ac-
tual plans), and the benefits of outdoor exercise.

The best of the American rowing almanacs, valuable for records of races
and regattas, are those of Fred J. Engelhardt, *The American Rowing Almanac
and Oarsman's Pocket Companion*, New York: Engelhardt and Bruce, 1873 (and
also editions in 1874 and 1875). Ed. James, *The Modern Oarsman*, New York:
Ed. James, 1878, features wood engraved portraits of famous professional
oarsmen. James Watson, *Rowing and Athletic Annual for 1874*, New York:
Watson, 1874 (and an edition in 1875), gives additional racing results.

Specialized American sporting periodicals of the middle and late century
provide detailed reports and analyses of rowing philosophy, heroes, clubs,
and races that cannot be found elsewhere. The most important are *Spirit of
the Times* (published in New York first as *Wilkes' Spirit of the Times* from 1831
on); *The Clipper* (published in New York from 1853-1924); *Turf, Field and
Farm* (published in New York from 1865-1906); and *Aquatic Monthly* (pub-
lished in New York from 1872-1881, then published as *Brentano's Monthly*).
The more general periodicals *Frank Leslie's Illustrated Magazine*, *Harper's New
Monthly Magazine*, and *Harper's Weekly* paid increasing attention to rowing all
across the continent after 1860. Philadelphia newspapers, particularly the
Press and the *Evening Bulletin*, began to devote attention to rowing in Phila-
delphia in the early 1870s.

Starting points in a study of English rowing, which played so crucial a
role in the development of the sport in America, are the summaries and
handbooks by "Argonaut" [Edwin D. Brickwood], *The Arts of Rowing and
Training*, London: Horace Cox, 1866, and Archibald Macleren, *Training, in
Theory and Practice*, London: Macmillan and Co., 1866 (both were strongly
recommended to American readers by Waters and Balch in their *Annual
Illustrated Catalogue*, 1871). William F. MacMichael writes an early history
of university rowing in *The Oxford and Cambridge Boat Races 1829-69*, Cam-
bridge: Deighton, Bell, and Co., 1870.

Histories of rowing written in the twentieth century place the nineteenth-
century preoccupation with the sport in perspective, but they also convey
little of the earlier flavor preserved in the specialized periodicals. The best
general treatment of American recreation is John R. Betts, *America's Sporting
Heritage: 1850-1950*, Reading, Mass.: Addison-Wesley, 1974. The most re-

cent history of American rowing is Thomas C. Mendenhall, *A Short History of American Rowing*, Boston: Charles River Books, 1980. Much of the history of rowing in Philadelphia is treated by Louis Heiland, *History of the Schuylkill Navy of Philadelphia*, Philadelphia: Drake Press, 1938. Of the twentieth-century accounts of English rowing, that of R. C. Lehmann, *The Complete Oarsman*, London: Methuen and Co., 1908 shows particularly well the rapid change in the character of rowing; also valuable are the photographs illustrating rowing techniques. Early twentieth-century studies of rowing, although informative, tend to be more celebratory than analytical. A good example is the work by former rower and coach Robert F. Kelley, *American Rowing: Its Background and Traditions*, New York and London: G. P. Putnam's Sons, 1932. The most balanced and concise recent history of English rowing is that of Keith Osborne, *Boat Racing in Britain 1715-1975*, London: Amateur Rowing Association, 1975.

As far as I know, there are no published studies of American rowing imagery. Informative articles on the history of English rowing imagery include V. Philip Sabin, "Old rowing prints; scarce but inexpensive views of early Oxford and Cambridge boat races," *Antique Collector* (London) 3 (1932), 134-136; 230-231; and Gordon Winter, "Rowing prints for the collector," *Apollo* (London) 25 (1937), 187-191. Helpful for its inclusion of many rowing prints from early in the history of rowing is Lionel S. R. Byrne and E. L. Churchill, *The Eton Book of the River with Some Account of the Thames and the Evolution of Boat-Racing*, Eton: Alden and Blackwell Ltd., 1952. The few rowing prints and paintings in the Paul Mellon Collection are catalogued and illustrated in Judy Egerton and Dudley Snelgrove, *British Sporting and Animal Drawings 1500-1850*, Woodbury, N.Y.: Barron, 1978; Judy Egerton, *British Sporting and Animal Paintings 1655-1867*, Woodbury, N.Y.: Barron, 1978; and Dudley Snelgrove, *British Sporting and Animal Prints 1658-1874*, Woodbury, N.Y.: Barron, 1981.

For specific discussions of Eakins' painting of Schmitt, see Bryson Burroughs, "An Early Painting by Thomas Eakins," *Bulletin of the Metropolitan Museum of Art* 29, no. 9 (September 1934), 151-153; and Gordon Hendricks, "The Champion Single Sculls," *The Metropolitan Museum of Art Bulletin* (March 1968), 306-307.

The Gross Clinic

A clear, comprehensive introduction to the history of medicine and surgery, a grasp of which is essential to an analysis of the *Gross Clinic*, is Arturo

Castiglioni, *A History of Medicine*, translated and edited by E. B. Krumbhaar, 2nd ed., New York: Alfred A. Knopf, 1958. A survey specifically of surgery—again, an essential context—is Owen H. Wangensteen and Sarah D. Wangensteen, *The Rise of Surgery: From Empiric Craft to Scientific Discipline*, Minneapolis: University of Minnesota Press, 1978. Both of these studies are illustrated with reliefs, manuscript illuminations, engravings, portraits, history paintings, and genre scenes inspired by the medical and surgical practice of the era.

On the history of medicine and surgery in America, twentieth-century analytical studies provide the general historian the best survey of the variety of issues important in Dr. Gross's career and in Philadelphia. Discussing the training of physicians and surgeons, their social role, the scientific basis of their practice, and their ethical and professional ideals, three studies are by the pioneering American medical historian Richard Harrison Shryock: *Medicine and Society in America: 1660-1860*, New York: New York University Press, 1960; *American Medical Research Past and Present*, New York: The Commonwealth Fund, 1947; and *Medicine in America: Historical Essays*, Baltimore: The Johns Hopkins University Press, 1966. Two are by other authors: William G. Rothstein, *American Physicians in the Nineteenth Century: From Sects to Science*, Baltimore: The Johns Hopkins University Press, 1972; and Gert H. Brieger, ed., *Medical America in the Nineteenth Century*, Baltimore: The Johns Hopkins University Press, 1972. An article by Courtney R. Hall looks closely at surgery in the era in which Dr. Gross began his career: "The rise of professional surgery in the U.S., 1800-65," *Bulletin of the History of Medicine* 26 (1952), 231-262.

Because French surgery and medical education had such an impact on American practice, the following twentieth-century studies of French surgery are important: John Chalmers Da Costa, "The French School of Surgery in the Reign of Louis Philippe," *Annals of Medical History* 4 (1922), 77-79; Erwin H. Ackerknecht, "Medical Education in Nineteenth-Century France," *Journal of Medical Education* 32, no. 2 (February, 1957), 148-152, and *Medicine at the Paris Hospital 1794-1848*, Baltimore: The Johns Hopkins University Press, 1967.

For a perspective on the relationship between medicine and the scientific tradition in the nineteenth century, two collections of essays are particularly valuable: David D. Van Tassel and Michael G. Hall, eds., *Science and Society in the United States*, Homewood, Ill.: The Dorsey Press, 1966; and George H. Daniels, ed., *Nineteenth-Century American Science: A Reappraisal*, Evanston: Northwestern University Press, 1972.

Studies of medicine and surgery written in the nineteenth century are important in revealing ideals and points of view contemporary with Gross. On the development of surgery in France, see Jules E. Rochard, *Histoire de la chirurgie française au XIXe siècle*, Paris: Baillière, 1875. Also valuable in an investigation of French practice through the mid-century years are the French medical periodicals *Bulletin et mémoires de la Société des Chirurgiens de Paris*, and *L'Union médicale*. On the development of surgery and medicine in America the work edited by Edward H. Clarke is particularly important. His *A Century of American Medicine 1776-1876*, Philadelphia: H. C. Lea, 1876 (rpt. New York: Lenox Hill Publishing and Distributing Co., 1971), contains Gross's essay, "A Century of American Surgery." Two other important essays in the collection are John S. Billings, "Literature and Institutions," tracing the rise of medical periodicals and medical colleges, and Henry J. Bigelow, "A History of the Discovery of Modern Anesthesia." Helpful in establishing Gross's place in the evolution of surgery just after his era had ended is the essay by J. S. Billings, "The History and Literature of Surgery," in Frederic S. Dennis, ed., *Systems of Surgery*, Vol. 1, Philadelphia: Lea Brothers and Co., 1895.

The following medical journals published in Philadelphia during Gross's career provide rich information and insights about American as well as European (especially French) surgery and medicine: *The American Journal of the Medical Sciences*, n.s. (1841-1888); The *North American Medico-Chirurgical Review*, 1857-1861 (edited by Gross himself); *The Medical and Surgical Reporter*, from 1859; The *Philadelphia Medical Times*, 1870-1889; and *The College and Clinical Record* (a Jefferson Medical College publication), from January 1880.

The relationship between the study of anatomy and the practice of surgery and medicine is placed in historical perspective by Jack Kevorkian, *The Story of Dissection*, New York: Philosophical Library, 1959. Gweneth Whitteridge gives insight into the evolution of anatomical study in Rembrandt's era (so essential a consideration for the analysis of anatomy lessons as painting subjects) in "How Physiology grew from Anatomy in the Sixteenth and Seventeenth Centuries," *Journal of Physiology* (London) 263, no. 1 (December 1976), 1P-9P. Viewpoints on anatomical study contemporary with Eakins are expressed in the several published introductory lectures of Joseph Pancoast (Eakins' instructor at Jefferson) to his courses in surgery, from 1834-1869, and in the book by William W. Keen (the surgeon for whom Eakins acted as demonstrator of anatomy), *A Sketch of the Early History of Practical Anatomy*, Philadelphia: P. Madiera, 1870. Keen also wrote on anatomical teaching specifically in Philadelphia: *The History of the Philadelphia School of*

Anatomy, and Its Relations to Medical Teaching, Philadelphia: J. B. Lippincott and Co., 1875.

Several histories focus on Philadelphia medicine. Burton A. Konkle, ed. by Fred P. Henry, *Standard History of the Medical Profession of Philadelphia*, Chicago, 1897 (2nd ed., New York: AMS Press, 1977), contains biographical and topical summaries. R. H. Shryock discusses the complex factors in Philadelphia in the first part of the century in "The Advent of Modern Medicine in Philadelphia, 1800-1850," *Yale Journal of Biology and Medicine* 13 (1941), 725-731. The exhibition catalogue *The Art of Philadelphia Medicine*, Philadelphia Museum of Art, 1965 is invaluable for its historical essays and illustrated portraits.

The history of Jefferson Medical College is told by James F. Gayley, *A History of the Jefferson Medical College of Philadelphia, with Biographical Sketches of the Early Professors*, Philadelphia: J. M. Wilson, 1858; George M. Gould, *The Jefferson Medical College of Philadelphia: A History*, New York: Lewis Publishers, 1904; and Edward Louis Bauer, *Doctors Made in America*, Philadelphia: J. B. Lippincott and Co., 1963. All three viewpoints are valuable.

The best account of Gross's very active life is his autobiography: *Autobiography of Samuel D. Gross, M.D.*, 2 vols., edited by Samuel W. Gross and A. Haller Gross, Philadelphia: George Barrie, Publisher, 1887 (rpt. New York: Arno Press Inc., 1972). Of his many publications, the two works that brought him the most attention were his *Elements of Pathological Anatomy*, Boston: Marsh, Capen, Lyon & Webb, 1839 (3rd rev. Philadelphia: Blanchard & Lea, 1859); and *A System of Surgery*, 2 vols., Philadelphia: Blanchard & Lea, 1859 (6th ed. 1882). Of enduring importance were his centennial essays, the *History of American Medical Literature from 1776 to the Present Time*, Philadelphia: Collins, 1876; and "A Century of American Surgery," published in *A Century of American Medicine 1776-1876*, edited by Edward H. Clarke, Philadelphia: H. C. Lea, 1876.

Gross researched and brought to public attention many of the achievements of isolated American surgeons and physicians, in 1861 editing and publishing *The Lives of Eminent American Physicians and Surgeons of the 19th Century*, Philadelphia: Lindsay and Blakiston. His essay on the great French surgeon Ambroise Paré, *Discourse upon the Life, Character, and Services of Ambroise Paré*, Philadelphia: J. B. Lippincott and Co., 1861, was reprinted twice. The texts of many of Gross's addresses are in the Library of the College of Physicians of Philadelphia, in the Historical Society of Pennsylvania, and in the National Library of Medicine, Bethesda.

There are a number of well-illustrated surveys of medical imagery. Among the most comprehensive are, for early imagery, Pierre Huard and Mirko D. Grmek, *Mille ans de chirurgie en occident: V^e-XV^e siècles*, Paris: Les Editions Roger Dacosta, 1966; and for later medical imagery and its significance, Jean Rousselot, *Medicine in Art: A Cultural History*, New York and Toronto: McGraw-Hill, 1967; Leon Binet and Pierre Vallery-Radot, *Médecine et art: de la Renaissance à nos jours*, Paris: Expansion Scientifique Française, 1968; Carl Zigrosser, *Medicine and the Artist*, New York: Dover Publications (3rd ed.), 1970; and Albert S. Lyons and R. Joseph Petrocelli, *Medicine, an Illustrated History*, New York: Harry N. Abrams Inc., 1978. Valuable for its reproduction of nineteenth-century images is *Album Gonnon: Iconographie médicale*, Lyon: Gonnon, 1909. There is an excellent reference collection of medical images in the National Library of Medicine, Bethesda.

Several works catalogue and discuss collections of images, particularly portraits. Basic surveys of important French images are Noë Legrand, *La galerie historique et artistique de la Faculté de Médecine de Paris*, Paris: Steinheil, 1903, and *Les collections artistiques de la Faculté de Médecine de Paris*, Paris: Masson, 1911. Essays that discuss the collection assembled by the professional society of Parisian surgeons are *Bulletin de la Société des Chirurgiens*, 3 (20 October 1852), 154-159; and L. Hahn and E. Wickersheimer, "Les collections artistiques de la Société de Chirurgie de Paris (1843-1908)," *Bulletin et mémoires de la Société des Chirurgiens de Paris*, n.s. 34 (1908), 35-67. For a more general audience, Delpech, Paris issued the collection of portrait prints called *Médecins et chirurgiens célèbres* in 1837. Bound portrait collections were also popular in England: Thomas Joseph Pettigrew, *Medical Portrait Gallery*, London: Fisher, 1838-1840; *Photographs of Eminent Medical Men of all Countries*, London: Churchill, 1867-1868. There was even a small edition of Philadelphia medical portraits: *Portraits of the Professors of the Medical Departments of the University of Pennsylvania and in the Jefferson Medical College*, 2 vols., Philadelphia: V. F. Harrison, 1846 (engraved after daguerreotypes by M. P. Simmons). Several aspects of this surge of portraits are examined in Helen T. Knojias, "Medical Portraits of the Nineteenth Century," *Ciba Symposia* 6, no. 1 (April 1944), 1772-1777; 1780.

Several exhibitions have probed the relationship between art and medicine. In addition to the exhibition at the Philadelphia Museum of Art already mentioned, a valuable contribution is *200 Years of American Medicine (1776-1976)*, Washington, D.C.: National Library of Medicine, 1976. William H. Gerdts, in *The Art of Healing: Medicine and Science in American Art*, Birming-

ham: Birmingham Museum of Art, 1981, assembles a number of medical portraits. The William Bradley Collection at the College of Physicians of Philadelphia is an index (with photographs) of images of Philadelphia physicians from early in the nineteenth century.

In addition to Goodrich, the following art historians and other writers have discussed the *Gross Clinic*. The most important work is that of Ellwood C. Parry III, in two articles, "Thomas Eakins and the *Gross Clinic*," *Jefferson Medical College Alumni Bulletin* 16 (June 1967), 2-12, and "The *Gross Clinic* as Anatomy Lesson and Memorial Portrait," *Art Quarterly* 32 (Winter 1969), 373-391. Gordon Hendricks, in "Thomas Eakins's *Gross Clinic*," *Art Bulletin* 51 (March 1969), 57-64 emphasizes critical assessment of the painting. Neil Hyman, "Eakins's *Gross Clinic* Again," *Art Quarterly* 35 (Summer 1972), 158-164 suggests a pictorial precedent. David Sellin devotes attention to the exhibition circumstances of the painting in his *The First Pose*, New York: W. W. Norton & Company, Inc., 1976. In addition there are two appreciations of Eakins' paintings of members of the Jefferson medical community by Gonzalo E. Aponte, M.D.: "Thomas Eakins," *Jefferson Medical College Alumni Bulletin* 12 (December 1969), and "Thomas Eakins: Painter, Sculptor, Teacher," *Transactions and Studies of the College of Physicians of Philadelphia* 32 (April 1965), 160-163.

William Rush Carving His Allegorical Figure of the Schuylkill River

The first exhibition devoted to Rush was Henri Marceau, *William Rush 1756-1833: The First American Sculptor*, Philadelphia: Pennsylvania Museum of Art, 1937. The more recent—and only the second—exhibition, was curated by Linda Bantel, with a catalogue that features essays on several aspects of Rush's work: *William Rush, American Sculptor*, Philadelphia: Pennsylvania Academy of the Fine Arts, 1982.

The first history of American art to discuss Rush was that by William Dunlap, *History of the Rise and Progress of the Arts of Design in the United States*, New York: George P. Scott and Company, 1834 (rpt. Dover, 1969). Recent histories of American sculpture that discuss Rush's career are Wayne Craven, *Sculpture in America*, New York: Thomas Y. Crowell Company, 1968; and the exhibition catalogue *200 Years of American Sculpture*, New York: Whitney Museum of American Art, 1976.

Valuable insights into Philadelphia during Rush's era and indications of

Rush's place in city life are found in John Fanning Watson, *Annals of Phila-delphia*, Philadelphia: E. L. Carey & A. Hart, 1830, rev. 1845, 1857, and 1879. Another important source is Abraham Ritter, *Philadelphia and Her Mer-chants, as Constituted Fifty or Seventy Years Ago*, Philadelphia: published by the author, 1860. A particular aspect of Philadelphia history in which Rush was involved is discussed in Nelson M. Blake, *Water for the Cities*, Syracuse: Syracuse University Press, 1956. Discussing Philadelphia's water supply system, Blake includes illuminating detail about Rush's occasionally contro-versial advocacy of proposals.

Studies about the history of the Pennsylvania Academy of the Fine Arts, a topic especially pertinent to Eakins' career from 1876 until 1886 and to his creation of the William Rush painting, include the essays by Frank H. Good-year, Jr., "A History of The Pennsylvania Academy of the Fine Arts, 1805-1976," and Louise Lippincott, "Thomas Eakins and the Academy," in *In This Academy*, Philadelphia: The Pennsylvania Academy of the Fine Arts, 1976. Evan Turner, in *The Thomas Eakins Collection*, Philadelphia Museum of Art, discusses Eakins' role at the academy.

Several scholars have studied the motif of the artist in his studio, a theme that Eakins explored to make his tribute to Rush. A recent examination of artists' interest in this motif in the eighteenth and nineteenth centuries is Ronnie L. Zakon, *The Artist and the Studio in the Eighteenth and Nineteenth Centuries*, Cleveland: Cleveland Museum of Art, 1978. Perhaps the best-known painting of this type is Courbet's *The Studio of the Painter*; it is studied by Benedict Nicolson in *Courbet: The Studio of the Painter*, New York: The Vik-ing Press, 1973. Although Courbet's *Studio* is a major monument of nine-teenth-century painting for twentieth-century historians, the extent of its influence in the nineteenth century (and certainly on American painters) after its initial exhibition in 1855 was limited: it was shown only twice after 1855 during Courbet's lifetime (and not in Paris), and was not acquired by the Louvre until 1920 (see Nicolson, p. 73). Studies of other paintings on the studio theme include entries on Octave Tassaert by Gabriel P. Weisberg in *The Realist Tradition: French Painting and Drawing 1830-1900*, Cleveland: Cleveland Museum of Art, 1981, catalogue 127 and pp. 310-311; Gabriel P. Weisberg, "Fantin-Latour and Still-Life Symbolism in *Un Atelier aux Bati-gnolles*," *Gazette des Beaux-Arts*, ser. 6, 90 (December 1977): 205-215; on a re-lated theme as explored by Degas, Henri Zerner, "The Return of 'James' Tissot," *Art News* 67, no. 1 (March 1968) 32-35; 68-70; on Manet's portrait of Zola (another work closely related to the studio motif), Theodore Reff,

"Manet's Portrait of Zola," *Burlington Magazine* 117 (1975), 34-44. A number of less well-known paintings with the theme are illustrated in *The Triumph of Realism: An Exhibition of European and American Realist Paintings*, Brooklyn Museum, 1967.

Francis Haskell studies the variation on the studio theme that Eakins was to tap for his painting of Rush in "The Old Masters in Nineteenth-century French Painting," *Art Quarterly* 34 (1971), 55-85. A related aspect is discussed by R. Verdi, "Poussin's Life in Nineteenth-century Pictures," *Burlington Magazine* 111 (December 1969), 741-750. Charles de Tolnay looks specifically at Delacroix's exploration of the theme in "Michel-Ange dans son atelier par Delacroix," *Gazette des Beaux-Arts*, ser. 6, 59 (1962), 43-52. Ann Coffin Hanson illustrates Manet's tribute to Velázquez in *Manet*, Philadelphia: Philadelphia Museum of Art, 1966-1967, p. 8. H. W. Janson and Peter Fusco, in the exhibition catalogue *Romantics to Rodin*, Los Angeles: Los Angeles County Museum of Art, 1980, discuss and illustrate a number of nineteenth-century sculptural tributes to Old Masters, pp. 160-161.

Besides the attention given by Goodrich, Sellin (*The First Pose*, New York: W. W. Norton & Company, Inc., 1976), Siegl (*The Thomas Eakins Collection*, Philadelphia: Philadelphia Museum of Art, 1978), and others to Eakins' painting of Rush, Gordon Hendricks discusses the work in "Eakins' William Rush Carving His Allegorical Statue of the Schuylkill," *Art Quarterly* 31 (Winter 1968), 382-404.

The Concert Singer

Comprehensive and balanced introductions to music in the nineteenth century are found in the essays in *The New Grove Dictionary of Music and Musicians*, edited by Stanley Sadie, London: Macmillan Publishers Ltd., 1980. Focused on cities, musical forms, types of instruments, and themes, these essays include extensive bibliographies. A recent survey of American music, into which the musical life of the late nineteenth century and that of Philadelphia assume perspective, is H. Wiley Hitchcock, *Music in the United States: A Historical Introduction*, Englewood Cliffs, N.J.: Prentice-Hall, Inc., 2nd ed., 1974. An invaluable study that focuses specifically on music during Eakins' era is Joseph A. Mussulman's *Music in the Cultured Generation: A Social History of Music in America, 1870-1900*, Evanston: Northwestern University Press, 1971, which includes an index of articles about music in the major late nineteenth-century periodicals. Illuminating books about American mu-

sic written contemporary with Eakins are those by Frederick Louis Ritter, *Music in America*, New York: Charles Scribner's Sons, 1883; and Louis C. Elson, *The History of American Music*, New York: The Macmillan Co., 1904.

Music in Philadelphia received basic study in the late nineteenth and early twentieth century, but there has been no recent comprehensive analysis. The best general survey is Robert A. Gerson, *Music in Philadelphia*, Philadelphia: Theodore Presser Co., 1940. More specifically focused are the essays of Louis C. Madeira, *Annals of Music in Philadelphia and the History of the Musical Fund Society from its Organization in 1820 to the year 1858*, Philadelphia: J. B. Lippincott and Co., 1896 (rpt. New York: Da Capo Press, 1973); *Centenary, Musical Fund Society of Philadelphia, 1820-1920*, Philadelphia, 1920; and W. G. Armstrong, *Record of the Opera in Philadelphia*, Philadelphia: Porter and Coates, 1884. The introductory chapter of Frances A. Wister, *Twenty-five Years of the Philadelphia Orchestra*, Philadelphia: Stern, 1925, surveys orchestral music in Philadelphia before the twentieth century.

The most detailed sources for a study of nineteenth-century musical life are contemporary music journals. These are indexed in William J. Weichlein, *Checklist of American Music Periodicals 1850-1900*, Detroit: Information Coordinators, Inc., 1970. Featuring essays on music, news of local, national and international musicians, illustrations and photogravures, and advertisements (and samples) of the latest best-selling music, particularly valuable in a study of Eakins' period are the *American Art Journal* (1864-1905), published in New York (and devoted primarily, despite its title, to music), the Boston journal *Musical Record* (1878-1885), and three Philadelphia journals—the *Amateur* (1870-1875), the *Philadelphia Musical Journal* (also called *North's Philadelphia Musical Journal*, 1886-1891), and *Etude* (1883-1957). The journals published in Philadelphia discuss the musical milieu of the city in great detail; the names of Eakins' sitters and colleagues occur frequently.

In addition to these major sources, a number of shorter-lived periodicals are preserved at the Free Library of Philadelphia and the Library of Congress. Musical programs on file in Philadelphia at the Historical Society of Pennsylvania, the Free Library, the Pennsylvania Academy of the Fine Arts, and the Academy of Music, and in the Library of Congress (especially in the collected scrapbooks of Thomas A'Beckett, an accompanist active in Philadelphia musical circles from 1865 to 1915) provide further insights.

For general surveys of musical imagery, helpful in assessing Eakins' treatment of musical instruments, see Donald D. Celender, *Musical Instruments in Art*, Minneapolis: Lerner Publications Co., 1966; and Robert Bragard, *Mu-*

sical Instruments in Art and History, London: Barrie and Rockliff, 1968. A valuable discussion that focuses on Renaissance and baroque imagery—the heritage of which was still very strong in the nineteenth century—is that of Emanuel Winternitz, *Musical Instruments and their Symbolism in Western Art*, London: Faber and Faber Ltd., 1967. An illuminating survey of historicizing nineteenth-century paintings of Old Master musicians is provided by Walter Rowlands, *Among the Great Masters of Music: Scenes in the Lives of Famous Musicians*, Boston: Longwood Press, 1978 (rpt. from 1900).

Several studies reveal the social, technological, and artistic role of types of instruments during Eakins' era. The best study of the development of the piano and of its social role is that of Arthur Loesser, *Men, Women, and Pianos: A Social History*, New York: Simon and Schuster, 1954; detailed and witty, the study probes into virtually every aspect of the spread of the instrument across Europe and America. Earlier points of view may be found in Daniel Spillane, *History of the American Pianoforte: Its Technical Development, and the Trade*, New York: Spillane, 1890 (rpt. New York: Da Capo Press, 1969); and Albert E. Wier, *The Piano: Its History, Makers, Players and Music*, London, New York, Ontario: Longmans, Green and Co., 1940. Helpful to the art historian because of the many reproductions of paintings and drawings that show keyboard instruments is Helen Rice Hollis, *The Piano: A Pictorial Account of Its Ancestry and Development*, London: David and Charles, 1975.

Josef Brandlmeier analyzes the zither in its great variety in *Handbuch der Zither*, Munich: Süddeutscher Verlag, 1963. Sibyl Marcuse, in *A Survey of Musical Instruments*, New York and London: Harper and Row, 1975, places the instrument in historical context. Paul N. Hasluck, ed., *Violins and Other Stringed Instruments: How to Make Them*, London: La Belle Sauvage, 1906 and Philadelphia: David McKay, 1907, provides the reader with measurements and materials for actual nineteenth-century instruments. Issues of *The Zitherplayer*, Washington, D.C., 1879-1881, in the music collection of the Library of Congress, discuss zithers and equipment, zither clubs in America, and zither repertory.

In assessing Eakins' interest in the violincello, two histories of the instrument written during his lifetime are particularly illuminating: Wilhelm Joseph von Wasielewski, *The Violincello and its History*, New York: Da Capo Press, 1968 (originally, 1894), and Edmund S. J. van der Straeten, *History of the Violincello, the Viol da Gamba, Their Precursors and Collateral Instruments, with Biographies*, 2 vols., London: William Reeves, 1915 (rpt: New York:

AMS Press, 1976). For a recent study, see Elizabeth Cowling, *The Cello*, New York: Charles Scribner's Sons, 1975.

Invaluable in studying the development of theories of music history in the nineteenth century is the work by Warren Dwight Allen, *Philosophies of Music History: A Study of General Histories of Music 1600-1960*, New York: Dover Publications, Inc., 1962 (orig. 1939).

On the phenomenal popularity of singers and opera in the nineteenth century, see, for treatments contemporary with Eakins, Ellen C. Clayton, *Queens of Song*, Freeport, N.Y.: Books for Libraries Press, 1972 (orig. 1863); and George T. Ferris, *Great Singers: Faustina Bordoni to Henrietta Sontag*, 2 vols., New York: D. Appleton, 1888. A more recent point of view is that of Oscar Thompson, *The American Singer: A Hundred Years of Success in Opera*, New York: Dial Press, 1937 (rpt. New York: Johnson Reprint Corp., 1969). These works include many reproductions of portrait photographs. Images of singers in prints are discussed by Heino Maedebach in *Die Singenden in der Graphischen Kunst, 1500-1900*, Coburg: Druckhaus A. Rossteutscher, 1962.

Several works are important for a detailed study of the parlor song. Frances M. R. Ritter, in *Some Famous Songs: An Art-Historical Study*, New York: Schuberth and Company, 1878, reveals the new historical point of view that informed many musicians' study of their work. Illustrations of actual songs, with illuminating accompanying discussion, are provided by Wilson Flagg, "Parlor Singing," *Atlantic Monthly* 24 (October 1869), 410-420; and, more recently, William Treat Upton, *Art-Song in America*, Boston: Oliver Ditson Co., 1930 (with supplement, 1938); Paul Fatout, "Threnodies of the Ladies' Books," *Musical Quarterly* 31, no. 4 (October 1945), 464-478; Nicholas E. Tawa, *Sweet Songs for Gentle Americans: The Parlor Song in America, 1790-1860*, Bowling Green, Ohio: Popular Press, 1980; and Michael R. Turner, ed., *The Parlour Song Book: A Casquet of Vocal Gems*, New York: The Viking Press, 1973. On the song, particularly, Mussulman (*Music in the Cultured Generation*) is invaluable.

Cowboy songs are recorded and studied in *Cowboy Songs and Other Frontier Ballads*, collected by John A. Lomax and Alan Lomax, New York: The Macmillan Co., 1938 (orig. ed. 1910); Nathan H. Thorp, *Songs of the Cowboys*, New York: C. N. Potter, 1966; and Samuel J. Sackett, *Cowboys and the Songs They Sang*, New York: William R. Scott, Inc., 1967. Frederic V. Grunfeld, *The Art and Times of the Guitar*, New York: The Macmillan Co., 1969, discusses the guitar in the West, pp. 235ff. S. S. Stewart discusses almost every

aspect of contemporary attitudes toward the banjo in "The Banjo Philosoph-ically: Its Construction, Its Capabilities, Its Evolution, Its Place as a Musical Instrument, Its Possibilities, and Its Future," *S. S. Stewart's Banjo and Guitar Journal* (a Philadelphia publication), 3, no. 12 (October/November 1886), 6.

James W. Fosburgh has written on Eakins' music paintings in "Music and Meaning," *Art News* 56, no. 12 (February 1958), 24-27, 50-51.

Walt Whitman

The best introduction to Walt Whitman is his own voice. His poetry and prose are collected in *The Collected Writings of Walt Whitman*, New York: New York University Press, 1961-1978, in which is published the "Compre-hensive Reader's Edition" of the *Leaves of Grass*, edited by Harold W. Blodgett and Sculley Bradley, 1965. Many insights are provided by Whitman's con-versations and reminiscences during his last years in Camden, as preserved by Horace Traubel, *With Walt Whitman in Camden*, 5 vols., Vol. 1: Boston: Small, Maynard and Co., 1906; Vol. 2: New York: D. Appleton and Com-pany, 1908; Vol. 3: New York: Mitchell Kennerley, 1914; Vol. 4: Philadel-phia: University of Pennsylvania Press, 1953; Vol. 5: Carbondale, Ill.: Southern Illinois University Press, 1964.

The classic study of Whitman's achievement in the contexts of literature and ideas in America is that of F. O. Matthiessen, "Whitman," in *American Renaissance: Art and Expression in the Age of Emerson and Whitman*, New York: Oxford University Press, 1941. A sensitive biography is that of Gay Wilson Allen, *The Solitary Singer*, New York: The Macmillan Co., 1955. The more recent biography by Justin Kaplan, *Walt Whitman, A Life*, New York: Simon and Schuster, 1980, challenges earlier emphases on Whitman's sudden flow-ering of poetic genius in 1855. Special focus on one aspect of Whitman's poetic development is pursued by Robert D. Faner in *Walt Whitman and Opera*, Philadelphia: University of Pennsylvania Press, 1951. In *The Historic Whitman*, University Park and London: The Pennsylvania State University Press, 1973, Joseph Jay Rubin roots Whitman in a detailed historical context, in part to redress the early twentieth-century idolatry of the poet, the subject of Charles B. Willard's *Whitman's American Fame: The Growth of His Reputation in America after 1892*, Providence: Brown University, 1950. Gay Wilson Al-len lists the many portraits of Whitman in several media in "The Iconogra-phy of Walt Whitman," in Edwin Haviland Miller, ed., *The Artistic Legacy of Walt Whitman*, New York: New York University Press, 1970.

On the relationship between Eakins and Whitman, Lloyd Goodrich, *Thomas Eakins*, 2 vols., Cambridge, Mass.: Harvard University Press, for the National Gallery of Art, 1982, vol. II, 28-38, draws a sensitive, incisive picture. Henry B. Rule, in "Walt Whitman and Thomas Eakins: Variations on some common themes," *Texas Quarterly* 17, no. 4 (Winter 1974), 7-57, analyzes a broad range of the two men's shared concerns.

A number of studies are invaluable in assessing the vast cultural changes that influenced Eakins in the last years of his life. Stephen Toulmin and June Goodfield, in *The Discovery of Time*, New York: Harper and Row, 1965, trace the evolution of the ideas about time, antiquity, and the meaning of change that had an increasingly greater impact toward the end of the century. Gertrude Himmelfarb discusses the influence of the work of Charles Darwin in *Darwin and the Darwinian Revolution*, Gloucester, Mass.: P. Smith, 1967 (c. 1962). Two studies draw a valuable broad picture of the intellectual climate of the age: Walter Houghton, *The Victorian Frame of Mind*, New Haven: Yale University Press, 1957, and Gertrude Himmelfarb, *Victorian Minds*, New York: Alfred A. Knopf, 1968. Focusing primarily on America is Larzar Ziff, *The American 1890s*, New York, Viking Press, 1966, who pays close attention to shifting ideas of American writers. Paul Carter examines the American religious climate in *The Spiritual Crisis of the Gilded Age*, DeKalb: Northern Illinois University Press, 1971. The special issue of *American Quarterly* in December 1975 (vol. 27, no. 5) entitled "Victorian Culture in America" includes essays particularly valuable in insisting on the complexity of the period: Daniel Walker Howe, "American Victorianism as a Culture," pp. 507-532, and D. H. Meyer, "American Intellectuals and the Victorian Crisis of Faith," pp. 585-603.

Developments in anthropology in the nineteenth century, including its character in the United States and Philadelphia, are discussed by T. K. Penniman, *A Hundred Years of Anthropology*, New York: International Universities Press, Inc., 1935 (rpt. 1970). Valuable for an analysis of American advancements in the discipline are June Helm, ed., *Pioneers of American Anthropology: The Uses of Biography*, Seattle and London: University of Washington Press, 1966, and Curtis M. Hinsley, Jr., *Savages and Scientists: The Smithsonian Institution and the Development of American Anthropology, 1846-1910*, Washington, D.C.: Smithsonian Institution Press, 1981. A. Irving Hallowell, "Anthropology in Philadelphia," in Jacob W. Gruber, ed., *The Philadelphia Anthropological Society*, Philadelphia: Temple University Publications, 1967, discusses the implications of Philadelphia's activities in the field. Joan

Mark devotes a chapter to one of Eakins' sitters, Frank Hamilton Cushing, in *Four Anthropologists: An American Science in its Early Years*, New York: Science History Publications, 1980.

An excellent introduction to the evolution of the study of the mind, a development that had major influence at the end of the century, is Henri F. Ellenberger, *The Discovery of the Unconscious*, New York: Basic Books, Inc., 1970, with a comprehensive bibliography. Although William James (*The Principles of Psychology*, 1890, and *The Will to Believe and Other Essays on Popular Philosophy*, 1897) was the major American figure in psychology, two Philadelphia physicians achieved prominence also: S. Weir Mitchell and Horatio C. Wood. Richard D. Walter's *S. Weir Mitchell, M.D.—Neurologist*, Springfield, Mass.: Thomas, 1970, studies Mitchell's scientific career. Mitchell's own writings include *Wear and Tear, or Hints for the Overworked*, Philadelphia: J. B. Lippincott and Co., 1871 (with eight subsequent editions and rpt., 1973, Arno Press); *Fat and Blood: and How to Make Them*, Philadelphia: J. B. Lippincott and Co., 1878 (2nd ed., with six subsequent editions); *Lectures on Diseases of the Nervous System, Especially in Women*, Philadelphia: J. B. Lippincott and Co., 1886 (see especially, "Outdoor and Camp-Life for Women," pp. 155-179). Horatio C. Wood discusses his most influential theories in *Brain-Work and Overwork*, Philadelphia: Presley Blakiston, 1880, and *Nervous Diseases and Their Diagnosis: A Treatise Upon the Phenomena Produced by Diseases of the Nervous System*, Philadelphia: J. B. Lippincott and Co., 1887.

Several studies of American portraitists active late in the century show the significant contrast of their careers to that of Eakins. Ronald G. Pisano has studied *William Merritt Chase*, New York: Watson-Guptill, 1979. Carter Ratcliff examines the implications of Sargent's flamboyant career in *John Singer Sargent*, New York: Abbeville Press, 1982. H. Barbara Weinberg traces the recent renewed interest in Sargent's career in "John Singer Sargent: Reputation Redidivus," *Arts Magazine* 54, no. 7 (March 1980), 104-109. *Cecilia Beaux: Portrait of an Artist*, exhibition catalogue of the Pennsylvania Academy of the Fine Arts, Philadephia, 1874, shows the scope of work of this Philadelphia portraitist. Other popular portrait painters are discussed in *American Portraiture in the Grand Manner: 1720-1920*, Los Angeles: Los Angeles County Museum of Art, 1981.

Essays about portraits by Eakins discussed in this chapter include William H. Gerdts' survey of Eakins' clerical portraits in "Thomas Eakins and the Episcopal Portrait: Archbishop William Henry Elder," *Arts Magazine* 53, no. 9 (May 1979), 154-157. Phyllis Rosenzweig, *The Thomas Eakins Collection of*

the Hirshhorn Museum, Washington, D.C.: Smithsonian Institution Press, pp. 153-156, discusses Eakins' preparations for his portrait of Frank Hamilton Cushing; Judith Zilczer adds information in "Eakins Letter Provides More Evidence on the Portrait of Frank Hamilton Cushing," *The American Art Journal* 14, no. 3 (Winter 1982), 74-76. John Wilmerding discusses a number of Eakins' late bust portraits in "Thomas Eakins' Late Portraits," *Arts Magazine* 53, no. 9 (May 1979), 108-112.

INDEX

Unless otherwise specified, works of art are by Thomas Eakins

Abbey, Edwin Austin, 162n

Abel, Carl Frederic, Figure 7; 6, 124

Academicians of the Royal Academy, The (Zoffany), 103

Academy of Natural Sciences of Philadelphia, 155n, 164n

Actress, An (Portrait of Suzanne Santje), Figure 108; 150, 164n, 167

Addicks, Stanley, 143n

Addie (Portrait of Mary Adeline Williams), Figure 122; 167

Agnew, Dr. D. Hayes, Plate 6; 78-79, 116, 150

Agnew Clinic, The, Plate 6; 78-79, 80n, 116, 148, 150, 166

Agriculture (Rush), 96

Alexander, John White, 144n, 153n

Allegory of the Schuylkill River in its Improved State (Schuylkill Chained, Rush), 86, 88

Allegory of the Waterworks (The Schuylkill Freed, Rush), Figure 49; 86, 88-90, 101, 105, 107n

Alphonse Leroy (David), Figure 8; 6

Ambroise Paré Applying Ligatures after an Amputation (after Matout), Figure 43; 73-75

American Catholic Historical Society (Philadelphia), 151

American Philosophical Society (Philadelphia), 59, 86, 150

amputation, 56, 69, 70, 75

anatomical dissection, 55-56, 69

anatomical models (Rush), 86n

anatomy instruction, 11, 53-55, 58

anatomy lesson, as image, 71, 72

Anatomy Lesson of Dr. Nicolaas Tulp, The (Rembrandt), Figure 36; 56, 67, 70, 71, 73

Anatomy Lesson of Dr. Velpeau, The (Feyen-Perrin), Figure 42; 72, 76n; lithograph of, 73

anesthesia, 47-48, 57, 59-60, 65

anthropology in the nineteenth century, 158-59

Antiquated Music (Mrs. William D. Frishmuth), Figure 107; 137n

Appel, Dr. Daniel, 48, 51

Arcadia (Bouguereau), 128n

Arcadia (Corot), 128n

Arcadia, (oil), Figure 89; 128-29; studies for, Figure 88; 128-30

Arcadia (plaster relief), Figure 90; 128-30; studies for, Figure 87; 128-30

Arcadia and Arcadian themes, 127-30

An Arcadian, 129n

Archbishop James Frederick Wood, 82, 149

Archbishop William Henry Elder, 148n

Arnold, Thomas, 26

Arrangement in Black: Pablo de Sarasate (Whistler), Figure 85; 126

Artist and His Model, The (Gérôme), Figure 65; 102

Artist and Model (Susan Eakins), 111n

Artist in His Museum, The (Peale), Figure 62; 94

artist in his studio (convention), 91-95, 99; in photographs, 95. *See also* Old Master in his studio

Artist's Studio, The (Courbet), Figure 59; 92, 103

asepsis, 47n, 49, 78-79

Asher Brown Durand (Huntington), 95

At the Piano, Figure 79; 116, 120

At the Piano (Whistler), Figure 75; 117

Atelier de Rembrandt (Robert-Fleury), 100n

Aze, Adolph, 93n

Baby at Play, 82

Bache, A. Dallas, 9

Ballantyne, J., 93n

banjo, 131, 136

Barber, Alice, Figure 67; 104
"Barnes Bridge" (*Harper's*), Figure 22; 32
Barton, Dr. James M., 48, 52
Baseball Players Practising, xixn
Batoni, Pompeo, Figure 81; 124
Baudelaire, Charles, Figure 3; 4, 5, 11, 169
Baudouin, P. A., 100n
Beale, Joseph Boggs, 23, 24n, 53n, 54n
Beaux, Cecilia, Figure 113; 153-54, 157n, 162
Bebie, Henry, 94n
Beckwith, Carroll, 112n
Bement, William, 157n
Benjamin Franklin (Peale), Figure 9; 6
Benjamin Rush (Rush), 86, 88
Benjamin Rush (Sully), Figure 10; 6
Bensell, G. F., 157n
Bichat, Marie-François, Figure 39; 71-72
Biglin, John, Plate 3, Figures 29 and 30; 41-43
Biglin brothers, Eakins' paintings of, 21, 41-42
Biglin Brothers About to Start the Race, The (The Biglin Brothers Racing), Figure 29; 42n
Biglin Brothers Practising, The (The Pair-Oared Shell), Plate 3; 21, 42
Biglin Brothers Racing, The (The Biglin Brothers About to Start the Race), Figure 29; 42n
biography, interest in, 7-8, 57, 92, 155
Birch, Thomas, Figure 11; 8n
Bispham, Henry C., 157n
Black Fan, The [Mrs. Talcott Williams], 146n
Boat Race, Boston Harbor (Lawrence), Figure 27
Boccherini, Luigi, Figure 81; 124
Boldini, Giovanni (Jean), 154n
Bond, Dr. Thomas, 58
bone diseases, 68-70
Bonheur family, 17
Bonnat, Léon, Figure 13; 13, 16, 71n, 92n, 148, 154, 156n
Borie, Adolph E., 157n
Boston Art Club, 100
Botticelli, 93
Bouguereau, A. W., 128n
Bourgeois, Louis, 74n
boxing, 43, 47
Boy Reclining, 129n

Breckenridge, Hugh H., 157n
Briggs, Dr. Charles S., 48, 52
Brinton, Daniel H., 150, 151n
Brinton, Dr. John H., 78n, 82
Brooklyn Art Association, 106
Brown, Walter, Figures 21 and 25; 32-33, 39, 44
Bryant, Walter C., 163
Bufford's Comic Sheet, Figure 31; 45
Bush-Brown, Margaret Lesley, 157n

Cadwalader, Gen. George, 151
Calder, Alexander Stirling, 51n
Carjat, Etienne, Figure 3; 57n
Carl Frederic Abel (Gainsborough), Figure 7; 6, 124
Carlyle, Thomas, Figure 4; 4-5, 159, 162n, 169
Carolus-Duran, C.-E., 112n, 154n
Caspar Wistar (Rush), 86, 88
Cassatt, Mary, 115
Catholic University of America, 151
Cellist, The (Homer), 125n
Cellist Pillet, The (Degas), Figure 82
Cello Player, The, Plate 12; 123-26, 150-51
Centennial celebration, 46, 95, 98
Centennial exhibition, 48, 55, 76-77
Central High School, 9-11, 13, 17n, 18, 23, 39, 150, 157, 161; Eakins' course of study, 10; medical emphasis of curriculum, 53; professorship of writing and drawing, 11
Centre Square (Philadelphia), 84-86, 96, 104-105, 107n, 108
Centre Square (Tiebout), Figure 48; 85
Champêtre (Giorgione), 128n
Champion Single Sculls, The (Max Schmitt in a Single Scull), Plate 1, Plate 2 (detail); 19-23, 33-35, 38-42
Charity Hospital (Paris), 72-73
Charles Baudelaire (Carjat), Figure 3
Charles E. Dana, 165n
Chartran, Théobald, 154n
Chase, William Merritt, Figures 69 and 112; 112, 153n, 156n, 162, 167
Chicago World's Fair (1893), 80n, 128n, 147n
Claghorn, James, 157n

Clara Louise Kellogg as Aïda, photograph of, Figure 98; 139

Clark, William J., 47n, 49n, 52n, 77n, 108-109

Clarke, Hugh, 130n

Clarke, Thomas B., 121

clinical teaching in surgery, 57, 61, 63-67, 79, 80n

clinics, surgical: of Dr. Gross, 53-54, 66-67, 69-70, 79-80, 159; in Paris, 55, 60, 61n; in Philadelphia, 53-55, 78-80

Cochereau, L. M., Figure 66; 103

College of Physicians of Philadelphia, 59, 86, 164n

Commerce (Rush), 96

Composition Study for the Portrait of Professor Gross, Figure 32; 46, 51

Composition Study for William Rush Carving (1877), Figure 58; 90

Concert Singer, The, Plate 10, Figure 97; 116, 138-43, 150, 153, 159

conservative surgery, 68-70, 75

Cook, Weda, 133n, 138-40, 143

Corot, Camille, 128n

Courbet, Gustave, Figure 59; 92, 103

Courtship, 102n

Couture, Thomas, Figure 16; 15-16, 22

Cowboy Singing, Figure 95; 136-37, 150

Crawford, Thomas, 98

Crowell, Elizabeth, Figure 80; 121

Crowell, William (Billy), 16, 121

crucifixes (Rush), 84, 87n, 96

Crucifixion, xixn, 149, 153n

Culin, Stewart, 158

Currier and Ives, 31-34, 38-40

Cushing, Frank Hamilton, Plate 14; 150, 158-59

Da Costa, Dr. Jacob M., Figures 115, 116, and 119; 164n, 165-67

Dakota territory, 136, 160

Dana, Charles E., 165n

Danhauser, Joseph, 117n

Dante (Gérôme), Figure 12; 12

Darley, F.O.C., 157n

Darwinism, 157-58

Daumier, Honoré, 57, 131

David, Jacques Louis, Figure 8; 6, 103

Dean's Roll Call, The (Portrait of James W. Holland), Figure 117; 78n, 166

Degas, Edgar, Figures 73, 76, 82, 92; 92, 115, 117, 124-25, 131

Delacroix, Eugène, Figure 60; 92-93

Detaille, Edouard, 92n

de Vigne, Felix, 100n

Dr. Charles Lester Leonard, 78n

Dr. John H. Brinton, 78n, 82

Dr. Joseph Leidy, II, 78n

Dr. William Thomson, Figure 46; 78n

Dolph, John Henry, 94n

Donovan, William, 112n

Dorr, Otto, 92n

Doughty, Thomas, 8n

Drawing of the Girard Avenue Bridge, Figure 17; 21

Drexel, Mrs. Joseph H., 146n

Dumont, Augustin, 13, 148

Dunlap, William, 97-99

Dupuytren, Guillaume, Figure 38; 58n, 61, 71-72

Durand, Asher B., 95

Eakins, Benjamin, Figure 101; 8-9, 11, 17, 23, 92n, 153

Eakins, Caroline (Mrs. Benjamin), 8, 23

Eakins, Caroline, 9, 118

Eakins, Frances, Figures 78 and 79; 9, 13n, 15, 19, 23, 37; as Frances Eakins Crowell, 120, 129

Eakins, Margaret, Figures 77 and 79; 9, 23, 118, 120

Eakins, Susan Macdowell (Mrs. Thomas), Figure 91, Plate 16; 90n, 98, 99n, 108n, 111, 115, 130, 146n, 168

Eakins, Thomas: birth and early education, 8-11; on drawing, 13-14; images of, Figures 1, 2, 124; on imitation, 14-15; on language, 16-17; on Spanish painting, 16; modeling technique, 129-30; on motion, 17; painting technique, xix, 14-16, 19, 21-23, 40-42, 49-52, 88-90, 120-22, 125, 134, 137, 139, 162-63, 165-66, 168; and the portrait, xix, 3, 5, 8, 12, 13, 147-49, 152-58, 161-69; on simplicity, 16-17; on Spanish painting, 16; a study of anatomy, 11,

Eakins, Thomas (*cont.*)
17, 54-55; study in Paris, 11-17; and
teaching, 147-49; on technical virtuosity,
13-14
École de Médecine, 73-75
École des Beaux-Arts, 12, 152
egalitarianism, 3-5, 9-10, 29-30, 39, 64, 131,
141
Einstein, Florence A., 76n
Elijah (Mendelssohn), 139-42
Elizabeth at the Piano, Figure 80; 116, 120-21
Emerson, Ralph Waldo, Figure 5; 4-5, 145,
169
Erastus Dow Palmer in His Studio (Matteson),
Figure 64; 95

F. A. Kummer (unknown photographer),
Figure 83; 124-25
Fairman Rogers Four-in-Hand, The, xixn, 47n,
164n
Fairmount Park, 20n, 35, 88, 101; Art As-
sociation, 95n
Fairmount Waterworks, Figures 26 and 50;
33, 86, 88, 105, 108-109
Falconio, Archbishop Diomede, Figure 109;
150
Fantin-Latour, Henri, 92
Fedigan, Very Rev. John J., 151
Female Life Class (Barber), Figure 67; 104
Fenton, Dr. Thomas H., 76n
Fetter, George W., 150
Feyen-Perrin, F.-N.-A., Figure 42; 72-73, 76n
Fidelity Trust Co. (Philadelphia), 151
Flint, Dr. Austin, 59
Forbes, Dr. William Smith, Figure 118;
50n, 78n, 119, 150, 166
Fortuny y Carbó, Mariano, Figure 86; 128n
Fountain and Stand-Pipe (Lauderbach), Figure
51
Fourth of July in Centre Square (Krimmel),
Figure 55; 90, 100, 106, 107n
Frances Eakins, Figure 78; 116, 120
Frank Hamilton Cushing, Plate 14; 150, 158-
59
Franklin, Benjamin, Figure 9; 4, 58, 151n
Frazee, John, 98
Frishmuth, Mrs. William D., 137n, 150

Gainsborough, Thomas, Figure 7; 6, 124-25
Gavarni, Paul, 57n
General George Cadwalader, 151
genre, urban, in the nineteenth century, 7,
8, 103
George Washington (Rush), Figure 52; 82, 86-
88, 90, 101, 105, 107n, 108
George Washington sitting to Gilbert Stuart
(Schmolze), 94n
Gérôme, Jean-Léon, Figures 12, 61, and 65;
12-16, 22, 34, 42, 94, 99, 102-103, 112n,
148
Gervex, Henri, 72n, 79n
Gest, John B., 151
Gibelin, Antoine-Esprit, 74n
Gilchrist, Hubert H., 144n
Gillespie, Mrs. Elizabeth Duane, 146n, 150,
151n
Giorgione, 128n
Girard Avenue Bridge, Figure 17; 20-21
Girls Normal School (Philadelphia), 150
Gloucester landscapes, by Eakins, xixn
Gottschalk, Louis Moreau, 120
Greenough, Horatio, 98
Gross, Dr. Samuel D., Plates 4 and 5, Fig-
ures 32, 33, and 44; 46-48, 50-55, 59n,
61-70, 75-82, 119-20, 147, 150
Gross, Dr. Samuel W., 49, 79n
Gross Clinic, The, Plate 4, Plate 5 (detail); 46-
53, 55, 73n, 75-77, 79-80, 82-83, 89-91,
102, 107, 116, 119-20, 124, 149, 150, 153,
163, 166; autotype, 75, 77, 80n; *Composi-
tion study*, Figure 32; 46, 51; exhibition of,
76-77, 80; India ink wash, Figure 44; 75;
parody (photograph), 77n; photograph
showing installation, Figure 45; *Study for
the Head of Professor Gross*, Figure 33, 5;
Study for spectator [Robert C. V. Meyers],
Figure 34; 51
guitar, 121, 131-32, 136

Hamilton, James, 8n, 96, 157n
Hamilton, John McLure, 154n
Hamman, Edouard, Figure 40; 72
Hammill, James, Figure 21; 31-33, 36, 39-
40, 44
Harnett, William M., 8n

Harrison, Alexander, 128n, 133n

Harrison, Birge, 133n

Harrison, Margaret, 133

"Harry Kelley" (*Harper's*), Figure 24; 33, 40

Hart, John S., 17n, 150, 151n

Hartmann, Sadakichi, 109

Hayes, President Rutherford B., 82, 149

Healy, George P. A., 94n

Hearn, Dr. Joseph W., 48

Hennig, Rudolf, Plate 12; 123-26, 151

Henry, Rt. Rev. Mgr. Hugh T., 151

Henry Clasper, Champion of the North (Hodgretts and Walter), Figure 20; 26

Henry O. Tanner, Figure 102

heroism: ideals of, 4-6, 47, 115, 151-52, 154-57, 161, 167-69; in music, 130, 143; in rowing, 26-30, 39-40, 43-45; in surgery, 56-58, 65-68, 73-74, 79-81; for Whitman, 152

His Eminence Sebastiano Cardinal Martinelli, 151

historicism, 5, 55; in art, 71-74, 92-95; in music, 127-29; in rowing, 26; in surgery and medicine, 57, 67-68, 71-73

Holland, Dr. James W., Figure 117; 78, 151n, 164n, 166

Hollingsworth Family, The (Hollingsworth), Figure 74; 117

Hollingsworth, George, Figure 74; 117

Homage to Delacroix (Fantin-Latour), 92

Home Ranch, Figure 96; 136-37, 150, 153n

Home Scene, Figure 77; 116, 118

Homer, Winslow, 125n, 147n

Hopkins, George D., 34

Hôtel-Dieu (hospital), 72n

Hovenden, Thomas, 157n

hunting, xixn, 43

hunting and sailing scenes, by Eakins, 19, 150

Huntington, Daniel, 95

In Arcadia (Harrison), 128n

Ingres, J.-A. D., 93, 117

Installation of Rush's Nymph with Bittern in Fairmount Park near the Callowhill Street Bridge (unknown photographer), Figure 54; 88

J. Laurie Wallace Seated on Rock, Photograph of; Study for Arcadia Relief, Figure 87; 129

James Hammill and Walter Brown, in their Great Five Mile Rowing Match for $4000 and the Championship of America (Currier and Ives), Figure 21; 31-33, 39

Jarves, James Jackson, 98

Jefferson Alumni Association, 64, 77

Jefferson Medical College, 11, 18, 50n, 53-55, 61-67, 69, 70, 72, 82, 150, 166

John B. Gest, 151

John Biglin in a Single Scull, Figure 30; 41-42

Johnson, Samuel, Figure 6; 4

Jordon, Letitia Wilson, Figure 121; 167

Justice (Rush), 88

Keen, Dr. William W., Figure 120; 55, 61n

Kelley, Harry, Figure 24; 33, 40

Kershaw, Jennie Dean (Mrs. Samuel Murray), 164n

Kirkpatrick, F. L., 107n

Knight, D. Ridgway, 157n

Kremer, P., 93n

Krimmel, John L., Figure 55; 90, 100, 106, 107n

La Modèle Honnête (Baudouin), 100n

Lady with the White Shawl (Portrait of Mrs. C., Chase), Figure 112; 167

Lafayette (Rush), 88

Lambdin, George C., 8n

landscape, in the nineteenth century, 7-8, 103, 127

language, Eakins' interest in, 16-17

Las Meninas (Velázquez), Figure 15; 93, 99, 100

Latrobe, Benjamin, 84, 110n

Lawrence, A. A., Figure 27; 34

Leaves of Grass (Whitman), 145-46, 149

Lee, Hannah, 98

Leidy, Dr. Joseph II, 76n, 78n

Leonard, Dr. Charles Lester, 78n

Leonardo da Vinci and His Pupils (White), 94n

Lerolle, Henry, Figure 94; 134

Lesson on Anatomy (Milne), 107n

Linton, Frank B. A., 157n

Liszt at the Piano (Danhauser), 117n

lithotomy, 56, 69, 75

Little Confectioner, The (Couture), Figure 16

Louisiana Purchase Exposition, St. Louis (1904), 80n, 147n

Luigi Boccherini (Batoni), Figure 81; 124

McClellan, Dr. George, 61-62

Mlle. Dihau at the Piano (Degas), Figure 76; 117

Macdowell, Susan (later Susan Macdowell Eakins), 121n, 133. *See also* Eakins, Susan

Madrazo y Garreta de, Raimundo, 154n

Mahon, Mrs. Edith, Plate 15; 167

Make, J. H., 34n

Malgaigne, Dr. J. F., 57n

Manet, Edouard, 92-93, 115, 163

Marie-François Bichat (after Béranger), Figure 39; 71-72

Martinelli, His Eminence Sebastiano Cardinal, 151

Martinez Montañés (Velázquez), Figure 14; 75, 93, 99, 100

Match Between Eton and Westminster, Figure 19; 26

Matout, Louis, Figure 43; 73-75

Matteson, Tompkins H., Figure 64; 95

Max Schmitt in a Single Scull (or *The Champion Single Sculls*), Plate 1, Plate 2 (detail); 19-23, 33-35, 38-42, 49, 53, 58, 116, 123, 153, 163; exhibition of, 19n, 33, 34n

Meissonier, J.-L.-E., 15, 92n

Melchers, Gari, 113n

Melville, Rear Admiral George Wallace, Figure 105; 150

Mendelssohn, Felix, 118, 132, 139-42, 159, 161

Mercury (Rush), 88

Merritt, Anna Lea, 128n, 157n

Meyers, Henry, 122n

Meyers, Robert C. V., Figure 34; 49, 53

Michelangelo in His Studio (Delacroix), Figure 60; 93

Michel-Lévy, Henri, 34n

Miller, Leslie W. (Professor), Figure 104; 150, 164n

Minor, Robert C., 106n

Miss Amelia C. Van Buren, 165n

Mrs. Edith Mahon, Plate 15; 167

Mrs. Elizabeth Duane Gillespie, 146n, 150, 151n

Mrs. Joseph H. Drexel, 146n

Mrs. Thomas Eakins, Plate 16; 168

Mrs. William D. Frishmuth, or *Antiquated Music*, Figure 107; 137n, 150

Mitchell, Dr. S. Weir, 160, 161n

modern life, modernity, 4-5, 7, 12, 17-20, 28, 30, 39, 42, 103, 116-19, 121, 123, 126-27, 131-33, 141-43, 154-59, 160-63, 167-69

Monet, Claude, 34n

Moran, Edward, 33n

Moran, Thomas, 8n, 94n

Morgan, Dr. John, 58

Morin, E., 34n

Morris, Harrison, 148

motion, Eakins' interest in, 17, 40, 164-65

Mount, William Sidney, Figure 63; 94

Müller, Friedrich Max, 16

Murray, Samuel, 111-12, 137, 150

Museum of Charity Hospital, The (*L'Universe Illustré*), Figure 41; 72

Music, Figure 84; 121n, 126

music: egalitarianism in, 131, 141; emotion in, 120, 122-23, 125, 132, 135-38; as ideal, 126; virtuosity in, 118-21, 124-25, 143. *See also* Philadelphia, music in

Mütter, Dr. Thomas Dent, 61n

Mutual Assurance Co. (Philadelphia), 151

Muybridge, Eadweard, 113n, 164n

Myers, Samuel, 121n, 126

National Academy of Design, 147

Neagle, John, Figure 11; 8, 96, 150, 154

Neal, John, 98

necrosis, 68-70

Negro Whistling Plover, A, xixn

Nélaton, Dr. Auguste, 57n, 58n

New England Woman (Beaux), Figure 113

Nolan, Dr. Edward J., 164n

"O Rest in the Lord" (Mendelssohn), 139-43, 161

Oarsmen on the Schuylkill, 41

O'Donnell, Hughey, 49

Old-Fashioned Dress, The (*Portrait of Helen Parker*), Figure 123; 168

Old Master in his studio (convention), 92-95, 99

Operation under ether at Massachusetts General Hospital, An (unknown photographer), Figure 37; 67

Orchestra at the Opéra, The (Degas), Figure 73; 115-16

osteomyelitis, 68-70, 75

Painter's Triumph, The (Mount), Figure 63; 94

painting technique: of Eakins, xix, 14, 19, 21-23, 40-42, 49-52, 88-90, 120-22, 125, 134, 137, 139, 162-63, 165-66, 168; late nineteenth-century, 162-64

Pair-Oared Shell, The (The Biglin Brothers Practising), Plate 3; 21, 42; perspective drawing for, Figure 18; 21

Pan-American Exposition, Buffalo (1901), 147n

Pancoast, Dr. Joseph, 54

Paré, Ambroise, Figure 43; 57n, 67, 73n, 74-75, 76n

Parepa Rosa Reynolds (North's Philadelphia Musical Journal), Figure 100; 140

Paris, Eakins' studies in, 11-17

Parker, Helen, Figure 123; 168

Pasdeloup concerts, Figure 72; 17, 115

Pathetic Song, The, Figure 93; 121n, 133-34, 137, 139

Patient in the presence of Charles X after a cataract operation by Dupuytren (anonymous), Figure 38; 71

Peale, Charles Willson, Figures 9 and 62; 6, 8, 85n, 87, 94, 102n, 150, 154

Peale, James, 8n

Peale, Raphaelle, 8n

Peale, Rembrandt, 10n

Péan, Dr. Louis, 79n

Pen and Ink Drawing after William Rush Carving His Allegorical Figure of the Schuylkill River, Figure 68; 106

Penn Club, 77, 157n

Pennsylvania Academy of the Fine Arts, xix, 11, 33n, 54-55, 80n, 87-88, 94, 96, 100-103, 106, 109-111, 123, 134n, 136, 147-49, 151, 153n, 154, 156n, 157n, 165;

Gallery of National Portraiture in, 154

Pennsylvania Hospital, 58, 86

Pennsylvania Museum School of Industrial Art, 150

Perspective Drawing for "The Pair-Oared Shell," Figure 18; 21

Pestalozzi, Johann Heinrich, 10n

Peto, John F., 8n

Pettit, George, 13n

Phidias Studying for the Frieze of the Parthenon, 112n

Philadelphia, 7, 12, 17-18, 46, 55, 58-59, 60-65, 84-86, 94-97, 101-104, 106-112, 115-16, 123, 147-48, 150-51, 153-56, 158-61; artists in, 8, 12, 13n, 27, 33, 87, 94-97, 100-104, 108, 156, 157n, 166-69; music in, 115-16, 123, 131, 138-39, 141; portrait in, 8, 12, 112, 153-55, 156, 157n, 168; rowing in, 23-24, 27, 33, 35-39, 41, 43; surgery and medicine in, 58-59, 61-67, 77-80

Philadelphia School of Anatomy, 53n

Philip Syng Physick (Rush), 82, 88

Photograph of J. Laurie Wallace, Seated on Rock, Study for Arcadia Relief, Figure 87; 129

Photograph of Walt Whitman, Figure 114; 163

photographs, by Eakins, 51, 90, 128, 164n

photographs, portrait, 7, 154; of cellists, Figure 83; 124-25; of rowers, 30n, 33n, 42n; of singers, Figure 98; 130, 131n, 139

Physick, Dr. Philip Syng, 59n, 76, 86, 88

piano, 115-21, 131, 133, 135

"Picked Crew of London Rowing Club" (*Harper's*), Figure 23; 32-33

Pillet (cellist), Figure 82; 124

Piping Shepherd, The (after Fortuny), Figure 86; 128n

Piping Shepherd (Merritt), 128n

portrait: attitude of Eakins toward, xix, 3, 5, 8, 12-13, 147-49, 152-58, 161-69; Eakins' portraits as a gallery, 149-50, 152, 168; in the eighteenth century, 6; in the nineteenth century, 3, 6-8, 153-55, 168; in Philadelphia, 8, 12, 112, 153-56, 157n, 168

Portrait of a Lady with a Setter Dog [Susan Eakins], Figure 91; 130

Portrait of an Opera Singer (Weber), Figure 99; 139-40

Portrait of Archbishop Diomede Falconio, Figure 109; 150

Portrait of Dr. Horatio C. Wood, Figure 110; 78n, 136, 160

Portrait of Dr. Jacob M. Da Costa, Figure 115; 164n, 165-66

Portrait of Dr. Jacob M. Da Costa (seated, Vonnoh), Figure 116; 166 (standing, Vonnoh), Figure 119; 167

Portrait of Dr. William W. Keen (Chase), Figure 120; 167

Portrait of Emile Zola (Manet), 92

Portrait of Helen Parker (The Old-Fashioned Dress), Figure 123; 168

Portrait of James Tissot (Degas), 92

Portrait of James W. Holland (The Dean's Roll Call), Figure 117; 166

Portrait of John Taylor Johnston (Bonnat), Figure 13

Portrait of Letitia Wilson Jordan, Figure 121; 167

Portrait of Mary Adeline Williams (Addie), Figure 122; 167

Portrait of Mrs. C. (Lady with the White Shawl, Chase), Figure 112; 167

Portrait of Mrs. J. William White (Sargent), Figure 111

Portrait of Professor Leslie W. Miller, Figure 104; 150, 164n

Portrait of Professor Rand, Figure 35; 50n, 54, 150

Portrait of Professor William Smith Forbes, Figure 118; 50n, 78n, 119, 150, 166-67

Portrait of Rear Admiral George Wallace Melville, Figure 105; 150

Poussin, Nicolas, 93

Powers, Hiram, 98

President Rutherford B. Hayes, 82, 149

prints: portrait, Figures 20, 21, 24, 25, 39, and 100; 7-8, 26, 30-33, 38, 57; rowing, Figures 19, 20, 21, 22, 23, 24, 25, and 31; 26, 30-35, 38-40, 42n

Professionals at Rehearsal, Plate 11; 121, 123, 149

Professor George W. Fetter, 150, 151n

Professor Henry A. Rowland, Figure 103; 150, 159n

psychology, in the nineteenth century, 159-61

Pupils Drawing from a Nude Model (Sweerts), 103n

Pygmalion and Galatea (Gérôme), 103

Quaker heritage, 11n, 20, 39

Ramsey, Milne, 107n

Rand, Dr. B. Howard (Professor), Figure 35; 24, 50n, 54, 150, 164n

Raphael, 93

Raphael Showing Bramante the Sistine Ceiling (Gérôme), 94

Read, Buchanan, 13n

Rehearsal in the Choir Loft, A (Lerolle), Figure 94; 134

Rehearsal of the Pasdeloup Orchestra at the Cirque d'Hiver (Sargent), Figure 72; 115

Reid, George Agnew, 121n

Rembrandt van Rijn, Figures 36 and 61; 6, 22, 56, 67, 70-72, 93

Rembrandt Etching a Plate (Gérôme), Figure 61; 94, 99

Renforth, James, 32-33, 44

Regnault, Victor, 93n

Reynolds, Sir Joshua, Figure 6; 6, 103

Reynolds, Parepa Rosa, Figure 100; 140

Ribera, José de, 16

Richards, T. Addison, 98

Richards, Williams Trost, 8n, 96, 157n

Robert-Fleury, T., 100n

Rogers, Fairman, 47n, 157n

Rosenthal, Albert, 157n

Rothermel, Peter F., 8n, 96

rowing, college and university, 25-27, 32, 36, 43-44; development of shells, 25-27; and discipline, 28-29, 39, 42, 45; and egalitarianism, 29-30, 39; in England, 24-26, 42; in France, 33-34, 41; in Germany, 41; and health, 28, 30, 44; and morality, 29, 43; pair-oared, Figure 29; 41, 42n; in Philadelphia, 23-24, 27, 33, 35-39, 41, 43; single sculling, 25-27, 32, 34, 36-38, 41,

43; in the United States, 24-25, 27-32, 34-35, 42

"Rowing Courses Used on the Schuylkill River, The" (*Turf, Field and Farm*), Figure 28; 35

rowing prints: American, Figures 21, 25, and 31; 30, 35; English, Figures 19, 20, 22, 23 and 24; 26, 32-33

Rowland, Henry A. (Professor), Figure 103; 140n, 150, 159n

Rubenstein, Anton, 119

Rush, Dr. Benjamin, Figure 10; 6, 59n, 86, 88

Rush, William, Figures 47, 49, 52, and 53; 83-91, 95-102, 104-114; Eakins' statement on, 104-105, 107n

sailing, 19, 43

sailing and hunting scenes, by Eakins, xixn

Saint-Gaudens, Augustus, 144n

Salons, Paris, 17, 72, 93

Salutat, Figure 106; 150

Salvator Rosa Sketching the Banditti (T. Moran), 94n

Samuel Johnson (Reynolds), Figure 6; 6

Santje, Suzanne, Figure 108; 150, 164n, 167

Sarasate, Pablo de, Figure 85; 126

Sargent, John Singer, Figures 72 and 111; 115, 154, 156, 162

Sartain, Emily, 157n

Sartain, John, 157n

Sartain, William (Billy), 42n, 71n, 108n, 111, 157n

Schenck, Franklin, 137

Schendler, A. Z., 33n

Schmitt, Max, 20, 23-24, 33, 36-41, 43-44

Schmitz, Charles M., 133n, 138-40

Schmolze, Charles, 94n

Schreiber Brothers, The, 34n

Schuylkill Navy, 24, 36-39, 41, 43

Schuylkill River, Figure 28; 20, 23, 33, 35-36, 38, 42-43, 55, 84; racecourses on the Schuylkill, Figure 28; 35-38

Sculptor and Model [Susan Eakins], 111n

Self-Portrait [Eakins], Figure 124

Self-Portrait (Rush), Figure 53; 88, 90, 107n

Serres, John Thomas, 34n

Sharp, Dr. Benjamin, 164n

Shinn, Earl, xixn, 24n, 42n, 47n, 55, 87, 95-96, 146n, 147n

Singer in Green, The (Degas), Figure 92; 131

singers, 130-43

Sketch for William Rush and His Model, Figure 71; 113

Sleeping Chaperone, The (de Vigne), 100n

Smith, Dr. Nathan, 69-70

Smith, Sydney, 60, 98

Smith, T. Guilford, 53n

Society of American Artists, 80n, 106, 134n, 148

song, 131-43; "pathetic," 135, 140, 143; cowboy, 136-37, 143; oratorio, 138-42

Stewart Culin, 158

Stolte, C. F., 133

Stuart, Gilbert, 154n

Studio, Spanish interior, The (Kirkpatrick), 107n

Studio in the Batignolles Quarter (Fantin-Latour), 92

Studio in the Time of Louis XVI (Dolph), 94n

Studio of Corot, The (Minor), 106n

Studio of David, The (Cochereau), Figure 66; 103

Study for spectator (Robert Meyers), Figure 34; 51

Study for the Head of Professor Gross, Figure 33; 51

Study of Ben Crowell for Arcadia, Figure 88; 129

Study of Woman with Parasol, Figure 56; 90, 100

Sully, Thomas, Figure 10; 8, 150, 154n

surgery: clinical teaching of, 57, 61, 63-67, 79, 80n; conservative, 68-70, 75; as distinct from medicine, 56-57; and egalitarianism, 57, 61-64; history in Europe, 56-58, 65, 68-69; history in France, 56-61, 63, 71; history in Philadelphia, 58-59, 61-67, 77-80; history in the United States, 58-63, 65, 68, 78-80; as scientific, 57, 67; virtuosity in, 65-66, 68

Sweerts, Michael, 103n

Sweetbriar Mansion, 20

Sword, James B., 157n
Symphony Society of Philadelphia, 123

Tanner, Henry O., Figure 102; 149
Tarbell, E. C., 153n
Tassaert, Octave, 92
Tenth Street Studio, The (Chase), Figure 69; 112
Thomas, Dr. A. R., 54
Thomas Birch (Neagle), Figure 11; 8n
Thomas Carlyle (Cameron), Figure 4; 4
Thomas Eakins, Figure 124; 168
Thomas Eakins (Gutekunst), Figure 1
Thomas Eakins (unknown photographer), Figure 2
Thomson, Dr. William, Figure 46; 78n
Tissot, James, 34n, 92
Titian, 22
Titian's Model—from the Painting in the Louvre (Healy), 94n
Translator, The, 151
Tuckerman, Henry, 98
Tulp, Dr. Nicolaas, Figure 36; 56, 67, 70-71, 73
Tyson, Dr. James, 76n

Uhle, Albert Bernhard, 156n
Union League of Philadelphia, 19n, 54n, 82, 94n, 125n, 128n
Universal Exposition, Paris (1867), 93
Universal Exposition, St. Louis (1904), 80
University of Pennsylvania: medical college, 59, 61, 64n, 78, 150; rowing, 43

Van Buren, Amelia, 164n
Van Calcar, 71
van der Beemt, Hedda, Figure 84; 121n, 126
Van Dyck in His Studio (Bebie), 94n
van Rensselaer, Mrs. Marianna Griswold, 126
Vanuxem, Louisa, 85, 99, 100, 102n, 110n, 111n
Vanuxem, James, 85, 105
Vanuxem, Mrs. James, 99-100
Velázquez, Diego, Figures 14 and 15; 13, 16, 22, 75, 93, 99, 100

Velpeau, Dr. Armand A., Figure 42; 57n, 72-73
Very Rev. John J. Fedigan, 151
Vesalius, Figure 40; 71-72
Vesalius at Padua in 1546 (Hamman), Figure 40; 72
Veteran, The, 152
View of Fairmount Waterworks, A, Figure 26; 33
Villanova College, 150
Violinist, The, 126n
violoncello, 123-25, 132-33, 135
virtuosity: in music, 118-21, 124-25, 143; in painting, 13n, 14, 162; in surgery, 65-66, 68
voice, 131-32
Voltaire, 4
von Menzel, Adolph, 134n
Vonnoh, Robert, Figures 116 and 119; 156n, 166

Wallace, J. Laurie, Figure 87; 121
Walt Whitman, Plate 13; 144, 150-51, 163
Walt Whitman, Photograph of, Figure 114; 163
"Walter Brown" (Harper's), Figure 25; 33
Ward, Joshua, 36, 42n
Ward of Model Post Hospital, Centennial Exposition (unknown photographer), Figure 45; 76
Water Nymph and Bittern (or Allegorical Figure of the Schuylkill River, Rush), Figures 47, 48, 51, 54, and 55; 84-88, 90, 95-96, 101-102, 104-111; as "Leda and the Swan," 104-105, 107-108
Watson, John, 97
Watts, George F., 162n
Wax Studies for William Rush Carving His Allegorical Figure of the Schuylkill River (1877 version), Figure 57; 90
Weber, Paul, Figure 99; 139-40
Weir, John Ferguson, 95
Weir, Robert F., 95
West, Benjamin, 87
West, Dr. Franklin, 49-50
Wharton, Edith, 154n, 160n
Whistler, James A. McNeill, Figures 75 and

INDEX

Williams, Mrs. Talcott, 144n, 146n

Williams, Nannie, 102n
Williams, Talcott, 144
Wisdom (Rush), 88
Wistar, Dr. Caspar, 59n, 86, 88
Wood, Archbishop James Frederick, 82, 149
Wood, Dr. Horatio C., Figure 110; 78n, 136, 160, 161n
wrestling, 47
Writing Master, The, Figure 101; 149, 152

Youth Playing the Pipes, A, 129

zither, 121-23, 132
Zither Player, The, 121n, 149
Zoffany, Johann, 103
Zorn, Anders, 154n, 156n

85; 117, 126, 153n, 154, 156n
White, Edwin, 94n
Whitman, Walt, Plate 13, Figure 114; 76n, 144-49, 163, 169; on Eakins, 144-45
William Rush and His Model, Plate 9: 113-14
William Rush Carving His Allegorical Figure of the Schuylkill River (1877 version), Plate 7, Plate 8 (detail); 82, 88-91, 95, 98-108, 115-16, 149, 153, 163; exhibition of, 106-107; outline drawing for engraving, Figure 68; 106; studies for, Figures 56, 57, and 58; 90-91, 100
William Rush Carving His Allegorical Figure of the Schuylkill River (1908 version), Figure 70; 111-14; studies for, 113
Williams, E. L., 33n
Williams, Mary Adeline (Addie), Figure 122; 167